PAINTERS *of the* HUMBLE TRUTH

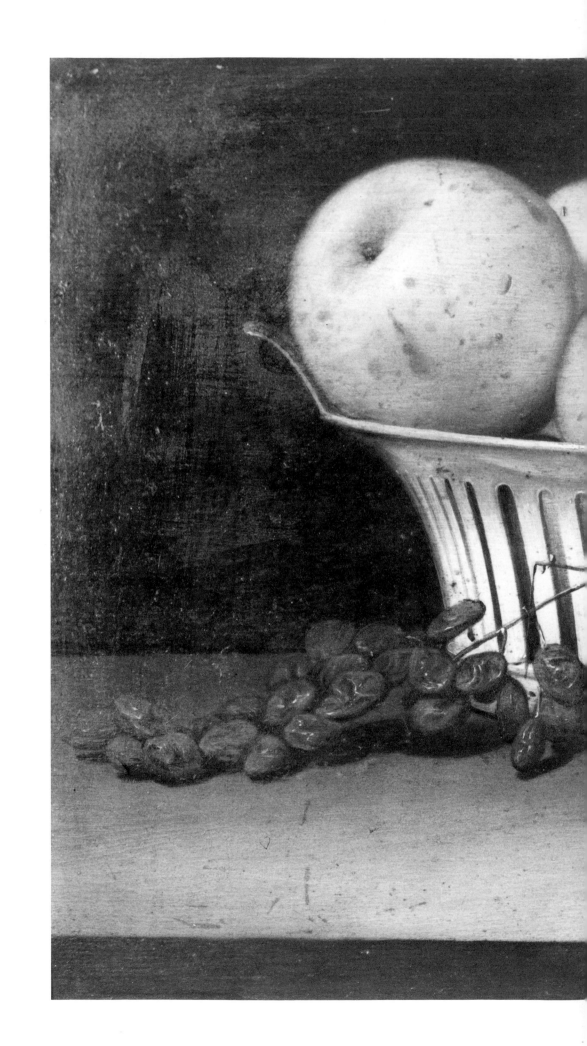

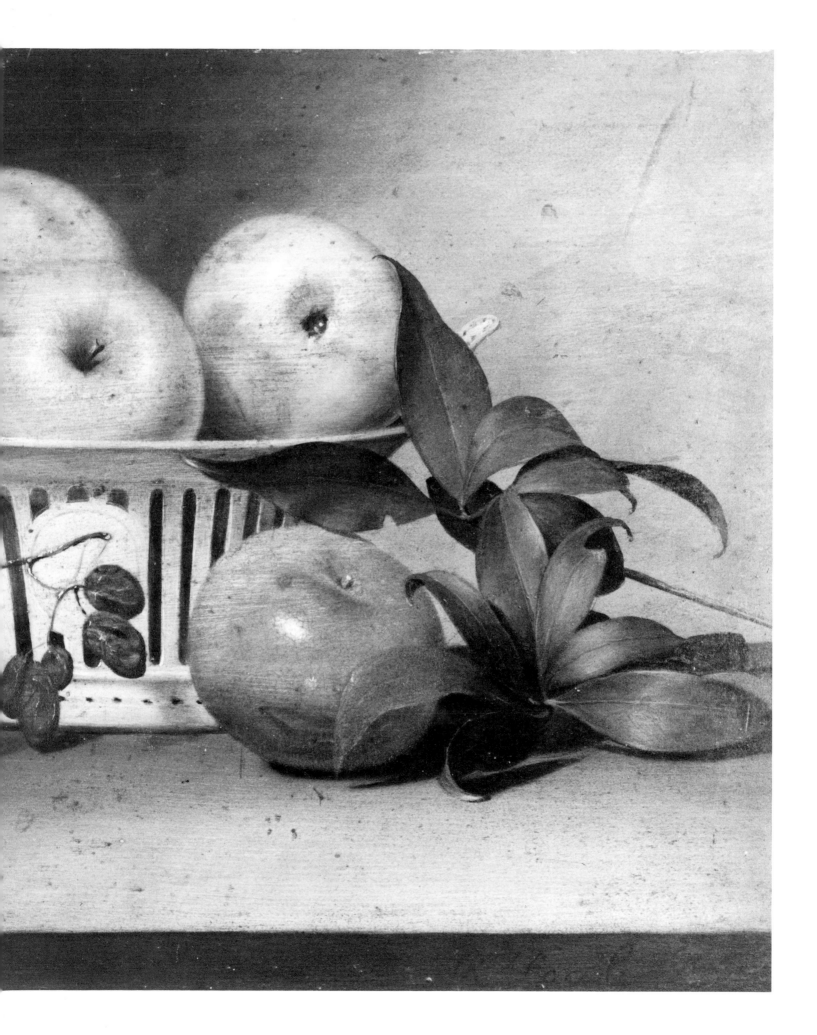

PAINTERS *of the*

HUMBLE TRUTH

MASTERPIECES
OF AMERICAN STILL LIFE
1801-1939

William H. Gerdts

Philbrook Art Center
with
University of Missouri Press
Columbia & London, 1981

Frontispiece:
RAPHAELLE PEALE (1774-1825), *Still Life with Raisins, Yellow and Red Apples and Porcelain Basket*; oil on panel, signed at lower right—*R. Peale*, 13½ x 18¾ inches; The Baltimore Museum of Art, gift of Mrs. Francis White, Collection of Mrs. Miles White, Jr.

Library of Congress Cataloging in Publication Data

Gerdts, William H.
 Painters of the Humble Truth.

 Based on: American still-life painting.
 Catalog of an exhibition held at Philbrook Art Center.
 Bibliography: p. 273
 Includes index.
 1. Still-life painting, American—Exhibitions.
I. Philbrook Art Center. II. Gerdts, William H.
American still-life painting. III. Title.
ND1392. G48 758′ .4′0973074016686 81-11400
 AACR2

ISBN 0-8262-0355-8 (cloth)
ISBN 0-8262-0358-2 (paper)

for Abbie

Contents

Preface

The publication in 1971 of *American Still-Life Painting* by William H. Gerdts and Russell Burke was an event of singular importance in historical studies of American art. Not since Wolfgang Born's *Still Life Painting in America,* published more than twenty years earlier, had an attempt been made to codify and to evaluate the entire field of American still-life painting from colonial times to the modern era. In retrospect, we see that Born's book, important though it was to our understanding in 1947, was circumscribed in its treatment of the subject. By 1971, and today, a decade later, our knowledge of American still-life painting has increased severalfold, a circumstance largely due to the investigations of scholars such as the late Alfred Frankenstein and William H. Gerdts and his students.

Art history as a distinct academic discipline, of course, is barely a century old, while American art history in its developed, professional form is largely a post-World War II phenomenon. Indeed, many of us can recall the days not long past, when European, classical, and Oriental interests so dominated university art history curricula that the very suggestion of concentration in American art was considered a sophomoric aberration. Homer the bard was apotheosized centuries ago; the apotheosization of Homer the painter was yet to occur. Generally, a cultural hierarchy has guided art historical research, just as surely as a hierarchy of subject matter had influenced art criticism, and continues to do so.

It takes a strong will, intellectual discipline, and not a small measure of energy to produce a book such as *Painters of the Humble Truth.* In its original form, it was to be merely an exhibition catalogue. The exhibition concept took shape during the early 1970s with materialization envisioned for 1976, the Bicentennial Year. With so many important exhibitions of American art being assembled to coincide with this historic celebration, it seemed logical to Dr. Gerdts and myself that a field as important as still life should not be neglected. No previous exhibition had ever attempted to illustrate the subject so exhaustively, as it has been treated by Gerdts and Burke in their work. A number of efforts were initiated to realize the concept but with no success. Large exhibitions frequently have large budgets, and budgets require funding that often is difficult to obtain.

In 1979, Philbrook Art Center in Tulsa, Oklahoma, began a program of special exhibitions that reaffirmed its commitment to serving its audience by collecting and displaying art of the finest quality and significance supported by interpretation based upon sound scholarship.

When I joined Philbrook the same year as Chief Curator, the opportunity developed to resurrect the idea of this exhibition, and when asked, Dr. Gerdts agreed to serve as guest curator, to select the paintings and to write the catalogue. With the encouragement of Jesse G. Wright, Jr., the Director of Philbrook Art Center, planning began. Despite the inevitable disappointments of not being able to borrow everything that was desired, most of what

we requested was forthcoming. As a result, nearly all of our goals have been realized.

In *Painters of the Humble Truth,* Dr. Gerdts builds upon his earlier work by refining previous concepts and by adding much information gleaned from continued research during the intervening decade. The present volume is more selective than that of 1971, treating in greater depth those artists whom the author considers most significant. At the same time, more thorough attention is given to cultural determinants and to contemporary art criticism throughout the period. What we have, then, is not only one of the most beautiful exhibitions of American art ever assembled, but a new art historical text quite distinct from a revision that should stand for some time as an essential reference work.

Working with Dr. Gerdts has been a pleasure at every step. His thorough professionalism, cordiality, and dependability have sustained all of us at Philbrook who have worked on the exhibition. More thought and time went into the manuscript than any of us had anticipated, including the author, so that the result is a book in which Philbrook is highly gratified to share the author's pride. The selection of the paintings, also, was considered with great care. Only outstanding examples were considered, and in the handful of cases where the best could not be borrowed, substitutes of lesser quality were allowed but reluctantly. Fortunately, lenders have been so generous that the exhibition has few lacunae, and none of serious consequence.

Philbrook, therefore, extends its deep appreciation to Dr. William H. Gerdts for all things personal and professional. To the many lenders, also, we are grateful for a display of generosity that allows these treasured paintings to be shared with others. Several notable private collectors and museums, through their early understanding and support, were extremely helpful in persuading others of the importance of this undertaking. The Oakland Museum, The Baltimore Museum of Art, the National Academy of Design, and the University of Missouri Press were essential partners without whom the exhibition and publication could not have been realized.

To thank all of those at Philbrook who deserve thanks would be to name the entire staff. Small museums such as ours only function through cooperating and sharing responsibility. Under the leadership of its President/Director, Jesse G. Wright, Jr., everyone gave the extra measure that so frequently marks the difference between defeat and success. It is a task well done.

John A. Mahey
Vice-President/Chief Curator
Tulsa, Oklahoma
May 1981

Acknowledgments

In offering appreciation to the many persons to whom I am indebted, my first responsibility is, with pleasure, to my friend, colleague, and former coauthor, Russell Burke, with whom I coauthored *American Still-Life Painting*, which was published in 1971. Russell has continued to share my interest in the subject and to support my efforts in this direction and I am extremely grateful and indebted to him.

Many other individuals have also been of great importance. To name all of them would be to recite the names of almost all the teachers of American art history, the staffs of most American museums with significant still-life holdings, and the dealers who have specialized in American art. To name only those who have been of the greatest assistance, I should begin with John K. Howat, Curator of American Paintings and Sculpture at the Metropolitan Museum of Art in New York City, and Doreen Burke, Assistant Curator there and wife of my former coauthor. Much gratitude is also due to Frank Goodyear, Curator, and Kathleen Foster, Assistant Curator, of the Pennsylvania Academy of the Fine Arts; to Dr. Theodore Stebbins, Jr., Curator of American Painting at the Museum of Fine Arts in Boston; to Elaine Evans Dee, Curator of Prints and Drawings of the Cooper-Hewitt Museum; to Bruce Weber, Curator of the University of Kentucky Museum of Art; to Catherine Hoover; the late Alfred V. Frankenstein; Marjorie Dakin Arkelian; Paul Magriel; Robert C. Graham; James Maroney; Antoinette Kraushaar of the Kraushaar Galleries; Deedee Wigmore of the Kennedy Galleries, Inc.; Sidney Bergen and Linda Hyman of the ACA Galleries, Inc.; and R. Frederick Woolworth and Jerald Fessenden of the Coe Kerr Galleries, Inc. Special thanks are extended to Mr. and Mrs. Richard Manoogian, for their great support; to Mr. and Mrs. B. B. Millhouse, for acquiescing to the disruption, for a year, of not one household but two; and to James Ricau, for agreeing to lend a sizable group of marvelous pictures for the umpteenth importuning on my part, and for the inspiration derived from his own zeal that led me toward the study of still-life painting in the first place.

I owe a great debt to Jesse G. Wright, Jr., President and Director of Philbrook Art Center, and even more to my good friend and colleague, John A. Mahey, Vice-President and Chief Curator of the Philbrook Art Center, for their faith in my efforts and for their complete support. And finally, of course, much more than gratitude is due to my wife, Abigail. She has shared in the pleasures of promised generosity and has sympathized in the disappointments that inevitably befall. There have been times when I thought she would have painted a work herself to alleviate the hurt of a failed expectation. I am forever grateful.

W. H. G.

New York, New York
May 1981

PAINTERS *of the* HUMBLE TRUTH

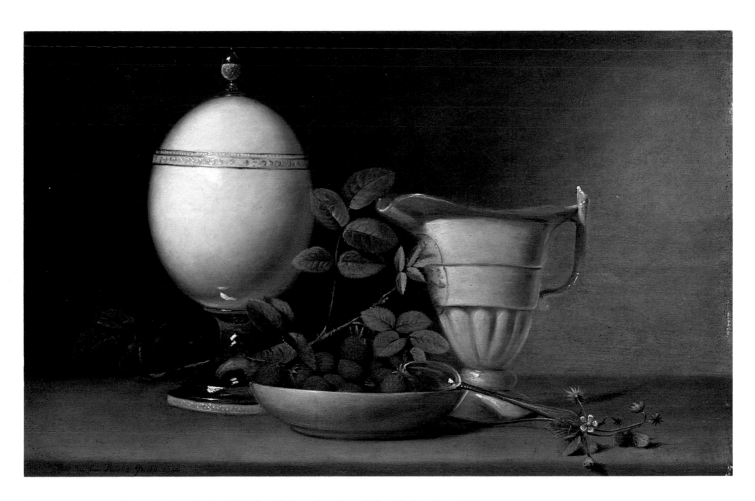

Plate 1. RAPHAELLE PEALE (1774-1825), *Still Life with Strawberries and Ostrich Egg Cup*, 1814; oil on panel, signed at lower left — *Raphaelle Peale*, 12¼ x 19¼ inches; Private Collection (see Chapter 3).

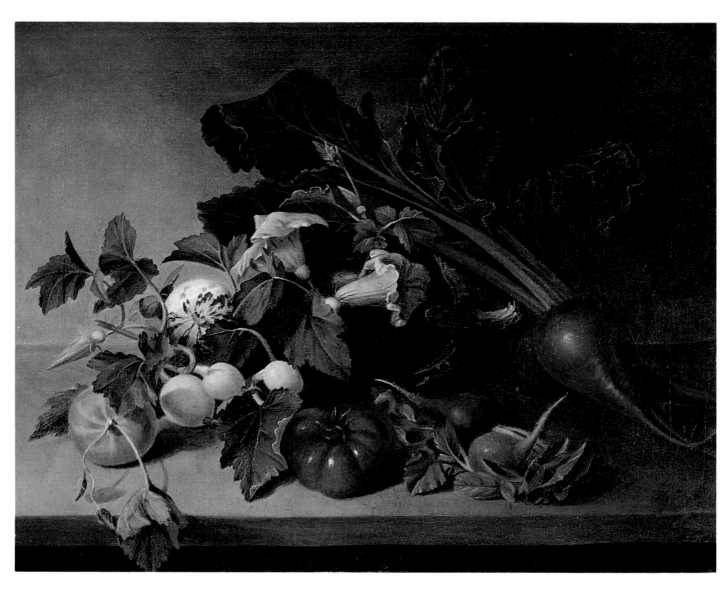

Plate 2. JAMES PEALE (1749-1831), *Vegetables with Yellow Blossoms,* 1828; Oil on canvas, 19¹³⁄₁₆ x 25⅜ inches; The Henry Francis du Pont Winterthur Museum (see Chapter 3).

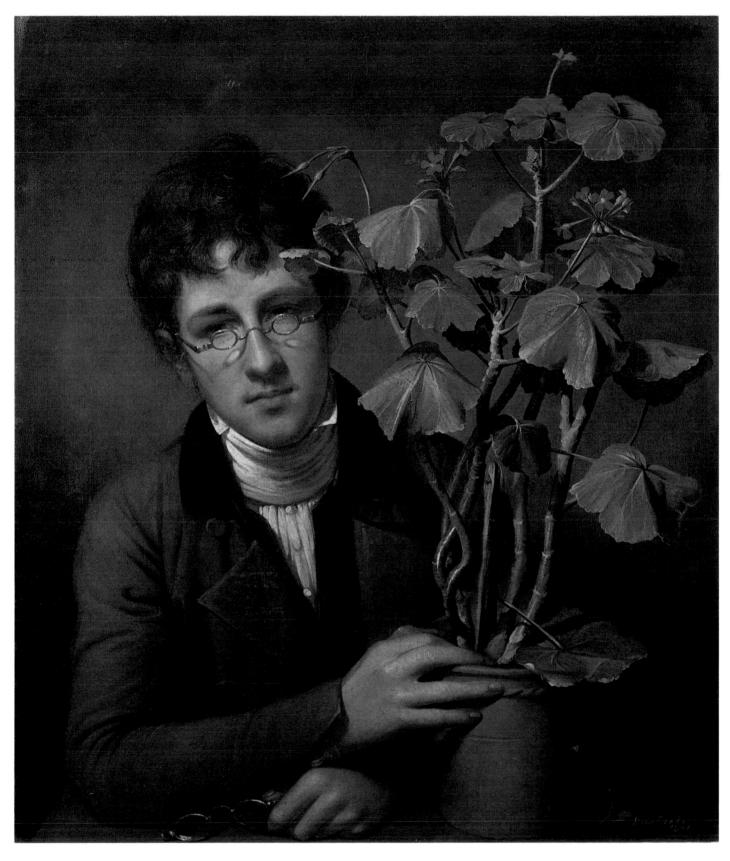

Plate 3. REMBRANDT PEALE (1778-1860), *Rubens Peale with Geranium*, 1801; oil on canvas, 28 x 24 inches; Mrs. Norman B. Woolworth (see Chapter 3).

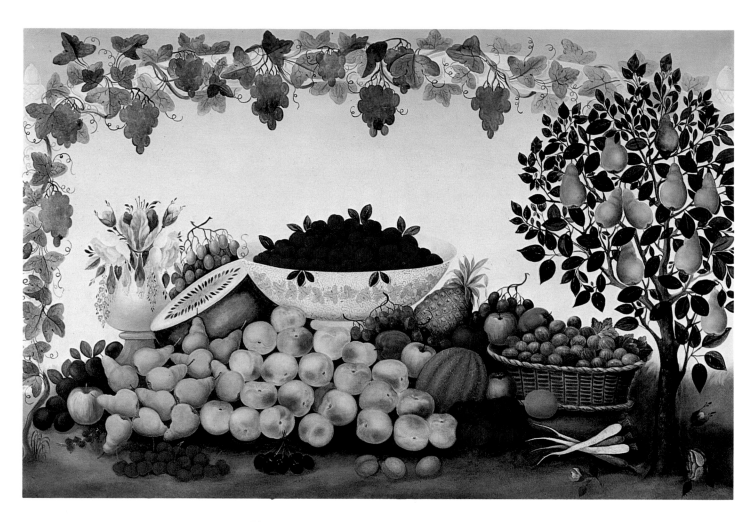

Plate 4. Isaac Nuttman (active 1835-1872), *Still Life*, circa 1865; oil on canvas, signed verso
— *I. W. Nuttman Painter/8 Coes Place*, 40¼ x 60 inches; Mr. and Mrs. William E. Wiltshire
III (see Chapter 4).

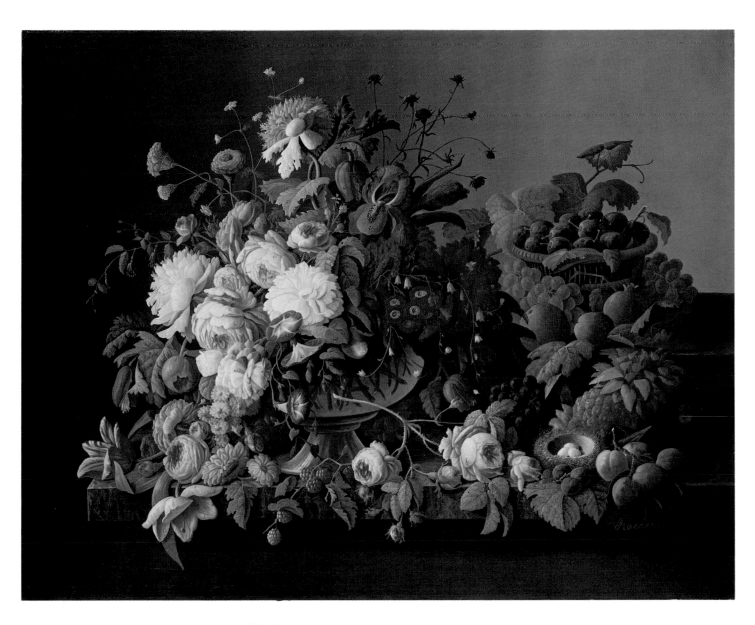

Plate 5. SEVERIN ROESEN (circa 1815-1871), *Still Life: Flowers and Fruit;* oil on canvas, signed at lower right — *Roesen,* 40 x 50⅜ inches; The Metropolitan Museum of Art; Charles Allen Munn bequest; Fosburgh Fund, Inc., gift; Mr. and Mrs. J. William Middendorf II, gift; and Henry G. Keasbey bequest (see Chapter 5).

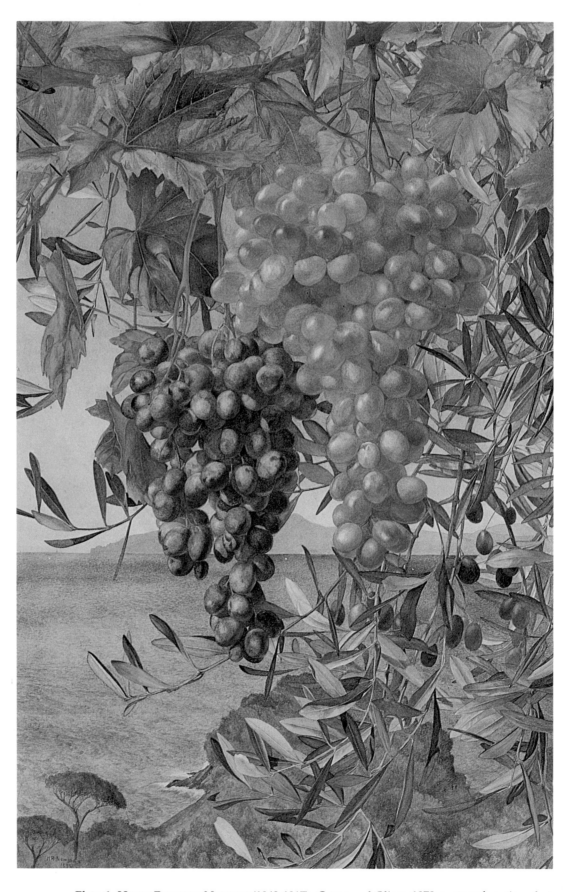

Plate 6. HENRY RODERICK NEWMAN (1843-1917), *Grapes and Olives,* 1878; watercolor, signed at lower left — *H. R. Newman,* 26 x 17 inches; Mr. and Mrs. Wilbur L. Ross, Jr. (see Chapter 5).

6

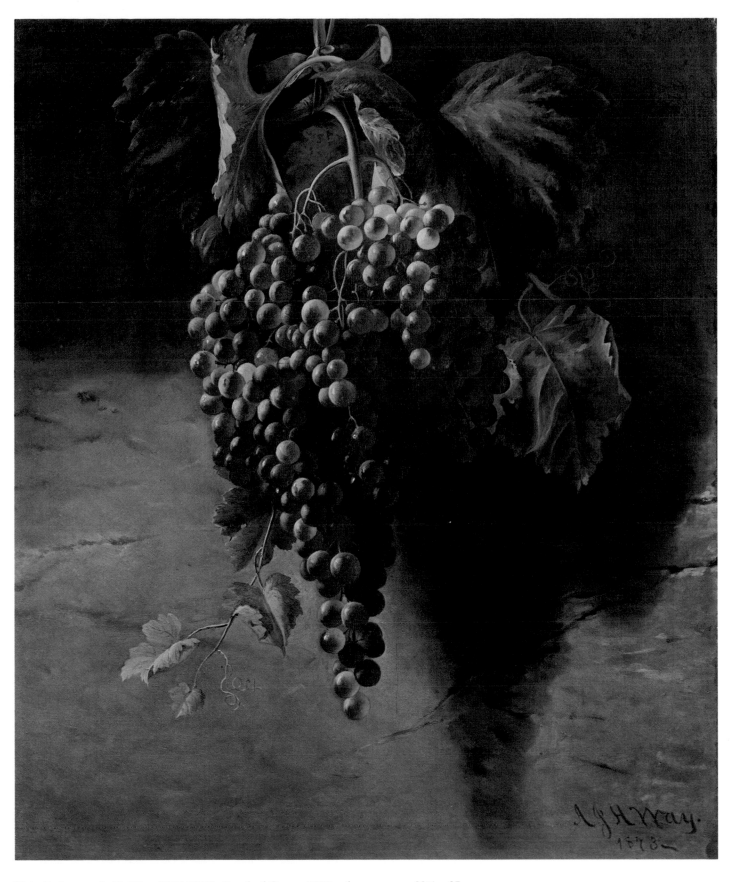

Plate 7. ANDREW J. H. WAY (1826-1888), *Bunch of Grapes*, 1873; oil on canvas, 29¾ x 25 inches; courtesy of the Walters Art Gallery, Baltimore (see Chapter 5).

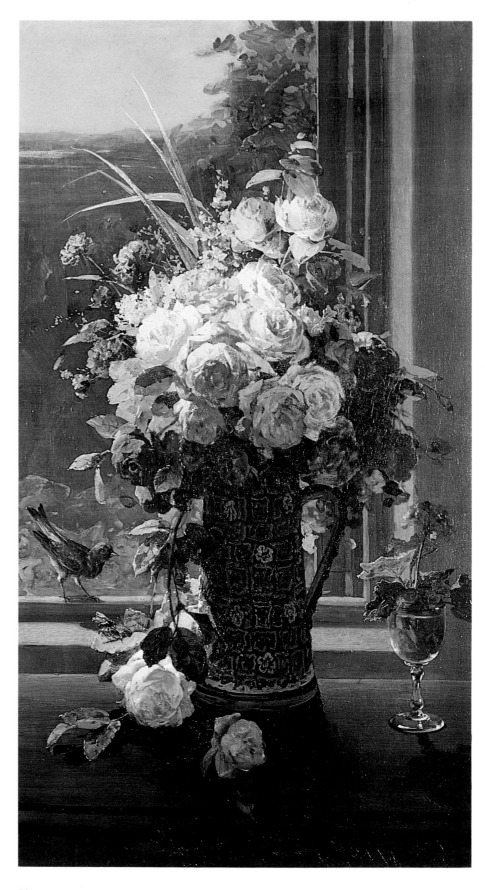

Plate 8. THOMAS HILL (1829-1908), *Flowers in a Window;* oil on canvas, signed at lower left — *T. Hill,* 36 x 20 inches; Collection of the Oakland Museum, gift of the Kahn Foundation (see Chapter 5).

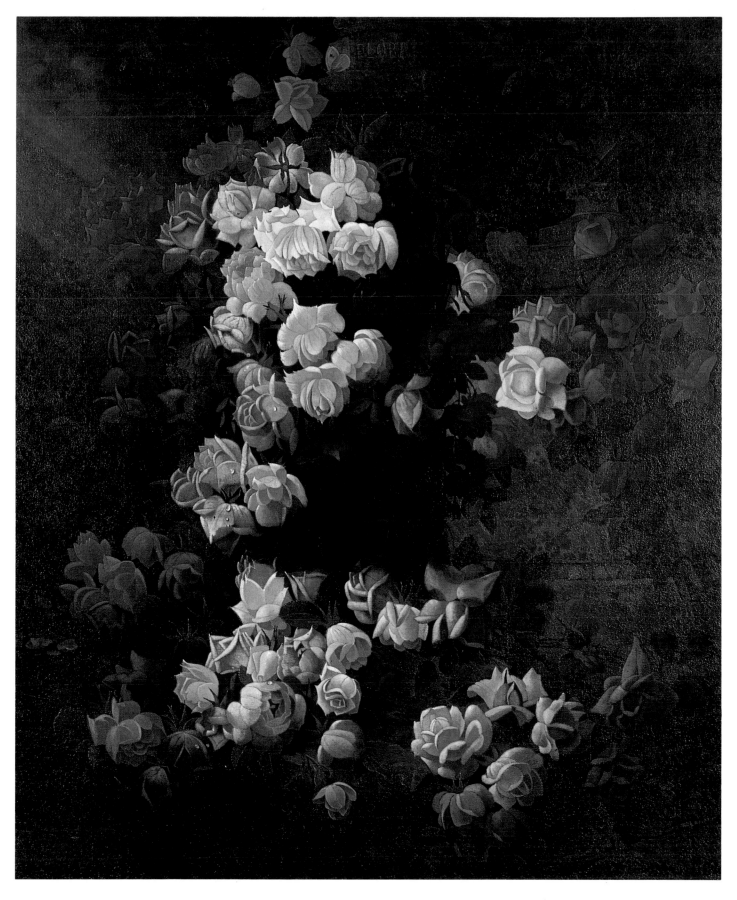

Plate 9. EDWIN DEAKIN (1838-1923), *Homage to Flora*, 1903-1904; oil on canvas, signed at
lower left — *Edwin Deakin 1903-4*, 36 x 30 inches; Private Collection (see Chapter 5).

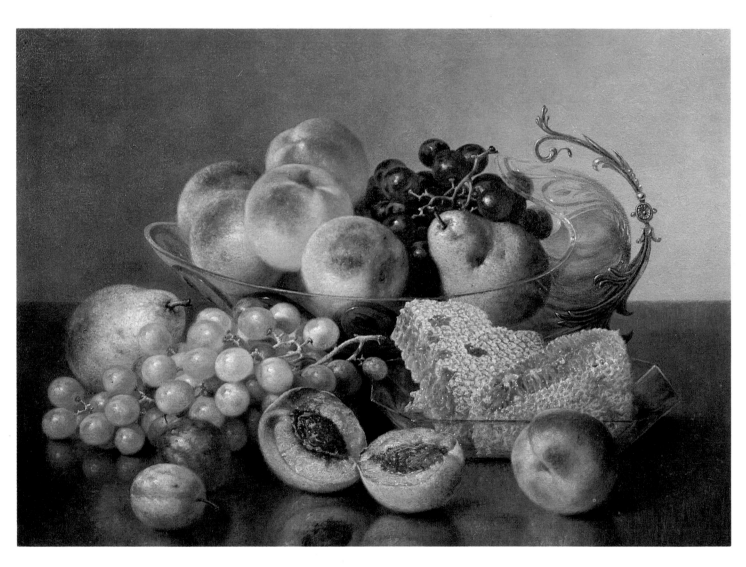

Plate 10. ROBERT SPEAR DUNNING (1829-1905), *Still Life*, 1892; oil on canvas, signed at lower right — *R. S. Dunning*, 18 x 22 inches; Jerald Dillon Fessenden (see Chapter 5).

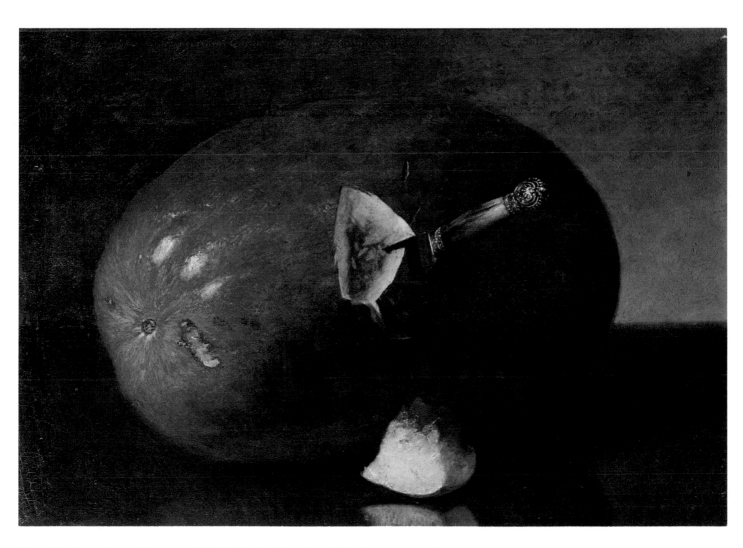

Plate 11. ROBERT SPEAR DUNNING (1829-1905), *The First Cut*, 1899; oil on canvas, signed at lower right — R. S. D. '99, 12½ x 17¼ inches; Collection of Mr. and Mrs. Warren Adelson, New York (see Chapter 5).

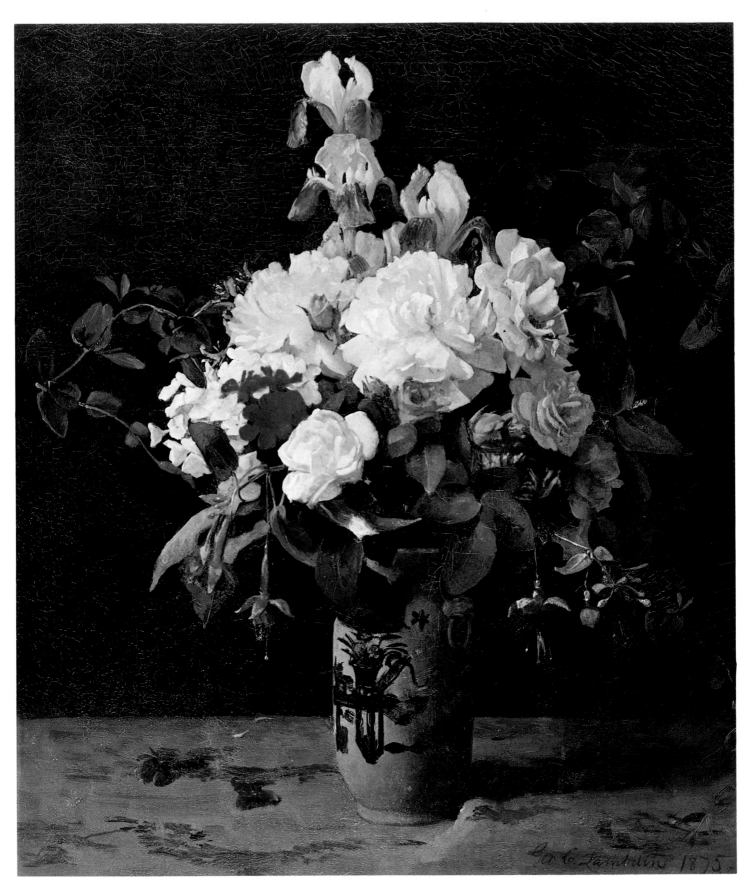

Plate 12. GEORGE COCHRAN LAMBDIN (1830-1896), *Flowers in a Vase,* 1875; oil on canvas, signed at lower right — Geo. C. Lambdin, 24⅛ x 20¼ inches; Private Collection (see Chapter 6).

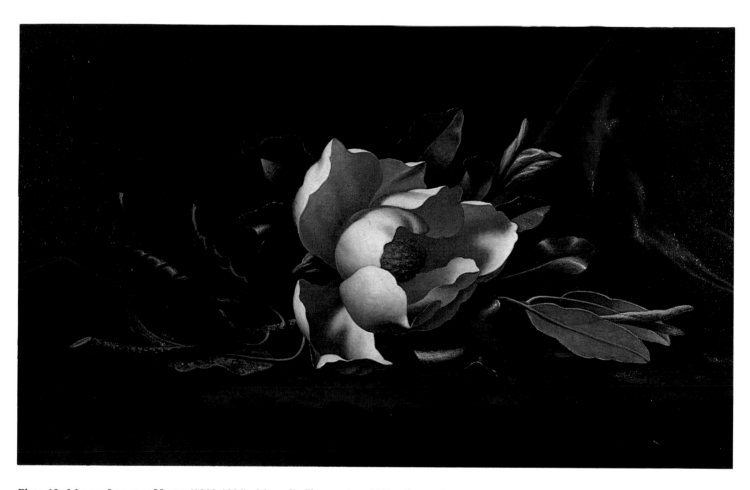

Plate 13. MARTIN JOHNSON HEADE (1819-1904), *Magnolia Flower*, circa 1888; oil on canvas, signed at lower right — *M. J. Heade*, 15⅜ x 24 inches; The Putnam Foundation, Timken Art Gallery, San Diego, California (see Chapter 6).

Plate 14. SAMUEL MARSDEN BROOKES (1816-1892), *Still Life*, 1862; oil on canvas, signed at lower left — *S. M. Brookes/Pinxt 1862*, 34 x 44 inches; Crocker Collection, Crocker Art Museum, Sacramento, California (see Chapter 6).

Plate 15. JOHN LA FARGE (1835-1910), *Flowers on a Window Ledge,* circa 1862; oil on canvas, signed at lower center — *La Farge,* 24 x 20 inches; in the Collection of the Corcoran Gallery of Art, Anna E. Clark Fund, purchase (see Chapter 7).

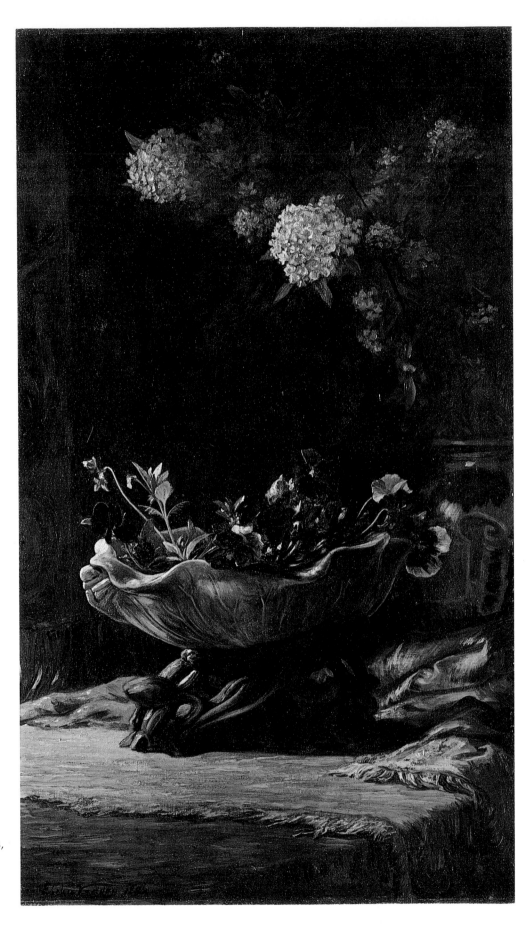

Plate 16. ELIHU VEDDER (1836-1923),
Pansies and Spirea, 1882; oil on canvas,
signed at lower left — *Elihu Vedder,
1882*, 28³/₁₆ x 16⁵/₁₆ inches; Yale
University Art Gallery, gift of JoAnn
and Julian Ganz, Jr. (see Chapter 7).

1 American Still-Life Painting

Explanations, Estimations, Expectations

The primary focus of this study is on the development of still-life painting in the United States, from its origin to about 1940. Particular attention is given to artists who chose this theme as their major, sometimes sole, area of specialization. However, the very occasional, and unique, still lifes painted by artists who are otherwise renowned for portraiture, landscape, genre, and history subjects are also fascinating, and some examples of such rare work by artists such as Winslow Homer and Sanford Gifford are included here.

While most still lifes are painted in the oil medium, we occasionally encounter examples in watercolor and pastel. In general, still-life artists did not produce extensively either finished still-life drawings or preparatory sketches. The reasons for these lacunae are not difficult to fathom. The lack of finished drawings probably stems from an attitude toward color as being essential for the transcriptional context in which still lifes were seen and estimated. Still-life sketches are rare because most still lifes were painted directly from fairly fixed models (although the majority of such models were prone to relatively speedy aging and disintegration), and there was no need to make quick recordings or notations "on the spot" that were to be worked up later into studio compositions. Nevertheless, highly finished still-life drawings are known by such diverse artists as James M. Hart and William Michael Harnett, while sketches for finished oil paintings, some of them located works, have been discovered by even such relatively obscure artists as Paul Lacroix. An exhibition of American still-life drawings would probably be an interesting and instructive experience.

Still-life prints were not created very often by American graphic artists in the nineteenth century. The only pure examples of that theme, by Whistler for instance, are prints. John Henry Hill, one of the leading American Pre-Raphaelites, produced a series of nature studies done in etching that follow the dicta of John Ruskin.[1] As Ruskin espoused, he concentrated upon the unobstructive and seemingly uncomposed elements of nature. But there were two other areas of graphic art that witnessed a great deal of still-life pictorialization. The earlier of these developments was the American concern with the scientific documentation of native plants and fruits in botanical books. John Bartram, of Philadelphia, was America's first great botanist; his son William was also a naturalist and a painter of American fauna and flora, many of whose drawings are now in the British

[1] See the etchings in John Henry Hill's *John William Hill: An Artist's Memorial,* and in his *Sketches from Nature.*

GARDEN ORCHARD AND VINE.

Figure 1.1. FRANCES BOND PALMER, *Still Life;* chromolithograph; published by Currier & Ives.

Museum. The younger Bartram drew the botanical illustrations for Benjamin Smith Barton's *Elements of Botany,* which was published in 1803. Although many of the earliest botanical books were unillustrated, pictures were essential to the purposes of such volumes. Therefore, the use of illustrations became standard with the publication of Jacob Bigelow's *American Medical Botany* (1817-1820). (Dissatisfied with the first illustrations prepared for his publications, Bigelow drew his own designs.) As the science of botany progressed in this country, more elaborate and more professionally illustrated publications appeared. Beginning in the 1830s, they took the form of individual volumes, illustrated magazines, such as the *Horticulturist,* and various gardners' journals. Probably the most beautiful of all was William Draper Brickle's *Northern American Pomologist* (1860), which is illustrated with hand-colored prints by Alfred Hoffy, who also illustrated the *Orchardist's Companion,* published in Philadelphia between 1841 and 1843.

Besides Hoffy, three other major botanical illustrators stand out: William Sharp, Isaac Sprague, and Edwin Whitefield. Sharp was an Englishman who settled in America in the late 1830s. Although he illustrated

Charles Hovey's *Fruits of America* (1847-1852), he was, like the others mentioned here, more active in floral illustrations than in pomological and orchardist subjects. Sharp's floral masterpieces are his six brilliant chromolithographs in John Fisk Allen's *Victoria Regia; or the Great Water Lily of America*, published in 1854. Sharp was the first practitioner of chromolithography in the United States. He had previously prepared the illustrations for Morris Mattson's *American Vegetable Practice* (1841), for the *Transactions of the Massachusetts Horticultural Society*, and Anna Dinnies's sentimental *Floral Year*, both in 1847.

Isaac Sprague was an assistant to John James Audubon before he wrote and illustrated *Flowers from Field and Forest* in 1848-1849. His continuing interest in floral illustration is indicated in his chromolithographs for George Lincoln Goodale's *The Wild Flowers of America* (1882).

Perhaps the best known of all the floral illustrators is Edwin Whitefield, also a native Englishman. His work appeared first in Emma Embury's *American Wild Flowers in Their Native Haunts* (1845), in which he presented delicately colored flowers against faint monochrome landscape backgrounds. This was quickly followed in 1846 by some of the plates in John B. Newman's *The Illustrated Botany of New York*, and Asa Strong's *American Flora* which began to appear in 1846; by 1855, four other volumes finally appeared. (Other related scientific areas involving still-life illustrations include publications relating to shells [conchology], eggs [oology], mushrooms, and gems.) Less scientific in nature were the many sentimental flower books, which were popular in this country from the 1830s through the 1850s. They were usually authored by women, and specific blooms were often matched with touching poetry. The better known among these sometimes contained scientific descriptions and histories of specific flowers. However, the illustrations were usually far less accurate and detailed, if often garishly colored, than those that appeared in the scientific publications.

The other graphic development was that of the popular lithographic prints that were published as decorative schemes for a home.

The earlier ones were hand colored over a monochrome printed design. The firm of Currier & Ives provided the largest and best known of these inexpensive lithographs, which were ideal for mass decoration. The firm's most famous staff artist was Frances Bond Palmer — Fanny Palmer, as she is better known — who prepared a number of the Currier & Ives still-life prints, though this was certainly not her only theme. However, the newer process of chromolithography, that is, printing with successive stones or sheets of color registry rather than hand coloring, rapidly supplanted the earlier form in the 1840s. By far, the most popular firm to specialize in this art was Louis Prang and Company. Due to Prang's own proclivity toward still life and floral designs, these were much featured as chromolithographs by his firm. Prang employed the talents of a number of very able staff flower specialists, many of them women, such as Fidelia Bridges and Ellen Fisher. Indeed, he provided new means of utilizing still-life prints, as will be discussed later. When at their best, his prints, and those produced by other firms, were fine works of art. Despite its subsequent reputation as a cheap and vulgar parody of fine art, the chromolithograph, or chromo, as it was known, was often a print of great beauty displaying consummate technical craft.[2]

[2]There has been no adequate study of the scientific floral, horticultural, and pomological illustrations in America. For the independent flower print, and particularly its popularity in chromolithography, see Peter Marzio, *The Democratic Art*, and Katherine M. McClinton, *The Chromolithographs of Louis Prang*. Neither of these deals solely with flower prints, of course, but both are quite concerned with the theme. See, for instance, McClinton, *Chromolithographs of Louis Prang*, Chap. 6, "Prang and Flowers," pp. 91-102. See also Katherine M. McClinton, "American Flower Lithographs," *Antiques* 4.9 (June 1946): 361-63.

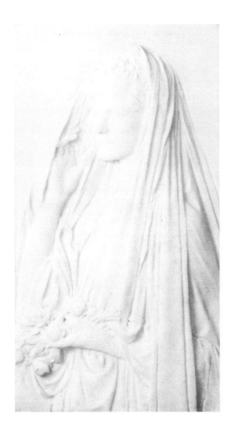

Figure 1.2. AUGUSTUS SAINT-GAUDENS (1848-1907), *Mrs. Stanford White;* marble sculpture, bas-relief; Saint-Gaudens National Historic Site.

[3]Mariana Van Rensselaer, "Flower and Fruit Pictures at the Academy of Design," *Garden and Forest* 1 (25 April 1888): 108. References to Van Rensselaer's still-life articles can be found in Cynthia Doering Kinnard, "The Life and Works of Mariana Griswold Van Rensselaer: American Art Critic" (Ph.D. diss., The Johns Hopkins University, 1977), pp. 260, 299. See also Lois Dinnerstein, "Opulence and Ocular Delight, Splendor and Squalor: Critical Writings in Art and Architecture by Mariana Griswold Van Rensselaer" (Ph.D. diss., The City University of New York, 1979); articles on still-life are listed on pp. 380, 387.

Nevertheless, the major printers in the nineteenth century were only occasionally involved in providing still-life designs for the prints of either the scientific, sentimental books and magazines or the popular, commercial, independent prints.

Likewise, the rare appearance of still life in sculpture is omitted here, despite the fascination of a small number of isolated examples that have surfaced. One such work is the carved and painted wooden pear documenting a piece of fruit grown in 1805 by David Choate, of Chebacco in the old South Parrish of Ipswich, Massachusetts, which weighed thirty-seven and a half ounces. Samuel McIntire, the famous architect, furniture designer, and occasional sculptor, did the carving; the painting has been variously ascribed to Michele Felice Corné and to Robert Cowan. In the latter part of the century, and at the other end of the scale, are the roses held by Mrs. Stanford White in the delicate bas-relief carved in 1884 as a wedding gift for the Whites by their good friend Augustus Saint-Gaudens. Though here the floral arrangement functions only as an accessory and attribute, it was found sufficiently striking to attract the attention of that most perceptive of late nineteenth-century critics, Mariana Van Rensselaer, who wrote in 1888:

> If it seems to be difficult to paint flowers well, and especially Roses, what must it be to carve them in marble? Yet even this task is not beyond the power of a good artist. The Roses which the lady holds in her hand whom Mr. St. Gaudens has portrayed in a marble low-relief, are absolutely perfect in their truth to the grace, the delicacy and the poetry of the flower.[3]

What are included in this essay as matters of discussion are paintings of subjects that constitute the traditional concept of still life: pictures of fruits, flowers, vegetables, and other edibles; dead game of all kinds; arrangements of man-made objects that were particularly popular at the end of the nineteenth century, especially books, musical instruments, and sheet music; *objets de virtu,* that is, fine and precious examples of antique or pseudo-antique ceramic, glassware, and metalwork together with their more rustic counterparts, and especially money, both coins and bills. To grossly simplify the development of still-life painting in the nineteenth century, one can point out that such painting in the first half of the century consisted primarily of pictures of fruits, and, occasionally, vegetables. The concept of flower painting was introduced about 1840. It began to be more popular by the 1850s and by the end of the century had outdistanced fruit painting in popularity. Game and fish pictures — hunting and fishing trophies — began to be common in the 1860s. They continued to be produced in large numbers through the end of the century when they were taken into the repertory of the trompe l'oeil or "deceive the eye" specialists who also concentrated upon pictures of man-made objects but tended to ignore subjects that were related to nature. With the more formalist considerations of the early twentieth century, fruit and flower subjects appear to have been equally popular. They shared this popularity with arrangements of man-made objects, often of a mundane character, chosen for expressive gesture, coloration, or structure.

A thematic area related to still-life painting also considered here is that of nature studies — flowers growing in a field, for example, or a bough of fruit, leaves, or blossoms. This theme derives from landscape, but instead of presenting a sweeping view, it focuses upon living forms in nature. Such paintings are included because they were usually depicted by still-life spe-

cialists and were the still-life subjects particularly favored by the English critic John Ruskin, whose work greatly influenced American artists beginning in the late 1840s. The nature study and the related approach of painting a traditional still-life subject in a natural setting both began to gain much favor in the 1860s. Two decades later, the nature study effloresced into the popular theme of the flower garden, which again falls into a penumbral area between still life and landscape.

Vanitas, another traditional theme that was once very popular in the repertory of still life, was undertaken rarely by American artists. Such pictures, usually characterized by the introduction of a skull — sometimes together with other symbols of temporality — were produced throughout Europe in the seventeenth century. However, the city of Leiden in Holland appears to have been the starting point and center for their popularity, perhaps due in part to the influence of theological theories and beliefs that were implicit in the teaching at the university there.[4] A phenomenon in American art that is both fascinating and in need of further investigation is the reemergence of these motifs at the end of the nineteenth century in the work of William Michael Harnett and some of his followers. This reemergence is particularly interesting when we recall the contemporaneous depictions of skulls and skeletons in the work of Vincent van Gogh, Paul Cézanne, Arnold Böcklin, Hans Thoma, Max Liebermann, and others, particularly of the late nineteenth-century German school.

A major difficulty in tracing and in studying the development of American still-life painting, at least until the early years of the twentieth century, is the paucity of critical discussion. Portraiture, landscape, and history painting were discussed not only in terms of their leading practitioners but also in terms of the directions, implications, and relative merits of the different genres. Such was not the case with still life. When it was mentioned at all — and that was seldom — it was usually denigrated as a theme not worthy of serious consideration by either critic or artist. Indeed, the dismissal of still-life painting had been institutionalized early on. As early as 1669, Andre Félibien presented the following definition of the hierarchy of artistic themes in his lectures for the French Royal Academy:

> It is certain that to the degree that painters are concerned with the most difficult and most noble things, they are separated from the lowest and most common, and ennoble themselves by more illustrious work. Thus, those that do landscape perfectly are above those who only created fruits, flowers and shells. Those who paint living animals are more worthy than those who represent only dead things without movement; and as the figure of man is the most perfect work of God on earth, it is thus certain that he who acts in imitation of God in painting human figures is much more excellent than all others . . . a painter who does only portraits has not yet attained the high perfection of Art, and cannot expect to receive the most knowing honor. It is necessary for him to pass from the single figure to the representation of several together; it is necessary to treat history and mythology; it is necessary to represent the great battles as the Historians, or agreeable subjects as the Poets; and to climb still higher, it is necessary through allegorical compositions to reveal through the veil of myth the virtues of great men, and the most exalted mysteries. One calls a great Painter he who acquits himself well of such enterprise.[5]

Félibien builds his hierarchy here from the bottom up, and at the bottom we note the fruits, flowers, and shells, the constituency of still-life painting. This hierarchy is repeated and maintained for almost two centur-

[4]See *Ijdelheid der Ijdelheden, Hollandse Vanitas-voorstellingen uit de zeventiende eeuw* (exhibition catalogue; Stedelijk Museum "De Lakenhal," Leiden, 1970). See also Naomi Popper-Voskuil, "Selfportraiture and Vanitas Still-Life Painting in 17th-Century Holland in Reference to David Bailly's Vanitas Oeuvre," *Pantheon* 31 (January-March 1973): 58-74.

[5]See the preface in Andre Félibien, *Conferences de l'Academie Royale de Peinture et de Sculpture,* (Paris, 1669), reprinted in vol. 5 of *Entretiens sur les vies et sur les ouvrages des plus excellens peintres,* (5 vols., Trevoux, 1725), pp. 310ff.

ies throughout the Western world with remarkable consistency. When a grudging admiration for the lowly art of still life was ccasionally acknowledged, it was usually in the form of damning with faint praise. If Félibien represents the academy's critical opinion in the seventeenth century, then Sir Joshua Reynolds's discourses to his students at the Royal Academy in London are certainly indicative of the beliefs in the eighteenth century — of the artists, critics, and patrons. Reynolds's discourses continued to be read as gospel by many nineteenth-century artists as well. Concerning still-life painting, he opined:

> Even the painter of still life, whose highest ambition is to give a minute representation of every part of those low objects which he sets before him, deserves praise in proportion to his attainments; because no part of this excellent art, so much the ornament of polished life, is destitute of value and use. These, however, are by no means the views to which the mind of the student ought to be *primarily* directed.[6]

[6]Sir Joshua Reynolds, *Discourses on Art*, 3d Discourse, ed. Robert Wark (1770; reprint ed., San Marino, Calif., 1959), p. 52.

We see in Reynolds's statement some of the apparent limitations in the genre of still life and ome of the objections that were raised against it as serious art. A still life represents "low objects"; the artist who chooses the theme has as his ambition only "minute representation." This reiterates Félibien's hierarchical concept that the value of successive thematic concerns rested upon two challenges, one technical the other philosophic and moral. Great art should be aesthetically demanding and it should be edifying and inspirational; still life is neither.

Allegiance to thematic hierarchy was not only pledged by American art students studying at London's Royal Academy schools, but it was acknowledged by American critics as well. Daniel Fanshaw, reviewing the second annual exhibition of the newly formed National Academy of Design in the *United States Review and Literary Gazette* (July 1827), defined the hierarchy in a preamble to organizing his review according to the thematic categories contained therein:

> It is no easy task to classify the subjects of criticism in the fine arts, so as to give to each its proper rank and due share of attention. The departments of art are so various, and so disproportioned in their relative value, that it is exceedingly difficult to construct a just scale. . . . Imperfect as the scale may be, we shall make the attempt at something like a just classification, taking as the leading principle, that that department or that work of art should rank the highest which requires the greatest exercise of mind, or, in other words, that mental is superior to manual labor.

Fanshaw went on to list the ten categories of painting in descending order of significance; sculpture, architecture, and engraving were followed with briefer subcategorization. The ten were: (1) Epic, Dramatic, Historic, each defined separately with the implication given that epic was superior to dramatic, and dramatic was superior to historic; (2) Historical or Poetic Portrait; (3) Historical Landscape; (4) Landscape and Marine Pieces, compositions; (5) Architectural Painting; (6) Landscape Views and Common Portraits; (7) Animals, Cattle Pieces; (8) Still Life and Dead Game; (9) Sketches; and (10) Copies.

As Fanshaw reviewed the works in the exhibition following this series of categories, still lifes were not discussed for many pages. When they were, they were few in number and briefly reviewed. Nevertheless, he devoted considerably more attention to still-life painting than did most critics of other or subsequent exhibitions, and his observations explain why:

The peculiar merit of this class of pictures consists of their *exactness of the imitation*. A single glance proves their success in this excellence; it is one that is always so striking; that most persons think it to be the great and most difficult attainment of painting; this is a great mistake. It is not the only instance where minor excellencies are exalted above greater. We can only observe, at present, that *exactness of imitation* is not the chief aim of painting, and that, although exceedingly fascinating, it ranks *low* when considered *separate* from other and higher qualities. The department we are considering although it ranks thus low in the scale of works of art, has always been popular, and for the very obvious reason, that its chief merit is intelligible to all.[7]

If we look back at Fanshaw's subdivision, we see that landscape *compositions* rank higher than landscape views. While in contemporary usage all pictures have some sort of composition, the term was used differently in the nineteenth century. It implied that the artist had composed his work and had assembled it from a variety of separate studies, transposing elements from nature into a scene that, though it was invented by his imagination, still derived from nature in the sense that it expressed his experience in the landscape. And this was *superior* to the common view. The point here is that in nineteenth-century critical terms, transcriptional representation was aesthetically inferior to invented imagery, and still-life painting for such critics could only be transcriptional. True, an artist might succeed in rendering faithfully the minutiae of that transcription, but that would only attest to his paucity of invention, and both Félibien and Reynolds had already defined the lowness of the subject choice.

Today we recognize the individuality that an artist could — and many did — bring to a rendering of the various substances of the still life. We see that still life may suggest the good life or it may impart gloom. It may reflect cultural conditions, economic progress, and social inequities. Prior to the end of the nineteenth century, this was seldom acknowledged, either here or abroad. For instance, four years after Fanshaw's review, a critic commented in the prestigious *North American Review* concerning the annual exhibition of paintings held at the Boston Athenaeum in 1831:

> But, much as we rejoice in the progress of the Fine Arts, we confess we care comparatively little about the merely mechanical labor that is sometimes called by that name. We do not think the country would be much benefited or its character much elevated, if our artists could paint brass-kettles as well as Ostade, or dead game as well as Snyders. The painter who copies such things, is indeed likely to be somewhat more refined than the tinker or cook who handles the originals; but he is still further removed in an opposite direction from the artist, who endows with form and color the beautiful objects of his own invention, or embodies in portrait the intellect and character as well as the features of the face. We would not absolutely denounce what is called still-life painting, but we value it very lightly; and we protest against admitting among productions of the Fine Arts, those works, of which the whole supposed merit consists in an imitation of what is in itself entirely insignificant, and the highest aim of which is to produce a momentary deception.[8]

Likewise, in the following article in the *American Review* (November 1843), a critic dismissed still-life painting with the following words:

> Before concluding our hasty remarks, we would mention that there is a class of paintings, the sole value of which, arises from their high finish, delicacy of touch, and the manual, technical skill which they exhibit. They are interesting to all as curiosities, and their study may be highly useful to artists. They

[7]Daniel Fanshaw, "The Exhibition of the National Academy of Design, 1827," *The United States Review and Literary Gazette* 2 (July 1827): 241-63; see especially pp. 244, 257-58.

[8]"Exhibition of Pictures at the Athenaeum Gallery," *North American Review,* 33 (October 1831): 512.

[9]"Tendency of the Fine Arts," *American Review* 1 (November 1843): 499-500.

deserve our admiration solely because they attain the excellence at which the artist aimed, and in this light we think all kinds of paintings should be examined; as productions of the fine arts, they certainly constitute the lowest order.[9]

Only rarely during the first half of the nineteenth century do we find an American voice speaking sympathetically of still-life painting. The most significant exception to this lack of sympathy is Washington Allston who, though his art constituted the quintessential American embodiment of the concept of "high art," nevertheless treated the genre of still-life painting in his *Lectures on Art* with his usual magnanimity:

> Indeed, so imperishable is this property of Truth, that it seems to lose nothing of its power, even when causing itself to be reflected from things that in themselves have, properly speaking, no truth. Of this we have abundant examples in some of the Dutch pictures, where the principal object is simply a dish of oysters or a pickled herring. We remember a picture of this kind, consisting solely of these very objects, from which we experienced a pleasure *almost* exquisite. And we would here remark, that the appetite then was in no way concerned. The pleasure, therefore, must have been from the imitated truth. It is certainly a curious question why this should be, while the things themselves, that is, the actual objects, should produce no such effect. And it seems to be because, in the latter case, there was no truth involved. The real oysters, etc., were indeed so far true as they were actual objects, but they did not contain a *truth* in *relation* to any thing. Whereas, in the pictured oysters, their relation to the actual was shown and verified in the mutual resemblance.[10]

[10]Washington Allston, *Lectures on Art and Poems,* ed. Nathalia Wright (1850; reprint ed., Gainesville, Fla., 1967), p. 34. Allston himself is not known to have painted any still lifes except for an early drawing in the collection of the Huntington Library and Art Gallery, in San Marino, California. Still-life accessories figure prominently in only a few of his works, notably the *Jeremiah* in the Yale University Art Gallery and his famous *Belshazzar's Feast* in the Detroit Institute of Arts.

It is characteristic of Allston to acknowledge the contemporary transcriptional evaluation of the still-life genre, while at the same time relating the theme to the artist's search for a Platonic truth that thus could ally the still life with the sublime, the edible with the epic.

It was not until the end of the century that the perception of still-life painting changed. This shift occurred, of course, because the whole thematic hierarchy was dismissed and because new value was placed upon personal expression and execution, regardless of subject matter. The philosophy of "art for art's sake," whether or not it is vivified in the expressive paint handling of the Munich school, in the personal expressionism of Manet, or in the subtle, near-abstract harmonies of Whistler, has as corollary and dividend a new tolerance for the formerly "low" modes of still-life, animal, and other themes even as vehicles for individual expression. This change was registered in an essay written in 1906 by the English critic and writer Frederick Wedmore:

> A minor cause which does its part, at least, in telling against the satisfactoriness of current Exhibitions, is the extraordinarily small encouragement bestowed upon Still Life and upon Flower-Painting; save, indeed, when these proceed from brush or pencil of an acknowledged master: a Vollon, a Fantin, a Francis James. Half-educated persons, whose chief care is that their taste shall have no initiative and no independence — that it shall be, above all, decorously conventional — would permit themselves the regulation ecstasies over the modern realism of the perspiring peasant: Bastien Lepage or Lhermitte; but would think they had betrayed themselves if they confessed to any warm appreciation of unknown artists' painting of Still Life, or had considered the lilies of the field, how they grow.
>
> Again, even with regard to the Masters. "We can have the fruit, the silver goblet, the roses, zinnias, and azaleas — the actual things," they say, "the

things themselves, which is better." But they forget that in the picture, wise men have the things — their charm at least — and the Art besides the things — the painter's own great way of looking at and rendering them — a humble truth which I commend to the reflection of those who do not quite understand that in Art that which endures and vivifies is the temperament of the artist.[11]

[11]Frederick Wedmore, *Whistler and Others*, pp. 215-16.

Arthur Edwin Bye, the first to treat the history of still-life painting as a distinct realm of art history, reiterated Wedmore's emphasis upon the primacy of individual interpretation, saying, "A still-life picture must first of all interpret or express a vision or emotion of the artist." Although Bye acknowledged the disadvantages under which the art of still life had labored in the title of his first chapter, "The Historic Prejudice," he began with the acknowledgment that "the appreciation of still-life painting has grown in recent times with the development of taste and the understanding of the true meaning of art."[12]

[12]Arthur Edwin Bye, *Pots and Pans or Studies in Still-Life Painting*, pp. 3-19; see especially pp. 3, 17.

Finally, we may notice at once both proof of the continuing historic prejudice and its refutation in Max J. Friedländer's *Landscape, Portrait, Still Life* (1947). Friedländer discusses the nature and characteristics of thematic categories in art, not in hierarchical order, and he deals with more than is indicated in the title. But while "landscape" occupies him for 143 pages, "genre" for 76, "portrait" for 33, and "religious and history" for 14 pages, "still-life" is dismissed in 8 pages. And indeed Friedländer begins quite apologetically, stating:

> The thoughtful art-lover, particularly if he is more given to thought than to art, may find it astonishing that a lemon, a herring, a wineglass can be regarded as objects worth painting in themselves. When and how did it happen? What change of artistic sense, of outlook, indeed of social conditions must have come about that production and demand turned to such simple, insignificant objects?[13]

[13]Max J. Friedländer, *Landscape, Portrait, Still-Life*, trans. R. F. C. Hull (original German edition, den Haag, 1947), p. 277.

As suggested by this paragraph, his short explication deals primarily with Dutch still life. Thus it is perhaps fitting that he, and we, conclude this section with a quotation from the great nineteenth-century German philosopher, Arthur Schopenhauer:

> . . . those excellent Netherlanders who turned such a purely objective eye on the most trivial matters and raised up a lasting monument to their objectivity and tranquillity of soul in the still-life, which no aesthetic observer can view unaffected, since it brings home to him the quiet, still undesiring frame of mind of the artist necessary to so objective a contemplation of such insignificant things.[14]

[14]Friedländer, *Landscape, Portrait, Still-Life*, p. 284.

If historical criticism offers relatively little guidance in discerning American attitudes toward still-life painting — except for occasional perjoratives and denigration — a study of the patronage of still life is even less instructive. Take for example the listings of collections that appeared throughout the nineteenth century in various art specialist and general periodicals, in occasional volumes on art history, such as Henry T. Tuckerman's *Book of the Artists* (1867), and in the increasingly numerous sales and auction catalogues of the nineteenth and early twentieth centuries. None reveals a major collector with a particular fondness for still life. The theme appeared occasionally; Tuckerman lists still lifes, for instance, in the New York collections of William T. Blodgett, Cyrus Butler, and Alexander Cozzens, but the theme seems never to have predominated. It is not surprising then that even when

such works were mentioned in the collection descriptions, they were given short shrift.

The most formidable collection of the early nineteenth century, that of Robert Gilmor in Baltimore, included still-life paintings by James Peale, Raphaelle Peale, and Sarah Miriam Peale of Philadelphia. Another Raphaelle Peale was listed in the large painting collection owned by John Towne, the Philadelphia patron. Towne's collection may have been instrumental in influencing his two daughters, Ann Sophia Towne Darrah and Rosalba Towne, to become artists. Rosalba in fact became a still-life specialist in Philadelphia.

In general, however, collections specializing in still-life painting were not conceived until well into the twentieth century. The first such collection of significance was formed by Paul Magriel in the early 1950s.[15] The Magriel collection in turn inspired a number of others in New York City, notably those of James Ricau and Cyrus Seymour. In the last decade, a good many other private collectors have turned to still-life painting as a historically important component of American art. But in the nineteenth century the hierarchical disdain of the theme precluded any such emphasis. Still lifes then figured strongly in sales and auction catalogues only when a still-life painter was attempting to raise money — usually for European travel — by auctioning off his studio contents. They also began to appear occasionally in the estate sales of artists, for it was a common practice then, as it is today, for artists to exchange their works, even when they did not share a common style or a preference for the same subject matter and were not dissuaded by the humbleness of the theme.

Portraits were acquired by collectors because they were reminders of those who were dear and memorials of the departed. Landscape paintings offered respite from the daily troubles of the urban metropoli and frequently enshrined a favorite view or locale of pastoral pleasure. Genre paintings often told stories, a visual anecdote or pun. History paintings were inspirational, sometimes in a strictly theological sense, sometimes recalling national valor. With rare exceptions, still-life painting offered none of these attributes.

A few still lifes are known to have been created to record prize achievements in horticulture. The carved pear by Samuel McIntire has already been mentioned. Wesley Vernier was commissioned in 1864 to record *The Great California Pear* (Los Angeles County Museum of Art), which "weighed 4 Pounds, Variety Duchesse d'Angouleme; grown by Charles Nova," as the work is inscribed. Jeremiah Hardy of Bangor, Maine, was called in to record the first McLaughlin pears grown by a farmer neighbor, and he brought along his young daughter, Anna Eliza. Hardy was primarily a superb portrait specialist, but his daughter developed into the finest still-life specialist in Maine in the nineteenth century. Andrew J. H. Way, Baltimore's leading still-life painter of the time, recorded the vineyard production of that city's leading art patron, William T. Walters, who grew choice grapes at St. Mary's, his estate at Govanstown north of Baltimore. The painting by Astley David Montague Cooper, of California, recording the jewels sold by Mrs. Leland Stanford for the benefit of Stanford University, is the prime example of pictorial apogee in ostentation. It is historically fitting that the horticultural achievements of the mid-century were followed by an almost scientific precision in recording symbols of wealth and materialism. On a more sentimental and literary plane were works such as Rosalba Towne's seven-

[15]See Elizabeth McCausland, "American Still-Life Paintings in the Collection of Paul Magriel," *Antiques* 67 (April 1955): 324-27, and *American Still Life Paintings from the Paul Magriel Collection* (exhibition catalogue; The Corcoran Gallery of Art, 1957).

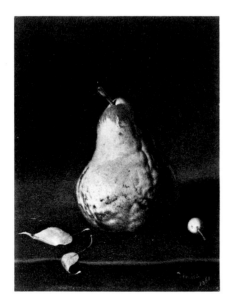

Figure 1.3. WESLEY VERNIER (circa 1820-?), *The Great California Pear*, 1864; oil on canvas, signed at lower right — *Vernier 1864*, 16 x 12 inches; Los Angeles County Museum of Art.

ty-three watercolors depicting 183 trees, plants, and flowers that were mentioned in the works of Shakespeare and were inspired by the Reverend Henry N. Ellacomb's *Plant-Lore and Garden-Craft of Shakespeare* (London, 1884).

Besides documentary utilization, the traditional function of still lifes falls into two not unrelated categories: the symbolic and the decorative. These must be recognized as primary in their creation and purpose. According to Friedländer:

> On a superficial view the still-life attempts nothing save the true-to-nature portrayal of familiar things. But deeper insight does not miss the symbolic and the decorative function. All art symbolizes or decorates in one way or another. Blossoming flowers, ripe fruit remind one of the gifts of creative nature, of increase, growth and genesis; the death's head warns one of transience, the vanity of earthly things. Still-life functions decoratively in so far as the picture's surface is artfully filled and the objects appear grouped, organized, built up to please the eye.[16]

Our essay here is concerned with *American* still-life painting and so is not the place to offer a preamble on the whole of the European background to American developments. It should be emphasized, however, that by the beginning of the nineteenth century when the serious and professional treatment of still life as an independent genre first appeared in America, the more moralistic aspect of symbolic purpose in the still life had waned considerably. To some extent, this is probably true also of the still-life accessories introduced into the portraits of the eighteenth century by both native artists and foreign visitors. This is not to say that symbolism did not occasionally surcharge nineteenth- and even twentieth-century still-life paintings, as in several somewhat didactic paintings that were done early in the last century by Charles Bird King. And given the vast interest in the "language of flowers," as described by numerous authors in the 1830s, forties, and fifties, the intriguing possibility of visual counterparts remains open to speculation, particularly since a few flower paintings, such as the one by George Harvey (p. 122), directly reflect that brand of popular literature. Such vestiges or transformations of symbolic content were primarily practical or sentimental rather than moral, and without the strength and purpose derived from theological dialectics that so informed the still-life art of seventeenth-century Holland.

During most of the nineteenth century, still lifes were viewed as decorations, particularly the floral component of that genre:

> Flower-painting belongs to the decorative side of art, as floral subjects themselves belong to the decorative side of nature; and remembering this, it is easy to understand why so few paintings of flower-subjects are altogether satisfactory, or come within the range of thoroughly good art.
>
> The knowledge of decorative effect is not by any means one of the early things in a painter's education, unless, indeed, his eye has been trained in one of the world's greatest schools of art, and he has learned to look for this quality in all painting.[17]

Two years before Candace Wheeler wrote the above in her essay "American Flower-Painters," a critic writing in the *Independent* about the art exhibitions in New York City in 1881 suggested that "if art is no more than decoration — and it is the fashion nowadays among a certain class of artists to hold that it is no more — then flower and fruit subjects furnish most

[16]Friedländer, *Landscape, Portrait, Still-Life*, p. 280.

[17]Candace Wheeler, "American Flower-Painters," *Catalogue of the Art Department of the New England Manufacturers' and Mechanics' Institute.*

[18]"Art and Artists in New York Sixth Paper," *Independent* 33 (14 April 1881): 8.

admirable motives for a display of the artist's skill."[18] It is not surprising that such notions existed in the early 1880s. For it was not until then that America began to see a fusion of artistic currents that led (among other far-reaching developments) to a growing, if grudging, appreciation of still life. This change is apparent in the statements made by both the *Independent* critic and Wheeler. First, we see the legitimization of decoration as an aesthetic concern. Wheeler was a guiding spirit of this trend. Second, we see the American artist and art student involved in the most professional formal art training. Finally, we see the acceptance, even the trumpeting, of art for art's sake and of virtuoso paint handling for its own expressivity. There was probably no greater proportion of still lifes in the early exhibitions at the Society of American Artists, which was formed in 1877 as the organizational stronghold of new aesthetic concerns, than in the older, more conservative National Academy of Design. However, the artists who exhibited still-lifes at the society were among its leaders and were leaders also of the younger generation of American artists: Julian Alden Weir, William Merritt Chase, Emil Carlsen, Wyatt Eaton, John La Farge, Helena DeKay, and Candace Wheeler, among others.

As Wheeler indicated, all art is decorative, but the use of still life for decorative purposes actually became institutionalized during the 1860s and 1870s. That purpose was delineated as early as 1868 by Louis Prang's advertisements for his chromolithographs: "Our fruit and flower pieces are admirably adapted for the decoration of dining-rooms and parlors." Ten years later, Prang formally introduced the term *dining-room pictures*. Such pictures, not surprisingly, depicted edibles and were often chromolithographs based upon paintings and designs by well-known still-life specialists of the 1860s and 1870s. Prang's series began with two works by Virginia Granbery, her *Cherries in a Basket* and *Strawberries in a Basket*. Dessert pictures by Cadurcis Plantagenet Ream and, perhaps more surprisingly, dead game pictures by George Nelson Cass were also advertised as "dining-room" art pieces in Prang's catalogues. Of course, other well-known painters, such as William Mason Brown, provided fruit subjects for "dining-room" chromolithographs by other firms. Flower pictures differed from the so-called dining-room pieces, because they presumably were more suitable in decorating parlors. In this aspect, Prang, too, occasionally employed some of the most talented artists in America, such as George Lambdin and Martin Johnson Heade, in addition to a staff that included Olive Whitney and Ellen Fisher. Heade's contribution to the Prang repertory was his *Flowers of Hope*, which was published in 1870 — another rare and late example of a picture book corresponding to the sentimental volumes of the language of flowers. The *Flowers of Hope* was one of a pair, published in tandem with the *Flowers of Memory*, by the little-known Elizabeth Remington, an art teacher in New York City.[19]

[19]Marzio, *The Democratic Art*, pp. 119-22, and William H. Gerdts and Russell Burke, *American Still-Life Painting*, pp. 69, 98.

Fortunately, a complete dining-room decorative scheme that was created at just the time that Prang conceived this use of the still life still exists, though the decoration consists of oil paintings and the artists involved were not concerned with reproduction through chromolithography. In 1865, John La Farge, short of cash, undertook a commission for the prosperous builder Charles Freeland. He was to execute a group of pictures to decorate the dining room of Freeland's new house on Beacon Street in Boston, which was built by Henry Van Brunt.[20] Only three of the pictures were completed before La Farge became ill that fall: *Fish, Hollyhocks and Corn,* and *Morning*

[20]Henry Adams, "A Fish by John La Farge," *The Art Bulletin* 62 (June 1980): 269-80.

Glories and Eggplant. Although the Freeland dining room has eight panels that allow for paintings with a decorative scheme, only six of them were used. What La Farge's ideas were for the other three are not known, and the three that were completed but never delivered are idiosyncratic in combining flowers and vegetables, idiosyncratic even in the general repertory of nineteenth-century American still lifes, as well as in La Farge's oeuvre, and as dining-room decorations. For William Harring's *The Kitchen Bouquet* (1868), for instance, Prang advertised Harring's display of tomatoes as appealing to the cook. While rhapsodizing over the potential elevation of this seemingly vulgar subject as suitable for a dining room, he directed this work more toward the commercial establishments — the restaurant, the seed store, and the dealer in provisions.

Albion Harris Bicknell, a young Boston painter, was La Farge's replacement in the project, and he completed the six paintings by the following year. They were presumably exhibited at Doll and Richard's gallery in Boston before being installed. Bicknell's subject matter is more straightforward and conventional in the still-life repertory: *Duck,* a floral *Wreath, Flowers in a Vase, Partridge, Yellow Grapes,* and *Purple Grapes.* He also did a figure piece, *Portrait of Dante,* for Freeland's drawing room. In February 1866, Bicknell wrote a letter to Elihu Vedder in Rome, boasting that his flower pictures were especially well received and had been compared to La Farge's. This was a high compliment, given the quality of La Farge's work at the time, but these may or may not have included the panels that were done for Freeland. Bicknell also painted other still lifes, including flower subjects, though he became best known for portraiture and especially for several multi-figured historical works.[21]

The dining room was one ideal area for still-life pictures. At the end of the century, the barroom became another. In this case, pictorial emphasis was upon the barroom nude and the barroom still life. If their compatibility appears questionable, consider that the two themes shared several common "aesthetic" qualities: a precise, factual delineation and a lack of ambiguity. The viewer knew exactly what he was looking at and why. And there was also the spirit of reality. The still life might consist of a peculiar conglomeration and the nude might synthetically sprout wings and be accompanied by cherubs and *putti,* but the former's factual content and the latter's anatomy were directly recognizable in experiential terms. Finally, both appealed to the male gender. The still life usually evoked the heat of the chase, hunting and fishing trophies, guns, knives, and hunting horns. The nudes were female. William Michael Harnett's final version of *After the Hunt* was the most famous of the former. It was displayed in Theodore Stewart's saloon on Warren Street in New York City, along with three of Harnett's other works. The most famous of the latter was by the French artist William Bouguereau, *Satyr and Nymphs.* Edward S. Stokes bought the painting for the Hoffman House in New York City. The appearance of Harnett's works in a New York saloon spawned imitation as far as Denver by other artists, such as Jefferson Chalfant, John F. Peto, and Richard La Barre Goodwin. The barroom nude became ubiquitous from New York to the Palmer House in Chicago and to the Palace Hotel in San Francisco. The frequency of unclothed women communing with deceptively "real" still lifes in American saloons and grill rooms is a subject worthy of further study.

Another purpose of still life should be mentioned, and that is in the training of artists. The word *still* itself implied one aspect of the theme that

[21]In addition to Adams, Bicknell's paintings for the Freeland house commission are cited in Gerdts and Burke, *American Still-Life Painting,* pp. 187, 192, and Elihu Vedder, *The Digressions of V.,* pp. 277-79, reproducing Bicknell's letter of 22 February 1866.

art teachers and students could utilize and depend upon: the "stillness," the motionlessness of the composed forms. Yet still-life classes at American art academies were not institutionalized until the end of the nineteenth century. Earlier, the various academies instituted "drapery classes," the primary purpose of which was not only to teach the skills necessary for the painting of drapery and the clothed figure but also to recognize the growing interest in the "costume piece" by Americans who were imitating the growing European vogue for both historical and genre pictures concerned with the past. These were often European costume subjects imitated in the style of the popular French artists Ernest Meissonier and Jean-Léon Gérôme (and countless others, who were as popular in America as they were in France). They reflected the increasing popularity of American costume pieces as well, particularly after the Philadelphia Centennial of 1876. Such works were painted by artists who were as different as Edward Lamson Henry and Thomas Eakins. Yet, costume and drapery classes were also useful in the study of and for teaching the art of still life, particularly the conglomerations of "period" and "antique" bric-a-brac, books, and *objets de virtu*, which were important considerations for a costume figure piece and which were painted independently in imitation of the popular (again with Americans) still lifes of the French artist, Blaise Desgoffes.

In view of the significance of the Philadelphia Centennial, Christian Schussele, a teacher at the Pennsylvania Academy of the Fine Arts since 1868, instituted a drapery class to study "grouped objects of art" and "various objects of still life." After Schussele's death in 1879, Thomas Eakins, Schussele's successor, organized a still-life class in 1882 for color and tone exercises. The recognition of the part that still life could play in the study of color and form by the novice art student was basic, but Eakins was innovative in America because of his emphasis upon immediate painting and color rather than on long years of drawing instruction. R. Swain Gifford at the Art School of the Cooper Union and William Henry Lippincott at the National Academy, New York City, both instituted still-life study in the 1870s. It was in the next decade though that still-life classes were regularized at the National Academy. They were instituted at the Art Students' League as well, where William Merritt Chase taught still-life classes, which were considered the art students' real introduction to the art of painting.[22]

Yet even in the proliferation of articles on American art-school instruction in the late nineteenth century, articles written in part to further the professional status of native art schools in competition with those abroad, especially in Paris, and in part to lure American art students back to the native institutions, instruction in still-life painting often received scant attention or none at all. Emil Carlsen, then teaching at the National Academy of Design, wrote an article on the situation in 1908 acknowledging that "still life painting is considered of small importance in the Art schools, both here and abroad, the usual course being drawn from the antique, the nude, and painting the draped figure and from the nude." He termed this routine work and wondered "then why should the earnest student overlook the simplest and most thorough way of acquiring all the knowledge of the craft of painting and drawing, the study of inanimate objects, still life painting, the very surest road to absolute mastery over all technical difficulties." As Wedmore and Schopenhauer had both acknowledged earlier, the key to still-life painting for Carlsen too was the wedding of technical mastery with the expression of individuality. Carlsen concluded his discussion of still-life

[22]See Doreen Bolger, "The Education of the American Artist," in *In This Academy: The Pennsylvania Academy of the Fine Arts, 1805-1976* — an exhibition organized by The Pennsylvania Academy of the Fine Arts in 1976 — p. 66. Chase's teaching of still life at the Art Students' League is described in John C. Van Dyke, "The Art Student's League of New York," *Harper's New Monthly Magazine* 83 (October 1891): 694.

painting with the observation that, "after all, a two penny bunch of violets in an earthern jug may make a great work of art, if seen through a temperament."[23]

[23]Emil Carlsen, "On Still-Life Painting," *Palette and Bench* 1 (October 1908): 6-8.

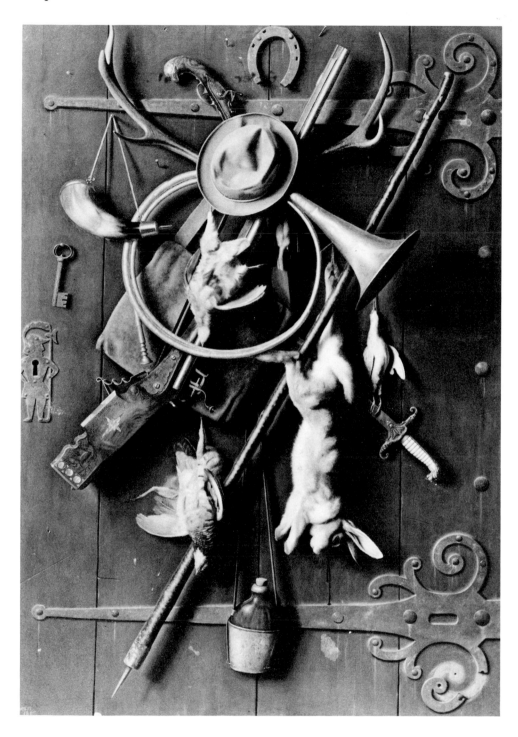

Figure 1.4. WILLIAM MICHAEL HARNETT (1848-1892), *After the Hunt*, 1885; oil on canvas, signed at lower left —
 W
 Harnett,
 1885
 M
71 x 48 inches; The Fine Arts Museums of San Francisco, gift of H. K. S. Williams.

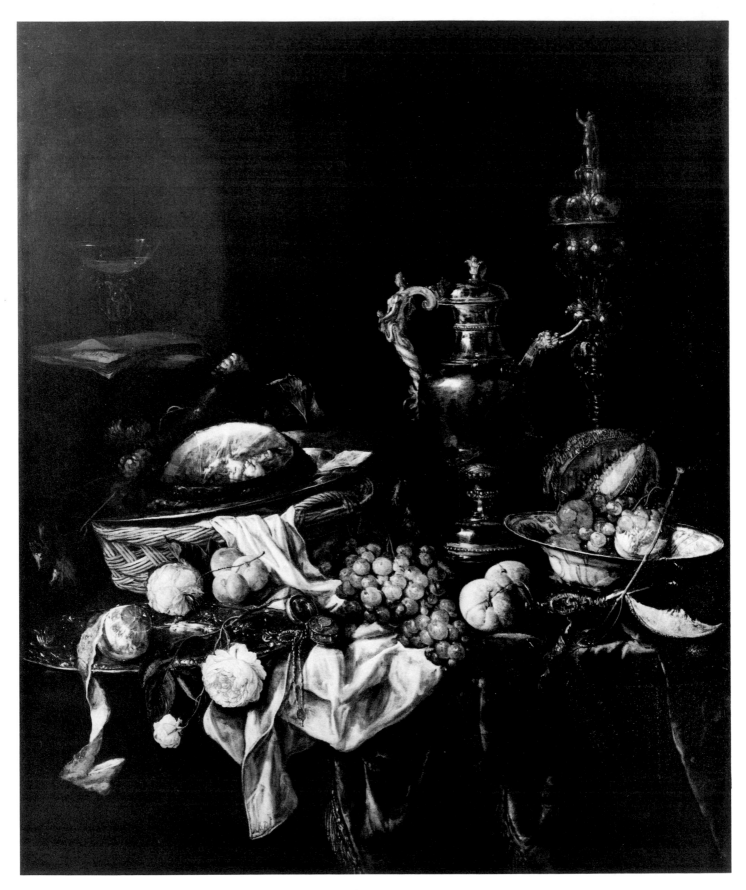

Figure 2.1. ABRAHAM VAN BEYEREN (circa 1620/1621-1690), *Still Life*, oil on canvas, 47 x 40 inches; Krannert Art Musuem, University of Illinois.

2 In the Beginning

The representation of what has come to be termed *still life* dates back to the earliest era of historical civilization.[1] Inside and outside Egyptian temples and tombs of monarchs and nobles are found symbols of food reflecting tribute to the deceased and hope for the hereafter. Of course, these still-life representations were painted and carved in conjunction with both human and supernatural figures, not independently, but they were overwhelming in their profusion, as those that decorate the great Temple of Hatshepsut at Dier el Bahari.

The ancient Greeks were the first to paint pure still lifes, but the earliest surviving records are those of ancient Roman mosaics and paintings, as indicated in the finds of Herculaneum and Pompeii. These representations of fruit, flowers, and man-made objects consisted of depictions of foodstuffs, meals with utensils on a table and decorative vases, and garlands of flowers. They shared the prevailing artistic styles of the day, from trompe l'oeil realism to impressionism to increased stylization. Though easel still lifes existed in ancient time, what survives today are wall decorations in several media, and, as we have seen, "decorative" was to remain a characteristic of still life, whether in commendation or perjorative.

After the long hiatus of the Middle Ages, when the easel still life seems to have disappeared and the still-life accessory became less ideographic and more naturalistic, the independent still life returned in the fifteenth century in the format of religious altar pictures. There it carried with it the iconographic Christian symbolism attached to inanimate objects. Hans Memling's *Irises and Lilies in a Vase* (dated about 1490) is an independent depiction of flowers that are symbolic of the Virgin's purity, but the work is one shutter of a diptych that when complete would have been paired with her image. Nevertheless, such images of flowers in a vase are objects of beauty. More ominous, and also appearing in the fifteenth century, are *vanitas* images, symbols of man's transience. The human skull is the most frequent element of a *vanitas* painting, sometimes accompanied by a burning candle and other references to the brevity of earthly life. Even Jacopo de Barbari's famous *Partridge and Arms* dated 1504 may be symbolic of death and warfare, rather than a mere hunting trophy. It is also the earliest surviving oil painting from modern times of the vertical still life: true trompe l'oeil, where objects illusionistically project into the space of the viewer as they hang in some

[1] The standard and indispensable study of the history of still-life painting is Charles Sterling, *Still Life Painting from Antiquity to the Present Time*. American still-life painting is treated only briefly in this volume.

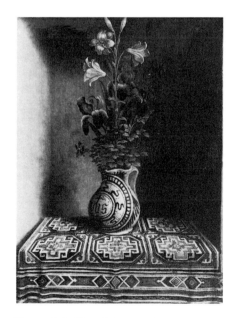

Figure 2.2. HANS MEMLING (circa 1440-1494), *Irises and Lilies in a Vase*, circa 1490, oil on canvas; Thyssen-Bornemisza Collection, Lugano/Switzerland.

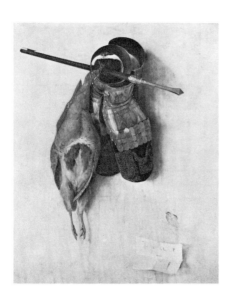

Figure 2.3. JACOPO DE BARBARI (circa 1440/1450-1516), *Partridge and Arms*; oil on canvas, signed at lower right on scrap of paper — *Jac de Barbari/1504*, 20⅝ x 16¹⁵⁄₁₆ inches; Alte Pinakothek, Munich.

[2]For Dutch still-life painting and the continuation of symbolic meaning, the acknowledged authority is Ingvar Bergström. See his *Dutch Still-Life Painting in the Seventeenth Century,* and his two-part article, "Disguised Symbolism in 'Madonna' Pictures and Still Life," *Burlington Magazine* 97 (October 1955): 303-8 and (November 1955): 342-49.

fashion against a wall, door, or other barrier to the possibility of recession back into space.

With rare exceptions, the few surviving still lifes of the fifteenth and early sixteenth centuries are quite small and relatively simple, containing few individual objects. In the work of the Flemish artist Pieter Aertsen, and his school, active in the middle of the sixteenth century, whole market scenes of meats, fish, and vegetables were represented. Human figures frequently accompanied these arrangements so that they are not, strictly speaking, still lifes. But, unlike the traditional figural compositions, these, sometimes with nominally religious subjects, invert the usual emphasis and relegate the live elements to peripheral areas. The emphasis is upon the still-life profusion for its own richness or grotesqueness. With or without figures, such paintings are important in the secularization of the still life and as a bridge to its emergence in the seventeenth century as a popular and independent genre.

What may never be ascertained completely is the degree of continuous symbolic content of the subject matter of seventeenth — and even eighteenth — century still lifes. Certainly, the *vanitas* pictures that were a particular specialty of Pieter and Harmen Steenwijck and David Bailly of the Dutch school of Leiden embody the consideration of mortality seen in earlier representations. Perhaps such considerations also inform the representation of falling petals from quick-wilting plants and short-lived insects. It is not a question of determining whether or not a particular still life is fully symbolic or purely decorative — many were both and much more.[2] Seventeenth-century still lifes — above all, those painted in Holland, the greatest school for the exploration of that theme — reflect the good life of the middle-class society that acquired the pictures and often commissioned them. Such works may not only characterize their favored foods and blossoms, their valued glassware, metalwork, and crockery, but may even define the kinds of meals consumed at different times of day. These pictures also reflect man's philosophy, his pursuit of sensual gratification and of material obsession, and his intellectual enlightenment. At the same time, they represent the artists' genius and skill — modulation of light and color, compositional balance at once reinforcing the moral pointedness of the aggregation, and abstractly defining structure, and often near wizardry in illusionistic representation.

This "golden age of still-life painting" in the seventeenth century was enjoyed throughout Europe. National schools arose, influencing one another. It would be far too simplistic to attempt to define in only a few sentences the characteristics of these individual schools or to suggest their national differences — measured Dutch realism, Flemish lushness, mystical Spanish still life, the more primitive German linearity, and the balanced, symmetrical, and rational French still life — all of which show myriad exceptions in any case. Originality, if sometimes idiosyncratic, was also apparent on a more localized level. The school of Leiden was one. So was that of Strasbourg, with the work of Sebastian Stosskopf, and all its juxtaposition of gleaming, wiry metalwork and transparent glassware.

England, the natural source of the early traditions of American art, did not participate in that golden age, however. Indeed, in the seventeenth century, British art was dominated — as it had been during the previous century — by imported Continental talent, such as that of Anthony Van Dyck and Peter Lely. But all of these adopted Englishmen were primarily

portrait painters; still-life painting was not practiced much in the British Isles. Of such practice as there was, much derived from the activities of foreign-born artists, particularly the French. The best known of these was Jean Baptiste Monnoyer, who journeyed to England in 1685, painted flower pictures and decorations at Hampton Court and Windsor Castle, and added floral accessories to the portraits by Sir Godfrey Kneller. Monnoyer was preceded by Nicholas de Largilliere, who went to London in 1674 primarily as a fruit and flower painter and later gained a reputation as a major French portraitist. The one outstanding British still-life specialist in the seventeenth century was the Scotsman William Gouw Ferguson, but he settled in The Hague in 1660, and his work, primarily of dead game subjects, belongs more to the Dutch school. A generation later, in the 1690s, the Dutch trompe l'oeil and *vanitas* specialist Edwaert Collier settled in London. Although his letter rack pictures are fascinating precursors of the early work of Raphaelle Peale and of the late nineteenth-century rack paintings of William Michael Harnett and John F. Peto, Collier's work seems unlikely to have been known by these Philadelphia artists, though they may all have derived from the same sources. Even in the eighteenth century, still life was as minor a theme in British art as it was lowly in the hierarchy of subject matter. Probably the best-known specialist then was Mary Moser, a flower painter whose work was acquired for the Royal Collection. She was one of the two women among the founding members of the British Royal Academy. Her artist-father taught drawing to George III and became the first keeper of the academy.

The British tradition of still-life painting, from which any American developments might have been expected to derive, thus was almost non-existent. The practice of portraiture instead influenced the Colonies. While the first emigrants may have brought family portraits with them, it is less likely that there was any substantial transportation of still life to inspire colonial artists. There was also little encouragement in the cultural climate of the New World to stimulate the art of still-life painting. Puritan traditions and the religious beliefs of the New England colonists encouraged portraiture that, in one way or another, was inspirational, but the painting of still lifes for their own sake probably would have been considered frivolous.

In Pennsylvania, the Quaker philosophy was particularly uncongenial to the arts. Considering the vitality of the Dutch pictorial tradition, especially its favorable concern with still life, one might have expected the early New York settlers to be more sympathetic with the arts in the seventeenth and early eighteenth centuries. However, there is no evidence of this, although there are references to still-life paintings in New York in the middle of the eighteenth century. Moreover, if early still lifes were brought here from Europe or were painted in the days of the earliest settlers, it is unlikely that their preservation would have been of as great a concern to subsequent generations as would the portraits that were treasured for sentimental reasons.

Since still-life paintings, per se, of the seventeenth or eighteenth centuries (if indeed they were painted then) are not extant, we must search for evidence of the theme, pictorial and written in three areas: advertisements for sale; written indication that colonial artists were available both to paint and to teach the theme; and its appearance in the form of subordinate accessories and attributes in the abundance of portraits that, indeed, constitutes almost the whole of colonial painting. The last offers the richest and

most diverse source of pre-nineteenth-century still-life painting as well as the earliest evidence of its appearance in colonial America.

Appropriately enough, the skull, the primal symbol of the *vanitas* theme, is seen in several examples at the beginning of colonial portraiture — that is, contemporarily with its greatest independent utilization in Europe in the seventeenth century — and then almost disappears in American painting for two hundred years. The most direct link with European traditions occurs with the *Self-Portrait* of Capt. Thomas Smith, which is undated, but perhaps was painted about 1680.[3] Smith's hand is upon the skull — although it is not his own skull, the emphasis upon transience and mortality is to be further adduced by a poem, signed with his initials, on a sheet under the skull, which draws attention to his departure from this world and his heralding of the next. The skull in the *Portrait of Dr. John Clark* (1664), which may be the earliest known American portrait and which is attributed to Augustine Clement (Francis A. Countway Library, Harvard Medical School), is a direct medical reference rather than an overt *vanitas* symbol.[4] Unlike Smith, Clement is known to have had some art training in England. John Clark was the first physician in North America to surgically trepan the skull, and thus this motif, together with his medical tools, constitutes direct reference to the doctor's skills. While the skull in this portrait is obviously not the doctor's own, given his advanced age and the impassivity of his expression, the skull here also may double as a *vanitas* symbol.

[3]For Captain Smith, see Louisa Dresser, ed., *XVIIth Century Painting in New England,* pp. 133-38, an exhibition held at the Worcester Art Museum, Worcester, Mass., 1934.

[4]For the portrait of Dr. Clark, see Dresser, *XVIIth Century Painting in New England,* pp. 50-53. For the attribution to Augustine Clement, see Sidney M. Gold, ''A Study in Early Boston Portrait Attributions,'' *Old-Time New England* 58 (January-March 1968): 61-78.

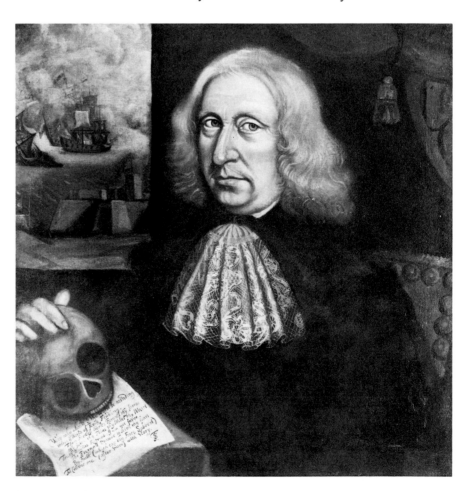

Figure 2.4. THOMAS SMITH (active 1650-1690), *Self-Portrait,* circa 1680; oil on canvas, signed on letter at lower left — *TS,* 24½ x 23¾ inches; Worcester Art Museum.

Figure 2.5. UNKNOWN ARTIST, *Portrait of Elizabeth Paddy Wensley*, circa 1670-1680; oil on canvas, 51½ x 33 inches; Pilgrim Society, Plymouth, Massachusetts.

[5]See Barbara Seward, *The Symbolic Rose* (New York, 1960), p. 22. The literature on flower symbolism and on the rose is extensive. Barbara J. Mitnick has written a paper entitled "A Look at the Symbolism of the Rose and Its Place in American Painting" (City University of New York Graduate School, 1979), forthcoming.

[6]Massachusetts Historical Society, *The Notebook of John Smibert* (Boston, 1969), pp. 99-101. For his American portraits of Jane Clark and Martha Allen, see p. 91.

After such a prompt introduction, the skull will in fact appear again in American painting only in medical portraits, such as Rembrandt Peale's *John Meer* (dated about 1801, Private Collection), until the end of the nineteenth century. But symbolic fruit and flowers also abounded in early American painting. The introduction of fruit in a woman's portrait suggested fecundity; that of flowers connoted beauty, a heritage from pagan association with the goddess Venus. As such, the rose was the flower of Venus and correspondingly was the most favored flower in colonial, and later, portraits of women. Of course, this use of the rose brought with it the Christian symbolism of the Virgin's pure love, not pagan sensuality. The red rose was a reflection of Mary's love and charity, the white rose her virtue and purity.[5]

In the portrait *Elizabeth Paddy Wensley*, painted between 1670 and 1680, the sitter is depicted next to a vase of red and white roses, the popular tulip and other flowers, and she holds a red rose in her hand. Love and virtue are therefore underscored, although association with the beauty of Venus and Flora are probably intentional connotations also. The artists of such portraits, or even later ones in the mid-eighteenth century, such as John Wollaston and Joseph Blackburn who came to the colonies from England and who frequently used flowers and whole garlands in their portraits of women, may or may not have been conscious of these traditions.

The first professional painter of significance in America was John Smibert who worked in Boston from 1729 and who utilized still-life accessories in some of his portraits. Smibert was a Scotsman who set out on 1 August 1719 for Italy and a three-year journey. Making the grand tour, he studied the works of the Old and Modern Masters, but he also made copies of Old Master paintings for himself and acted as agent for British collectors. In Florence in 1720, he acquired still lifes of flowers on three separate occasions, purchasing a flower piece from a Signor Theodoro, who was a landscape painter; buying another flower piece that included insects; and purchasing two flower pieces by "Baptist" from a Signor Salvi. He also purchased 250 drawings from a Signor Scatchati, who was a flower painter, though these may have had no still-life relationship.[6] It is likely that these acquisitions, as others, were for specific clients, but some might have been bought for future sales, and others may have been purchases for his personal collection. If the last is true, then they may well have been brought by him to America and been seen in his studio, which continued to be visited by artists and others long after Smibert's death in 1751, though no still lifes are identified in his will.

One of the finest still-life passages to appear in Smibert's portraits is in the portrait of Jane Clark, which was painted in 1732. Seated in a landscape, holding the basket of fruit, the young woman is not old enough, in all probability, for this to be a direct reference to union, fecundity, and offspring. Given the high infant mortality in the New World, however, such symbolism need not be remote. The basket of fruit, of course, is consistent also with the pastoral setting of the image. In the same year, Smibert painted a portrait of Martha Fitch Allen (private collection) holding a basket of flowers rather than fruit, with a single sprig in her right hand. In view of his competence to render accessories, it is not impossible that Smibert himself might have undertaken pure still life.

A third major still-life category is that of dead game, the trophies of the hunt, and these also inform colonial portraits even if they are not known

Figure 2.6. JOHN SMIBERT (1688-1751), *Portrait of Jane Clark (Mrs. John)*, circa 1732; oil on canvas, 49¹³⁄₁₆ x 40³⁄₁₆ inches; Massachusetts Historical Society.

Figure 2.7. Benjamin West (1738-1820), *Portrait of Thomas Mifflin*, circa 1758; oil on canvas, 48⅛ x 36¼ inches; Historical Society of Pennsylvania.

today as independent paintings. Probably the best-known example of the use of this accessory is to be found in Benjamin West's *Portrait of Thomas Mifflin*, painted about 1758. Though West is best known for the innovative role he played in Great Britain as a neoclassic history painter, his colonial production consists almost entirely of portraits. Naturally only males were associated with the hunt, particularly youths — such as Mifflin — who were occasionally painted with symbols of male aggression and were depicted as future providers, in a manner parallel to the young Jane Clark shown with symbols of fecundity. All these traditions of still-life symbolism, of course, derive from European practice and knowledge of European examples, the latter known primarily through engravings of British portraits that were printed in abundance. Jane Clark's portrait, for instance, appears to derive in part from an English mezzotint of Lady Carteret done after a painting by

Frederick Kerseboom. In the case of West's portrait of Thomas Mifflin, however, the young artist may have been inspired directly by the work of John Wollaston, the most popular of all the English painters who came to the colonies in the middle of the eighteenth century. Still-life attributes occur frequently in Wollaston's oeuvre. More specifically, his *Portrait of John Page* (College of William and Mary, Williamsburg), painted in the late 1750s, features a young Virginian who is endowed with a fowling piece and a dead game trophy similar to Mifflin's. While this portrait was done before Wollaston's sojourn in Philadelphia and his very obvious stylistic influence upon West, similar iconographic introductions to some of his paintings of 1758 in Philadelphia are not improbable. The Mifflin portrait was painted immediately after Wollaston's activities in Philadelphia began, and his influence is noted in Francis Hopkinson's well-known poem of 18 September 1758 in which, after encomiums toward Wollaston, the poet admonished the young West:

> may'st thou ever tread
> The pleasing paths thy *Wollaston* has led.
> Let his just precepts all your works refine,
> Copy each grace, and learn like him to shine.[7]

West went on to further his career in London. The culmination of the colonial portrait tradition lay rather in the hands of Boston's John Singleton Copley. If Copley's late colonial portraiture constitutes the greatest expression of our early painting, then his utilization of still-life attributes is infused with that same genius. This genius is apparent not only in his rendition of specific tactile qualities of objects — firm but pulpy fruit, sensuous flower petals, and gleaming metalwork — but in their connotations. The impressive display of still-life accessories began as early as Copley's still somewhat primitive portrait of his half-brother, Peter Pelham, Jr., (1753, Museum of Fine Arts, Boston), where the young subject is portrayed as an engraver. This adoption of his deceased father's trade is demonstrated in the engraver's tools that are laid out on a table before him.[8] The definition of craftsmanship in portraiture reached its peak in Copley's great *Portrait of Paul Revere*, circa 1765-1770, where the teapot, a masterwork of the subject's skill, is held in one hand balancing the equally globular quality of the patriot's head, which he rests upon his other hand.

Between 1764 and 1770, approximately, Copley made his most extensive and most elegant use of still-life elements, often reflected in highly polished tabletops placed before his seated subjects. The use of fruit as a symbol of fecundity reached an apogee in his *Portrait of Mrs. Ezekiel Goldthwait*, dated about 1770-1771, where the subject is shown contemplating a bowl containing thirteen pieces of fruit. In this case, the still life is not a wish of fruition to the middle-age subject but rather a blessing upon this woman who bore thirteen children.[9] It may also represent the fruit of other labor, for Mrs. Goldthwait had a reputation as an excellent gardener. Of course, the fruit is representative of the overall spherical design, which is repeated in the plate on which the fruit rests, the tabletop below, and the curves of Mrs. Goldthwait's head, chin, cap, bosoms, and total figure.

Flowers are also prominent in Copley's portraits of women: Mrs. James Warren (Museum of Fine Arts, Boston) stands before growing ones; Hannah Loring (Detroit Institute of Arts) picks a rose; Dorothy Murray (Fogg Art Museum, Cambridge) holds a bouquet; and Mrs. Benjamin Blackstone

[7]The poem appeared in *American Magazine* (September 1758). It was reproduced in full in facsimile in Theodore Bolton and Harry Lorin Binsse, "Wollaston: An Early American Portrait Manufacturer," *Antiquarian* 16 (June 1931): 33.

[8]All of Copley's American portraits are reproduced in Jules David Prown, *John Singleton Copley* (2 vols., Cambridge, Mass., 1966), vol. 1: "In America, 1738-1774."

[9]Barbara N. Parker, "Portraits of the Goldthwait Family of Boston," *Bulletin of the Museum of Fine Arts* 39 (June 1941): 40-44.

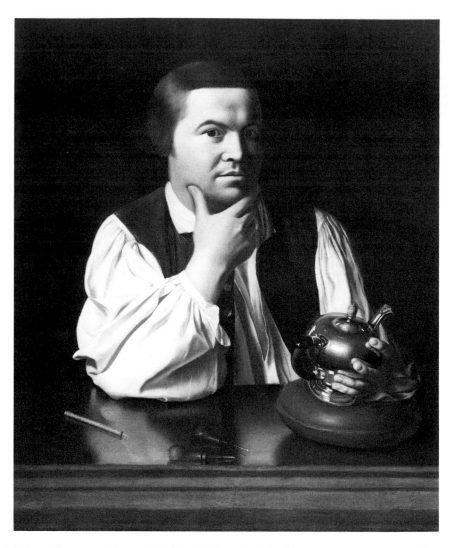

Figure 2.8. JOHN SINGLETON COPLEY (1738-1815), *Portrait of Paul Revere*, circa 1765-1770; oil on canvas, 35 x 28½ inches; Museum of Fine Arts, Boston, gift of Joseph W., William B., and Edward H. R. Revere.

(Amherst College Art Gallery) stands in front of one in a glass on a table. Copley varied his floral attributes, both for the sake of variety and to conform to his own compositional demands. The portrait of Mrs. Woodbury Langdon (circa 1765-1766, Private Collection) and the portrait of Mrs. Moses Gill (circa 1773) are the most effusive examples of his floral displays. The large branch of lilies held by Mrs. Gill is more dynamically positioned on a diagonal and is more animated than the flowers held by Mrs. Langdon. The lilies are, of course, the primary Christian symbol of purity.

That some colonial painters did in fact paint independent still lifes is probable. In addition, European still lifes were imported to these shores. It is likely, in fact, that as the rigors and austerity of Puritan life were ameliorated and as material concerns began to supersede theological ones, living became continually more gracious throughout the colonies and homes became more comfortable and more decorated. John Wetherhead, for instance, advertised in the *New-York Mercury* on 24 December 1764 that at his store on King Street he had imported twenty-four fruit and flower pieces by an artist named Jones, which were for sale.[10] Four years earlier, the *Boston News Letter* on 15

[10]Rita S. Gottesman, comp., ''The Arts and Crafts in New York, 1726-1776,'' *Collections of The New-York Historical Society for the Year 1936* (New York, 1938), p. 7. See also George Francis Dow, *Everyday Life in the Massachusetts Bay Colony* (Boston, 1935), p. 6.

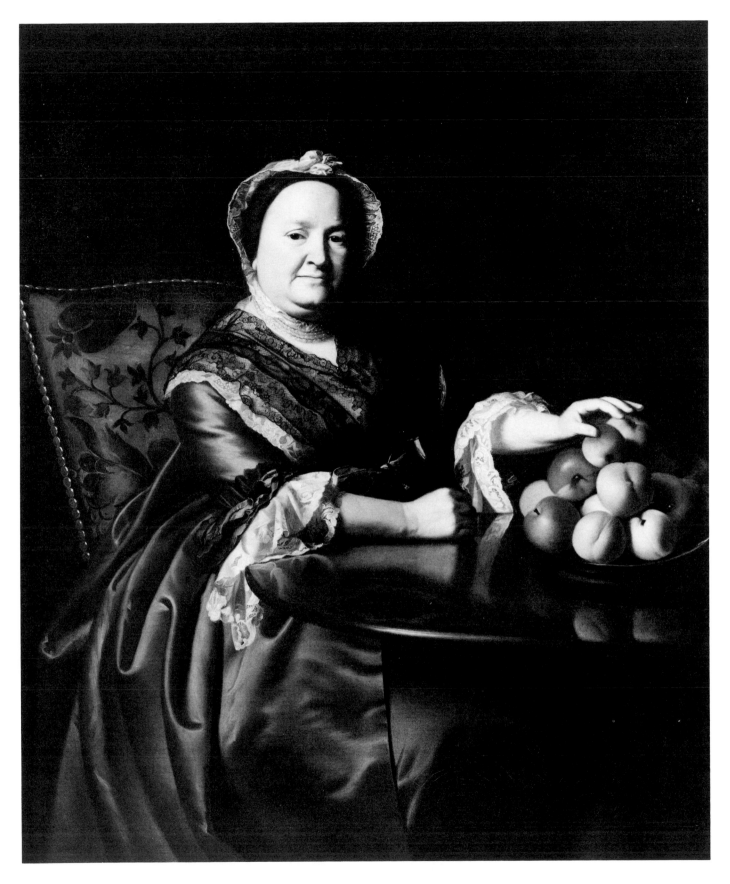

Figure 2.9. JOHN SINGLETON COPLEY (1738-1815), *Portrait of Mrs. Ezekiel Goldthwait*, circa 1770-1771; oil on canvas, 50 x 40 inches; Museum of Fine Arts, Boston, bequest of John T. Bowen in memory of Eliza M. Bowen.

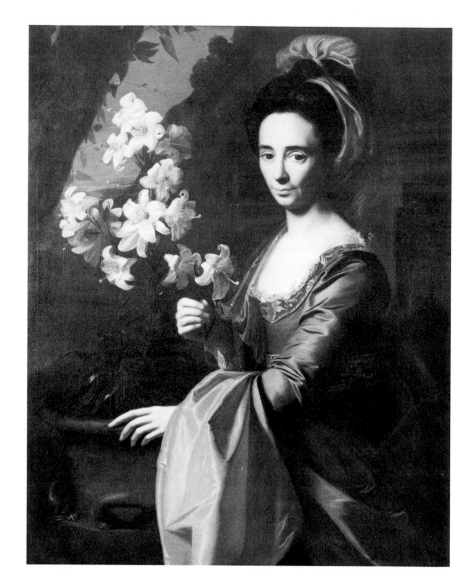

Figure 2.10. JOHN SINGLETON COPLEY (1738-1815), *Portrait of Mrs. Rebecca Boylston Gill*, 1773; oil on canvas, 49¾ x 39½ inches; Museum of Art, Rhode Island School of Design, Jesse H. Metcalf Fund.

Figure 2.11. WINTHROP CHANDLER (1747-1790), *Shelves of Books*, circa 1769; oil on canvas, 27 x 58 inches; The Shelburne Museum.

May 1760 advertised an appeal for "Two small Pictures of dead Game" lost in a fire, one of a hanging hare, the other of a falling lark. The pictures might have been painted in the colonies, but more probably were imported from abroad. Still lifes, however, were not only imported. An otherwise unknown artist named Warwell who had just come from London advertised in Charleston in the *South Carolina Gazette and County Journal* on 21 January 1766 that he had taken a house where he painted a variety of subjects. Among those he advertised were pictures of flowers and fruits.[11]

We may also assume that an artist who advertised his ability to teach still-life painting could answer a market for such works. In New York, Lawrence Kilburn advertised in the *New-York Gazette or Weekly Post Boy* on 13 October 1755 that during the winter season he would instruct "Gentlemen" in the art of drawing various subjects, including flowers.[12] Two brothers in Charleston, John Stevenson and Hamilton Stevenson, on 21 September 1773 advertised an academy where flower painting was taught.[13] Both brothers were in Jamaica in the West Indies by 1780.

In fact, we can be certain that still lifes were utilized to decorate rooms in colonial homes. When fireplaces were not in use in the summer, they were covered with a board — the fireboard — that often had a depiction of a large vase of flowers, an alternative to the age-old English tradition of actually placing a large bouquet in the unused fireplace.[14] These were not, however, created as formal works of art, and the artists who painted them would not have thought of themselves as professional artists but rather as artisans ranked similarly to those painters who provided decorative overmantels for fireplaces. These panels most frequently depicted landscapes, but one by the well-known "primitive" painter Winthrop Chandler depicted two shelves of books complete with quills and a bottle of ink in a rude, but still effective, trompe l'oeil manner.[15] Now in the Shelburne Museum, it was located over the mantel of the McClellan house, in South Woodstock, Connecticut, which was built in 1769. Still lifes depicting books were rare in this period but became common a century later. The book picture is a symbol of knowledge and learning. This theme is associated not with women, as were the fruits and flowers, but with men. Like the works of many of his colleagues who worked in western Connecticut, Chandler's portraits of men often show shelves of books in the background, as in one of his best-known, *The Portrait of the Reverend Ebenezer Devotion* (1770). In the overmantel of the McClellan house, however, he has rendered the books independently, detached from associative symbolic connotation.

On a more professional level, however, the earliest recorded easel still life by an American artist was painted by Matthew Pratt, a Philadelphia artist who studied in London with Benjamin West for two years. He was first in a long line of American pupils of West, who had just settled in England the year before. In 1765, while still one of West's pupils, Pratt exhibited *Fruit Piece* at the Society of Artists of Great Britain in London. After four more years abroad, Pratt returned to the colonies. While in Williamsburg, Virginia, he advertised in 1773 a "small but neat Collection of Paintings" that were for sale.[16] There were six of these — copies after Correggio, Raphael, Guido, Reni, and West, including his own *Fruit Piece* — all to be disposed of on 13 March. Though in the lowly genre of still life, Pratt nevertheless thought well enough of this, his one original effort, to advertise it with illustrious company. Perhaps some day, his *Fruit Piece*, the earliest recorded and exhibited American still life, will be found.

[11]Anna Wells Rutledge, "Artists in the Life of Charleston through Colony and State from Restoration to Reconstruction," *Transactions of the American Philosophical Society held at Philadelphia for Promoting Useful Knowledge*, vol. 39, pt. 2, p. 118.

[12]Gottesman, "The Arts and Crafts in New York, 1726-1776," p. 4.

[13]Rutledge, "Artists in the Life of Charleston," p. 121, mentions the first announcement of the drawing academy. The brothers' involvement in flower painting is from an advertisement in the *South Carolina and American General Gazette* (18 November 1774). See Alfred Coxe Prime, comp., *The Arts and Crafts in Philadelphia, Maryland, and South Carolina, Part I, 1721-1785* (Topsfield, Mass., 1929), pp. 9-10.

[14]For numerous illustrated examples, see Nina Fletcher Little, *American Decorative Wall Painting*, pp. 66-76, 137-41.

[15]For Chandler, see Little, *American Decorative Wall Painting*, pp. 135-37. Also, Nina Fletcher Little, "Winthrop Chandler," *Art in America* 35 (April 1947): 159.

[16]William Sawitzky, *Matthew Pratt, 1734-1805* (New York, 1942), p. 29.

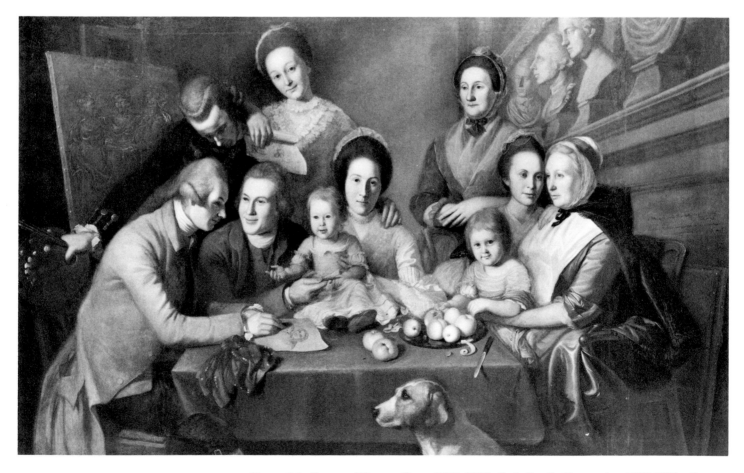

Figure 3.1. CHARLES WILLSON PEALE (1741-1827), *Peale Family Group*, circa 1773-1808; oil on canvas, 56½ x 89½ inches; The New York Historical Society.

3 The Peale Dynasty

Notwithstanding Matthew Pratt's exhibition held in Williamsburg immediately before the outbreak of the American Revolution, or even the extensive showing of his own works mounted by Robert Edge Pine in Philadelphia in 1784, the first truly public art exhibition held in America was the Columbianum show of 1795 in Philadelphia. The show was large, consisting of at least 137 works (the catalogue listed 133, but 4 others are recorded as added later, and it is possible that there were still further additions). Perhaps the most interesting aspect of the exhibition, beyond its presentation, was the diversity of themes among the entries, given the almost exclusive concentration upon portraiture, which characterizes eighteenth-century American art.

Although the purpose of the Columbianum exhibition was to display the work of American artists, some European work was shown, for example a *Still Life* by William Redmore Bigg.[1] Bigg was a London painter of "fancy pieces" and an associate at the Royal Academy. Given the large number of Philadelphians who traveled to London to study with their compatriot Benjamin West during the early decades of West's successful British career, it is possible that this work was even owned by one of the artist-founders of the Columbianum.

Works of several amateur artists were also included: one was John Foulke who exhibited his *Fruit and Ribs of Raw Beef*, and John Meer, a decorative artist of "Japan work," showed his flower painting on glass. There were also three still lifes by the Philadelphia writing and drawing master, Samuel Lewis. But the most surprising works included were "Four Fruit Pieces by Mr. Copeley [*sic*] of Boston" and a "Wood Duck by Ditto." No pure still lifes by Copley are known today, but his interest in the genre is at least attested to by the beautiful accessories in his portraits. By 1795, he had been abroad for over twenty years, and if these are indeed by Copley and not by some otherwise unknown painter of a similar name, they would suggest works painted much earlier, perhaps done while he stayed in Philadelphia during 1770 and 1771 and left behind there. That the artist was, in fact, the famous Boston portraitist is further indicated by the only other

[1]*The Exhibition of the Columbianum, or American Academy of Painting, Sculpture, Architecture, & etc. Established at Philadelphia, 1795.* Copy in the American Philosophical Society Library, Philadelphia.

picture by him in the show, "A Portrait in Crayons," that is, a pastel portrait. Pastel was a medium in which Copley excelled and which few other Americans practiced.

Lewis's three still-life entries were all "Deceptions," that is, illusionistic works, probably rack pictures with letters, cards, and the like by which he could display his calligraphic skill, as well as his ability at trompe l'oeil. Raphaelle Peale, who listed himself as a portrait painter with an address at his father's museum, showed thirteen works of which only five were portraits and eight were still lifes. Three of these were pictures of fish, two were just called "Still Life" and were probably fruit pictures, one was *A Bill,* one *A Deception,* and one *A Covered Painting,* probably also a trompe l'oeil.

Neither Raphaelle's father, Charles Willson Peale, nor his brother Rembrandt exhibited any still lifes; most of their entries were portraits. His uncle, James Peale, who listed himself as a miniature painter, showed a group of works in his specialty, and also a family group in oils, and a picture, entitled *Fruit.* Both Raphaelle Peale and James Peale would go on to establish still-life painting as a professional pursuit in America, and their efforts, together with those of other members of the Peale family, would help to make Philadelphia the major early center for that genre.

[2]Charles Coleman Sellers, "Portraits and Miniatures by Charles Willson Peale," *Transactions of the American Philosophical Society,* vol. 42, pt. 1, 1952, pp. 142-43.

Charles Willson Peale, like his near contemporary Copley, was not a still-life painter as such, although he too often introduced still-life accessories into his work. Roses, which appear to function symbolically, often accompany women; a bud attached to the flower denotes the young bride as a mother-to-be. In the case of the 1788 portrait of Elizabeth Miller who died in childbirth, the drooping rose in her hand refers to her death, and the white rosebud to her child.[2] Peale's most famous still life is the fruit and knife on the table in the *Peale Family Group,* 1773-1808, in which the ostensible subject is a painting lesson. Since many members of the family painted still lifes, the displayed fruit and knife on the table are appropriate inclusions. The still-life objects in this picture add to the suggestion of well-being and may carry with them the traditional symbolism of fecundity, since Peale himself was married three times and fathered seventeen children.

This still life is also a prototype for the "typical" Peale example. Like most still lifes painted by the Peales, it is of fruit, simple in arrangement, with a neoclassic emphasis upon solid form, simple shapes, and spatial clarity, and it is arranged on a table parallel to the picture plane. It is beautifully rendered. It is surprising that no pure still lifes by Charles Willson Peale are known and definitely accepted, although two fruit paintings in the collection of the Detroit Institute of Arts have been attributed to him. He did in fact write to his daughter Angelica on 22 November 1815 that he was painting "a piece of still life, a basket of apples and pears on a round stand."[3] Unlocated today, this, or a similar work, may be seen in the background of the portrait of his son Raphaelle, which was painted in 1817 at the father's country estate, "Belfield." The inclusion of this picture within a picture is meant to identify Raphaelle with what had come to be his primary thematic interest. It may, of course, be a work by Raphaelle himself that Charles Willson had, but it also may have been his own picture, which would serve equally well for such identification. Certainly, it is consistent with that included in the *Peale Family Group.*

[3]Charles Coleman Sellers, "Charles Willson Peale with Patron and Populace," *Transactions of the American Philosophical Society,* vol. 49, pt. 3, 1969, p. 41.

The Columbianum exhibition was the brainchild of Charles Willson Peale, part of his effort to establish and to broaden cultural life in Philadel-

Figure 3.2. CHARLES WILLSON PEALE (1741-1827), *Portrait of Raphaelle Peale*, circa 1817-1818; oil on canvas, 28⅞ x 24¼ inches; Private Collection.

[4]Rembrandt Peale, "Reminiscences," *The Crayon* 1 (9 May 1855): 290.

phia, which in 1794 was just established as the capital of the new Republic.[4] In December 1794, Peale called a meeting of professional and amateur artists to set up this organization "as [a] school or academy of architecture, sculpture, painting, etc., within the United States." Due to the divisiveness of some of the English-born artists, which led to a secession from the less-than-a-year-old Columbianum, the art school was never properly founded, and only one exhibit, that of 1795, was held. However, it was a landmark event.

Peale's motivations were civic and national — to help the new Republic and its capital grow culturally, as well as politically. It was the same goal he was pursuing with his museum of natural history and painting that led him to withdraw more and more from his role as a practicing professional artist. But he had other more personal goals as well, notably the professional destiny of his sons. The art school would have provided training for his children, especially the young Rembrandt Peale, recognized by his father as his most-talented offspring. The exhibition would act as a showcase for his own work, that of his family, and of his Philadelphia colleagues, while it elevated taste and — not inconsequently — promoted artistic patronage.

Such a purpose may partly explain the most curious aspect of America's earliest professional still-life paintings and that of the careers of the two major specialists of the family, Raphaelle Peale and James Peale. Both of them exhibited still lifes at the Columbianum in 1795; yet, outside of one deception picture of 1802, none of Raphaelle's still lifes is securely dated before the early second decade of the last century, and his uncle James's works in this genre are all of the 1820s. The vexing question thus remains: if both of these still-life painters began to exhibit such works as early as 1795, where are the examples they painted during the next quarter century? The disappearance of those works has made the task of tracing still-life development almost impossible.

Figure 3.3. RAPHAELLE PEALE (1774-1825), *A Deception*; ink and pencil, 16 x 10¾ inches; Private Collection.

The answer, I believe, is that they did *not* paint still lifes during those years, outside of perhaps an occasional example such as Raphaelle's 1802 *Deception*. They were, as the Columbianum catalogue indicates, portraitists. James worked primarily in watercolor miniatures and Raphaelle in miniatures and life-size oils. Both would certainly have known that still-life painting ranked very low in aesthetic esteem in their time, and for this and other reasons would yield little remuneration. But Charles Willson Peale most likely judged the outlet of the Columbianum exhibition as a possible market for expanding taste and encouraged his family and others to exhibit as wide a variety of themes as possible; he was probably also aware of the minimal attraction of a show solely of portraiture.

With the collapse of the organization, there was no public forum for art until the founding of the Pennsylvania Academy of the Fine Arts in 1805. Annual exhibitions were not inaugurated until 1811 when the newly formed Society of Artists of the United States opened the First Annual Exhibition at the academy. The following year, Raphaelle began to exhibit still-life painting, and it was then, I believe, that he turned to still-life painting as his major occupation. For by and large, portraiture in oil and in miniature, which he had previously practiced, was commissioned work. A public exhibition of such painting might well have attracted additional patrons, but the works exhibited were already ordered and, hopefully, paid for. Works of most other genre, such as landscape and still life, were occasionally ordered but more often painted, at least by most artists, on speculation. Therefore, when artists could only show such paintings to the occasional studio visitor

or singly in the windows of bookstores and frame shops, there was little incentive to create such works. There are other factors involved, of course, not the least of which was an answer to the European charges of cultural inferiority, but it is not a coincidence that the broadening of artistic themes in the second decade of the nineteenth century occurred just when annual public exhibitions of art were instituted. This was even more essential for the still-life painter than for the landscape or history painter, for the latter two might at least garner the admiration and approval of the cognoscenti; the still-life specialist could expect no such encomiums. The annual exhibitions at the Pennsylvania Academy in fact spurred public awareness of art beyond the confines of its own premises. In 1812, T. C. Carlisle wrote: "I have seen in Philadelphia, two very fine flower-pieces, which however inferior this style of painting may be, are not to be despised as specimens of skillful execution."[5]

It was Raphaelle who turned first to still-life painting, and it is Raphaelle who should thus be regarded as the earliest professional still-life painter in our history, despite his uncle James's seniority. It is, therefore, perhaps significant that he entered the largest group of works of this class in the Columbianum show. Raphaelle was also to be found in that exhibition in another way. For the centerpiece of the exhibition, and his father's own most ambitious work, was the famous *Staircase Group*, a life-size trompe l'oeil representation of Raphaelle, pallette, brushes, and maulstick in hand, ascending a staircase and looking back toward the viewer, while his younger brother Rubens peers down from above. Considering the illusionistic still lifes that were displayed by Raphaelle in the show, we can safely project that both talent and taste for deception were obvious traits of the Peale family. The more profound nature of the subject matter should also be noted. It was the presentation of Raphaelle Peale, the artist, to the Philadelphia public. Here was a giant, even life-size calling card for the attractive young painter best represented in the same exhibition. And it was painted by a devoted father whose pupil he was, for an exhibition conceived by the older man to further the fortunes of his sons to whom he had already turned over his portrait business.

Unfortunately, such predicted success was not to be. Raphaelle was much involved with his father's museum; he even journeyed to South America in 1792 for specimens to exhibit and he followed his family's interest in portraiture in both oils and miniatures.[6] But he was less successful in such art when compared to his father, uncle, or younger brother Rembrandt, whether living in Philadelphia or traveling as he did to Baltimore, Annapolis, Norfolk, and Charleston. However, while on a tour through the South, his profile silhouettes, cut with the aid of a physiognotrace machine, brought him one brief moment of success in 1803-1804. But, generally, poor patronage, increasing ill health, alcoholism, and the shrewish temper on his nagging, difficult wife made Raphaelle's life miserable. All the more startling, therefore, is the calm serenity, the crisp forms, the sense of formal balance that characterize his still lifes, the theme that he turned to about 1812.

Charles Willson Peale viewed the art of still life as being appropriate for only beginners and amateurs, and he recognized the meager support this form of art received from critics and the poor remuneration it brought. Thirty dollars was a respectable sum if Raphaelle was able to get it, and sometimes the works were used as barter. Raphaelle not only disappointed

[5]T. C. Carlisle, "Remarks on Various Objects of the Fine Arts," *Port-Folio* 7 (June 1812): 539.

[6]For Raphaelle Peale, see *Raphaelle Peale, 1774-1825: Still Lifes and Portraits*, introductory essay by Charles Coleman Sellers (exhibition catalogue; Milwaukee Art Center and M. Knoedler & Company, New York, 1959). Much pertinent material on the members of the Peale family can be found in the following volumes: *The Peale Family: Three Generations of American Artists* (exhibition catalogue; The Detroit Institute of Arts and the Munson-Williams-Proctor Institute, Utica, New York, 1967); *Four Generations of Commissions: The Peale Collection of the Maryland Historical Society*, Baltimore, 1975; Charles Coleman Sellers, *The Artist of the Revolution: The Early Life of Charles Willson Peale*, Hebron, Conn., 1939; Charles Coleman Sellers, *Charles Willson Peale, Volume II: Later Life (1790-1827)*, Philadelphia, 1947; and Charles Coleman Sellers, *Charles Willson Peale*, New York, 1969.

his father but also drained his resources. Charles Willson wrote in 1808 that "Raphaelle is continually drawing on me for cash, for the low price he gets and withal not constantly employed renders my aid necessary." To alleviate the situation, Charles Willson encouraged his son in the art of still-life painting in November 1817:

> If you applied yourself as you ought to do, you would be the first painter in America. Your pictures of still life are acknowledged to be, even by the painters here, far exceeding all other works of that kind — and you have often heard me say that, with such talents of exact imitation, your portraits ought to be more excellent. My dear Raphaelle, why will you neglect yourself? Why not govern every unruly passion? Why not act the man, and with a fine determination act according to your best judgement? Wealth, honors and happiness would be your lot![7]

In September 1818, Charles Willson wrote to his daughter Angelica about her brother:

> It is not too late to recover his wanted stamina, provided he will follow my advice and to encourage him to be diligent in painting still life, I will purchase every piece that he cannot sell, provided it is well painted, he tells me that he has improved in portrait painting and that he is fonder of doing them than he was formerly. If so I know he will excell [sic] in a high degree, if his imitations of the human face is like those faithful tints he produces of still-life. For he has not his equal in that line of painting.[8]

Obviously, then, Charles Willson still hoped that his son would flourish in the "higher" rank of portraiture rather than in still life, while at the same time recognizing that Raphaelle's special talents for this chosen speciality were unique in America. In fact, he attempted to bring those abilities to the attention of a wider audience. In September 1815, he wrote to his old teacher, Benjamin West, in London:

> The bearer of this is Mr. Welford, an Amateur of the fine arts, and I believe an encourager of that of painting, he carries with him several pieces of Still-Life painted by my son Raphaelle which I wish you to see. Raphaelle seems to possess considerable talent for such paintings.[9]

West's reception of the works is not known; it is doubtful that he could have summoned much interest. But, Charles Willson continued to notice Raphaelle's still-life abilities, encouraging him when he could. He mentioned Raphaelle's talent in several letters he wrote to his son Rembrandt. "Raphaelle has painted some still-life pieces equally good, if not superior to any he has ever painted. He works diligently but at a low price, and conducts himself very well,"[10] he wrote in February 1819, and in August 1822, he wrote that "Raphaelle is diligent at his pieces of still life, but of portraits he has nothing to do, for some time past, he very seldom can get anything for what he does, of course I am obligated to find him market money."[11]

It is of significance that the father's extended references to his son's ability at still life occurred in the 1810s and 1820s, for it is not surprising that it was then that Raphaelle turned to this genre. A public showplace had opened up at the Pennsylvania Academy, fortuitously it would seem, since the artist's increasing battle with gout made it impossible for him to continue miniature painting. Overall, his portraits in large were not found pleasing.

It has been suggested that Raphaelle Peale's still lifes were not as well received as those of his uncle James; in terms of patronage, this may or may

[7]Sellers, *Peale,* 1969, pp. 327, 396; and Charles Willson Peale papers (American Philosophical Society, Philadelphia, Letter Box 14, 15 November 1817). The Peale papers are now available on microfiche. See Lillian B. Miller, *The Collected Papers of Charles Willson Peale and His Family.*

[8]Peale papers, Letter Box 15, p. 60.

[9]Peale papers, Letter Box 13, p. 152.

[10]Peale papers, Letter Box 16, p. 35.

[11]Peale papers, Letter Box 17, p. 51.

not have been true, but judging by the admittedly spotty reception still-life painting received from critics, his works were admired. In 1813, the first year in which Raphaelle exhibited a substantial group of still lifes at the Pennsylvania Academy of the Fine Arts, the critical encomiums were lavish. The writer in the *Port-Folio*, in considering one of the *Fruit Pieces* by Raphaelle Peale, made the following assessment:

> This is a most exquisite production of art, and we sincerely congratulate the artist on the effects produced on the public mind by viewing his valuable pictures in the present exhibition. Before our annual exhibition this artist was but little known. The last year he exhibited two pictures of still life, that deservedly drew the public attention, and were highly appreciated by the best judges. We are extremely gratified to find that he has directed his talents to a branch of the arts in which he appears to be so well fitted to excel . . . Raphael [sic] Peale has displayed talents so transcendant [sic] in subjects of still life, that with proper attention and encouragement, he will, in our opinion, rival the first artists, ancient or modern, in that department of painting . . . we have seen fourteen annual exhibitions of the Royal Academy, and one of the Incorporated Society of Artists, in London; and we are bold as well as proud to say, that on this particular branch of the arts as those now exhibited by Raphael Peale.[12]

Raphaelle did continue to paint works of deception after the Columbianum in 1795. In fact, in 1812, with his first showing of still lifes at the Pennsylvania Academy, one of his pieces was a *Catalogue for the use of the Room, a ception* [sic], and a similar work was shown in 1818. In 1820, one of these two, or perhaps another piece, was exhibited in Baltimore.[13] Such deceptive works evinced both a great talent and wit: the visitor to these exhibitions was expected to reach out to take hold of the catalogue, only to find it a painted illusion.

Raphaelle's most famous work is, in fact, an illusionistic picture, but a more ambitious one. *A Covered Painting* was one of his first works, shown at the Columbianum. It may well have been the prototype for his *After the Bath* (1823), painted to goad and tease his nagging wife, Patty. Tradition has it that Raphaelle exhibited the work in his studio, hoping that Patty would think he had covered a salacious nude with one of her linen napkins, for all that can be seen of the figure above the top of the painted linen is one arm and hand in the subject's long hair. A bare foot emerges below. Patty would have known what to expect in the more painterly figure hidden by the sharply delineated cloth, for it would have been based, as indeed were the revealed extremities in the picture, on an engraving after James Barry's *The Birth of Venus* (1772).[14] What is not clear is the relationship of *After the Bath* to Raphaelle Peale's *Venus rising from the sea — a Deception*, exhibited by Raphaelle at the Pennsylvania Academy in 1822, and surely the same *Venus Rising from the Sea* sold that year from the first annual exhibition of fine art at the Baltimore Museum (the Peale Museum in Baltimore) to William Gilmor for twenty-five dollars.[15] They may, of course, be the same picture but *After the Bath* is dated a year after the *Venus* deception was painted, exhibited twice and sold; and the identification of the former with the latter subject matter would have been a very "in" joke only for those familiar with the engraving. It would seem, rather, that having painted an exhibition piece of deceptive wit and having succeeded in disposing of it, Raphaelle the following year did a second picture with a less specific reference to its British and ultimately classical source.

[12]*Port-Folio*, n.s. 2 (August 1813): 126-27.

[13]For this and all subsequent references to exhibitions at the Pennsylvania Academy, see Anna Wells Rutledge, *Cumulative Record of Exhibition Catalogues: The Pennsylvania Academy of the Fine Arts, 1807-1870; The Society of Artists, 1800-1814; The Artists' Fund Society, 1835-1845.*

[14]See the entry on *After the Bath* in *Philadelphia: Three Centuries of American Art* (exhibition catalogue; Philadelphia Museum of Art, 1976), p. 257.

[15]Peale papers, consulted in microfiche at the National Portrait Gallery, Smithsonian Institution, Washington, D.C., receipt of Rubens Peale to William Gilmor, 1 October 1822.

Figure 3.4. RAPHAELLE PEALE (1774-1825), *After the Bath*, 1823; oil on canvas, signed on towel at lower right — *Raphaelle Peale 1823/Pinxt*, 29 x 24 inches; Nelson Gallery — Atkins Museum (Nelson Fund).

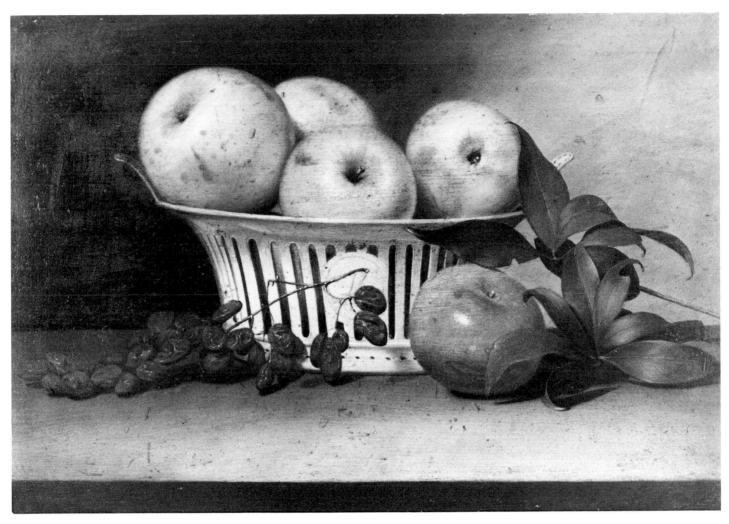

Figure 3.5. RAPHAELLE PEALE (1774-1825), *Still Life with Raisins, Yellow and Red Apples and Porcelain Basket;* oil on panel, signed at lower right — *R. Peale,* 13½ x 18¾ inches; The Baltimore Museum of Art, gift of Mrs. Francis White, Collection of Mrs. Miles White, Jr.

When all is said and done, however, Raphaelle's most famous work today is not typical of his still-life production. This point is important because if our hypothesis concerning the chronology and impetus of the development of American still-life painting is correct, then Raphaelle Peale is the originator of the professional still life in this country, though precedent may still be found in the still-life accessories of the portraits done by his father and other artists. Raphaelle's other still lifes exhibited in 1812 were *Eggs, etc.,* and a pair, *Bread, Cheese, etc.* and *Fruit, etc.* From then on, his production and the exhibition of his works appear prodigious: ten still lifes were shown in 1813, seventeen in 1814 and 1817, and further new examples, which were fewer in number up until 1822, except in 1819 and 1820 when only the pair of fruit pictures that had entered the collection of the academy appeared. Apart from his deceptions and one picture that included a book along with fruit, the titles indicate, as do the located paintings today, that Raphaelle's subject matter consisted totally of edibles and crockery and glassware of the table. Fruit was, by far, the most common subject; vegetables, meat, and fish were featured occasionally, and some pictures showed cheeses and sweets; from 1817 to 1819, wine is also mentioned in some picture titles, perhaps significantly.

Figure 3.6. RAPHAELLE PEALE (1774-1825), *Still Life with Peaches, White Grapes and Porcelain Dish*; oil on panel, signed at lower right — *Raphaelle Peale*, 13¼ x 18¾ inches; The Baltimore Museum of Art, gift of Mrs. Francis White from the Collection of Mrs. Miles White, Jr.

Raphaelle's subjects then were what were later known as "dining-room pictures," and occasionally what we think of as "kitchen pictures." They fall into two not totally distinguishable groups: small, almost intimate arrangements of a few objects, often a little cake, with a wine glass furnishing a vertical accent; and other more complex and more "exuberant" arrangements on a larger scale. In almost all his pictures, however, the forms are arranged on a shelf of some kind. They are referred to as "tabletop still lifes," but the support on which the edibles rest is not so surely defined. It is always a plain shelf, undecorated and without covering of any kind, a board or a ledge perhaps. Likewise, the background is bare and is often divided quite sharply by a strong light creating a diagonal separation between light and dark with some shade in between. The dark colors are almost always at the left, the light ones at the right. The edibles too are brightly illuminated, a dramatic presentation that suggests a kinship with Spanish seventeenth-century prototypes. It would seem significant, therefore, that two still lifes by the Spanish master Juan Sanchez Cotan were shown at the academy in 1818. These works may have been in the collection of Joseph Bonaparte who had settled in nearby Bordentown, New Jersey; his collection included samples of works done by Sanchez Cotan. Sanchez Cotan's preference for vegetable subject matter may also have inspired both Raphaelle and James to investigate this theme, which, otherwise, was not very common in American art.

Upon the rather undefinable shelf support, Raphaelle almost always arranged his subject matter parallel to the picture plane. All the objects were contained comfortably within the space provided for them, although part of an object might often project beyond the shelf or hang over it — the edge of a leaf, a morsel of meat, the handle of a knife — a bit of trompe l'oeil

illusionism, but this was not the artist's preoccupation here. Laterally, too, all elements are contained in these closed-end arrangements; forms are not cut off. The food subjects can ''breathe''; there is space all around them. They are usually arranged symmetrically, an object balancing an object, although often with a single strong diagonal to give compositional form and to offer some abstract liveliness — often a branch with fruit and leaves.

The forms themselves utilize what is called local color, that is, a single color describing each piece of fruit, each leaf, or other object, and though it may vary in value by the addition of black and white, it is not mixed. The forms so described tend toward the abstract; peaches and grapes are perfect spheres, watermelons are perfect ellipses and are most often sliced cleanly rather than broken. Leaves, crisply defined, repeat one another in perfect order. There is rarely a suggestion of age, but rather Raphaelle's still lifes are of timeless perfection. They are, in effect, totally responsive to the then-prevailing neoclassic aesthetic. This is seldom recognized for the simple reason that the major artists of neoclassicism, such as Jacques Louis David, disdained still life exactly because of its transcriptional qualities and its lack of inspirational value. Yet in purely formal terms, Raphaelle's still lifes conform to that aesthetic. As a matter of fact, they could be compared to the still life upon the table in David's great painting, *The Lictors Bringing Brutus the Bodies of his Sons* (1789, Paris, Louvre), or the still lifes by the fine Lyonnais specialist Antoine Berjon, although it would seem extremely unlikely that Peale could have known Berjon's work.

The question of Raphaelle Peale's development during the ten- to fifteen-year period of his active exploration of still life is an extremely difficult one. Judging by both his located works and those known through exhibition references (we can safely assume that the works exhibited and offered for sale by most artists were recent works, of the current or preceding year), his subject matter did not noticeably change. The general vocabu-

Figure 3.7. RAPHAELLE PEALE (1774-1825), *Still Life*, 1818; oil on board, signed at lower right — *R. Peale*, 10¼ x 15¼ inches; Edith and Robert Graham.

Figure 3.8. RAPHAELLE PEALE (1774-1825), *A Herring*, 1815; oil on canvas, signed at lower right — *Raphaelle Peale Feb. 22 1815/Philadelphia*, 10⅛ x 15 inches; Historical Society of Pennsylvania.

RAPHAELLE PEALE, *Still Life with Strawberries and Ostrich Egg Cup.* See plate 1, page 1.

lary of his known oeuvre is mostly contained in the titles of the twenty-seven pictures that were shown in 1813 and 1814 at the academy. Two pictures of 1813, his *Still Life with Raisin Cake* (Stralem Collection) and his *Watermelon with Morning Glories* (National Museum of American Art), establish the two basic approaches the artist took — one small and intimate, the other large and imposing. As in his exhibition record, so in the located works; more pictures are known from 1814 and 1815. The number of dated works located for each year remains fairly constant from then on except that works are not known from 1819 and 1820 and, logically enough, he did not exhibit still lifes in 1820 and 1821. These were years when he was extremely ill, and he spent much of his time in the South.

Raphaelle Peale did not paint flowers. The few that appear in his known works, such as the morning glories of the title mentioned above, those in the *Still Life with Ostrich Egg Cup* (1814) or the *Strawberries and Cream* (1816, Mellon Collection) all appear to be early works. The kitchen pictures — those depicting vegetables, fish, and meat — again were generally

exhibited in his earlier still-life years, and those that have come to light were painted before 1817. The utilization of elegant crockery, metalwork, glassware, and the above-named ostrich egg cup occurs more in his earlier works than in later ones. While all his still-life paintings appear extremely formal, the compositions are less symmetrical and more relaxed in the pictures of 1822 than in those of earlier years.

The year 1822 was Raphaelle Peale's great year. Some of the works known from 1821 are among the artist's weaker pictures, not as crisply painted and somewhat monotonous in composition. But, in 1822, he produced several masterful paintings of a watermelon: one just of the mountainous fruit (Springfield, Massachusetts, Museum of Art), and another of great conglomeration, including an exotic balsam apple (The Newark Museum). This fruit appears also in the only still-life study by Raphaelle (formerly, M. Knoedler and Co.) and in a work of his uncle James (Metropolitan Museum of Art). One of the finest of all of Raphaelle's work is his *Still Life with Wild Strawberries* (circa 1822) where the early strict symmetry reasserts itself, and the combination of fruit and nuts with Oriental export ware porcelain — creamer, sugar bowl, and dish — is finely balanced. While

Figure 3.9. RAPHAELLE PEALE (1774-1825), *Still Life with Wild Strawberries*, 1822; oil on board, signed at lower right — *Raphaelle Peale Pinxt 1822*, 15½ x 22 inches (framed); Edith and Robert Graham.

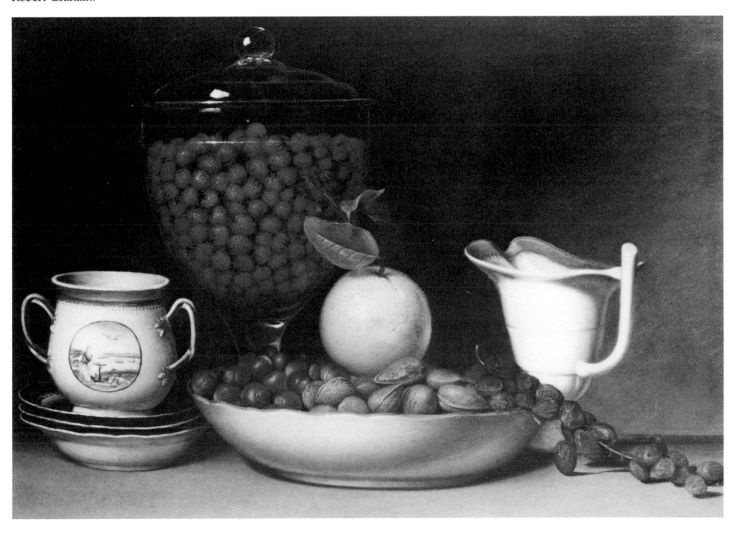

reveling in his virtuoso ability to portray the transparency of the giant glass compote containing the wild strawberries, his compositional skill in rhythmic balance (enlivened by a diagonal branch of raisins picked up by the angle of the leaf atop a central orange) is quite obvious. His masterpiece, *After the Bath*, was done the following year; then, due to illness and death, Raphaelle's artistic wizardry ended.

That it was Raphaelle, not James Peale, who originated this art form in America was recognized as early as 1834 by the great chronicler William Dunlap, who wrote:

> Raphael [*sic*] was a painter of portraits in oil and miniature, but excelled more in compositions of still life. He may perhaps be considered the first in point of time who adopted this branch of painting in America, and many of his pictures are in collections of men of taste and highly esteemed.[16]

James Peale grew up in Annapolis, Maryland. His father was English and had come to the colonies as a schoolteacher.[17] While James Peale was not an enigmatic figure, his artistic career was overshadowed by that of his older brother, Charles Willson Peale, who guided James professionally. Both brothers served in the American Revolution. After the cessation of fighting, James joined Charles Willson in Philadelphia, where in 1782 he married Mary Claypoole, who was the daughter of James Claypoole and sister of James Claypoole, Jr., both artists. In 1786, James Peale and his brother agreed formally to divide the field of portraiture; Charles Willson would paint oil portraits "in large," and James would paint miniatures. The division was not complete, of course, and numerous life-size oil portraits by James are known, as are historical paintings and landscapes. However, he did specialize in miniature painting from the late 1780s until about 1810. The miniatures, in particular, have been studied by twentieth-century scholars. Less attention has been given to his other works.

James Peale gradually abandoned miniature painting during the first decade of the nineteenth century due to poor health and weakening eyes. The strain of detailed precision required by miniature painting was difficult to maintain. Like many members of the Peale family, he began to exhibit at the Pennsylvania Academy as soon as annual exhibitions were instituted in 1811, but between 1811 and 1821 he showed large oil portraits almost exclusively. Only one work was labeled as a miniature during this period, and we may presume that portraits not so designated were life-size oils. Although he exhibited a still life in the Second Annual Exhibition in Peale's Museum in Baltimore in 1823, it was not until 1824 that James began to exhibit such works at the Pennsylvania Academy. From then on, he exhibited mostly works of that theme, as well as some examples of his revived interest in landscape in 1830 and 1831. Most of the paintings by him and copies of his works shown there subsequent to his death, were also still lifes, and it was for that genre that he was immediately remembered. After the initiation in 1827 of annual exhibitions at the Boston Athenaeum, a number of his still lifes were shown there.[18]

Although the format of James's pictures is extremely similar to Raphaelle's, his works are less variegated. They are primarily pictures of fruit and, occasionally, of vegetables, but the depiction of sweets, cheeses, nuts, and other subjects was not of particular interest to him, and his concern with decorative objects was more perfunctory and less inspired. Neither does James appear to have essayed illusionistic trompe l'oeil paintings.

[16]William Dunlap, *History of the Rise and Progress of the Arts of Design in the United States* (New York, 1834; new edition, 3 vols., New York, 1965), vol. 2, p. 181.

[17]For James Peale, see the references above, footnote 6. A half-dozen articles have been published on James Peale's miniatures and oil portraits but ignoring his still lifes.

[18]For the exhibition records of the Boston Athenaeum, see Robert F. Perkins, Jr., and William J. Gavin III, comps. and eds., *The Boston Athenaeum Art Exhibition Index, 1827-1874*.

Figure 3.10. JAMES PEALE (1749-1831), *Still Life with Grapes;* oil on canvas, mounted on panel, 16 x 22 inches; The Butler Institute of American Art, Youngstown, Ohio.

The fruits and vegetables in James's works are displayed in various ways: frequently, in several varieties of ceramic vessels; sometimes directly upon a table or shelf; and occasionally in a wicker basket. However, within the short chronological range of his works — the decade of the 1820s — it has so far proven difficult to establish an order or pattern even of the usage of the ceramic vessels. Furthermore, James made replicas of some of his works a number of times, only to further confuse chronological analysis.

Despite formal similarities between the works of James and Raphaelle, there are significant differences.[19] In technical terms, many of Raphaelle's still lifes are painted on panels, while few of James's are. Raphaelle usually signed his work on the front, James on the back. Compositionally, James preferred several arrangements that differed from the austere clarity of Raphaelle's: sometimes his fruits are arranged in simple curvilinear rhythms; at other times, such as with the *Still Life #2* (1821, Pennsylvania Academy of the Fine Arts; replicas, De Young Museum of the San Francis-

[19]For an important discussion of the Peale still life and the contrast of the work of Raphaelle and James, see John I. H. Baur, "The Peales and the Development of American Still Life," *Art Quarterly* (Winter 1940): 81-92.

JAMES PEALE, *Vegetables with Yellow Blossoms*. See plate 2, page 2.

co Fine Arts Museums, and New York auction market, Christie's, April 1981), the composition is strongly geometric, built up on several tiers. It may be, in fact, that James's earliest still lifes of the decade owe more to Raphaelle in their clarity and precision of form than do his later works that partake of a more individually developed idiom. A number of these still lifes of the early 1820s by James are also on wood panels, as are many by his nephew, again suggesting the initial influence of the younger artist upon the elder.

It is, however, in their interpretation of the fruit theme that uncle and nephew differ most. James's edibles reveal far more brushwork. Instead of an emphasis upon local color, hues are mixed. The separate pieces of fruit show variegation within themselves and also reflect the colors of one another. Leaves, in particular, age from green to yellow to brown, unlike the pure verdancy of Raphaelle's leaves. James favored irregular forms in his works, as opposed to the geometric perfection of Raphaelle. Their watermelon paintings are prime examples. Although Raphaelle's watermelons are sometimes broken, they are more often cleanly sliced, and even in the former cases the outlines are usually unbroken, sweeping curves. James, in such works as his *Still Life with Watermelon* (1829, Mrs. Norman Woolworth Collection), depicts the "picturesque" outline of the broken melon, the irregular form of a chunk of watermelon detached on the table.

Nature's imperfections abound in James's work, while they appear only rarely in Raphaelle's. That is, age spots, worm holes, and other blemishes often appear in James's fruit. In a larger sense, James was conscious of and concerned with change and age. If Raphaelle's still lifes are truly neoclassic, James's are more romantic, both in their formal paint handling and in their reflection of transience, as opposed to the timelessness of Raphaelle's examples. This is consistent with James's other work; his portraits, compared with those of his brother Charles Willson, are also more romantic.

In 1827, James exhibited three vegetable pictures at the Pennsylvania Academy, a theme to which he returned in exhibition two years later. One of the 1827 pictures shown in Philadelphia is almost surely the example now in the collection of the Metropolitan Museum of Art, the *Still Life with Cabbage and Balsam Apple*. The *Vegetables*, exhibited in 1829, may well be the 1828 *Still Life* in the collection of the Henry Francis Du Pont Winterthur Museum. The vegetables selected by James appeal through their unusual, somewhat bizarre shapes, irregular outlines, and because of their contrasting textures: shiny and matte, smooth and crinkly.

REMBRANDT PEALE, *Rubens Peale with Geranium*. See plate 3, page 3.

Of all the artist-sons of Charles Willson Peale, the most famous, and ultimately the most favored by his father and then by the public, was Rembrandt Peale. Rembrandt was not a still-life painter, although in 1838 and 1839 he did exhibit a still life in each of the three exhibitions that were held by the Apollo Association in New York City; it may well be the same painting shown each time. Since the work was offered for sale, there is no reason to doubt that Rembrandt was the painter, not the long-deceased Raphaelle, of these particular still lifes. But if Rembrandt's interest in the theme was at best sporadic, he proved his consummate ability with it in his early portrait of his brother, *Rubens Peale with Geranium*, which was painted in 1801. The potted plant is believed to be the first geranium brought to America. Given the Peales' interest in science, this work is a fitting testimony to the alliance of art and science that was enshrined in the family's

Figure 3.11. RUBENS PEALE (1784-1865), *Still Life with Grapes, Watermelon and Peaches*, 1863; oil on canvas, signed at lower right — *Rubens Peale/1863*, 18½ x 27¼ inches; courtesy of Kennedy Galleries, Inc., New York.

philosophy and in their institutions. Both Rembrandt, the painter, and Rubens, the subject, were much involved in the activities and business of their father's museums. But the picture is more than that. It is a touching, sympathetic likeness of the young man and a brilliant rendering of the leaves and flowers of the plant, which actually shares "equal space" with Rubens and is pushed forward to be as fully significant in the picture as he. In some respects, the painting is similar to the earlier portrait of John Bartram attributed to the artist John Wollaston (National Portrait Gallery, Washington, D.C.) in which the sitter points conspicuously to the Lady Petre pear he had grown in 1758 from seeds that were sent to him in Philadelphia from England. In the Bartram portrait, as in Peale's, the still life is a scientific specimen, but Rembrandt's ability to monumentalize the geranium and to empathetically endow it with some of the same tenderness given to the image of Rubens marks the work as a masterpiece in this specialized genre.

Rubens himself turned to painting only at the end of his life, having spent most of his earlier years involved with the family museums. His final venture in that line was ruined in the financial panic of 1837. With the help of his wife's family, he was enabled to start a new life in the farm country of Pennsylvania, and, in October 1855, he began a decade of painting, primari-

[20]See Charles Coleman Sellers, ''Rubens Peale: A Painter's Decade,'' *Art Quarterly* 23 (Summer 1960): 139-51.

ly still lifes. He kept a very precise diary of such activity; many of his still lifes are recorded as copies of those by other members of his family, often repeated copies, and some of them were given away within the clan.[20] In general, Rubens's pictures display the general format used by the Peales, but often in a more primitive manner that may be due either to his limited artistic training and to his late developed interest or, perhaps, to his poor eyesight. Yet some of his displays of edibles, both copies and original compositions, have decorative charm. As his artistic interest developed at the mid-century, and unlike Raphaelle and James, he investigated the floral theme. His *Flower Piece* (Private Collection, Washington, D.C.) puts to new use a pierced bowl found earlier in the work of James, but it is overwhelmed by the profusion of exuberant blooms that seem to have a life very much of their own. As is characteristic of most Peale still lifes but also of much primitive painting, the exuberance is tempered by a fairly strict symmetry and a tendency to flatten forms, so that the compositional movement is restricted within a single plane parallel to the picture plane.

The still-life tradition was carried out by many women members of the Peale family too, including Rubens's daughter Mary Jane Peale, who con-

Figure 3.12. MARGARETTA ANGELICA PEALE (1795-1882), *Still Life with Watermelon and Peaches*, 1828; oil on canvas, initialed at lower right — *M.A.P.*, 13 x 19⅛ inches; Smith College Museum of Art, Northampton, Massachusetts, given anonymously by a member of the class of 1952.

tinued working into the twentieth century. Four of James's daughters also painted still lifes, although Anna Claypoole Peale turned quite early in life to miniature painting where she had a successful career.[21] She exhibited a still life at the Pennsylvania Academy, labeled as her "first attempt," in 1811; she did not show any works of this theme after 1817. Her sister Maria also showed her first painting, a still life, in 1811, but an example by her that has come to light suggests that she continued, at least occasionally, to essay still lifes into the middle of the century.

Sarah Miriam Peale developed into one of the earliest professional women portraitists in America.[22] She was trained first by her father and then by her cousin Rembrandt, whom she joined at the Baltimore Peale Museum in 1818. In 1847, she moved to St. Louis, Missouri, extending the Peale influence. A number of her early fruit still lifes suggest both a strong talent and interest in the theme. These vary somewhat in quality; at her best, Sarah Miriam was extremely competent. Some of her works are as simple and clear in form as Raphaelle's, while others show her father's concern with transience. Given her activity in Baltimore, it is not surprising that one of her still lifes was in the collection of Robert Gilmor of that city, probably the most significant collector in America of his day. Though Sarah Peale spent many years in St. Louis, where her health began to decline, her artistic activities there are far less documented; relatively few of her works, either portraits or still lifes, from those years have been identified. Yet, she exhibited still lifes at the first exhibit held by the Western Academy of Art in 1860 in St. Louis, and she may have even influenced the gifted Harriet Skeele, of St. Louis.[23]

Most active as a still-life painter among the daughters of James Peale was Margaretta Angelica Peale, who exhibited regularly at the Pennsylvania Academy, showing still lifes between 1828 and 1837. Located examples of her fruit paintings, however, are dated as late as 1866. Again she, like her sisters, followed the style that was first developed by Raphaelle Peale, but there is a psychological quietness about her paintings and a certain starkness and sense of isolation of individual forms that are quite engaging and distinguished. Her late pictures of a few cherries or strawberries or pears are "humble" representations, but extremely appealing, nevertheless.

[21]See Wolfgang Born, "The Female Peales: Their Art and Its Tradition," *American Collector* 15 (August 1946): 12-14.

[22]To date, Sarah Miriam Peale is the only one of James Peale's daughters to be the subject of an extensive, scholarly monograph; see Wilbur H. Hunter and John Mahey, *Miss Sarah Miriam Peale, 1800-1885: Portraits and Still Life* (exhibition catalogue; The Peale Museum, Baltimore, 1967).

[23]For Harriet Skeele, see Judith A. Barter and Lynn E. Springer, *Currents of Expansion: Painting in the Midwest, 1820-1940* (exhibition catalogue; The St. Louis Art Museum, 1977), p. 96.

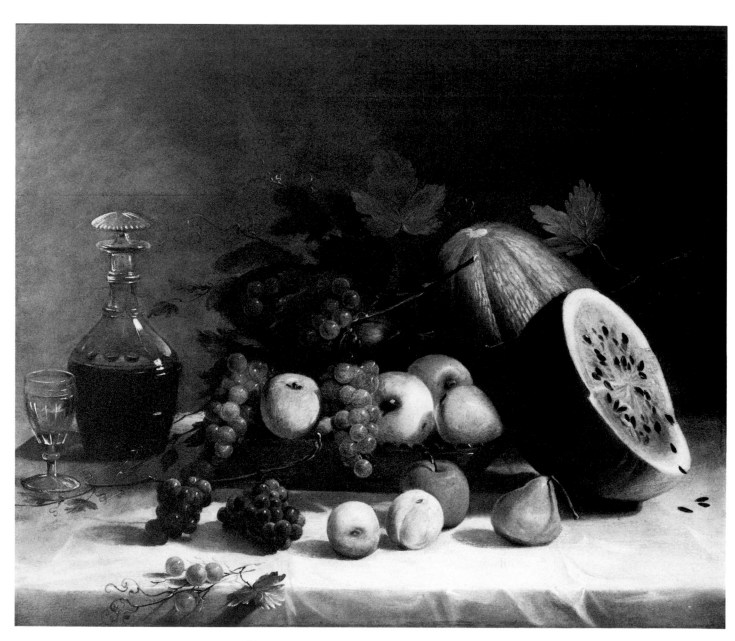

Figure 4.1. ELIAB METCALF (1785-1834), *Still Life with Wine*, 1824; oil on panel, signed verso
— *E. Metcalf/1824*, 21¾ x 26¾ inches; Mr. James Ricau.

4 Beyond the Peales

Professional and Folk

The dominant role played by the Peale family must be put into perspective when we consider American still-life painting in the early nineteenth century. Although Raphaelle Peale and James Peale — and, to a lesser degree, other members of the family — were among the first professionals to paint still lifes, their involvement with this theme was transient. The development of this art form itself was not of great importance at the time, however much these works are now admired and sought after.

Nevertheless, Philadelphia experienced some concentrated activity in still-life painting during the early decades of the century, certainly more than New York or Boston. How much the Peale family influenced this general interest is difficult to ascertain. On the one hand, the Peales' concern with the theme must certainly have prompted others to investigate it and surely must have stimulated some degree of patronage, however meager, which other artists would want to share. On the other hand, the determination to pursue still-life painting on the part of first Raphaelle and then James may reflect a cultural climate of practice and patronage already in development.

William Groombridge, for instance, already somewhat innovative as one of the first landscape specialists in America, showed four still lifes at the first annual exhibit of the Pennsylvania Academy in 1811. Unfortunately, these still lifes were the last he was to exhibit and to paint, for he died the same year in Philadelphia. Though hardly the equivalent of the Peales, several members of the Birch family in Philadelphia painted and exhibited still lifes. These included the patriarch of the clan, printmaker and enamel miniaturist, William Russell Birch; his daughter, Penelope Birch Barnes; and the best known of the family, the marine painter, Thomas Birch. Only Penelope, however, painted the theme with any frequency. John Archibald Woodside was primarily a sign painter in Philadelphia, but he too painted fruit pictures, somewhat in the tradition of the Peales, though his were more wooden and more sharply drawn. Robert Street, the portrait specialist in Philadelphia, exhibited his *Flower Piece* and *Fruit Piece* in a large exhibition devoted primarily to the display of his own works, which was held in that city in 1840; the *Fruit Piece* may be the beautiful *Basket of Apples* (Flint Institute of Arts, Michigan), as we know it today.

We have located only a few still lifes done by artists, other than the Peales, who worked in Philadelphia between 1800 and 1840. Although these works appear sporadic in the oeuvres of their artists, still they are more numerous than the still lifes done by painters who worked outside of Philadelphia. A few early still lifes painted in New York City have come to light; one of the finest is the *Still Life with Wine* (1824) by Eliab Metcalf. Metcalf, born in Massachusetts, was a portrait painter who based his career in New York City but traveled from Nova Scotia to the West Indies and lived his last decade in Cuba, where works by him can now be found.

Metcalf's painting is similar to the Peale conception — an arrangement of fruit, wineglass, and decanter upon a tabletop, the forms compacted well within the edges of the picture and arranged parallel to the picture plane. However, the overall effect in Metcalf's work is more dense. The grouping is less composed, more "natural," and the colors are richer and deeper, with stronger *chiaroscuro* accomplished, in part at least, through silhouetting the fruit against a bright white tablecloth. Yet, the precise location of the

Figure 4.2. THOMAS BADGER (1792-1868), *New England Still Life*, oil on canvas, 21⅜ x 26½ inches; Colby College.

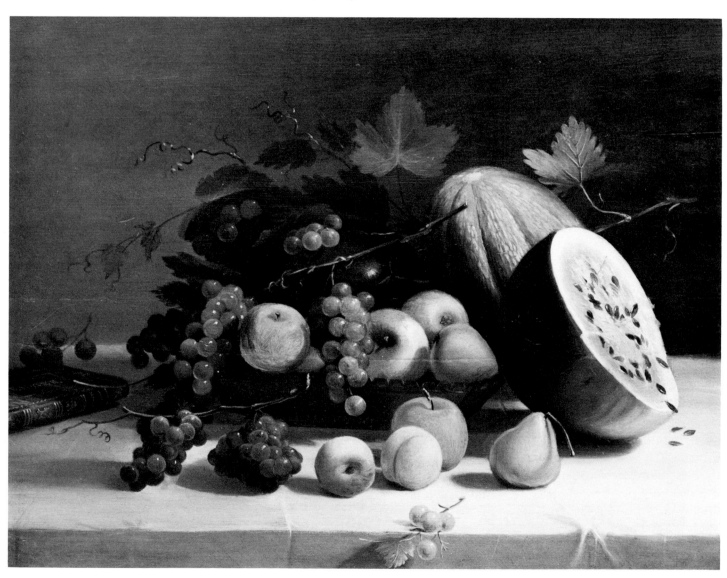

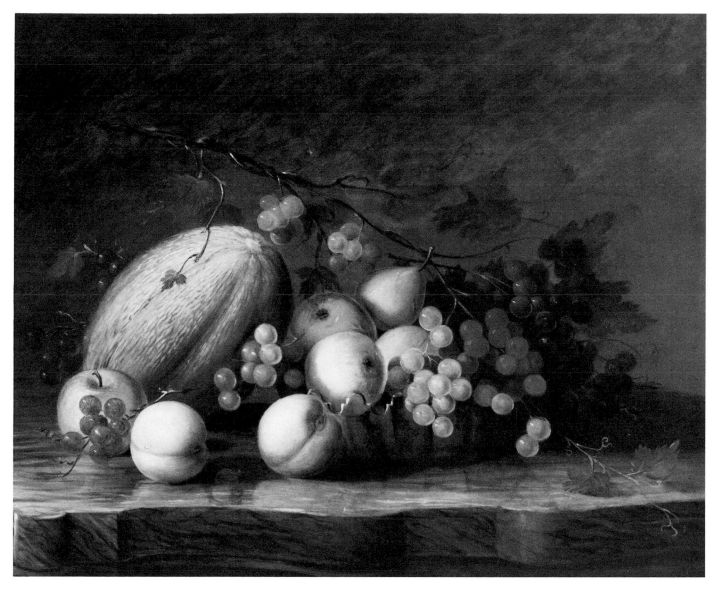

Figure 4.3. THOMAS BADGER (1792-1868), *Still Life on Marble Ledge*, 1818; oil on panel, signed verso — Painted and presented by/Thomas Badger to Francis Field/Jany 1818, 21 x 26½ inches; courtesy of Kennedy Galleries, Inc., New York.

arrangement is no more obvious than in a Peale still life. There is no background of a room, no firmly identifiable furniture, no structural limits to the covered tabletop.

Metcalf exhibited still lifes in New York at the American Academy of the Fine Arts in 1817, 1819, 1823, and 1824; the present work, the only one that so far is unquestionably his own, may be the one that was shown in 1824. What is more remarkable is that an almost identical work has appeared by a Boston portraitist, Thomas Badger, who also exhibited still lifes at the American Academy during this same period, although he showed only portraits in Boston. A few other still lifes by Badger have also appeared, and, as in the example by Metcalf, they utilize more monumental forms than many of the works done by the Peales, thus suggesting the existence of a more grandiose mode of still-life painting that coexisted with that of the Peales.

Figure 4.4. SHEPARD A. MOUNT (1804-1868), *The Rose of Sharon — Remember Me*, 1863; oil on canvas, signed at lower right — *By S A Mount*, 12½ x 10½ inches; The Museums at Stony Brook, bequest of Dorothy deBevoise Mount, 1959.

These particular works by Badger and Metcalf are identical in composition and subject matter, except for one area: Badger substituted an elegantly bound book for the decanter and wineglass at the left. One might interpret the change as suggesting a more literary or cultural temperament on Badger's part in contrast to Metcalf's more convivial — and perhaps imbibitional — habit, but, in fact, several other paintings exhibited by Badger in New York were of fruit and wine. A melon similar to that which rises in the background of both works had already appeared in a work by Badger in 1818, suggesting that the conception may have begun with Badger, whom Metcalf was imitating, but Metcalf's work is the stronger of the two paintings. Perhaps both artists worked from the same still-life arrangement in either New York or Boston, or, more remotely, perhaps both were reinterpreting an, as yet, unlocated original piece.

Besides Metcalf, a few other artists displayed still lifes in New York in the early exhibits that were held by the American Academy and by the

National Academy, but most of these are not extant. Such activity was sporadic, even in Philadelphia. William John Coffee, an English sculptor, showed two studies of dead game at the American Academy in 1817 about the same time William Jewett showed fruit, flower, and game pictures there. Jewett was then still a pupil of Samuel Waldo, whom he subsequently joined in partnership in a portraiture business. A decade later, William Page made his exhibition debut with two still lifes.

In the same year, 1827, Henry Smith Mount began to exhibit still-life paintings at the National Academy of Design. The three Mount brothers, Henry, Shepard, and William Sidney, all painted still lifes at one time or another during their careers, as did Henry's daughter Evelina. However, only Henry, the eldest, was a still-life specialist. He was a sign and ornamental painter, whose partner, William Inslee, also debuted at the academy in 1827 with a still life. Although Henry's few known still lifes of fish and beef are, in fact, easel pictures, their apparent simplicity and boldness suggest their origins as advertisements for fishmongers and butchers.

Figure 4.5. WILLIAM SIDNEY MOUNT (1807-1868), *Spring Bouquet*, 1847; oil on oiled paper, signed at lower right — *W.S.M. (1847)*, 6⅝ x 6⅛ inches; The Museums at Stony Brook, bequest of Ward Melville, 1977.

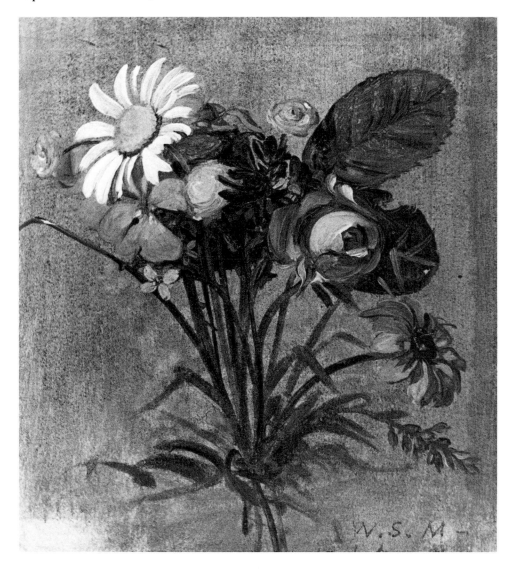

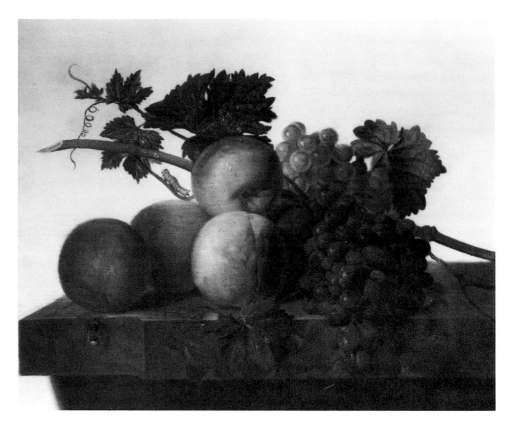

Figure 4.6. John Johnston (1753-1818), *Still Life — Fruit*, 1810; oil on panel, 25 x 31½ inches; St. Louis Art Museum.

Shepard Mount was primarily a portrait painter but his concern with still-life painting seems to have been sustained. Known today are his fish pictures and several attractive flower paintings. However, the most talented and most famous of the Mount brothers was William Sidney, who worked in New York City and at Stony Brook, in Long Island. In his lifetime, he became the most significant interpreter of American rural life. He produced about a dozen or so still lifes, but these works were done late in his career, in the 1850s. They differ in character from the still-life painting discussed previously in that those which are located are not formal arrangements, but rather studies of nature — fruit on a branch, or a bunch of wildflowers that were just plucked.[1] As such, they suggest a dual motivation: artistic enjoyment in their immediate recording, unhampered by the necessity for formal compositional arrangement, and a possible ultimate use as accessories in larger and more elaborate compositions of figures in an outdoor setting. As independent still-life notations, they have a vivacity of paint quality, vivid coloration, and freshness unlike the scientific exactitude of most still lifes of their period, calling to mind the similar nature studies, including arrangements of wildflowers, by John Constable, the great English landscape specialist in the early nineteenth century. Unlike the earlier investigation of still life by his brothers, however, William Sidney Mount only began to paint still lifes when American artists and art patrons had expressed, significantly, greater interest in this art form, which was not the case during the period of the Peales.

During those years, there was even less enthusiasm for the theme in Boston than in New York City. Yet, one of the earliest and most beautiful of

[1]Although there is a fair amount of published material on William Sidney Mount, very little of it touches upon his still-life painting. References to Mount's still lifes are best consulted in Bartlett Cowdrey and Hermann Warner Williams, Jr., *William Sidney Mount, 1807-1868: An American Painter*.

all nineteenth-century American still lifes is *Still Life with Fruit* (1810, St. Louis Art Museum), by John Johnston, a portrait painter in Boston.[2] The only known still life done by Johnston, it is a sophisticated interpretation of European traditions in the late-baroque era — painted insects, droplets of water or dew, and thick stone slab support. Its unusual white background, which effectively silhouettes the fruit and leaf arrangement, relates to Caravaggio's work, to Jean-Etienne Liotard, the eighteenth-century Swiss pastellist (Johnston's contemporary), and to Jan Frans van Dael, a Belgian still-life specialist who worked in Paris. A lost work by van Dael is particularly close to Johnston's example. While van Dael is not well known today, he was in his own time a favorite of the Empress Josephine, and a painting of his was shown at the Pennsylvania Academy in 1811.

Still-life painting was not, however, a particularly popular genre in Boston in the first half of the nineteenth century. While a few fruit and vegetable pictures by James Peale and Raphaelle Peale were shown in the first five annual exhibitions of the Boston Athenaeum, 1827-1832, and a fair number of Dutch and Flemish examples from the schools of the Old Masters were also exhibited there, few local artists exhibited still lifes in the 1820s and 1830s. Most of those who did are extremely obscure figures whose works are unknown today, painters such as Benjamin Nutting, Rueben Rowley, Edward H. Whitaker, and Henry (or Hiram) Jacobs.[3] Charles Codman, a landscape painter in Portland, Maine, exhibited his *Still Life* in 1830. Probably the most significant Boston artist to paint occasional fruit pictures was Thomas Badger, a portrait specialist, but as previously mentioned, he exhibited his still lifes in New York City rather than in Boston. By far, the most interesting early still-life painter to reside, at least temporarily, in Boston was George Harvey, essentially a specialist in the watercolor medium, first in miniature portraits and then in landscape scenery. As the earliest body of American flower paintings, his still-life work merits special attention, and he will be discussed in a later chapter.

In Baltimore, the one early still-life painter known was Cornelius De Beet; the only located work by him was done in a rather dark and dramatic manner, imitating the late baroque style, which he most probably learned in Germany, his native home. Further afield, Asa Park, who died in 1827, was active as a portraitist in Lexington, Kentucky, but his best work was said to have been his fruit and flower painting. However, none of these works is known today.

The most significant American painter of still life in the first third of the nineteenth century, other than the Peales, was Charles Bird King, but such concern is deceptive, if not exaggerated. King was primarily a portrait painter, who was active in Philadelphia and Baltimore in the second decade of the century. He finally settled in Washington, D.C., in 1819, becoming the first important resident artist in the capital. His still lifes were occasional paintings, but together with his Indian portraits, they are the works by which he is best known today, and they constitute his most original conceptions.[4]

About a dozen and a half still lifes by King are recorded, but a number of these separate references may be to the same pictures; little more than half a dozen of such paintings have been located today. Several of these are tabletop arrangements of fruit and quite complex, elaborate arrangements, more in the manner of Metcalf and Badger than of the Peales. More interesting and unusual, however, are the works that depart from this

[2]For the John Johnston still life, see *City Art Museum of Saint Louis Bulletin*, n.s. 2 (March-April 1967): 4-5.

[3]For references to works of art exhibited in Boston, see Robert F. Perkins, Jr., and William J. Gavin III, comps. and eds., *The Boston Athenaeum Art Exhibition Index, 1827-1874*.

[4]For King and his still lifes, see the publications by Andrew Joseph Cosentino: "Charles Bird King: An Appreciation," *The American Art Journal* 6 (May 1974): 54-71; "Charles Bird King, American Painter, 1785-1862" (Ph.D. diss., University of Delaware, 1976); *The Paintings of Charles Bird King (1785-1862)* (exhibition catalogue; The National Museum of American Art, Washington, D.C., 1977).

Figure 4.7. CHARLES BIRD KING (1785-1862), *Still Life — Game*, 1806; oil on canvas; IBM Corporation.

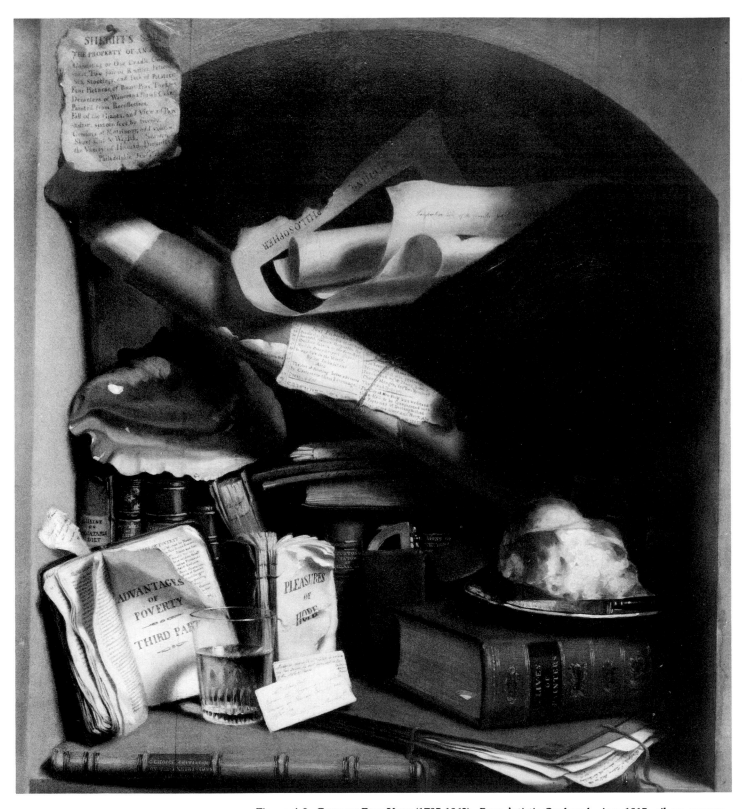

Figure 4.8. CHARLES BIRD KING (1785-1862), *Poor Artist's Cupboard,* circa 1815; oil on canvas, 29¾ x 27¾ inches; Corcoran Gallery of Art.

familiar theme and format. The earliest of these is King's *Dead Game* (1806, IBM Collection), the first known piece to be signed and dated, and almost the earliest located American still life. This work was painted in London, where King had gone to study under Benjamin West, having previously studied portraiture in New York City with Edward Savage. Though such dead game still lifes were common in European baroque art and were used as accessories in portraits of male youths in American art (including West's works), they were not so common among American painters until many decades later. The well-rendered textural differentiation among the forms in the picture, the strange, slightly surreal spatial juxtaposition of the table of game with mysterious, shadowy ambience — perhaps more fortuitous than purposeful — and the general thematic similarity to Old Master still-life traditions that King had probably studied in London all suggest that this work was a product of his first months of foreign study.

Unusual for an American painting of that date, King's *Dead Game* is nevertheless a competent, if not a conventional, game piece. His several niche or cupboard paintings, however, done after his return from London in 1812, are extremely unusual. These include *The Poor Artist's Cupboard* (circa 1815), which was probably painted in Baltimore, and the later *Vanity of an Artist's Dream* (1830, Fogg Art Museum, Cambridge, Massachusetts). In both of these, King contrasts symbols of artistic hope and ambition with the reality of an artist's day-to-day existence — a fare of bread and water, torn volumes entitled *Advantages of Poverty* and *Pleasures of Hope,* and a sheriff's sale notice.

The traditional view of these pictures is that King was moralizing upon the sad plight of the American artist, and that these works are, therefore, autobiographical. Facts contradict this, however, and internal evidence supports the contradiction. King himself, while hardly a wealthy man, was not unsuccessful. He garnered important portrait commissions in Baltimore and was highly regarded in the social and artistic circles in Washington, D.C., after he settled there in 1819. But his success was in portraiture. These still lifes, rather, refer to the condition of the history painter in America. Artists of this "high art" — a tradition that was practiced by West and pursued by fellow artists who were studying in London, including Washington Allston, Samuel F. B. Morse, and others — found little comprehension and less patronage in this country. Thus, the artist's vain dream in 1830 was represented in his still life by a rich cornucopia that was juxtaposed with a discarded head of Apollo Belvedere. These classical and allegorical symbols of the ideal art were rejected by King in order to pursue a more prosaic, but surer, road to success in portraiture.

Instead of following the formal arrangements of edibles seen in the still lifes done by the Peales and others of his time, King chose to create moralizing, storytelling still lifes — works that are almost literally meant to be "read." Formally, these niche pictures are precursors of the late nineteenth-century vertical still lifes. Although forms do not seriously project out into the viewer's space, the eye is blocked from traveling beyond a shallow space, and forms are read across and vertically. King's arrangements are sophisticated. The forms of various sizes, textures, and colors are extremely complex but not at all chaotic, and the horizontal and vertical balance is carefully worked out. One strong diagonal cuts across the arrangement in each picture to impart a dynamic vitality to the composition.

Figure 4.9. CHARLES BIRD KING (1785-1862), *Still Life with Catalogue,* 1828; oil on canvas, 29½ x 24½ inches; Redwood Library and Athenaeum.

One other work by King that falls, at least partially, into the realm of still-life painting is his *Landscape with Catalogue* (or *Environs of Milan, Italy*), painted in 1828. Most of the painting is a landscape, perhaps a copy of a work by Salvator Rosa as it is presently labeled, or at least a copy of a work once presumed to be by Rosa. The picture is not meant to be thought of as a landscape but rather as a *picture of a landscape painting,* and a trompe l'oeil. For while the landscape part of the picture is painted in a broad, painterly fashion, the lower right-hand corner depicts very meticulously a *Descriptive Catalogue of the Pictures in King's Exhibition . . . 1828.* Almost concealed by the painted catalogue are two figures, a crouching male in maroon pantaloons who is obviously approaching a woman whose naked legs appear outstretched at the left, beyond the catalogue. The spectator is thus titillated by what he or she does, or does not, see.

This is a different form of "catalogue deception" than Raphaelle Peale's though it is conceivable that King was familiar with Raphaelle's work. He also may have known European "deceptions." A further deception lies in the fact that such an exhibition of King's work has never come to light and probably never occurred. Thus, the work is a humorous example of double deception, one that looks forward to the trompe l'oeil "pictures of pictures" by John Haberle in the late years of the century, where again very little of the painting was actually done in a trompe l'oeil manner, and as here "less is more."

We have thus surveyed the gradual growth of professional still-life painting in American metropolitan cities up until about 1840. The term *professional,* of course, is an elastic one. Using the work of Raphaelle Peale as comparison, Henry Mount might seem quite an amateur, but Mount exhibited professionally, and his work would appear academically competent if compared in turn to that of artists who truly are designated *folk, primitive,* or *naive.* Yet, there exists a copious amount of superior folk painting done in this country during the nineteenth century — "superior" in the sense that the artists possessed talents, however innate rather than trained, which allowed them to render their designs with special incisiveness or with great decorative brilliance. Many of these artists were amateurs; most of them worked in the back country of America, not in the larger cities and towns.

One of the problems in discussing folk paintings lies in the grouping of various categories of nonprofessional painting into one general summation. Itinerant portraitists did not have the same motivation as the schoolgirl who followed instructions to produce theorem paintings in watercolor on velvet as part of her cultural education.[5] Many of the latter works, though certainly not all, are still lifes. They were copied, in part with the aid of stencils, from contemporary prints. Other still lifes, often bolder in their design and far more complicated in their multitudinous subject matter than most theorem paintings, were probably done by amateur artists as decorative panels for dining rooms in their own homes or those of neighbors, friends, and family. All three of these — the itinerant portraitist, the schoolgirl, and the inspired amateur — are essentially quite different artistic personalities.

A problem in any study of primitive still-life painting is its chronological placement by art historians. Until recently, this placement suggested that primitive painters either worked independently of the professional currents of their time or were in fact innovators in still-life painting. This is because the earlier art histories almost invariably assigned dates to primitive still lifes (which were themselves generally undated) indicating that they were done

[5]For theorem paintings, see Louise Karr, "Paintings on Velvet," *Antiques* 20 (September 1931): 162-65.

[6] For instance, the well-known Anonymous, *Bountiful Board* (Rockefeller Collection, Williamsburg) is dated circa 1800 in Jean Lipman, *American Primitive Painting,* p. 16. This date is unfortunately accepted and acknowledged by the first historian of American still-life painting, Wolfgang Born, in his "Notes on Still-Life Painting in America," *Antiques* 50 (September 1946): 158. The same picture is more properly dated as circa 1855 in Mary Black and Jean Lipman, *American Folk Painting,* p. 210. Likewise, the well-known *Fruit in a Wicker Basket* (Rockefeller Collection, Williamsburg) was dated 1830 in Alice Ford, *Pictorial Folk Art New England to California* (New York and London, 1949), p. 127, but circa 1855 in Black and Lipman, *American Folk Painting,* p. 212.

[7] For Nuttman, see Richard B. Woodard, *American Folk Painting Selections from the Collection of Mr. and Mrs. William E. Wiltshire III* (exhibition catalogue; The Virginia Museum, Richmond, 1977-1978), pp. 96-97; for the earlier dating of this painting, see *Plain and Fancy: A Survey of American Folk Art* (exhibition catalogue; Hirschl and Adler Gallery, New York, 1970), p. 27.

[8] See Ruth Piwonka and Roderic H. Blackburn, "New Discoveries about Emma J. Cady," *Antiques* 113 (February 1978): 418-21; for an example of the earlier dating of Emma Cady's work, see Lipman, *American Primitive Painting,* p. 108.

ISAAC NUTTMAN, *Still Life.* See plate 4, page 4.

prior to most professional painting. Occasionally, these dates were given as circa 1800, and often they were in the 1820s.[6] Yet, the aesthetic to which most primitive still lifes relate in the professional tradition is that of the mid-century in America, the still lifes of lushness and abundance that we associate, for example, with Severin Roesen in particular — pictures of the 1850s and 1860s. Recent research, which has succeeded in disengaging some of the more prominent talents among the primitive still-life painters, has proved that the more primitive or naive painters did in fact work in the time of their better known professional counterparts, rather than preceding them.

Isaac W. Nuttman is a case in point. When his bountiful still life first appeared in recent years, it was dated as 1830-1840; it is now believed to have been painted around 1865.[7] The former date would have marked Nuttman as *the* painter who had introduced the concept of natural bounty into American still-life painting, supplanting the austerity of the Peale tradition. Now we can recognize him as, admittedly, no innovator but as a talented designer with a good eye for color, who translated the professional tradition of Roesen and others into a concept of decorative abundance. Particularly noteworthy is his almost theatrical device of combining the grapes and their arbor with the pear tree at the right to create a proscenium through which we view hundreds of fruits piled up on the ground. This closed-in design may also reflect Nuttman's actual vocation. He was an ornamental painter in Newark, New Jersey, from 1835 to 1872; the address — 8 Coes Place, Newark — inscribed on his *Still Life* would seem to confirm a date of between 1863 and 1868 since those were the years he lived at Coes Place. The bright, decorative quality of his still life, and the enclosed design with a slightly arched top to the arbor trellis, suggests the parameters he would have dealt with in the painting of chairbacks.

Even more to the point is the most famous of all folk or primitive American still-life painters, Emma Cady. Thanks to the researches of Ruth Piwonka, a good deal of Emma Cady's life and something of her art is now known, but for years she was identified solely with *Fruit in a Glass Compote,* a watercolor on paper that was usually dated around 1820.[8] Emma Cady was not born until 1854. She lived almost her whole life in East Chatham, New York, though she died in Grass Lake, Michigan, in 1933. Like so many women still-life painters of the nineteenth century, she utilized a stencil, both in this painting and in the few other still lifes that are known to have been painted by her. But this does not prevent her work from taking on a personal sense of symmetry and balance, a combination of convincing appearance and consistent approach in the carefully articulated outlines and in the brightly highlighted central areas of each large piece of fruit. This last device creates bright luminosity, a concern that led the artist to affix mica flakes to the glass compotes in which the fruit is resting, creating a gentle glittering pattern. But her still lifes were painted at the end of the nineteenth century, not at the beginning.

It is probable that the dating of most primitive still-life paintings of the century should be revised upward, which does not, of course, denigrate their quality or their attractiveness. Indeed, an untrained artist could, and occasionally did, create a minor masterwork; but the nonprofessional tradition should be seen as reflective rather than as innovative in the main currents of American still life.

Figure 4.10. EMMA CADY (active 1820s), *Fruit in Glass Compote*, circa 1820; watercolor on **paper**, 16½ x 19½ inches; Abby Aldrich Rockefeller Folk Art Center.

Figure 5.1. JOSEPH BIAYS ORD (1805-1865), *Fruit*, 1844; oil on canvas, 17 x 24½ inches; courtesy of The Reading Public Museum and Art Gallery.

5 An Abundance of Still Life

The Still Life of Abundance

Between the death of James Peale in 1831 and the late 1840s, the nascent art of still-life painting was almost dormant in America. Relatively few examples were painted or, at least, exhibited, and most of the artists that exhibited even an occasional example have remained obscure. Only one painter of real quality and significance has so far emerged from that almost twenty-year period. This was Joseph Biays Ord, of Philadelphia. Before he was twenty, Ord exhibited several still lifes at the Pennsylvania Academy, and three years later, in 1827, he showed another work that was a copy after a work done by Raphaelle Peale. Subsequently, however, he turned to portraiture and to figure paintings after the Old Masters, only to return to still-life painting in 1838; from that year until 1862, it remained his primary area of creativity. This is manifest in the exhibition annals of the Pennsylvania Academy, although he had exhibited a group of still lifes at New York's National Academy in 1835.

Ord thus stands as the prime intermediary figure between the period of the Peales and the flowering of still-life painting at mid-century. Likewise, the character of his work falls midway between the austerity of the early artists and the lush abundance of the 1850s and 1860s. Despite his prominence, so few of his works have come to light that a discussion of his development is not yet possible. It is clear that a number of his paintings have an intimacy that is related to the smaller pictures of Raphaelle Peale, and he utilized some of the same motifs — nuts, iced cakes, decanters, wineglasses, and other objects that we associate with that earlier master. Ord's backgrounds and supports also follow the simplicity of the Peale model, but they are defined more specifically — though plain, they usually are tabletops, laterally defined and identifiable.

Many of Ord's still lifes are fruit pictures, somewhat more complex than the standard Peale model. Ord borrowed Raphaelle Peale's favorite single, strong diagonal axis, but in a number of his pictures the diagonal unites objects that recede into space, rather than being parallel to the picture plane, giving greater vitality to more dynamic and baroque compositions. The fruit and other objects introduced vary more substantially in size, texture, and color than in the earlier still lifes by Raphaelle. Also, Ord begins to revel in the variety that becomes a hallmark of the following generation. Like James Peale, and like many of his successors, he is concerned with age

and temporality, and also like James, he is a more painterly painter than Raphaelle Peale. Ord's father, with whom the artist lived, was a noted ornithologist in Philadelphia; the two lived comfortable, successful lives, and Ord's still lifes are imbued with more optimism than are the dark and dramatic works of his predecessors.

Still lifes, again painted by mostly obscure artists, began to reemerge slowly on the exhibition scene in New York and Philadelphia in the middle years of the 1840s. The brothers Thomas Wightman and William Wightman, of Charleston, painted fruit pictures. Thomas exhibited at the National Academy occasionally from 1844 on, having been a pupil of Henry Inman while in New York City; William Wightman is remembered today for a group of fruit pictures in the collection of the Gibbes Art Gallery in Charleston. Louis Grube began exhibiting his fruit paintings in both oil and pastel in 1846 at the National Academy, and James Henry Wright began to show still life there the following year. Grube was living in Poughkeepsie in the late 1840s but a decade later moved to Brooklyn, where he continued to exhibit through 1877. His few located works are competent pictures in a mid-century manner, more elaborate than those painted in the Peale tradition. Probably the most unusual and distinct aspect of his still-life art was his

Figure 5.2. Louis Grube (fl. 1847-1860), *Fruit Bowl*, 1847; pastel on paper, signed at lower right — *Louis Grube 1847*, 17½ x 24 inches; courtesy of Kennedy Galleries, Inc., New York.

partiality for the pastel medium. Numerous folk and amateur still lifes in pastel that were painted in the nineteenth century are known today, but few truly professional artists used the medium extensively until the pastel revival of the late nineteenth century. Grube, though little known in his own time and less so today, is therefore our tentative link between the American pastel portraitists in the eighteenth century — Copley, Benjamin Blyth, the Sharples family painters — and the masters of pastel in the late nineteenth century, such as William Merritt Chase and Robert Blum. But even then, pastel was used infrequently for still life, though Chase did paint some exceptionally beautiful examples.

In Philadelphia, Ord's only rival was A. B. Engstrom who also exhibited occasionally in New York in the 1840s, but none of Engstrom's work has surfaced, and his/her first name is still unknown.

Thus, before 1848 we have almost two decades that, except for one specialist of some signifiance, were quiescent, with faint stirrings of new interest in the theme about the middle of the 1840s. The two related questions that arise are: first, the reasons for that quiescence, and, second, what accounts for the renewal of interest. One would like, of course, to discover some socioeconomic or cultural explanation for either or both developments, but in still-life painting these may not suffice. The deaths of Raphaelle Peale and James Peale may have deprived the art form of its major practitioners, and its rewards may have been too few to attract immediate followers. Then, too, there were few collectors, and their attention may have been focused primarily upon the traditional theme of portraiture or upon the more exciting new genre of landscape, to dissuade younger artists of real talent from taking up still life. And the economic failure in 1837, whose impact upon the fine arts still deserves greater study, certainly slowed the serious practice of a theme that had few cultural implications and little nationalistic import.

Gradually, however, economic growth in the 1840s permitted more refinements in the average home, and a still life in one's dining room was a part of such an improved standard of living. The rise of the art unions, those enormously popular lottery organizations that were introduced to America from Europe in 1838, brought an awareness and ownership of art into countless American homes.[1] Such organizations were, however, restricted as to the kinds of works they could acquire and distribute, as the works were awarded by lottery and thus were to have some general appeal. Portraits, for instance, were considered inappropriate, but appealing genre scenes, attractive landscapes, and decorative still lifes were ideal for such distribution. The art unions began in New York City, but separate organizations were established in Cincinnati, Philadelphia, Newark, New Jersey, and Boston.

The art unions thrived between 1838 and 1852, when they were declared illegal as lottery organizations; they did not perish because of any lack of public interest. However, it was only in the mid-1840s that they began to assume a really major role in art patronage and in the guidance of public taste. It was at this same time that still lifes began to appear substantially amidst the exhibited acquisitions and ultimately the distributions of the American Art-Union in New York. In other words, due at least partially to the activities of the art unions, still-life painting came to appear as a regular component of our art exhibitions, an accepted and expected theme in annual displays beginning about 1845. The theme was further stimulated a

[1]See Mary Bartlett Cowdrey, *American Academy of Fine Arts and American Art-Union, 1816-1852*, and E. Maurice Bloch, "The American Art-Union's Downfall," *The New York Historical Society Quarterly* 37 (October 1953): 331ff.

few years later by the appearance of works that were painted by immigrants who arrived in the wake of the European revolutions in 1848.

Compared to the paucity of still-life specialists in the early nineteenth century, the art world in America after 1850 had an ever-increasing number of painters who devoted their talents primarily to fruit and flower painting. In fact, the growing popularity of the theme led a number of artists to abandon their prior area of specialization so as to concentrate upon the increasingly lucrative and appealing specialty, despite the relatively low sums that were paid for still lifes: John F. Francis abandoned portraiture for still life; Samuel Fanshaw gave up miniature painting for the most part; George Henry Hall and George Cochran Lambdin turned almost completely from genre painting to still life.

Seven artists stand out as being among the most significant still-life specialists of the mid-century, although not all of them were so recognized in their own time. They are George Henry Hall, John F. Francis, Severin Roesen, William Mason Brown, Andrew John Henry Way, and the flower painters, Martin Johnson Heade and George Cochran Lambdin. The last two will be discussed in the following chapter dealing with flower painting, though it should be recognized that all of these specialists painted floral pieces at one time or another. The activity of this group of artists was roughly contemporary, and they are usually treated in art historical discussions as such, but it may prove useful to recognize priority within the group. In any case, that priority belongs to Severin Roesen.

Roesen is an exceedingly difficult figure to discuss in a history of American art or in a history of American still-life painting.[2] He is certainly the most famous of all mid-nineteenth-century American specialists today, and judging by the great number of enormous pictures painted by him, it seems that he also was tremendously popular in his own time. Furthermore, the many works that have appeared in recent decades, which are at least similar to Roesen's oeuvre, suggest a powerful influence of Roesen upon other artists. Yet, critical documentation of Roesen's art is all but nonexistent, and even biographical information is so meager that the dates of his birth and death are unknown. The American Art-Union in New York acquired his works in 1848, the year when he arrived in New York City. Eleven pictures in total were distributed between 1848 and 1852. Roesen's works were also shown at the Maryland Historical Society in Baltimore in 1858, at the Pennsylvania Academy in 1863, and at the Brooklyn Art Association in 1873. Although his painting was seen publicly, its exposure in any major center was brief, and its impact no doubt was limited at best.

It is believed that Roesen was a German Rhinelander, probably born in that region about 1815, and that it was he who exhibited a flower painting at an art club in Cologne in 1847. He came to this country in the wake of the revolutions in Germany during 1848, settling in New York City. About 1857, he abandoned his family — perhaps due to the economic depression of the time — and went to Pennsylvania, first to Philadelphia and then to Harrisburg where he was active in 1859. The following year, he was in Huntington in that state, and by 1862, he had settled in the then prosperous community of Williamsport, Pennsylvania, where he remained for a decade, establishing a celebrated local reputation. A picture dated 1872 proves him to have been alive that year, but tradition attests that he left Williamsport about that time. Nothing more is known of him or of his activities.

[2]The latest and most complete study of Roesen is by Lois Goldreich Marcus, *Severin Roesen: A Chronology*. Marcus includes a bibliography of other writings on Roesen, the most important of which are those by Maurice A. Mook and Richard B. Stone.

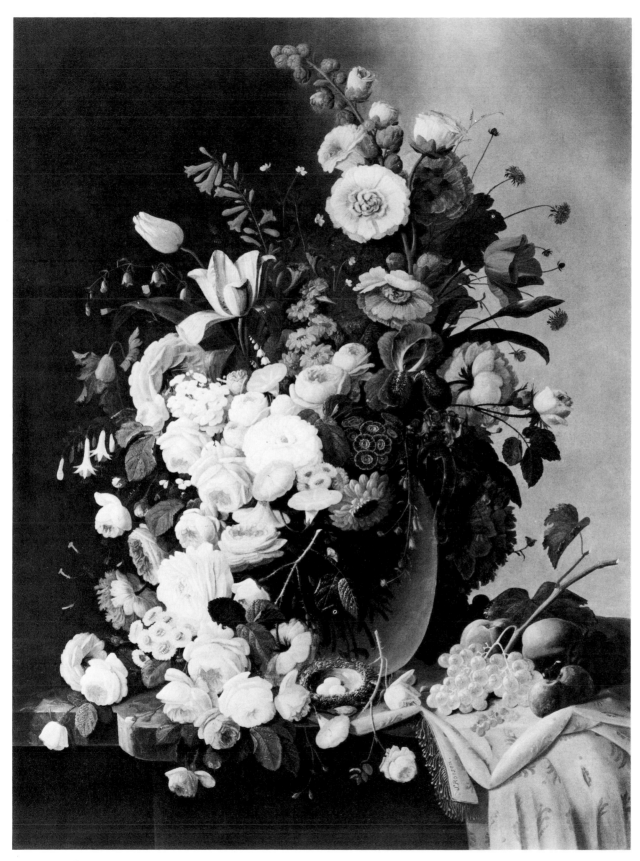

Figure 5.3. SEVERIN ROESEN (circa 1815-1871), *Flowers with Bird's Nest*; oil on canvas, signed at lower right — *S. Roesen*, 50 x 36 inches; Private Collection.

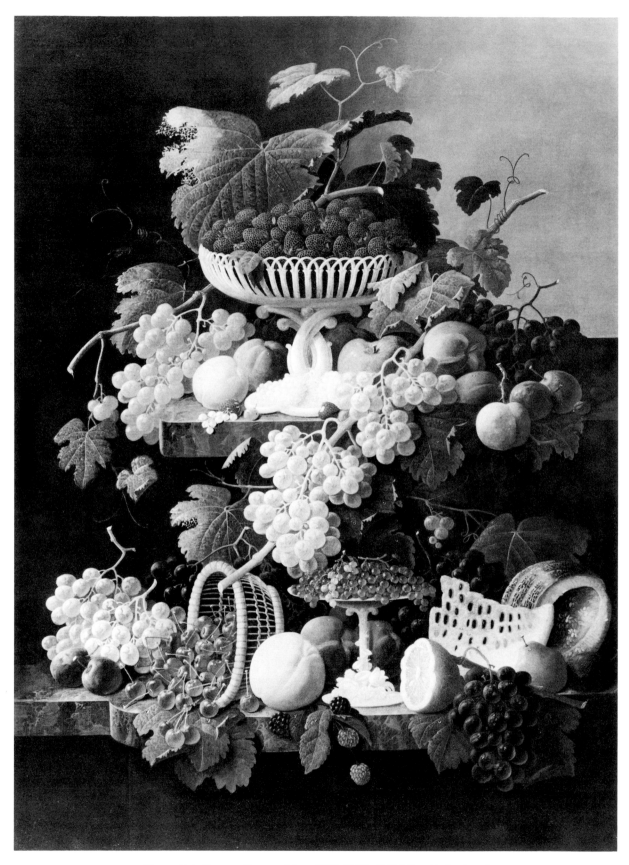

Figure 5.4. SEVERIN ROESEN (circa 1815-1871), *Still Life with Fruit;* oil on canvas, signed at lower right — *Roesen,* 50 x 36 inches; Private Collection.

It is astonishing, for an artist whose life is obscure, that as many as three to four hundred works have come to light, and this is probably only a fraction of his activity in America. Though he is said to have painted portraits, all of his known works are still lifes: fruit pictures, flower pictures — sometimes done in pairs as such — and pictures of flowers and fruit together. Some of these are small pictures, and occasionally the subject is rendered less than life-size, but most often the fruit and flowers are combined in great proliferation, leaving no area unfilled. The fruit, flowers, birds' nests, and man-made decorative objects of ceramic and glass are sometimes piled up on a double-tiered table, the tiers almost always of grained grayish marble, which appears to have been his preference. While these often gigantic paintings of literally hundreds of objects have been interpreted as standard Victorian *horror vacui*, they are also the ultimate embodiment of mid-century optimism, representing the richness and abundance of the land, the profusion of God's bounty in the New World, his blessing upon the American Eden through this cornucopia of plentitude.

While we are hampered by the lack of documentation concerning Roesen's patronage and indeed in regard to almost all details of Roesen's artistic life, the matter of scale would seem to be a significant factor in his art and in its appreciation. By introducing pictures of such large proportions into American art, Roesen added a significant factor to their possible and presumably actual appeal, judging by the large numbers of his works that we have today. We do not know, of course, whether or not Roesen's pictures were painted primarily on speculation or were actually commissioned works. The latter seems more likely in Williamsport, where he became well known and was the only professional resident artist. With Roesen's appearance in America, the country had for the first time a still-life painter whose work could command the decoration of a room — in this case, of course, the dining room. Previously, still lifes — by the Peales and others — and probably most of the imported ones might find a place in a decorative scheme. But a great many of Roesen's paintings were appealing not solely for their intrinsic attractiveness, but because with one picture, they "made" the room. This factor, of course, belongs to the history of interior decoration rather than to art, but it must have played a significant role in Roesen's patronage. And a further clue to its importance is the appearance of a good number of works by other artists of the period, which are substantially larger than the earlier still lifes: for instance, the near imitations of Roesen's work by Paul Lacroix; the dessert pictures of John F. Francis; and a number of George Hall's paintings that are of truly commanding proportions.

Roesen's methodology is an extremely synthetic one. While he may have worked, in part at least, from actual objects, the size of so many of his works would preclude his dependence upon the "living models," which would spoil and perish before he could complete such works. It seems that he may have had templates that he rearranged from painting to painting, for almost every element in a Roesen still life is repeated in other works, occasionally many times over — sometimes individual flowers or pieces of fruit, sometimes entire arrangements of fruit or bouquets of flowers. Another aspect of his synthetic methodology is his introduction into the same compositions of fruits and flowers that bloom at different seasons of the year. However, since basic studies, or templates, of individual flowers and fruits or groupings by Roesen have not yet come to light, there is the

SEVERIN ROESEN, *Still Life: Flowers and Fruit*. See plate 5, page 5.

possibility that he based the various components of his arrangements upon published prints, possibly American but more likely the more elaborate botanical prints of contemporary English, French, and German origins, or earlier Dutch ones. An exhaustive study of such material and a comparison of it with a broad range of Roesen's painting might confirm this speculation.

Little more than two dozen of Roesen's known and accepted works are dated, so that attempts to establish a chronology of his painting are exceedingly difficult. Perhaps the most that can be said is that his occasional use of white rather than gray marble can be connected with several of his later pictures that were painted in Williamsport, and therefore the motif may be a late one. Likewise, his introduction of a landscape background rather than a totally neutral one seems again to be an influence of his Williamsport environment, logical enough considering that city's isolated location amidst the rugged countryside of north-central Pennsylvania and the contrast to his previous urban residence in New York. Suggestions that the composition of Roesen's works changed from a simple to a more complex one or from a more careful draftsmanship and coloration to a less scrupulous technique are not valid; rather, he seems to have been an artist of tremendous variation in quality. He seems to have had many "dog days," perhaps because of his overaffection for the bottle, but at his best he produced still lifes of great quality.

What role then did Roesen play in the development of American still life? In Williamsport, he was the acknowledged resident master and is known to have had a number of pupils and followers, but by then he and his work were all but lost to the greater American art establishment.[3] Did he have an impact earlier? I think he did. Although we do not have critical documentation, his huge productivity, the number of paintings done in imitation of Roesen by Paul Lacroix and others, and the general impetus his work seems to have given to the art of still-life painting would indicate such impact. Even if the majority of his known work was commissioned by private patrons in Williamsport, he must have had a certain amount of patronage in New York City, which may have been sparked by his exhibition and distribution at the American Art-Union. This exposure must have led to further commissions or possible exhibitions perhaps in frame shops and bookstores. For even if still-life painting continued to be poorly received in critical circles, Roesen came to America in 1848, just when the art unions were becoming established as a major cultural force. His transplanted pictorial ideals, which were derived ultimately from late seventeenth- and early eighteenth-century Dutch still lifes, must have been much appreciated. Art lovers in this country had seen such Dutch paintings exhibited here early on. Works by or given to Jan Van Huysum, for instance, were shown at the Pennsylvania Academy in 1821, at the American Academy in New York between 1821 and 1827, and at the Boston Athenaeum in 1827 and 1833. Two decades later, an immigrant contemporary artist appeared on the scene who could provide equivalents in a hard, sharp drawing style with bright clear colors, which reflected the current practice of painting in the then favored art school and center in Europe, Düsseldorf, the city near which Roesen grew up and where he may well have studied.

Brief reference should be made to the impact the city of Düsseldorf had in developing taste and style in American art. In the 1840s, many American artists went to Düsseldorf to study and work. The year after Roesen came to New York, the Düsseldorf Gallery was opened to the public as a means in

[3]Among his pupils in Williamsport were John Talman and Christopher Ludwig Lawrence, born Christopher Ludwig Leverentz, in Hamburg, Germany. In Huntington he had a pupil, Henry Miller.

part to provide the American audience with a complete range of the best productions of that school and in part to provide safety for a major collection of German art after the political upheavals of the previous year. In a sense, Roesen and the Düsseldorf Gallery were both refugees in New York for the same reason. In fact, the Düsseldorf Gallery in New York contained works by Jacob Preyer, who was the greatest of the Düsseldorf still-life painters and perhaps the consummate technician of the whole school. Roesen's work at its best is very much a reflection of Preyer's art, including such motifs as birds' nests, trailing, sinuous grape stems, and elaborate marble tabletops. While Roesen's work is the most significant group of still lifes by any German immigrant in that crucial period, 1848-1852, the impact of such work was probably reinforced by examples acquired by the American Art-Union by other artists who were not as well known as Roesen: Charles Baum, Werner Hunzinger, Johannes Oertel, Fridolin Schlegel. They were all able, trained artists, and the still lifes that have appeared by such painters as Baum and Hunzinger were painted very much in the style of Roesen and Preyer.

Concerning the other major specialists of Roesen's generation, we have no precise documentation concerning the appearance of their still lifes on the American scene. John F. Francis, however, appears to be the first of the native-born painters in the group to turn to still life. In the 1830s and 1840s, he was a portraitist, working in central Pennsylvania in such communities as Harrisburg, Pottsville, Sunbury, Lewisburg, Bellfont, and Milton. He spent his last quarter century as a still-life painter in Jeffersonville, where he had settled in 1856.[4]

[4]For Francis, see Alfred V. Frankenstein, "J. F. Francis," *Antiques* 59 (May 1951): 374-77, 390, and *A Catalogue of Paintings by John F. Francis*, with an introductory essay by George L. Hersey (exhibition catalogue; Bucknell University, Lewisburg, Pa., 1958).

Figure 5.5. JOHN F. FRANCIS (1808-1886), *Still Life*, 1850; oil on canvas, signed at lower right — *J. F. Francis/Pt 1850*, 20¼ x 24¼ inches; Nebraska Art Association, Nelle Cochrane Woods Collection.

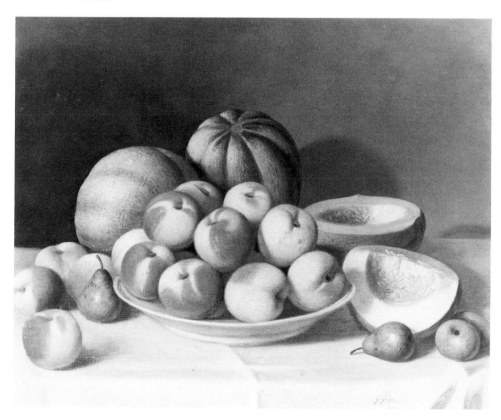

Francis's portraits are quite romantic both in their soft, smooth paint handling and in their lyrical interpretation of sitters. What interested him in still life is not known, although the accessories he introduced into his portraits are lovely elements, and they were probably much admired. Perhaps he recognized the gift he had for this theme, or perhaps he was attracted by the growing market for still lifes, which developed in the late 1840s — most likely spurred on by the art unions and the impetus of European examples. Perhaps it was simply the ease and practicality that the theme offered: a still-life painter could compose and paint at home among familiar surroundings, arranging his compositions according to his own will, whereas the portrait painter had to travel, to seek out clients, to conform to their wishes, and to react to their complaints.

When exactly Francis turned from portraiture to still life is not known, nor can we be sure if the change was gradual or abrupt. However, the earliest known still life by him is dated 1850, precisely the time when still lifes were being exhibited more and more by American art organizations and by the art unions. His latest portraits seem to date from 1852. Therefore, we can speculate that the early 1850s was a period of transition for him between the two themes, but by 1854 he had turned to still life almost exclusively.

Francis's 1850 picture, *Still Life,* is an unusual one. It is apparent from this painting that by 1850 he had established his preference for the support covered by a white tablecloth with some impression of folds, for a careful symmetry of fruit arrangements, and for the repetition of spherical and hemispherical shapes of different sizes, which creates a rhythmic composition quite distinct in his oeuvre. However, the cool, greenish tonality in this work is unlike his later preference for warm reds and yellows. This early picture is also traditional in its subject matter, purely a fruit arrangement.

Francis went on, however, to establish himself as the master of luncheon and dessert pictures. These two related categories require in a sense a new, more complicated vocabulary of forms, yet they resemble some of Raphaelle's Peale's pictures of cheeses, nuts, cakes, and other such objects, and, ultimately, Dutch seventeenth-century models. Dessert pictures, such as Francis's *Strawberries and Cakes* (1860), combine edibles such as strawberries and cakes with elaborate ceramics, glassware, and other items — all the appurtenances necessary for a meal of sweets. To add greater elegance and to further soften the effect, a colorful, patterned napkin is placed on top of the typical white tablecloth. The 1860 composition must have been a popular one. Francis replicated it at least three times making only minor changes, either in details of the arrangement and of the background or by replacing a ceramic sugarbowl with a metal one. Replications, sometimes dated, are available for many of Francis's larger and smaller compositions. Indeed, Francis's habit of replication with variations makes it extremely difficult to establish a chronology of his art from the standpoint of either style or motif, for one can never be sure if an earlier version of a specific composition, though presently unlocated, did not exist.

The works considered luncheon pictures are even more elaborate than the dessert subjects, often including wineglasses and wine bottles, which the artist varies in height, shape, and color of the liquid contained. Fruits, nuts, and cheeses are included, together with his favorite object — "jawbreakers," or oyster crackers. Both the luncheon and dessert pictures help to

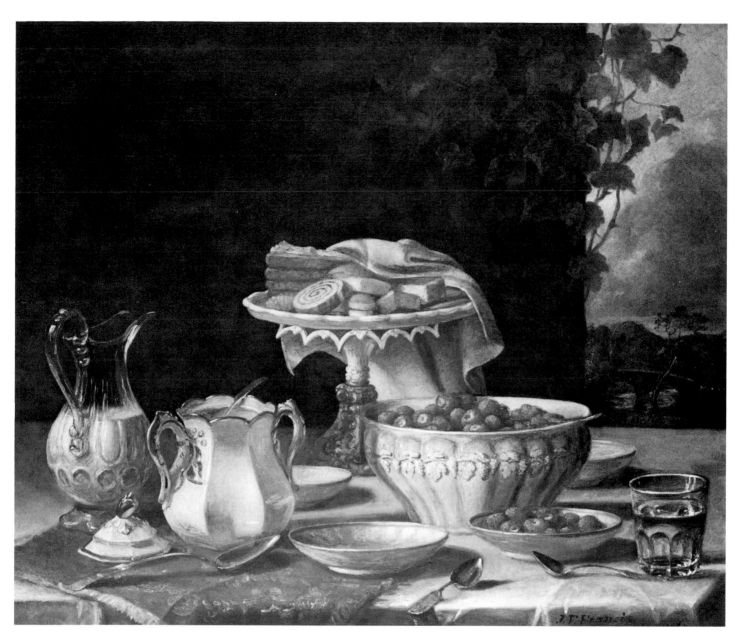

Figure 5.6. JOHN F. FRANCIS (1808-1886), *Strawberries and Cakes*, 1860; oil on canvas, signed at lower right — *J. F. Francis/Pinxit 1860*, 25 x 31 inches; Mr. James Ricau.

explain Francis's attraction to still life and, for that matter, the attraction of many of his colleagues: glorification of the specific. The oyster crackers, for instance, are never merely repeated. Each cracker is distinct in shape and position: no two are alike. Their texture is specific, not as soft as cake, not as crumbly as cheese, not as nubbly as an orange, and not as hard as metal, glass, or ceramic. Francis's primary interest, and that of his mid-century colleagues, was in the individuality and in the tactility of an object, which superseded the abstract formalism that so appealed to Raphaelle Peale.

Francis also painted many elaborate pictures of fruit in baskets, usually of wicker and often with a ribbon or napkin tied around the handle. Sometimes, the fruit spills out onto the tablecloth atop the support on which the basket sits, allowing one to study the fruit from all angles. Usually, at least one piece of fruit is opened or quartered, allowing us to examine the

fruit inside and out. Pears and apples were particular favorites, perhaps more than peaches, because they are more irregularly shaped allowing for more individuality. The watermelons painted by Francis are invariably shown as broken, never sliced, the artist reveling in the irregularity of the pulp and the random pattern of seeds.

Of all the mid-century still-life specialists, Francis was the most painterly. There is often a freshness and a brio to his paint application that successfully balance his sure delineation of form and his establishment of texture. Francis's color is also distinct; he preferred the primary tones. Pastel pinks and blues show up in his ceramic ware and in the decorating ribbons and napkins, which are unique to his art. The same pale blue used rather than pure white as a highlight is almost a Francis signature. Like Roesen, but unlike many other of his colleagues, Francis never placed his arrangements directly in a natural setting, but again, like Roesen, he did occasionally incorporate a distant landscape view behind his still life, always at the

Figure 5.7. JOHN F. FRANCIS (1808-1886), *Still Life — Grapes in Bowl;* oil on canvas, 25 x 30 inches; Newark Museum.

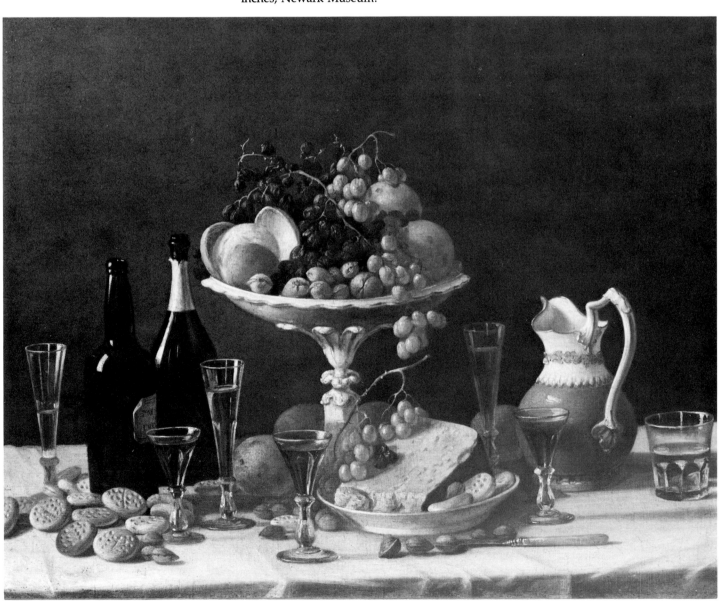

right, and with a hanging ivy acting as a buffer between the landscape and the background wall at the left. His interest in landscape backgrounds developed around 1858, just about the time when the concept of a natural setting for still life was first introduced to America through the writings and theories of John Ruskin.

In his own time, George Hall was the best-known specialist of still life in the mid-nineteenth century, certainly better respected and noticed more often than either Roesen or Francis. He is the only such specialist discussed by Henry T. Tuckerman in his famous *Book of the Artist* (1867), though Tuckerman is most impressed by Hall's ability to raise $12,000 in 1865 in a sale of seventy-five of his still-life paintings. Hall was born in Manchester, New Hampshire, and without formal instruction began painting in 1842 in Boston. In 1849, he traveled with Eastman Johnson to Düsseldorf, but Hall spent only a year there before going to Paris, where he remained before returning to New York in 1852.[5] He continued to be an inveterate traveler throughout his life, visiting Spain in 1860 and 1866, Italy in 1872, and Egypt in 1875.

There is no evidence that he knew Johann Preyer in Düsseldorf, nor should that have been expected, because he was not a still-life painter first but a figure and genre artist, often using his exotic travels as picturesque subject matter in his work. Among the works of the early 1850s, which first brought him public acclaim, are his *Roman Wine Cart* and *Parisian Wine Cart*. Nor did he give up genre subjects when, in about 1857, he turned to fruit and flower pictures. Again, what accounts for Hall's interest in still life is difficult to fathom, but he certainly was both proficient and successful at it. *The Cosmopolitan Art Journal* in 1860, in an article called "The Dollars and Cents of Art," chose Hall as their example of the prices a still-life specialist could command. The article also acknowledged his popularity and estimated his receipt of forty to one hundred dollars for smaller canvases — and proportionately higher prices were charged for more expansive works.[6] This notice is also indicative of the rapid acclaim the artist had achieved in his newly chosen field in only about three years.

That same year, 1860, Hall had a sale of 143 of his paintings from the last eight years that were exhibited at the National Academy of Design. The money he received from the sale enabled him to live in Spain for several years. About fifty of the pictures were still lifes. He continued to concentrate upon this theme both in Europe and in America through 1868. In fact, *The Crayon* magazine in March 1861 recorded a notice of an exhibition of several of Hall's paintings in a shop in Seville, Spain, and said that the local Spanish press profusely praised the two pictures of grapes, recommending them as models to local artists.

For what reason Hall decided to return to figure painting in about 1868 is not known. In part, it may have been the new interest generated toward French-inspired figure painting following the years after the Civil War, which led so many young American art students to study in Paris. Or, it may have been the criticism that was directed at his still lifes. In 1864, James Jackson Jarves classified Hall's work as the most barren of art. Clarence Cook, the art critic of the *New York Tribune*, made similar observations two years later, feeling that Hall artistically failed in his work when compared to the works of the American Pre-Raphaelites, Thomas Farrer and John Henry Hill, and that his work lacked the poetry found in Japanese still lifes or the floral details found in the paintings of the English artists, Dante Rossetti and

[5]See *Frank Leslie's Illustrated Weekly* (11 July 1857): 89-90.

[6]"The Dollars and Cents of Art," *Cosmopolitan Art Journal* 4 (March 1860): 30.

[7] James Jackson Jarves, *The Art-Idea,* ed. Benjamin Rowland, Jr. (1864; reprinted, Cambridge, Mass., 1960), pp. 204-5, and *The New York Tribune* (1 June 1866): 8.

[8] *The Nation* 2 (8 March 1866): 314; (22 March 1866): 357; and (29 March, 1866): 409.

[9] "Art and Artists in New York," *Independent* 33 (2 June 1881): 8.

Frederick, Lord Leighton.[7] In March 1866, Hall became a figure of controversy when the critic of the new magazine, *The Nation*, reviewed his work that was on display at Miner & Somerville's Gallery. In response to the critic's objections to his usage of gray, rather than purple, shadows in his picture of purple grapes, Hall insisted that "if he [the critic] will hang a bunch of purple grapes against a grey wall, he will see, as I did, that its shadows are filled with grey reflections." Hall went on to condemn the crude writing of so-called art critics. As a result, two successive editorials appeared defending the art critic with a reiteration of the charges against Hall in the second, which appeared on 29 March:

> Mr. Hall's renderings of the shade and shadow colors of nature are generally exaggerated abstractions of the darkness or depth of those colors only, their quality being wholly disregarded. Of his many fruit-pieces we do not remember one that has been conceived and painted in full color. This may be of no importance; it was the sole charge we made, and is the sole charge we now make against his paintings of fruit.[8]

Due to the success of his *Bric-a-Brac of Damascus, Rome and Seville* (1880, New York Art Market), still-life painting again began to be Hall's dominant theme some time in 1881, although he continued to paint figure pieces of Italian and Spanish subjects. The critic writing for *The Independent* in 1881 praised the recently exhibited master still life in his comment: "His still-life pictures are his best, and in the really picturesque delineation of fruit and flowers he has few superiors in the country. In this class of subjects his coloring is rich and harmonious, and his drawing as correct as need be."[9]

Hall composed a number of large pictures of fruit and flowers, but his smaller pictures are far more appealing. The pictures sometimes are of a

Figure 5.8. GEORGE HENRY HALL (1825-1913), *Bric-a-Brac Still Life of Damascus, Seville and Rome, 1880;* oil on canvas, signed at lower left — *Geo. Henry Hall, 1880,* 35 x 47⅞ inches; Berry-Hill Galleries, Inc.

Figure 5.9. GEORGE HENRY HALL (1825-1913), *Still Life with Flowers*, 1868; oil on canvas, signed at lower right — *G. H. Hall, 1868*, 18⅛ x 14¼ inches; Mr. James Ricau.

Figure 5.10. GEORGE HENRY HALL (1825-1913), *Raspberries in a Gauntlet*, 1868; oil on canvas, signed at lower right — *G. H. Hall*, 11 x 14 inches; Henry Melville Fuller.

single fruit such as a peach or a pomegranate, sometimes painted in the exotic locales where he traveled, and so designated. Hall painted many beautiful flower pictures, which portray delicate bouquets of many different and contrasting blooms, and exotic gardens in miniature that reflect the variety and beauty of God's natural handiwork, such as his *Still Life with Flowers* (1868). The different flowers were chosen to deliberately contrast size, shape, color, and texture, the last a quality that Hall was much more sensitive to than Roesen. Here, as in many of his pictures, Hall's vase sits, along with several ripe strawberries, upon a highly polished wooden table-top whose gleaming reflections add elegance to the presentation. The polished tabletop is a Hall trademark, like Francis's white tablecloth or Roesen's thick marble slabs.

But the tabletop still life was, for Hall and for many of his colleagues, only one option; his *Raspberries in a Gauntlet*, also of 1868, represents another alternative. Raspberries were one of Hall's favorite fruit subjects. He painted them as pouring out of a cup, a tin pail, a wicker basket, or as resting in a

large leaf in a landscape. The gauntlet picture is the most elaborate of all. Though the medieval glove of armor is one of his most bizarre accessories, it makes a perfect foil in its gleaming hardness for the round, soft, lush raspberries, which the armor, nevertheless, carefully protects and cushions. Hall may have intended this still life to show the contrast between man and nature, the evanescence of a bygone era of civilization with the permanence of natural forms. Here too the still life itself has a natural setting rather than the artificiality of a tabletop, no matter how "unnatural" the introduction of the armor may appear.

The natural setting still life in the late 1850s is indicative of the then-rising popularity in America of the English aesthetician John Ruskin.[10] The first volume of Ruskin's *Modern Painters* appeared in 1843 and an American edition soon followed. It was with the publication of the first American art magazine, *The Crayon*, with William Stillman as editor, which ran from 1855 to 1860, that Ruskin's ideas became widely disseminated. Associated with Stillman was the "Brooklyn School," a group of artists that eventually became known as the American Pre-Raphaelites because of their allegiance to the precepts of Ruskin. This aesthetic was dutifully praised in *The Crayon* when the first major American Exhibition of British Art was held in New York City in 1857. The exhibition subsequently was shown in Philadelphia and Boston where the Pre-Raphaelite selection was enjoyed particularly.

Therefore, it is not a coincidence that the natural setting still life began to appear in America soon after these events had taken place. They represent the popularity of the English painter William Henry Hunt, who was Ruskin's favorite still-life specialist and whom Ruskin praised in his monograph on Pre-Raphaelitism for his "simple love of our summer fruit and flower."[11] William Cullen Bryant in praise of Hunt's work wrote:

> It seems to me impossible to carry pictorial illusion to a higher pitch than he has attained. A sprig of hawthorne flowers, freshly plucked, lies before you, and you are half tempted to take it up, and inhale its fragrance; those speckled eggs in the bird's nest, you are sure might, if you pleased, take into your hand; that tuft of ivy leaves and buds is so complete an optical deception that you can hardly believe that it has not been attached by some process to the paper on which you see it.[12]

Ruskin contrasted this "natural" type of still life in which "a flower is to be watched as it grows in its association with the earth, the air, and the dew; its leaves are to be seen as it expands in sunshine; its colours, as they embroider the field" with the Old Master Dutch tradition of tabletop still lifes. He preferred flowers that were relieved by grass or moss, fruit-tree blossoms that were relieved against the sky.[13]

When the influence of Ruskin was paramount in the late 1850s, George Hall began painting many such arrangements of fruits in natural settings. Artists such as Francis and Roesen did not attempt such compositions but did settle for an occasional landscape background. Hall's Ruskinian still lifes were much admired and were even preferred over the traditional form. The initial article written for *The Nation* in 1866 concerning his New York exhibition and his sale on 8 March stated that "groups of fruit in a state of nature . . . seem to us much better worth having than the 'dining-room picture' of fruit prepared for dessert."

Hall was only the best known of many in his generation who adopted the Ruskinian approach. As we shall see, William Mason Brown, Paul

[10]See William H. Gerdts, "The Influence of Ruskin and Pre-Raphaelitism on American Still Life Painting," *The American Art Journal* 1 (Fall 1969): 80-97.

[11]See *The Old Water Colour Society's Club 12th Annual Volume, 1934-1935*, pp. 37-38.

[12]William Cullen Bryant, *Letters of a Traveller; or, Notes of Things Seen in Europe and America*, pp. 402-3.

[13]See John Ruskin, *Praeterita* (2 vols., Orpington and London, 1899), vol. 2, p. 300; "Academy Notes, 1857," *The Complete Works of John Ruskin*, eds. E. T. Cook and Alexander Wedderburn (30 vols., London, 1905), vol. 14, p. 116; *Modern Painters* (5 vols. London, 1856), vol. 3, p. 18.

[14]John Henry Hill, *John William Hill: An Artist's Memorial*.

HENRY RODERICK NEWMAN, *Grapes and Olives*. See plate 6, page 6.

[15]For Newman, see H. Buxton Forman, "An American Studio in Florence (Henry Roderick Newman)," *The Manhattan* 3 (June 1884): 525-39, and more recently, Kent Ahrens, "Pioneer Abroad, Henry R. Newman (1843-1917): Watercolorist and Friend of Ruskin," *The American Art Journal* 8 (November 1978): 85-98. *Italy* is discussed by Forman on p. 536. The exhibition of *Grapes and Olives* in Florence is mentioned by Clara Erskine Clement and Laurence Hutton in *Artists of the Nineteenth Century and Their Works* (2 vols., Boston, 1884), vol. 2, pp. 147-48; specific place of exhibition is not indicated.

Lacroix, and others who took up still-life painting about the same time also investigated the Ruskinian setting, though they eschewed Pre-Raphaelite fidelity to nature. Yet in the 1860s, the period of Ruskin's greatest impact in America, the artistic community witnessed not only the appearance of a Pre-Raphaelite art organization, The Society for the Advancement of Truth in Art, but also an outlet for Ruskinian aesthetics in their publication, *The New Path*. The leading spokesman for the movement and the principal voice for the magazine was the Ruskin-trained Thomas Charles Farrer, whose interests included still life and who taught the drawing and painting of still life at the Cooper Union for the Advancement of Science and Art in New York in 1863-1864 and perhaps after. Thus, Ruskinian principles, particularly in still-life painting, were academically disseminated.

The American artist who most faithfully followed Ruskinian and Pre-Raphaelite dictates was John William Hill, who responded to the English movement and to Ruskin about 1855. By 1857, he was painting directly from nature, particularly enjoying the depiction of weedy banks, masses of garden flowers and fruits, all portrayed out-of-doors in natural growth without any grandiosity or pretense.[14] Hill, and his son John Henry Hill, who followed his father in espousing Pre-Raphaelite aesthetics, painted in watercolor like their English model, William Henry Hunt, adopting the detailed stipple technique of earlier watercolor miniature painting to create a highly exact, miniaturistic art form of brilliant color. Both Hills were also competent etchers, and the younger artist produced his *Sketches from Nature* in 1867, in which he announced his credo in Ruskinian terms: "I would say, drawing a single flower, leaf, or bit of rock thoroughly well is something better worth doing than conjuring up pictures in the studio without a bit of accurate drawing to account for their evident pretensions."

Ruskin's influence in American art continued for several decades. Farrer himself returned to England and to obscurity in 1872. In the meantime, however, he strongly supported the Ruskinian direction that his friend Henry Roderick Newman, who also taught at the Cooper Union in the mid-1860s, had taken in his art work. In 1870, Newman went abroad where he remained for his lifetime, in Florence. Newman usually painted in watercolor, primarily architectural studies and still lifes, and working in a meticulous, Pre-Raphaelite manner, he garnered the admiration of Ruskin in 1877 and met him several years later. Newman painted a number of detailed flower studies, some in dense vegetations in a manner that Ruskin sufficiently liked to collect; anemones were a favorite subject of both Newman and Ruskin. Newman's most original approach to still life, however, can be seen in such works as his *Italy* (1883, Jo Ann Ganz and Julian Ganz Collection). Using a colorful and glowing Pre-Raphaelite stipple technique, he combined his theme with one of landscape, enframing a distant Mediterranean view with a proscenium of meticulously painted flowers and/or fruit, such as hanging, still living vines of grapes. The example illustrated here is not as large and does not have the historical references to Shelley and Dante embodied in the geography of the landscape as the *Italy*, but it is no less technically sumptuous, no less original in concept. Indeed, this may be Newman's *Grapes and Olives* exhibited in Florence in 1878 and thus a prototype for the better-known picture painted five years later.[15]

Probably the most significant of the American Pre-Raphaelites was William Trost Richards, but he was completely a landscape specialist. His involvement with the Pre-Raphaelite and Ruskinian aesthetic, however,

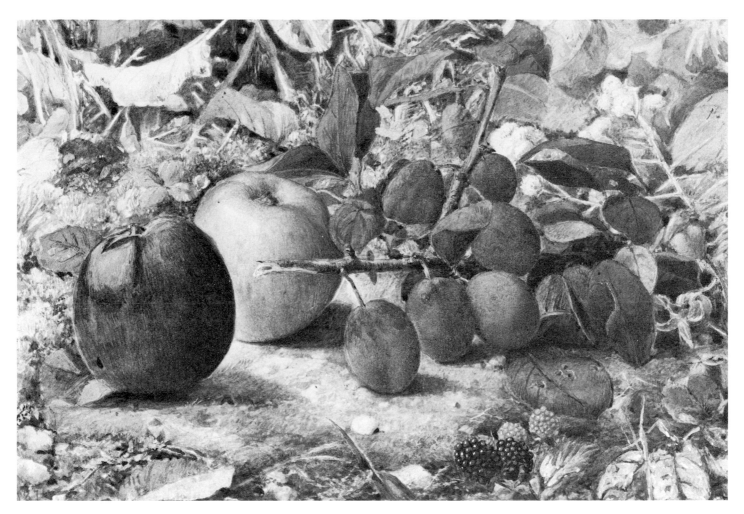

Figure 5.11. JOHN WILLIAM HILL (1812-1879), *Apples and Plums*, 1874; watercolor, signed at lower left — *1874 J. W. Hill*, 7⅞ x 11⅜ inches; Private Collection.

enabled him to paint some fascinating minutiae of nature. This was particularly true of his work dated about 1858-1865, during which time he was most involved with the Pre-Raphaelite movement and during which time Ruskin's influence was the strongest in this country. As Tuckerman wrote about his landscapes in 1867: "We seem not to be looking at a distant prospect, but lying on the ground with herbage and blossom directly under our eyes."[16] Though not a still-life painter himself, Richards was the teacher and mentor of Fidelia Bridges, who adopted the Ruskinian aesthetic in the 1870s and afterward. Some of Bridges's best-known pictures are nature studies, works that fall between still life and landscape — pictures of grasses, weeds, plants, and flowers, often uncultivated and still growing, precisely in the manner of which Ruskin had written approvingly. Most of those known are in watercolor, and some were used as the basis for the famous series of chromolithographs of *The Months*, which was published by Louis Prang in 1876. These works introduced birds among the grasses and flowers — each item appropriate to the months and seasons represented. These may have been the most famous, but they were by no means the only chromolithographs produced by Prang from Bridges's designs; Prang's role in popularizing and in disseminating still-life painting should not be underestimated. Bridges's *Thistles in a Landscape* is a rare oil painting of a subject that is similar

[16]Henry T. Tuckerman, *Book of the Artists: American Artists Life* (New York, 1867), p. 524.

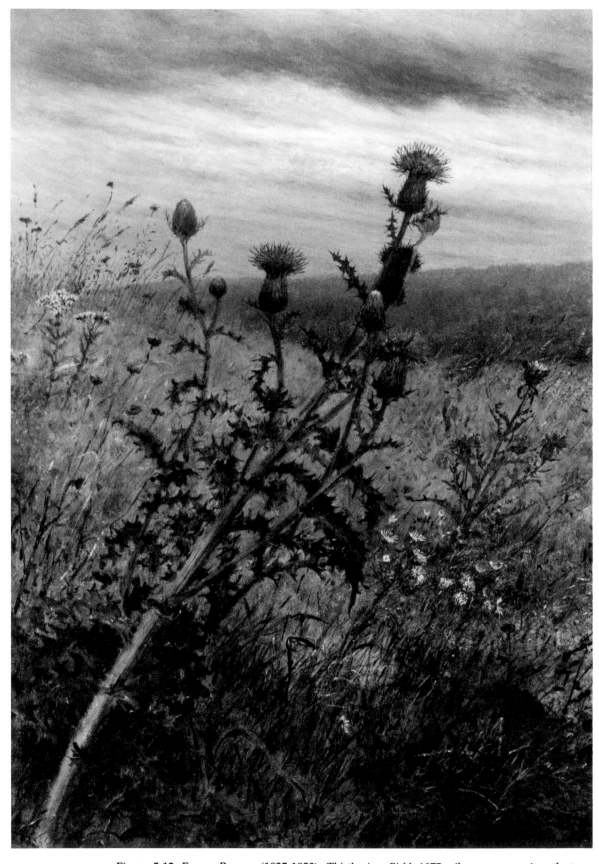

Figure 5.12. FIDELIA BRIDGES (1835-1923), *Thistles in a Field*, 1875; oil on canvas, signed at lower right — *F Bridges/1875*, 14 x 10 inches; Jeffrey R. Brown, Fine Arts.

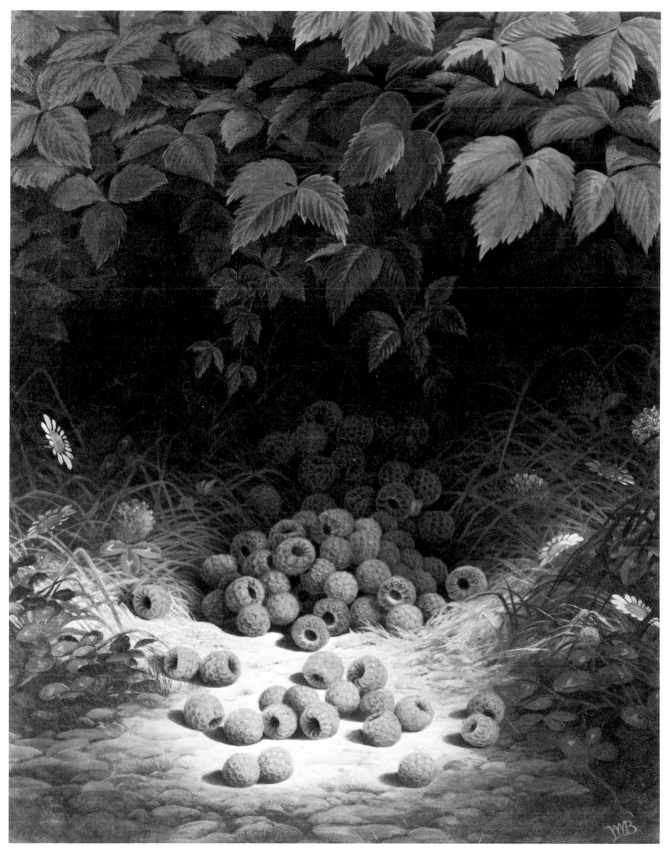

Figure 5.13. WILLIAM MASON BROWN (1828-1898), *Raspberries;* oil on canvas, signed at lower right — *WMB,* 20 x 16 inches; The J. B. Speed Art Museum, Louisville, Kentucky.

[17]Frederic A. Sharf, "Fidelia Bridges, 1834-1923, Painter of Birds and Flowers," *Essex Institute Historical Collections* 104 (July 1968): 1-22, and earlier, Alice Sawtelle Randall, "Connecticut Artists and Their Work (Fidelia Bridges)," *Connecticut Magazine* 7 (February-March 1902): 583-88. For Bridges's work for Prang, see Katherine M. McClinton, *The Chromolithographs of Louis Prang*, especially pp. 98-101.

[18]See Brown's obituary in *The Brooklyn Daily Eagle* (6 September 1898): 14.

to her watercolors and to the prints produced after them. It is correspondingly stronger and more dense, but no less Ruskinian in inspiration.[17]

The fourth among the more significant still-life specialists in mid-century was William Mason Brown. He was born in Troy, New York, and studied with Abel Buel Moore, the leading portraitist there. Brown himself was first a portrait painter in Troy and then, in 1850, moved to Newark, New Jersey, where he turned his attention to landscape painting. In 1858, he moved to Brooklyn, and in the early 1860s, he abruptly changed to still life, and with this shift in theme came a shift in style. Brown's landscapes are broad and painterly, romantic works that are in the vein of the earlier Thomas Cole. His still lifes are the most meticulous and photographic of his generation and during his lifetime his technique was compared to that of the great French academician, Jean-Léon Gérôme. Unlike Francis, Brown almost never allowed his paint handling to be apparent. He reveled in textural duplication: the "halo" of the fuzziness of a peach, the "map" of the rind of a cantaloupe. In painting humbler fruits — berries and cherries — each particular item in a group had its own color, its own highlight, its own quality of weight. Brown's turn to still life in the 1860s meant that he too shared in the predilection for the natural setting still life. Some of his pictures are tabletop works where the fruit share equal attention with *objets de virtu*, elaborate metalware and ceramics. These works are indicative of increasing fondness for bric-a-brac still lifes that appeared in the post-Civil War era and of the growing materialism and love of collecting, which characterized the new richness of the era.

Brown's second career, now as a still-life painter, received great impetus when he sold *A Basket of Peaches Upset* to William Schaus, a well-known art dealer in New York, for the then unheard-of sum of $2,000.[18] The work was reproduced by the relatively new process of chromolithography, color-printed lithography, which, in turn, brought Brown's art to the attention of a wide public. Subsequently, other pictures of raspberries, strawberries, and apples were also lithographed, and at least one apple picture was reproduced by Currier & Ives in 1868. Dominique Fabronius chromolithographed Brown's *Autumn Fruits* the same year. Brown's work was especially well suited to chromolithography because of his hard, tight drawing and particular color scheme. It is possible, of course, that he and other artists adopted or adapted a particular tonal scheme to make their work more susceptible to this process.

By the 1860s, still-life painting had become an integral component of American art exhibitions, and specialists such as Hall and Brown were fairly numerous. Many of them, however, are still little more than names found in the catalogues of annual exhibitions of the period and are affixed to pictures that occasionally surface today. Some of these are especially intriguing. George Forster was a distinctive painter, many of whose pictures have been located, but nothing at all of his life is known except that he was sometimes referred to as "Professor Forster." Many of these still-life specialists were women, such as Sarah Wilhelmina Wenzler, whose work was admired by the critic of *The New Path*, or Virginia Granbery and Henrietta Granbery, prolific artists who taught in Brooklyn, the former at the Packer Institute and the latter at Professor West's Seminary. Biographical information is exceedingly scanty on all of these artists.

Some of these mid-nineteenth-century specialists were immigrants, perhaps attracted here by the expanding patronage of art in the period. One

such artist was Arnoud, or Arnoldus, Wydeveld, a Dutch painter from Nijmegen who arrived in this country about 1855. His earliest pictures that were exhibited in New York and at the Washington Art Association, in Washington, D.C., in the late 1850s were figure works, some of them moonlight scenes in the manner of the then popular Dutch artist Peter van Schendel. By 1861, however, he had turned to fruit and flower pieces, and two years later preparatory to returning to Holland he held an auction of almost a hundred works, almost all still lifes. The same year, 1863, he painted one of his most unusual paintings, which depicts two contrasting onions and a garlic bud, where the peeling skin of the onions offered him a fascinating challenge in texture and transparency. This work is probably the one he showed at the National Academy of Design that year. Wydeveld's flower pictures are among the loveliest known by artists of the period.

Wydeveld is known to have returned to his native Nijmegen. In 1865, he exhibited in Amsterdam, showing some fish pictures. When he returned to New York, by 1867, he seems to have made fish subjects something of a specialty, painting them in a hanging position, on riverbanks and even on dinner plates. In the fish pictures in natural settings, he collaborated with James Crawford Thom who painted the landscape backgrounds. Wydeveld remained in New York City until he disappeared from the city directories in 1888.[19]

There is some evidence to suggest that Paul Lacroix was French or possibly French-Swiss in origin. He lived in New York City from 1858 to 1866 and spent his last several years living in Hoboken across the Hudson River. He died in New York City in 1869.[20] A few landscapes are known by him, but he was primarily a still-life painter, working in a variety of manners and under a number of influences. Roesen is one among several who seem

[19]For Wydeveld, see Pieter A. Scheen, *Lexicon Nederlandse Beeldende Kunstenaars, 1850-1950* (2 vols., 's-Gravenhage, 1969-1970), vol. 2, p. 629; Henry H. Leeds & Co., Auctioneers, *Catalogue of a Choice Collection of Paintings, and Studies from Nature, of Fruit and Flowers, Painted by Arnoldus Wydeveld, Monday, June 8th, 1863; Carnegie Art Library Exhibition of Important Collection of Oil Paintings and Water Colours* (Pittsburgh, 1892), p. 6.

[20]William H. Gerdts, "Paul Lacroix," *Antiques* 82 (November 1972): 855-61.

Figure 5.14. ARNOUD WYDEVELD (1832-circa 1888), *Onions and Garlic*, circa 1863; oil on panel, signed at lower right — *A. Wydeveld*, 8 x 10⅛ inches; Private Collection.

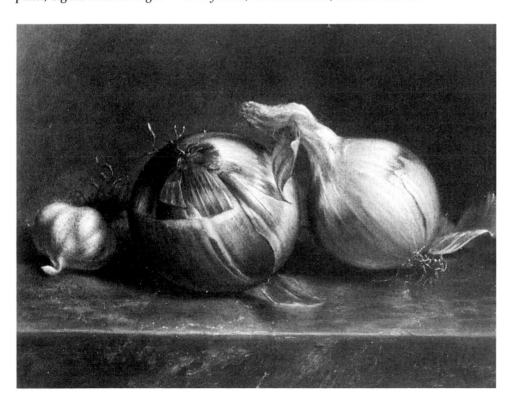

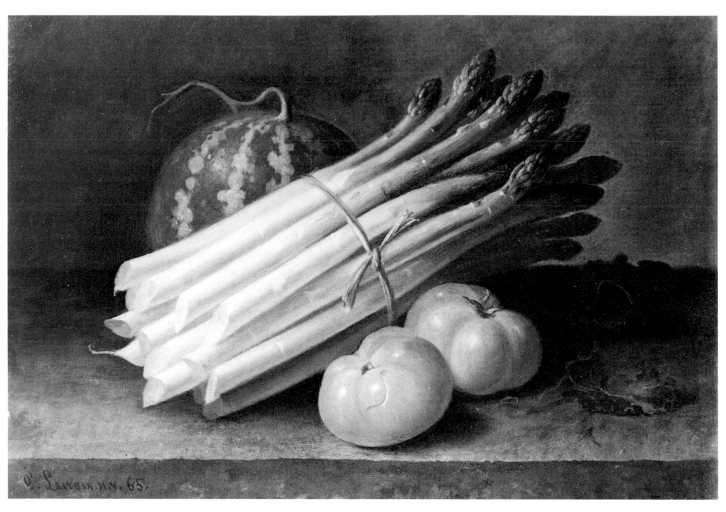

Figure 5.15. PAUL LACROIX (active 1858-1869), *Asparagus, Tomatoes and Squash*, 1865; oil on canvas, signed at lower left — *P. Lacroix*, 13½ x 16¼ inches; Private Collection.

to have influenced him. Some of Lacroix's more ambitious works are almost total imitations of Roesen's work. Interestingly, Lacroix did not appear in New York until after Roesen had left the city and had gone to Pennsylvania. A good number of Lacroix's known works are natural setting pictures, although the variety of objects juxtaposed in such a setting is often very *un*natural. Like James Peale and the above-mentioned Wydeveld, Lacroix painted a number of vegetable still lifes, which are rare in American art, and in his *Asparagus, Tomatoes and Squash* (1865), he essayed a most unusual subject, one particularly associated with the Dutch Old Master, Adriaen Coorte. In this work, the striking contrast of colors, shapes, and textures of the three vegetables is the main attraction. Here, too, Lacroix uses an unusual support for his vegetables, a thick, rough stone slab, rather than an elegant marble, polished wood, or cloth covering. Such a slab was a favorite device of the eighteenth-century French master Chardin, a revival of interest in whose work had recently begun in France. His several paintings introducing the stone support may herald the first awareness of that revival in America.

The experimentation with themes by artists who were generally associated with other subjects is indicative of the growing attraction of still-life painting; such artists' excursions began in the 1850s and continued there-

after. It may ultimately turn out that almost every American painter in the second half of the nineteenth century painted at least one or two still lifes, although so far none are known to have been painted by some of the most famous artists of the period, such as Thomas Eakins, Eastman Johnson, and George Inness. Landscape artists particularly occasionally painted still lifes, perhaps because by the very nature of their specialization they dealt with nature, which was the source of the fruit and flowers of the still-life painter. While most such still lifes, which are presently known, by landscape specialists are works completed and independent in themselves, Frederic Church's *Pitajaya Fruit* is one of the many oil sketches he made while traveling throughout the world seeking pictorial subjects. These oil sketches are the most dramatic of such works in American art, and this — a unique still life among the hundreds of landscapes and nature studies that he painted — combines Church's unsurpassed sensitivity to form and color and a freshness of paint handling with the scientific sensibility of the natural historian. The exotic fruit was painted in June 1853 in Colombia, a product of the first of his voyages to South America in the middle of the nineteenth century.

Church's *Pitajaya Fruit* conjures up images of a tropical Eden; fascinating and attractive, might this be the temptation of the Garden of Eden? For the most part, the isolated still lifes by other mid-nineteenth-century landscape painters are more mundane, but often no less well painted. Only a few still lifes by Jasper Cropsey are known. Of these, his single *Green Apple* of 1865, which is richly colored and exhibits an awareness of the uniqueness of the apple, makes one wish he had painted more fruit pictures. The apple, on the ground, with age spots and leaves curling from lack of moisture,

Figure 5.16. FREDERIC EDWIN CHURCH (1826-1900), *Still Life, Pitajaya Fruit, Colombia*, 1853; oil and pencil on cardboard, signed at lower right — *Pitajaya-53*, 11⅜ x 14¾ inches; Cooper-Hewitt Museum, Smithsonian Institution.

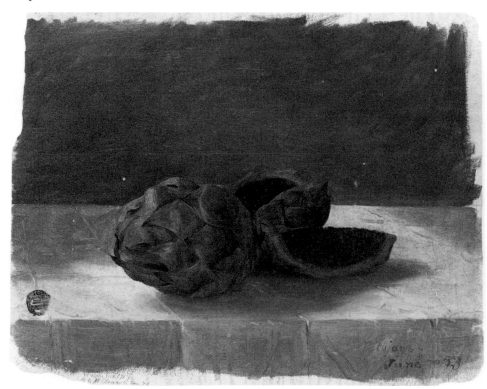

suggests the artist's concern with time and age, which is not surprising since his specialty was the evocation of seasonal change.

Cropsey's best pupil was his near contemporary David Johnson, who was also an attractive landscape specialist. About four still lifes are known to have been done by Johnson. His work *Three Pears and an Apple* (1857) is the finest; its informal dedication suggests it was painted spontaneously for a friend. Again, typical of the mid-nineteenth century, Johnson favors the irregularly shaped pear and apple, and each of the three pears is a different variety. Each is individual and distinct; combined they suggest the multifariousness of nature's bounty. Age spots again represent transience, which is underscored by the two flies in the painting, one on the tablecloth, one on the apple. They are present for the moment; in the next, they will be gone.

Even more rare than Cropsey's *Green Apple* is the undated *Two Pears* by Sanford Gifford. The warmer tonality and the glowing luminosity suggest the work of one of the leading luminist landscape artists of the day. Again, the subject is the ubiquitous pear, and Gifford elegantly incorporates his signature into the imagery by making himself the addressee of the envelope at the left.

Compared to the isolated still lifes by Church, Cropsey, Johnson, and Gifford, the dozen or so known works by the landscape painter William Rickarby Miller suggest a veritable profusion. Miller was an English artist who came here at mid-century. Extremely adept in both oils and watercolor paintings, he was one of the most proficient watercolorists in America before Winslow Homer. A number of his finest still lifes are groups of apples painted in the 1860s, but more unusual, and unique to him, is the series of pineapple pictures that he painted between 1881 and 1885, which are freer and more painterly than his earlier still lifes, and which exhibit a keen interest in the lushness of form and the fruit's spikiness of outline. The

Figure 5.17. Jasper Cropsey (1823-1900), *Green Apple*, 1865; oil on canvas, signed at lower right — *J. F. C. 1865*; Private Collection.

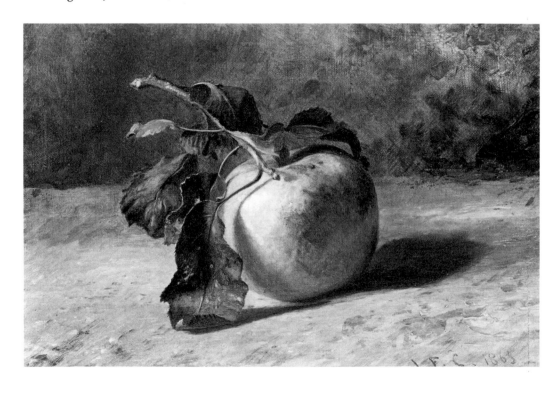

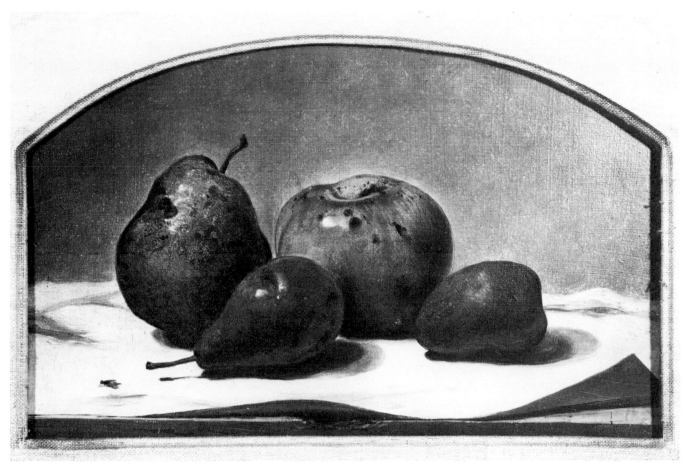

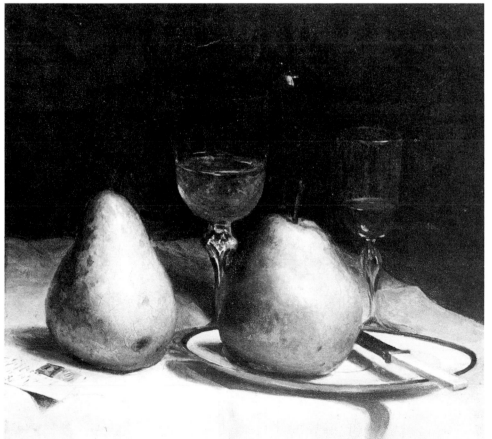

Figure 5.18. DAVID JOHNSON (1827-1908), *Three Pears and an Apple*, 1857; oil on academy board, signed at lower right — *D. Johnson*, 11⅜ x 16⅛ inches; Private Collection.

Figure 5.19. SANFORD GIFFORD (1823-1880), *Two Pears on a Table Top*; oil on canvas, signed at lower left — *S. Gifford*, 11¼ x 11⅞ inches; Private Collection.

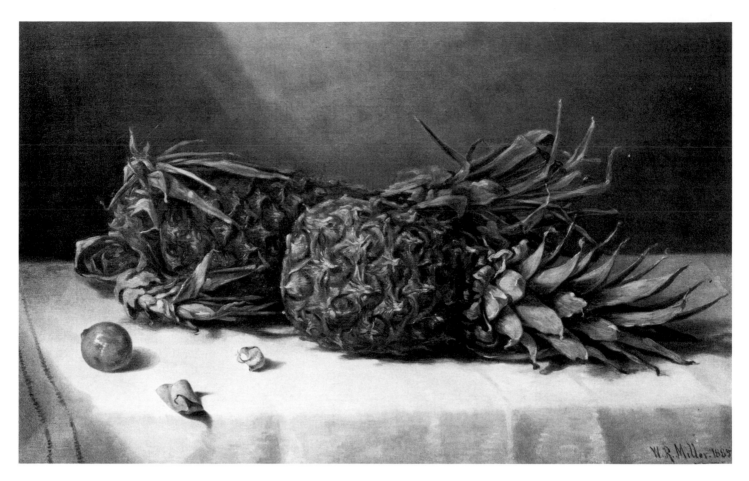

Figure 5.20. WILLIAM RICKARBY MILLER (1818-1893), *Two Pineapples*, 1885; oil on canvas, signed at lower right — *W. R. Miller 1885*, 13¾ x 21½ inches; Mrs. James M. Brown III.

[21]Miller exhibited a pineapple painting at the National Academy of Design as early as 1863, but this work has not yet come to light. For Miller, see Grace Miller Carlock, "William Rickarby Miller (1818-1893)," *The New-York Historical Society Quarterly* 31 (October 1947): 199-209, and Donald H. Shelley, "Addendum: William R. Miller," *The New-York Historical Society Quarterly* 31 (October 1947): 210-11.

pineapple's unusual shape and the exoticness of both its form and its origin are probably indicative of Miller's attraction to the fruit.[21]

The best known of the few still lifes by Worthington Whittredge conform particularly to the dictum of John Ruskin, which was so popular in the 1860s. These pictures are of apples or of peaches — silhouetted against the open sky — still growing on tree branches. These are still lifes or nature studies, perhaps, but not really "nature morte" since the fruit is very much still alive. These close-up pictures of fruit, such as his *Apples* (1867), are vignettes of nature falling somewhere between the still-life category and the landscape. The fruit appears to be "living" not only because it is still upon the branch but also because Whittredge has painted it in so rich and colorful a manner. Again, one would wish to locate more such works by the artist, which are equivalent in quality to the best of his landscapes.

One indication of the growing popularity of still-life painting in the mid-nineteenth century is its increased appearance in annual exhibitions. Another is the growing number of artists known to have practiced it, those who were specialists in the theme and those who were painters of landscapes. Still another is that artists adept in still-life painting began to appear in centers throughout the expanding nation: some were specialists, some were not; some were in larger, often eastern cities, while others were in smaller cities in the more remote parts of the land.

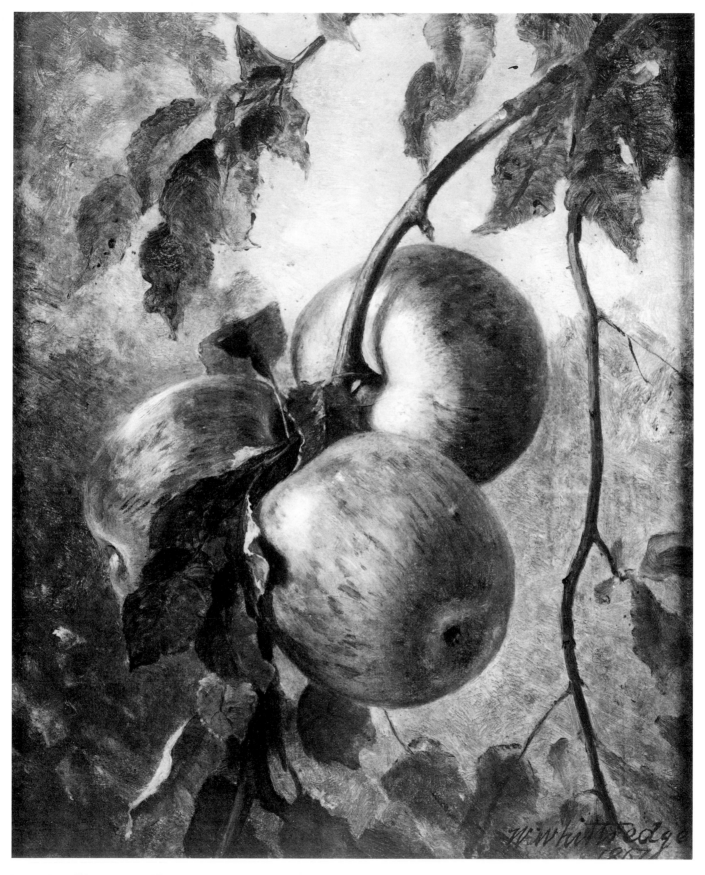

Figure 5.21. WORTHINGTON WHITTREDGE (1820-1910), *Apples,* 1867; oil on canvas, signed at lower right — *W. Whittredge/1867,* 15¼ x 11¾ inches; Museum of Fine Arts, Boston, M. and M. Karolik Collection.

One of the finest of all the still-life specialists of the third quarter of the century was Andrew J. H. Way, who worked in Baltimore. He was, arguably, in fact, the finest resident painter in the city. Way was born in Washington, D.C. After studying with John Frankenstein in Cincinnati and with Alfred Jacob Miller in Baltimore, he studied in Europe from 1850 to 1854, the first year under Martin Drölling in Paris and the last three in Florence. Returning to Baltimore, he started his professional career as a portrait painter but turned to still life when Emanuel Leutze, who had recently returned from Düsseldorf, commended Way's work in that vein. From then on, Way took Leutze's advice to specialize in still-life painting, gaining a medal "for excellence in still life" for two panels of grapes that were exhibited at the Philadelphia Centennial.

Two subjects that Way specialized in particularly were oysters — so indigenous to Baltimore — and grapes. He painted the latter to reveal not only their lushness but also to differentiate, quite scientifically, between the different kinds of grapes, such as Prince Albert, Gros Colmo, Flammede Tokay, California, and others. Critics and collectors acknowledged his ability to depict each variety with clarity; they recognized his conscious "portraiture" of his subjects. For the great Baltimore collector, William T. Walters, Way painted one of his finest works: choice Prince Albert grapes such as the

Figure 5.22. ANDREW J. H. WAY (1826-1888), *Oysters,* 1872; oil on academy board, signed at lower right — *A. W. 72,* 6½ x 9½ inches; Private Collection.

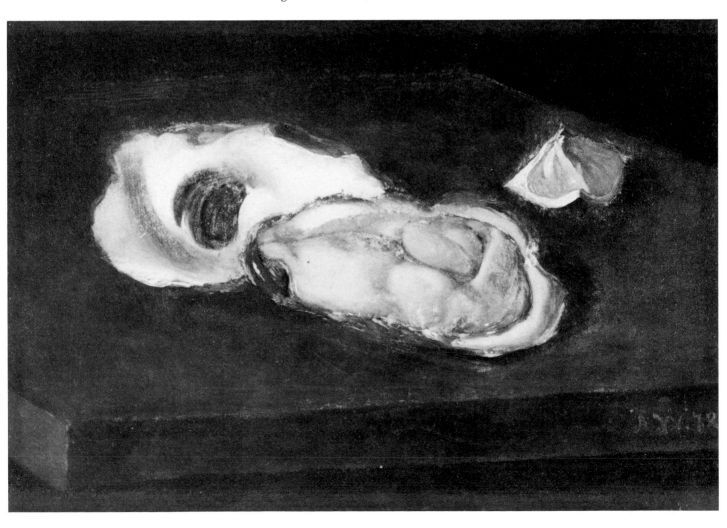

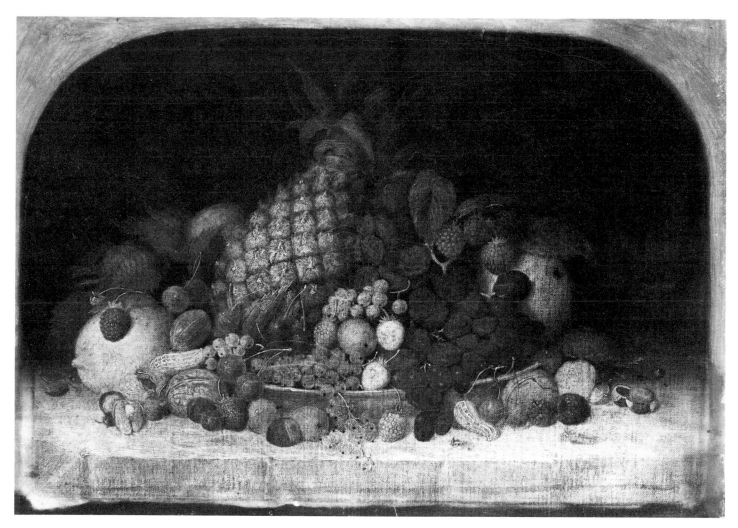

Figure 5.23. ROBERT S. DUNCANSON (circa 1817/1822-1872), *Fruit Piece;* oil on canvas, signed at lower right — *R S Duncanson,* 14 x 20 inches; The Detroit Institute of Arts, gift of the estates of Miss Elizabeth Gray Walker and Mr. Henry Lyster Walker.

ones that were grown at "St. Mary's," Walter's estate at Govanstown, north of Baltimore. Along with his scientific accuracy, Way carefully modulated the light to emphasize the translucency of his subjects and modulated the background behind his grapes, often silhouetting light grapes against dark ones, and vice versa. His grapes, like those depicted by many American still-life painters in the 1860s, were often shown hanging against a wall if not actually still growing on a vine. This again was a Ruskinian feature, the display of grapes in their "natural" position, rather than laid out horizontally — and artificially — on a tabletop. Lacroix, Morston Ream, Sarah Wenzler, and especially George Hall painted the hanging grape still life. It is probably impossible to determine exactly when this form was first introduced into American still-life painting, or which artist first adopted it, but Hall and Way seem to have indulged in such depictions especially. Way's reputation for such works reached well beyond Baltimore, as E. S. Crosier pointed out at the time of the 1879 Louisville Exposition:

ANDREW J. H. WAY, *Bunch of Grapes.* See plate 7, page 7.

> To Mr. Way, more than to any living artist, are the people of Louisville indebted for the elegant delineations of flowers, fruit and ocean shells, that from time to time have graced the galleries of the Exposition. There certainly could not be anything more real than the Muscat and Colmo de Canto grapes, numbered 83 and 168 in the present exhibition. They are indeed marvels of art.

[22]E. S. Crosier, ''Art at the Louisville Exposition,'' *Louisville Monthly Magazine* 1 (September-October 1879): 592, and Latrobe Weston, ''Art and Artists in Baltimore,'' *Maryland Historical Magazine* 33 (September 1938): 220-22.

Way spent his whole career in Baltimore, except during his years as a student. He became the central figure in the art circles of the city and something of a chronicler of the Baltimore art world, contributing articles to local newspapers from his Paris days onward. Baltimore had a thriving but still unstudied art colony in the period from about 1860 to 1890, which included Way's son George, but Andrew Way remained the only significant still-life specialist.[22]

Moving on to the Midwest, the ''Athens of the West,'' Cincinnati, though a major center for art, did not produce a substantial still-life specialist. However, Robert S. Duncanson, the landscape painter and the son of a black mother and a Scotch-Canadian father, produced a number of fine easel still lifes in addition to several overdoor still lifes that yet adorn ''Belmont,'' the Cincinnati home of the great local patron Nicholas Long-

Figure 5.24. EDWARD EDMONDSON (1830-1884), *Still Life with Pawpaws*, circa 1870-1875; oil on canvas, signed at lower right — *Edw. Edmondson*, 14 x 17 inches; The Dayton Art Institute, gift of Mrs. Frank A. Brown.

worth, which is now the Taft Museum.[23] These still life and landscape murals are among the earliest surviving mural decorations in America. The several easel still lifes by Duncanson, painted simultaneously with the murals in Cincinnati, are typical mid-century arrangements of a multitude of different fruits that are composed in strict and simple pyramidal form. They are unusual, however, in that they are set into niches and thus appear doubly self-contained.

By far the finest midwestern still-life specialist in the mid-century was Edward Edmondson, Jr., of Dayton, Ohio, who was a Quaker artist.[24] Edmondson was primarily a portraitist, but he painted a sizable number of still lifes, the subject matter of which was probably more unusual than that of any other artist in that period. His paintings include *Paw-Paws*, a *California Snow Plant*, a *California Pepper Tree*, and even such themes as a *Lettuce Leaf* or a *Geranium* — these day-to-day items are common enough but are rare pictorially. Edmondson's unusual botanical subjects are dramatized frequently by the sharp studio lighting that he employed and that often lent a slightly spooky aura to the interpretation of his subjects. Edmondson infused a sense of deep personal involvement into his still-life paintings of the 1860s and 1870s, which was necessarily absent in his commissioned, often photographic formal portraiture.

Mention should be made also of the somewhat later work of the brothers Cadurcis Plantagenet and Morston Constantine Ream — certainly the most elaborate and historically fraught pair of names in American art. Cadurcis, particularly, was an extremely able painter who became a still-life specialist at an early stage in his career. He worked in New York City in the mid-1870s but settled in Chicago in 1878. Cadurcis Ream's work was used by Louis Prang & Company in its advertisements to promote the sale of its series of dining-room chromolithographs. His *Purple Plums* is a late example, or perhaps a second phase of interest in the Ruskinian "natural setting" still life, a form that attracted Ream on numerous occasions. The velvety nature of the fruit, so sensually painted, is also typical of the artist's highly engaging and individual approach to color, texture, and paint quality.

Interest in still-life painting can be discerned in the newly and quickly formed artistic community that developed in San Francisco after the discovery of gold there in 1849. California's most significant specialist, Samuel Marsden Brookes, will be discussed in the next chapter, but he was not alone in such ventures in San Francisco. Thomas Hill, the English-born landscape painter who gained national fame as the foremost interpreter of Yosemite, settled in California in 1861 and four years later was associated with Brookes in the California Art Union.[25] The following year, he went to Paris to broaden his horizons and to improve his artistic techniques. Hill's *Flowers in a Window* is a ravishing still life with a breadth of handling that is suggestive of contemporary French art.

Another close friend of Brookes's was Edwin Deakin who, like Brookes and Hill, was born in England. He came to America in 1869 and the following year settled in San Francisco. In 1874, he painted a well-known portrait of Brookes in his San Francisco studio (Fine Arts Museums of San Francisco). Deakin's artistic fame was gained for his picturesque architectural renditions of California missions, which he recorded on sketching trips throughout California, often with Brookes. Some of Deakin's pictures of hanging grapes are quite like those painted by Brookes, but he seems to have been extremely versatile in his still-life work. The broken outlines of

[23]For Duncanson, see James A. Porter, "Robert S. Duncanson, Midwestern Romantic-Realist," *Art In America* 39 (October 1951): 98-154, and Guy McElroy, *Robert S. Duncanson: A Centennial Exhibition* (exhibition catalogue; Cincinnati Art Museum, 1972).

[24]For Edmondson, see Bruce H. Evans, *The Paintings of Edward Edmondson (1830-1884)* (exhibition catalogue; The Dayton Art Institute, 1972).

THOMAS HILL, *Flowers in a Window*. See plate 8, page 8.

[25]For Hill, see the recent catalogue essay by Marjorie Dakin Arkelian, *Thomas Hill: The Grand View* (exhibition catalogue; The Oakland Museum, 1980).

Figure 5.25. CADURCIS PLANTAGENET REAM (1837-1917), *Purple Plums*, 1895; oil on canvas, signed at lower right — *C. P. Ream*, 16 x 22 inches; The Art Institute of Chicago, gift of Catherine M. White.

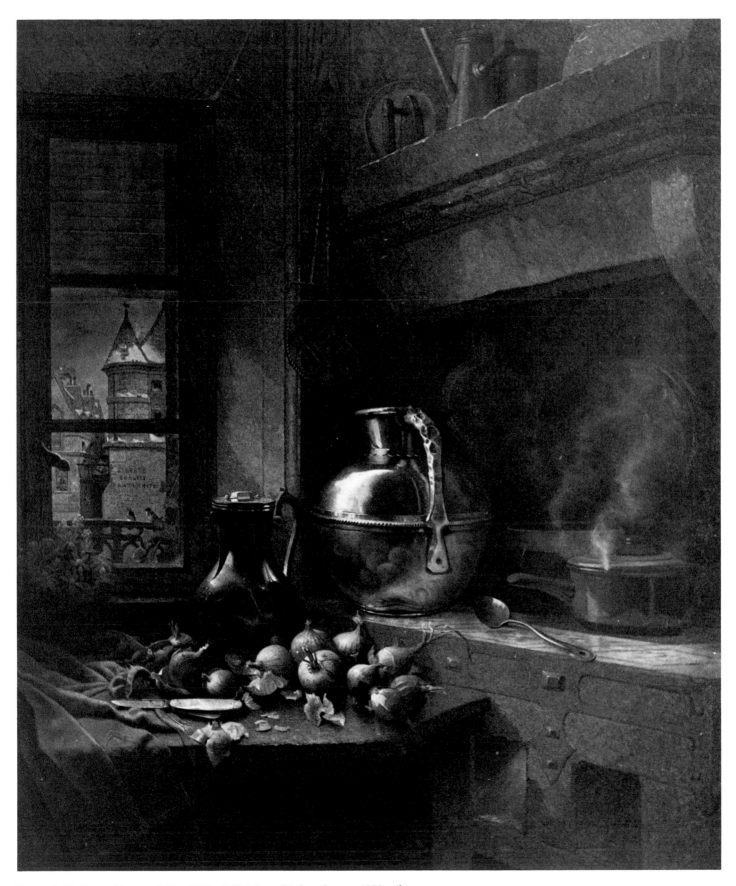

Figure 5.26. EDWIN DEAKIN (1838-1923), *Still Life — Kitchen Corner*, 1890; oil on canvas, 48 x 40 inches; State of California, bequest of Dorothy Holroyd Deakin.

buildings and the emphasis upon stone patterning found in his mission paintings also characterize the architecture in Deakin's pictures of grapes in niches and are prominent in his *Still-Life Kitchen Corner*. This painting of a French kitchen interior with a glimpse of buildings through the window is inscribed "Liberté, Egalité, Fraternité." Its very nature as a kitchen still life — and even more the interpretation of a meal in preparation rather than a juxtaposition of elements for purely formal consideration — can be traced back to the French still-life master Chardin, the revival of whose work is reflected in Deakin's work. So is the fascination with copper pots, jugs, and kettles, though Deakin replaces the French artist's hazy, luminous atmosphere with precision and a fascination with the reflection of a mass of onions along with the artist's own reflection in the large central copper container, a masterpiece of illusionism. Indeed, Deakin's fascination with the precision of form and with the reflective surface of the vessel shows his respect for craftsmanship equivalent in still-life terms to the then universally popular depictions of hand craftsmen such as *The Coppersmith* (Metropolitan Museum of Art), by the American Edgar Melville Ward, which was probably painted at much the same time. Another of Deakin's forays into still-life painting yielded a profusion of roses as overwhelming as those of Heliogabalus: *Homage to Flora* (1903-1904) was the result of using his own rose garden in Berkeley as a model every morning over a period of two years. The painting suggests an awareness of the floral art of the leading southern California still-life painter at the turn of the century, Paul de Longpré, "Le Roi des Fleurs," a French artist who came to America in 1890 and settled in Hollywood in 1898 in a home surrounded by three acres of flowers.

The mid-century aesthetic of profusion and abundance was superseded by newer approaches to still-life painting, but it did not quickly and simply disappear in the 1870s and after. In fact, a whole regional school perpetuated the aesthetic well into the twentieth century. This school, under the guidance of Robert Spear Dunning, was developed in Fall River, then a major industrial town of monumental homes and textile mills in Massachusetts. The school represented one of the most fascinating regional groups of still-life specialists, though only Dunning was truly a first-rate master. Most of the other school members were pupils there, and some of them went on to become teachers. The majority followed Dunning's aesthetic precepts, though some, like Franklin Miller, adopted a looser brushwork, and others, like Bryant Chapin, occasionally revived the Ruskinian natural setting format that held little interest for Dunning himself. By 1870, surely by 1880 — let alone 1920 — the work of the school would certainly have been considered conservative. It preserved intact the lushness and opulence of the mid-century and shared almost nothing with the trompe l'oeil tradition of William Michael Harnett that came about at the end of the century, nor did those artists adopt the bravura brushwork practiced in Munich or the flickering light of impressionism.

Many of the works of Dunning and his followers are still treasured in Fall River. Dunning studied in New York City under Daniel Huntington between 1849 and 1852, then returned to his home in Fall River, and thereafter confined his activities to that town and to nearby Providence, Rhode Island. His earliest paintings were portraits, and he was also an able landscaper painter, but in local annals he was first and foremost a painter of fruits and flowers, to which he had devoted almost all of his attention in 1865.[26]

EDWIN DEAKIN, *Homage to Flora*. See plate 9, page 9.

ROBERT SPEAR DUNNING, *Still Life*. See plate 10, page 10.

[26]For Dunning and the artists of the Fall River School, see the articles "Early Painters of Fall River," *Fall River Daily Globe* (27-30 June, 1, 3, 8 July 1944); *The Fall River School, 1853-1932* (exhibition catalogue; Greater Fall River Art Association, 1970); *Exhibition of Paintings, Drawings, and Unfinished Work of Robert S. Dunning* (exhibition catalogue; Fall River Public Library, 1911); and Dunning's obituaries in the *Fall River Evening News* and the *Fall River Daily Globe* (14 August 1905).

A typical Dunning still life contains a large piece of crystal, silver, or the like, with emphasis upon ornate, Victorian design. Fruit is lusciously rendered, usually resting upon a highly polished wooden tabletop with an ornately carved border, which marks the edge of the picture plane and is parallel to the viewer's gaze. This adoption of the polished wooden support is, in all probability, a derivation from Hall's work of the same period. A characteristic component of Dunning's paintings is the honeycomb, which adds a touch of the unusual and the exotic both in terms of edibles and of form, texture, design, and outline. Like so many of mid-nineteenth century still-life painters, he preferred a profusion of ripe fruit, juxtaposing different shapes, colors, sizes, and the like and usually opening up at least one piece of fruit so that the viewer can study it inside and out.

ROBERT SPEAR DUNNING, *The First Cut.* See plate 11, page 11.

Dunning shared with his predecessors, Roesen and Francis, Hall and Brown, the sense of bountifulness that fit comfortably with the optimism of pre-Civil War America. Although figures are by definition eliminated from still life, the beautiful luncheon and dessert still lifes of the period evoke the contented well-being of a happy family gathered around the bountiful table. This, as we shall see, contrasts sharply with the implications of solitary activity in the often dark and drab still lifes of the late nineteenth century.

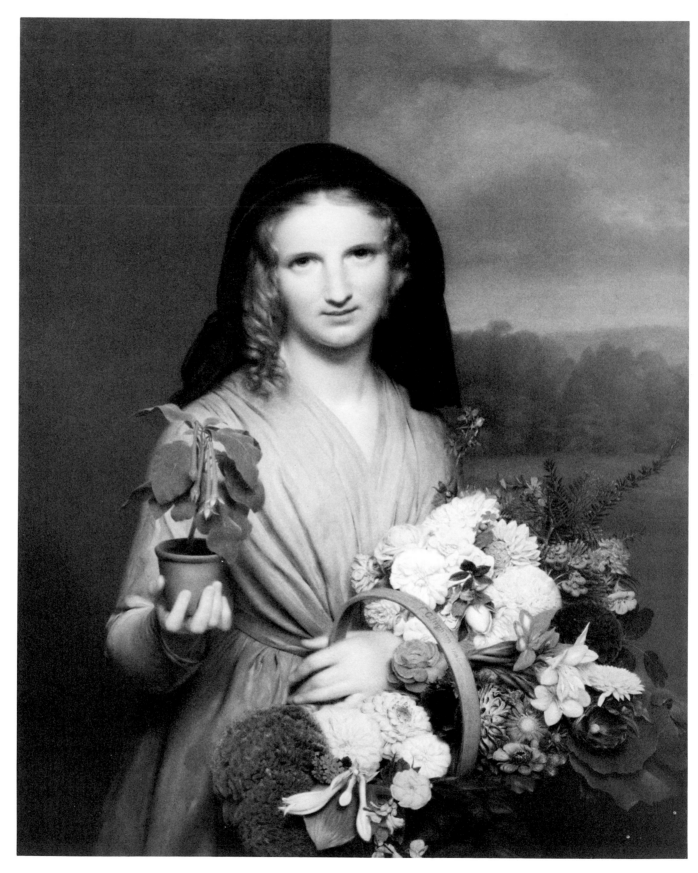

Figure 6.1. CHARLES C. INGHAM (1796-1863), *The Flower Girl*, 1846, oil on wood, signed on basket handle — *C. C. Ingham 1846*, 36 x 28⅞ inches; The Metropolitan Museum of Art, gift of William Church Osborn, 1902.

6 Thematic Expansion

Flowers, Fish, and Dead Game

Until the middle of the nineteenth century, flower painting was largely ignored by artists in America. This is somewhat surprising as European floral art was certainly not unknown in the early part of the century and even earlier. Dozens of volumes, which perpetuated the age-old symbolism attached to flowers, were published in America from about 1830 through the following three decades; Sarah Edgerton Mayo's *The Flower Vase: Containing the Language of Flowers* (1844) is typical in title, content, and even the gender of the author—the majority of the books were written by women. Sometimes accompanied by scientific descriptions or historical notes, but more often by sentimental poetry, such books would inform the reader that, for instance, the anemone was symbolic of frailty, the bluebell of constancy, the carnation of pride, the daisy of innocence, the hollyhock of ambition, the iris of a message, the violet of faithfulness, and the water lily of eloquence. The different species of roses encompassed a plethora of meanings. Despite some divergencies, the many varying volumes were surprisingly consistent in their symbolism.

We can only speculate upon the impact and interaction of such popular volumes on the nature and growth of flower painting in America. It is true that the early art exhibitions in New York, Philadelphia, and Boston — where annual exhibitions held at the National Academy, the Pennsylvania Academy, and the Boston Athenaeum offer a basis for consistent analysis — displayed a slow but growing presentation of flower pictures. However, most of these pictures that were painted and shown before the 1850s have disappeared, as have the records of the artists themselves. Interestingly, however, the majority of these presently unknown artists were also women who may have illustrated the various flower books of the nineteenth century. There is no documentation that later flower pictures, such as the bouquets painted by George Cochran Lambdin, resulted from sentimental flower books of a generation earlier. We are on safer ground, occasionally, in attempting to interpret the floral accessories that accompany some early and mid-century figure paintings. The several pansies held by the children in Henry Inman's work *The Children of Bishop Doane* (1835, The Newark Museum) may well represent "tender and pleasant thoughts," and we know that the beautifully rendered dead flowers in a silver goblet shown in the portrait of the young Nicholas Longworth Ward by Lily Martin Spencer (The Newark Museum) mark the portrait as posthumous. Indeed,

Lily Martin Spencer's *We Both Must Fade* (1869, National Museum of American Art, Washington, D.C.) depicts a portrait subject, a Mrs. Fithian, who is holding a rose from which the petals are falling. The rose symbolizes Mrs. Fithian's youthful beauty, and the falling petals her loveliness that will vanish in time.

Flowers accompanying figures in paintings may or may not be symbolic, which, in turn, may or may not relate to contemporaneous floral literature. What must certainly be the masterpiece of such flower-and-figure painting is *The Flower Girl* (1846) by Charles Cromwell Ingham, the Irish-born portrait and figure painter who settled in New York City in 1816 and soon became famous for his personal technique of laborious glazings, which were so flattering to his female sitters. Out of his technique, Ingham evolved a surface of glowing hardness, so different from the transparent Venetian glazes favored by American painters such as Washington Allston and William Page. This, together with an elaboration of accessories and bright colors, identifies Ingham's unique appeal.[1]

The Flower Girl is almost certainly the *Lady with Flowers* that was lent by Ingham on its completion to the New York Gallery of the Fine Arts in New York City for exhibition in 1846 and that was acquired by Jonathan Sturges. Sturges in turn lent it to "The Washington Gallery," a New York exhibit in 1853, under its present title of *The Flower Girl*. The picture is reputed to be a portrait of one Marie Perkins of New Orleans, but this attribution may confuse it with the portrait of a Mrs. Perkins of New Orleans that Thomas Sully painted in 1846. In any case, the picture is something more than a portrait. With her simple dress and black headdress, she appears to be a young widow in distressed condition. Distress does not conceal her beauty. The beauty, combined with her appealing and direct gaze, makes her pathetic floral offering irresistible. She is attempting to sell a small fuchsia plant — the message here in contemporary literary terms would be "humble love," appropriately enough — but in her other arm she holds a basket filled with brilliant blooms of many varieties. Indeed, this display vies for our attention with the lovely young lady herself and is too elaborate to describe a message in floral language. In practical terms, it is difficult to see how our heroine could disentangle a few flowers from the display to make a further sale. Painted with a scientific accuracy seldom attained by even flower specialists, the message may rather be the gloriousness of nature's bounty in contrast to the fluctuation of human fortunes, the two yet allied in freshness and beauty. Implied also, of course, is a duplication of Mrs. Spencer's message, that such beauty is in both cases transient. Nothing could be more striking in the contrast between the art of the federal and the early Victorian periods in America than the stark objectivity of Rembrandt Peale's portrait of his brother Rubens in 1801, with the geranium plant, and Ingham's lush and sentimental *Flower Girl* painted forty-five years later.

A mention should also be made of the drawing and painting books that were devoted specifically to floral still life, which constitute a barometer of the popularity of the theme.[2] The earliest of these was *A Series of Progressive Lessons Intended to Elucidate the Art of Flower Painting in Colours*, which was written by John Hill, the father and grandfather of John William Hill and John Henry Hill, and published in 1818 in Philadelphia. It remained an isolated example for twenty years, but then in the next two decades — contemporary with the sentimental flower books and with the beginning of the appearance of flower pictures in our annual exhibitions — a series of half

[1]Strangely, given his contemporary prominence, Ingham has never been the subject of a major study. For Ingham, see Albert TenEyck Gardner, "Ingham in Manhattan," *The Metropolitan Museum of Art Bulletin*, n.s. 10 (May 1952): 245-53.

[2]For the drawing books, see Peter C. Marzio, *The Art Crusade: An Analysis of American Drawing Manuals, 1820-1860* (Washington, D.C., 1976). There are also the earlier studies by Carl W. Drepperd, "American Drawing Books," *Bulletin of The New York Public Library* 49 (November 1945): 795-812, and his *American Pioneer Arts and Artists*, Chap. 2, "Art Instruction Books for the American People," pp. 13-38.

a dozen such books appeared. They are R. De Silver (?), *Progressive Lessons in Flower Painting* (Philadelphia, 1836): Anne Hill's *The Drawing Book of Flowers and Fruits* (1844) and her *Progressive Lessons in Painting Flowers and Fruits* (Philadelphia, 1845); John Henry Hopkins, *The Burlington Drawing-Book of Flowers* (Burlington, 1846), one in a series of landscape-figure flower drawing books by Bishop Hopkins, which, in the strictest sense, may not actually have been published; A. Smith's *Drawing Book of Flowers* (1852); and "H. B.," *Leaf and Flower Pictures and How to Make Them* (New York, 1857). The last, written during the heyday of Ruskinian influence in America, eschewed the floral bouquet in preference for the more natural depictions of spontaneously chosen and picked wildflowers, leaves, and the like. Bishop Hopkins's book, generally referred to in later literature as *The Vermont Drawing Book of Flowers*, is the most interesting. It consists of a series of lithographs of progressively more difficult plant designs, ten in black and white, followed by duplicates of nine of these, which were colored by hand. His son's name, John Henry Hopkins, Jr., was printed on the title page, but John, Jr., acknowledged in his biography of his father that almost all the work was done by the elder Hopkins. In his introduction to the set of plates, the younger Hopkins set forth the general purpose of such volumes of instruction:

> There is, perhaps, no branch of the pictorial art better suited to the objects of a refined and polished education, than the drawing of Flowers. To the student of Botany, this art should be considered indispensable. And to all who love these beautiful works of the Creator, it is surely an accomplishment of high value to be able to transplant them, as it were, from the garden to the living page of the Port-Folio, or frame them for the permanent embellishment of the parlour; and thus secure the expressive image of these transient favorites, after the originals have faded and died away.

The flower pictures that began to appear in the annual exhibitions in the 1830s and that were seen in increasing numbers in the 1840s were painted almost all by artists who are only slightly known and documented or completely unknown today, such as Henry Smith Mount and James Henry Wright. Unquestionably, the earliest flower specialist and painter of real significance in America was George Harvey. Harvey worked in both oils and watercolors, but he was more successful, as well as more distinct, as a watercolorist, which derived from his early pursuit as a portrait miniaturist.[3]

Harvey's major undertaking was his series of forty views in his *American Scenery* that he hoped to have reproduced in aquatint engraving. The work, painted about 1835-1840, was exhibited in both the United States and Europe. Only one number of four engravings and a frontispiece ever appeared, but in the late 1840s, he found another way of disseminating his material through public presentation in magic lantern slide illuminations. Harvey's watercolor landscapes have overshadowed his pioneering work in flower painting, but he was exhibiting such works as early as 1828, when he showed a *Vase of Flowers* at the National Academy and the following year at the Boston Athenaeum. Fruit pictures are recorded by him also, but the vast majority of his recorded still lifes, and all those known today, are floral pieces — with beautiful large blooms in vases or pitchers that are resting on marble tabletops. These are forerunners of motifs that were used in the pictures of Severin Roesen from 1848 on, which are more underplayed in Harvey's works. Harvey showed such florals again at the Boston Athenaeum in 1834 and 1844, at the National Academy in New York City in 1837,

[3]For Harvey, see Donald A. Shelley, "George Harvey and His Atmospheric Landscapes," *The New-York Historical Society Quarterly* (April 1948): 104-13. The most profound study of Harvey is by Stephen R. Edidin, "George Harvey: An Interpretation Based on His Watercolors" (Master's thesis, Williams College, 1977).

Figure 6.2. GEORGE HARVEY (circa 1800-1878), *Still Life*, 1865; watercolor on paper, signed at lower center on letter — *Geo. Harvey/A.N.A.*, 15 x 9¼ inches; Private Collection.

1842, and 1847, and was represented by his flower subjects at the American Art-Union in New York in 1845, 1846, and 1847. One of the two pictures that were shown at the American Art-Union in 1847 was his *Roses and Tulips*. It is almost certain that this painting, dated 1847, is the one that is in the collection of the New-York Historical Society. A painting dated two years earlier is on exhibit at Sunnyside in Tarrytown, New York, the home that Harvey designed for his friend and neighbor Washington Irving.

These paintings were created when the vogue for flower symbolism reached its peak, as indicated by the sentimental volumes on the language of flowers. Whether or not these pictures of 1845 and 1847 are actually meant to be "read" is not known, but Harvey is the one significant flower painter who *is* documented as painting works in the spirit of such literature. Included in the one-man showing of his *American Scenery* pictures, held at 322 Broadway in New York City, in 1843 were six still lifes, five of which were floral pieces. Two of these were specifically meant to convey a sentimental message, for the catalogue entries for *A Complimentary Letter from Flora* and *For Eulogy Conveyed by Flowers* list the flowers contained therein, the symbolic significance of each, and their messages. Thus, in the former, the more simple of the two, the combination of hollyhock, mignonette, convolvulus, scarlet lily, white and blue periwinkle, and yellow jasmine were meant to suggest respectively, "Aspiring," "Worth and Liveliness," "Worth Sustained by Affection," "High Souled," "Pleasures of Memory," "Early Friendship," and "Grace and Elegance." Their combined message was: "The pleasures of memory of our early friendship, when grace and elegance were to be seen by the side of high souled worth and loveliness, causes me to aspire in all my actions to be worthy of your affections." In the *Eulogy* picture, with an even more complicated meaning, the vase containing the flowers rests on a *Dictionary of Flora*, designed thus specifically to call attention to the meaning that can be found in that book.[4] It is almost certain that the later work *My Dear Anglican Friends* (1865) embodies a similar intent, although its actual meaning is unclear. The letter alongside the vase of flowers is dated "London 1865" and is addressed to "My dear anglican friends." It reads: "To all those who may take any interest in this group of flowers, it will be worthy to remark, that the tulip is taken from a study [sic] one half a century back. The other flowers are from somewhat later productions." It is signed "Geo Harvey/A.N.A."

The later flower specialists of significance may not have been so inspired. One of these was George Cochran Lambdin of Philadelphia, who first established his success in the field of genre painting. Among these, which ranged from sweet illustration of childhood to home and camp subjects related to the Civil War, were a number of pictures of beautiful women shown with lovely flowers — usually roses that undoubtedly were meant to convey a message of "like unto like." Lambdin turned to still life as early as 1857, but his concentration on the theme began only in the mid-1860s. This became even more pronounced after 1870, when he settled in Germantown near Philadelphia and cultivated a flower garden famous in its own day for fine roses. Lambdin was able to go to his own backyard for his subject matter, and naturally enough, his preference was the rose. His works became extremely popular, a popularity that was further enhanced through their reproduction by chromolithography.

Lambdin's flower pictures fall into two categories. There are his bouquet pictures, which are often of mixed blossoms, usually including some

[4]*An Index to the Original Water Color Drawings and Oil Paintings, Executed by Mr. (George) Harvey, and Now Exhibiting for a Short Time at No. 322 Broadway, Opposite the Hospital* (exhibition catalogue), pp. 28-29.

Figure 6.3. GEORGE COCHRAN LAMBDIN (1830-1896), *Still Life with Roses*, 1874; oil on canvas, signed at lower left — *George C. Lambdin*, 19¾ x 15¾ inches; Mr. and Mrs. William C. Burt.

GEORGE COCHRAN LAMBDIN, *Flowers in a Vase*. See plate 12, page 12.

roses, but sometimes of roses alone. The vases or containers in these paintings are usually fairly austere, unlike the baroque exuberance of the bouquets themselves, as in his *Flowers in a Vase* (1875). Backgrounds too are usually understated, providing a simple dramatic foil for the brightly colored blooms. Lambdin knew his flowers and painted them with such unconscious sureness and accuracy that he allowed himself considerable bravura in his paint handling. As a result, the flowers in his works have vitality from this very dash and verve of painting. Often, a few petals fall from his bouquet onto the tabletop, decorating this support surface and adding to the sense of fragility and transience of his lovely, but fragile, blossoms.

Lambdin's other mode of flower painting relates even more directly to his gardening interests. This is the presentation of flowers growing in situ. Almost all the known pictures of this kind are of roses, although he did paint other growing flowers as well; a *Wisteria* has come to light (Private

Collection). These are pictures of gardens, but the concentration is on the living blooms, not the setting — Lambdin's contribution to the "natural setting" still life. The flowers do, indeed, appear "natural," but careful study reveals that Lambdin arranged his composition. This was done partially for compositional control, but also to reveal the life cycle of the flowers, from bud to bloom to slightly aging flower, a Darwinian evolutionary concept that was favored among the artists of his time. Usually, these growing flowers in an outdoor setting are silhouetted against a garden wall of buff or gray stucco, a flat surface mottled in color and paint texture, which reflects the light and dramatizes the form and outline of the darker flowers.

There is a subcategory of more decorative paintings of growing roses that Lambdin also pioneered, the painting of the flowers against a black enamel background in which the naturalness of the growing flowers themselves is at striking variance with the total abstraction of their setting. This type of flower painting originated in the 1870s and influenced many other flower painters, although the exact chronology of Lambdin's art awaits fuller study. These black background pictures were also reproduced as chromolithographs.

Lambdin's attachment to the rose theme was extreme. He rejoiced in painting lovely women where the transparencies of their garments and the tints of their flesh would correspond to the texture and tones of his favorite roses, and where the roses held in their hands could be repeated in the "roses in their cheeks."[5] He wrote a short essay entitled "The Charm of the Rose."

[5]See Anne H. Wharton, "Some Philadelphia Studios," *The Decorator and Furnisher* 7 (December 1885): 78.

There is probably no inanimate object in the world more beautiful than a delicately tinted Rose. There is certainly nothing else which combines such beauty of form and color with such exquisite delicacy of texture and such delicious perfume. I can think of nothing to equal a half open flower of La France. I choose La France because of its perfume, of its color. The perfume is certainly unequaled; powerful, yet never heavy, it seems the very breath of summer. Then look into the rose's heart! Was ever such glowing, rosey [sic] rose seen elsewhere? Like the perfume, it is powerful yet always tender and delicate. As we look into the flower's cup we see it all aglow with this brilliant, tender, vibrating red, but the outer part where the petals turn back is of a milky whiteness, a satiny smoothness. The inner petals are small and ranged around the cup, the outer ones are long and somewhat irregular, making a very attractive shape.

While every one acknowledges the beauty of the Rose, and recognizes its color and its perfume, very few indeed know truly why it is so charming. The charm seems to me to lie, in great part, in the fine silky texture of the petals and in their translucency. No other flowers have these in such marked degree, and it is these qualities which make the contrast between the cool, clear rim and the outside of the cup, and its glowing heart. The other charm is that which is most felt when we look down into the depths of the half open bud. It is the charm which it shares with every beautiful thing which is "hidden yet half revealed."[6]

[6]George Cochran Lambdin, "The Charm of the Rose," *The Art Union Magazine* 1 (June-July 1884): 137. One should not overlook the plethora of rose literature just prior to Lambdin's concentration on the theme: Robert Buist's *Rose Manual* of 1844; William Prince's *Manual of Roses* of 1846; Samuel Parsons's *The Rose* of 1847, and the *American Rose Culturist* of 1856.

A second flower specialist, a contemporary of Lambdin, who also adopted the mid-century method of natural setting and scientific analysis in his still-life depictions, was Martin Johnson Heade. As Lambdin was also a painter of genre, so was Heade quite as well known for his marsh and coast scenes as for his still lifes. Like Lambdin, Heade did paint an occasional fruit picture, although only a few are known today, but even those — depictions of oranges — are accompanied by the orange blossoms. Heade painted still

[7]For Heade, the definitive study is Theodore E. Stebbins, Jr., *The Life and Works of Martin Johnson Heade;* for Heade's floral still life, see especially pp. 110-54, 166-77.

lifes throughout most of his long lifetime, probably beginning about 1860 and continuing even into the twentieth century. Although characteristically peripatetic, he settled in St. Augustine, Florida, for the last twenty years of his life, where he painted flower pictures of high quality.[7]

Heade's earliest known flower pictures are bouquets, often strangely combined with paraphernalia, on tabletops in dark interior settings. Frequently, the flowers are in unusual, distinct Victorian vases of glass, ceramic, or metalware and seem to wriggle out of the spindly mouths of these containers that also appear too small to hold the flowers. The earliest such work known dates from 1863 (St. Louis Art Museum). In their dark surroundings, the bright, light, and often white flowers appear unusually alive and active, but they lack the sense of bountifulness with which Lambdin imbues his bouquets. In fact, one would hesitate to refer to a "bouquet" at all in relation to Heade, considering the sense of human presence and *gemütlichkeit* that the term implies. Instead, Heade's flowers have a life of their own, independent of the observer. For that reason, perhaps, among the most impressive of these vase pictures are those in which a single flower is the subject, rearing its lovely blossom almost in independent life and action, such as the artist's *Red Flower in a Vase* (Mrs. Norman Woolworth Collection) or *The White Rose.* Rather, Heade's biographer points out that the *White Rose* is not a "pleasant" picture, but "hard and chilling," and a "fearsome image,"[8] made all the more so by the lack of either atmospheric illusion or painterly brushwork, which would ameliorate the hallucinatory effect of the picture by conveying either a sense of time and place or the hand of the artist.

[8]Stebbins, *Martin Johnson Heade,* p. 125.

Heade's earliest vase-tabletop florals preceded what are today his best-known flower pictures: the orchid and hummingbird paintings that were inspired by his trip to Brazil in 1863-1864. It should be mentioned immediately that he did not paint orchids in Brazil; his purpose there was to record the hummingbirds in a series of chromolithographs that were to be published in London. Only after the failure of the print project did Heade turn to new interpretations of the hummingbirds, combining them with large orchids in pink, yellow, or white, which, in size and magnificence, overwhelm the small exotic birds. The earliest dated orchid-and-hummingbird pictures are from 1871 and come after his 1870 trip to the island of Jamaica, but they do, of course, derive from the Brazilian venture. These pictures are larger than the original bird paintings, and Heade added panoramic tropical landscapes in the background. The orchids themselves are specific, identifiable varieties, some Brazilian but others native to Central America, or even the East Indies. It should be noted that the same orchids were often introduced into different pictures, not only in the sense of being the same kind of flower, but in specific formation. This suggests that Heade had basic studies of the flowers and birds that he transposed from picture to picture up until 1901.

Heade's pictures of orchids are unusual in the eyes of today's viewers. They must have been exceptionally strange in the artist's own time, for tradition as for back as antiquity associated the orchid with sex and lust — forbidden subjects, even by implication, in the Victorian period. The orchid, for instance, does not figure in the language of flower literature; this bloom dared not speak. Not only the orchid's tradition, but its name, derived from the Greek *orchis* meaning 'testicle,' its vaginal shape, and its gynandrous nature all would mitigate the popularity of such imagery.[9]

[9]Stebbins, *Martin Johnson Heade,* pp. 138-43.

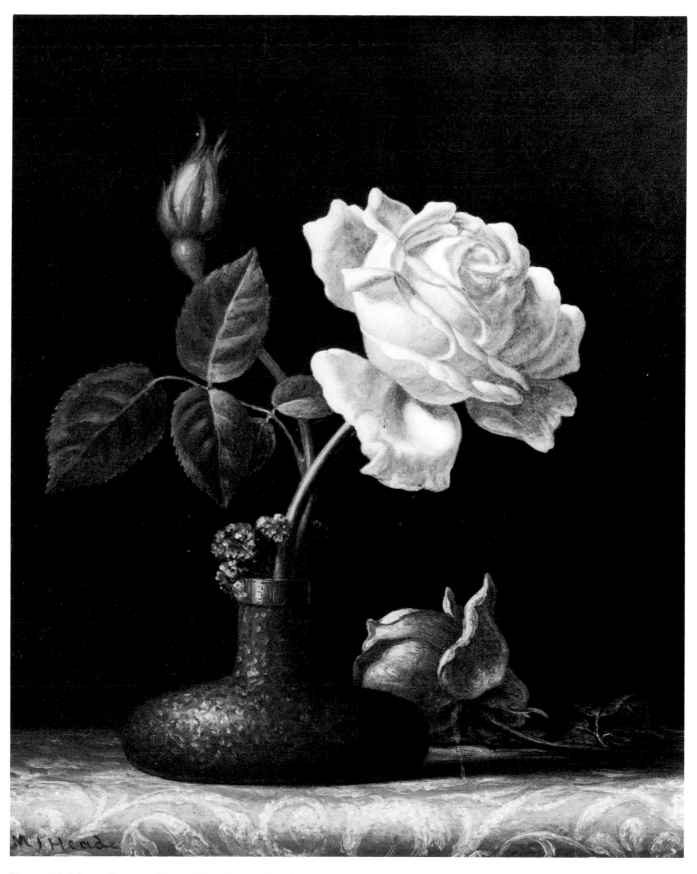

Figure 6.4. MARTIN JOHNSON HEADE (1819-1904), *The White Rose*, circa 1880; oil on artist's board, signed at lower left — *M J Heade*, 12 x 10 inches; Private Collection.

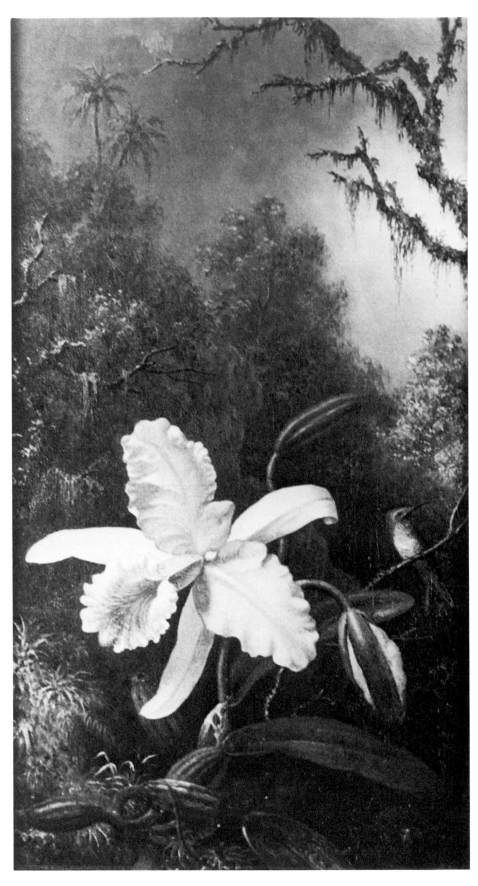

Figure 6.5. MARTIN JOHNSON HEADE (1819-1904), *Orchid and Hummingbird;* oil on canvas, 18¼ x 10 inches; Cummer Gallery of Art.

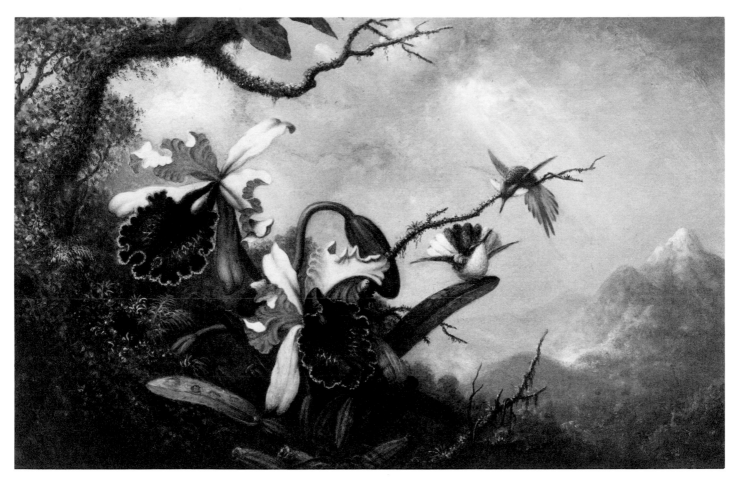

Figure 6.6. Martin Johnson Heade (1819-1904), *Yellow Orchid and Hummingbirds*, circa 1875-1885; oil on canvas, signed at lower right — *M. J. Heade*, 14 x 22 inches; lent by David Rust.

Yet, in the hothouse and in the laboratory the orchid was popular, and its history and nature were well known. Certainly, Heade's familiarity and preoccupation with the flower are reflective of the orchid mania of the 1830s and 1840s in England and the ensuing literature that corresponds directly to Heade's pictures: John Lindley's *The Genera and Species of Orchidaceous Plants* (London, 1830-1840), James Bateman's *A Second Century of Orchidaceous Plants* (London, 1867), Edward Rand's *Orchid Culture* (New York, 1876). But, above all, behind Heade's emphasis upon the orchid and his particular interpretation of it was Charles Darwin's *The Various Contrivances by Which British and Foreign Orchids Are Fertilised by Insects* (1862). This last followed immediately after Darwin's most famous work, *On the Origin of the Species* (1859). Naturally, his more concentrated orchid study did not achieve the worldwide fame of the earlier study, but certainly cognizance and attention were drawn to his later book by the impact of the earlier.[10]

Darwin wrote about the orchid and its fertilization in 1862; Heade painted his first hummingbird picture in 1863. In 1865, Darwin wrote *The Movements and Habits of Climbing Plants*, and within a few years, Heade began his famous series of pictures of orchids and hummingbirds in which not only the suggestion of growth and fertilization is present, but in the greatly emphasized orchids, the plant is intrinsically related to its environment, with emphasis upon the sinuous stems snaking through its tropical terrain with its thrusting, climbing momentum. From our vantage point, we

[10]For the relationship of Darwin's writing to Heade's painting and its impact upon the floral still life, see Stebbins, *Martin Johnson Heade*, pp. 142-46. In turn, Ella Millbank Foshay developed Stebbins's findings in her work "The Emergence of the Flower Genre in Nineteenth Century American Art" (Ph.D. diss., Columbia University, 1979). See especially chap. 7, "The Darwinian Revolution — A New View of Nature," and chap. 9, "The Flower Paintings of Martin Johnson Heade: Another Reflection of Darwin." Millbank also has published some of these findings separately in "Charles Darwin and the Development of American Flower Imagery," *Winterthur Portfolio* 15:4, pp. 299-314.

MARTIN JOHNSON HEADE, *Magnolia Flower*
See plate 13, page 13.

[11]John I. H. Baur, *Commemorative
Exhibition: Paintings by Martin Johnson
Heade and F. H. Lane from the Karolik
Collections in the Museum of Fine Arts,
Boston* (exhibition catalogue),
introduction, and Stebbins, *Martin
Johnson Heade*, p. 176.

might see Darwin's *The Power of Movement in Plants* (1880) as a coda and
confirmation of Heade's interpretation. While Darwin did not specifically
relate the hummingbird to the pollination of the orchid, he did recognize
that role as assumed by birds as well as insects in the pollination of flowers,
using the hummingbird as his first example in *The Effects of Cross and Self
Fertilisation in the Vegetable Kingdom* (1876). If, from the late 1850s the presen-
tation of the still life in its natural setting was initially a response to John
Ruskin's concept of "truth to nature," Heade's orchid and hummingbird
pictures of the 1870s and later took on, in addition, the far weightier
indebtedness to Darwin. One might well question what Ruskin's critical
(and personal) response might have been to the exotic aura, let alone the
dark sexual overtones, of Heade's pictures.

In Florida after 1883, Heade continued to paint marshy landscapes, as
well as orchid and hummingbird pictures. He also painted a large number of
tabletop flower pictures, some depicting local flowers such as the Cherokee
rose and the lotus, and, less successfully, a whole series of pictures of red
roses. His masterpieces in the last decades, however, are his paintings of
giant magnolias, resting not directly on tabletops but luxuriously reclining
on thick folds of soft velvet. The velvet cushioning in these paintings
appears variously in shades of brown, red and blue. Heade came to under-
stand the magnolia — its form, its texture, its intrinsic life force — as well as
he had the orchid, fully realizing the thick, fleshy white petals in contrast to
the deep green, waxy leaves. The contrast of these textures with the lux-
uriant pile of the velvet creates a tactile sensuousness that several scholars
have identified with the female nude. John I. H. Baur's description of "the
fleshy whiteness of magnolia blossoms startlingly arrayed on sumptuous
red velvet like odalisques on a couch"[11] deftly suggests the erotic and exotic
parallel. Heade, who married late in his life, may have regarded these
pictures as personal reflections; none appear to have been publicly ex-
hibited, but in the dozen or so magnolia pictures, Heade embodied and
transcended the old sentimental literary symbolism of that flower as "mag-
nificence and love of nature" in a manner that presages the great flower
pictures of Georgia O'Keeffe.

As the nineteenth century progressed, more and more artists became
involved in flower painting, so that by the end of the century it was the most
popular subject among still lifes. Many women, particularly, became flower
specialists, following the tradition of their involvement in still-life painting,
and some of them, such as Julia McEntee Dillon and Ellen Robbins,
achieved real distinction and some fame.

A third major category traditional to still life, in addition to edibles and
flowers, is fish and game. These subjects entered the repertory of American
art in force relatively late, not only after the mid-century but also after the
Civil War, although Raphaelle Peale had exhibited a *Fish* at the Co-
lombianum in 1795 and had continued to paint the subject, as is known
from one surviving example dated 1815. This latter work, a herring painting,
is crucial to the distinction between early still-life paintings in the nineteenth
century and those by fish and game specialists. Peale's work presents the
fish as part of a meal in the tradition of Chardin, not of the artists of
seventeenth-century Flanders and Holland, such as Frans Snyders, Jan Fyt,
and Jan Weenix. The American artists who used this theme in the second
half of the nineteenth century were concerned with fish and game as
trophies — records of the catch or the bag — that were representative of not

the cook at the stove but of the hunter and fisherman in the woods and at the stream. There is one profound difference here: this viewpoint is a distinctly masculine one, given the mores of society at that time, and appropriately or inevitably, women painters were not involved in the creation of such works. One can explain the increasing popularity of such pictures by referring to the growing urbanization of society and the pantheistic philosophy that drew both the artist and the citizenry to nature and nature-based pursuits. These game still lifes were also symptomatic of the increasing separation of the genders and thus were pictorial reflections of society of the time.

Fish and game specialists multiplied in the late nineteenth century. In 1873, Walter M. Brackett achieved an international reputation as a painter of piscatorial pursuit when his four-part series of a successful catch was shown at the Crystal Palace in London, although strictly speaking, only the last of the four — *Landed* — constitutes a still life, since the fish in the other paintings were depicted as being alive and fighting. Brackett, who had made this theme his specialty by the early 1860s, was in fact often compared with Henry Leonidas Rolfe, the leading English painter of fish pictures, but soon America had many others. There was James H. Cafferty in New York who exhibited many fish paintings during the 1860s, and we have already mentioned Arnoud Wydeveld's turn to fish subjects in the mid-1860s. Gurdon Trumbull was Connecticut's favorite fish painter; Ohio spawned William H. Machen; and the South had a coterie of fish painters: Achille Perelli, George Viavand, and William Aiken Walker (who was better known for immortalizing the black field hand).

Thus, the fishing trophy still life became popular in the 1860s. That of the trophy of the hunt began its popularity a decade earlier with the work of Arthur Fitzwilliam Tait, who left England and settled in the United States in 1850. Tait was predominantly a painter of animals, both domestic and wild. The latter was often portrayed with hunters, but in the period 1850-1855 he executed at least twenty-six game still lifes. This activity, along with the reproduction of four of them by Currier & Ives in a series entitled "American Feathered Game," certainly furthered the popularity of both the theme and the artist. Interestingly, Tait too turned to fish still life in the early 1860s, painting a number of them in 1862; a second group was completed in 1870-1871. The success of Brackett in England, the familiarity with Rolfe's work in this country, and Tait's activity here all suggest an English origin for the introduction and growth of interest in the sporting still life in the United States. Given the tradition of sporting art in Great Britain, such a source is quite likely. In the trompe l'oeil game pictures of the next generation, however, the theme took a native form that was in turn imitated by English artists.

Before the emergence of large numbers of fish and game still lifes, man's pursuit of field sports as pastime and pleasure was portrayed by many artists, from Thomas Doughty's fishermen in landscape and onward. Junius Brutus Stearns painted a whole series of pictures showing the sport of fishing after 1850 — children fishing, group portraits of convivial fishermen, and the like — although only one fishing still life by him, *Still Life With Trout and Fishing Tackle*, which was painted in 1853, has so far come to light. Even here, the fisherman himself is indistinctly seen in the background, at the edge of the stream, silhouetted against a broad landscape, but the emphasis is upon the still life that is propped up on the bank of the stream

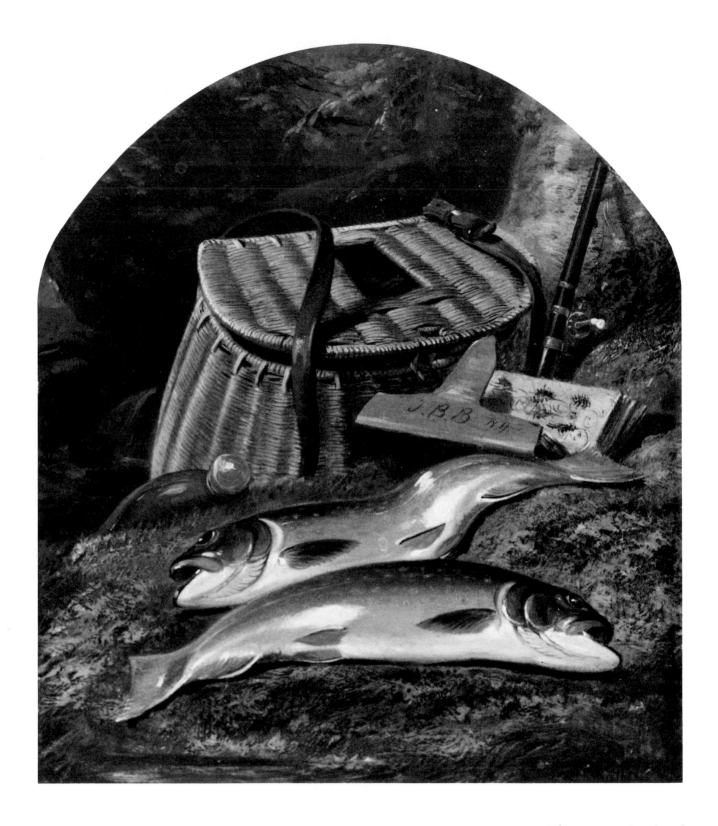

Figure 6.7. ARTHUR FITZWILLIAM TAIT (1819-1905), *American Brook Trout*, 1862; oil on board, signed at lower right — *1862 J. B. B.*, 9 x 8 inches; Private Collection.

in the foreground, the fish accompanied by tackle box and rod and reel. Stearns's involvement with fishing is suggestive of an autobiographical note, which is further documented in his signature that is printed on a bottle half-submerged in the stream in this still life: this is Sterns's own experience, a documentation of his successful catch and perhaps a self-portrait, idealized or otherwise, in the background.[12]

Possibly the most beautiful trophy still life in all of American art is the extremely rare example of Winslow Homer, his *Two Trout* (1889), one of only a handful of still lifes, properly speaking, by him, and one of only two fishing still lifes so far known. As is the case with many of Homer's works in watercolor, the picture is part of a series all painted at the same time. This is not a series of fishing trophy subjects but rather records of various fishing

[12]For Stearns, see Millard F. Rogers, Jr., "Fishing Subjects by Junius Brutus Stearns," *Antiques* 98 (August 1970): 246-50.

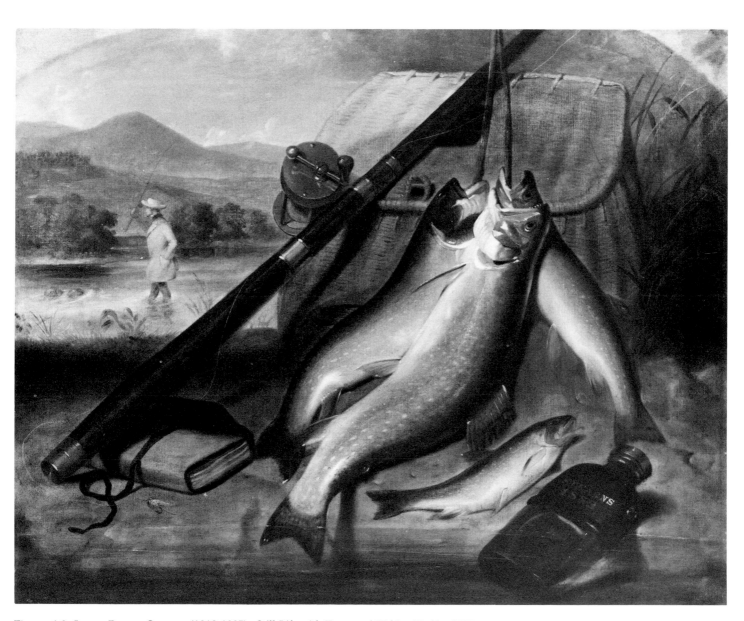

Figure 6.8. JUNIUS BRUTUS STEARNS (1810-1885), *Still Life with Trout and Fishing Tackle*, 1853; oil on canvas, signed on bottle at lower right — *Stearns/1853*, 22 x 26¹⁵⁄₁₆ inches; Toledo Museum of Art.

incidents, in a sense culminating in the view of the hanging catch; in one painting (Private Collection), it is seen from a distance and is seen up close in *Two Trout*. Homer's *Trout Breaking* (1889, Museum of Fine Arts, Boston) is another in this series, recording an earlier moment in the sportsmen's experience when the fish is still quite lively, and thus technically is not a still life.

Perhaps the greatest of all the specialists of fish still lifes in America, however, was also the most famous still-life painter on the West Coast in the nineteenth century and one of the best-known painters in the artists' community in San Francisco, Samuel Marsden Brookes. Brookes was born and grew up in England, his family emigrating in 1833 and settling in rural Michigan. In 1842, Brookes traveled to Milwaukee where he spent most of the next two decades, painting his first still life in 1858. However, it was in 1862, when he went to California and settled in San Francisco, that he found the true outlet for his talents. He continued to paint portraits as he had in the Midwest. When he painted still lifes, he employed a variety of subjects including the traditional flowers and fruits; his pictures of peaches and of grapes, often silhouetted against a wall and sometimes in a shallow niche, were greatly admired. Brookes's still lifes influenced the art of his good friend and colleague, Edwin Deakin. But it was as a painter of fish that Brookes achieved truly extraordinary fame.[13]

Brookes's first great success, and in some ways one which he never surpassed, was his 1862 *Still Life*, a vividly baroque composition of many different kinds of fish and fowl and a variety of vegetables that are sitting on a stone ledge and hanging against a stone wall. It was acquired by the prominent collector Judge Edwin Bryant Crocker of Sacramento. The exuberance of the color and the composition, as the fish, game, and vegetables almost cascade down the wall and off the ledge, suggest seventeenth-century precedent and even a relationship to the sixteenth-century market pictures of Pieter Aertsen and Joachim Beuckelaer, important figures in the origins of still-life painting. However, the concern here for the ingredients of a meal relates the work also to the eighteenth century and to Chardin. The emphasis in the background on the construction of the wall and stone ledge prefigures Brookes's later fruit pictures with their "activated" backgrounds.

The catch of fish in this early work of Brookes's is only one of several elements present. Brookes went on to establish a reputation for fish still life unequaled in this country. Typical of such work, and Brookes at his best, is his *Steelhead Salmon* (1885). Here, as in many of his works and in many paintings by Tait and Wydeveld, Brookes places his subjects out-of-doors and on the ground — still hanging against a landscape and accompanied by reel and rod. The finish in many of his pictures is almost microscopic, and this, together with his ability to capture the delicate tints of the fish, gives his work almost the quality of an optical illusion. Indeed, his skill in representing the fish was cause for a minor mythology to grow up around his work. One anecdote records the following debate between two of the artist's admirers: "Wonderful, wonderful! So natural you can almost *smell* them!" "No, no! There is no smell there; fish as well composed as those are not susceptible to decomposition."

Nor was the muse of poetry unmoved by the quality of Brookes's work. One such poem, entitled "To Brookes after a visit to the gallery of the San Francisco Art Association" begins:

[13]For Brookes, see *Samuel Marsden Brookes*, ed. Joseph Armstrong Baird, Jr. (exhibition catalogue; California Historical Society, San Francisco, 1962), and the clipping file at the society, containing mostly undated clippings, from which the following excerpts are taken.

SAMUEL MARSDEN BROOKES, *Still Life*. See plate 14, page 14.

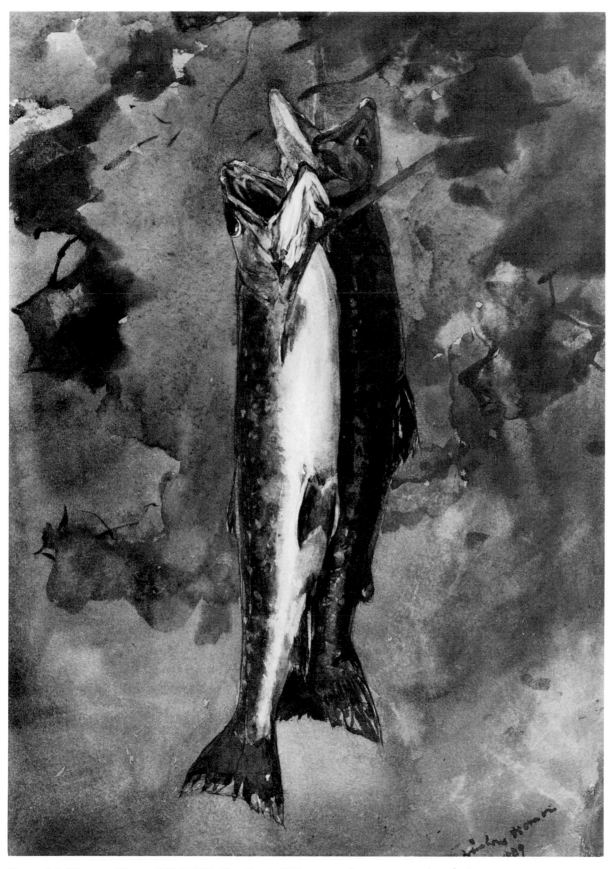

Figure 6.9. WINSLOW HOMER (1836-1910), *Two Trout*, 1889; watercolor on paper, signed at lower right — *Winslow Homer*, 19⅜ x 13⅛ inches; IBM Corporation, Armonk, New York.

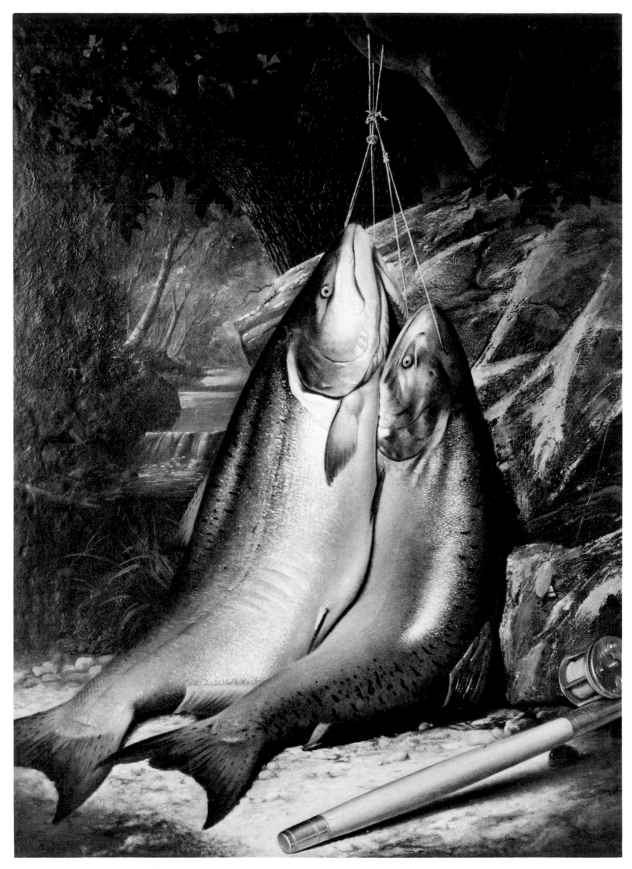

Figure 6.10. SAMUEL MARSDEN BROOKES (1816-1892), *Steelhead Salmon*, 1885; oil on wood panel, signed at lower left — *S. M. Brookes*, 29½ x 30 inches; Collection of the Oakland Museum, gift of the Kahn Foundation.

Oh Brookes! Brookes! Brookes!
Thou must have dealt
In magic to produce
Such Smelt
With water drops
In plash and quiver,
Just from the bed
Of bay or river.
Prolific Brookes!
By thy great art,
The salmon
From the canvas start
With rod, reel, line —
With hook and fly,
That competition
All defy

Brookes was admired above all for the close detail and labored texture of his fish, their roundness and solidity of appearance, and the polish and silvery sheen of his subjects; it was said that no one hid paint like Brookes. He was honored beyond the favor of the critics. Much involved in the art community in San Francisco, he helped to organize the California Art Union in 1865 that, though short-lived, was important as a forerunner of the San Francisco Art Association in which Brookes was also much involved. He was extensively patronized by such figures as Judge Crocker and Mrs. Mark Hopkins. During the years of his greatest popularity, from the early 1860s to the early 1880s, his financial success was second to that of no other California artist. Perhaps in no other place and at no other time during the nineteenth century did a still-life specialist achieve such stature.

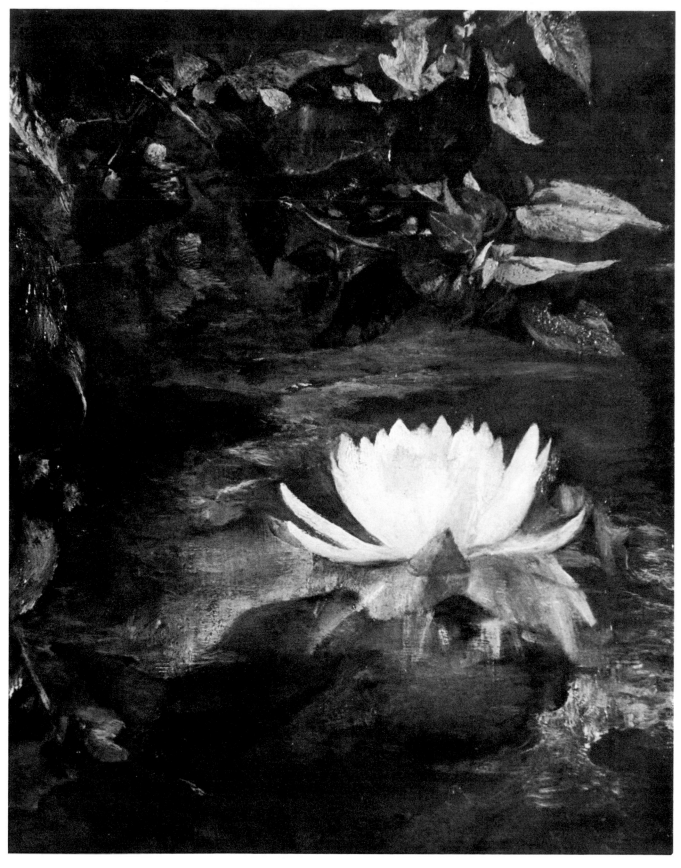

Figure 7.1. JOHN LA FARGE (1835-1910), *Water Lily,* circa 1874; oil on canvas, 12 x 10 inches; Mead Art Museum, Amherst College, purchase.

7 The Poetic Flower

The scientific mode of careful botanical analysis dominated American still-life paintings during the 1850s and 1860s. This was due in part to the impact of John Ruskin and perhaps also to the tradition of using botanical illustrations in published volumes beginning with the end of the second decade of the century. It may well have been further influenced by the writings of Charles Darwin. But side by side with the botanical handling of still life, a far different approach surfaced — the poetic and lyric, sometimes visionary, interpretation of the flower. The poetic still lifes are flower paintings; fruit and vegetables were unsusceptible to such interpretation for the most part. This may be due to the symbolism that was long connected with flowers, associations iconographic in both literary and pictorial imagery. Furthermore, the flower was, and is, regarded as a thing of beauty as opposed to vegetation that was meant to be consumed. It exists in the world of the decorative, abetted by its sensory associations of brilliant color, fragile texture, and often exquisite smell. Due to its associations, iconographic and physical, the flower was the natural still-life vehicle for poetic artists.

Such interpretations were made by John La Farge. In the 1860s and 1870s, the period when La Farge was especially involved with still-life painting, he attracted a group of critics who greatly admired and praised his work. This championing, however, though it continued well into the twentieth century, was gradually forgotten as were La Farge's still lifes themselves. They were overshadowed by his other work, his easel figure paintings, his murals, his stained glass, and his writing. In part, the neglect of his still lifes was due to chronological supersession; in part it may have been still a relic — though by the twentieth century an unconscious one — of the hierarchy of themes that classified still life as a lowly art form. Yet, criticism often runs in cycles, and there are many collectors, critics, and historians today who regard La Farge's flower pictures as his finest works and as the most beautiful floral pieces ever painted in America.

When La Farge began to paint and to exhibit professionally, much of his work consisted of flower pictures, which were well received. La Farge's earliest known still lifes are dated 1859,[1] the year after he returned from several years in Europe, where he studied briefly in France with Thomas Couture. While abroad, he also visited the Art Treasures exhibition in Manchester, England, where he became impressed by the work of the

[1] The most recent and most complete account of La Farge's still lifes is by Kathleen A. Foster, "The Still-Life Paintings of John La Farge," *The American Art Journal* 11 (July 1979): 4-37. Equally important is Henry Adams, "John La Farge, 1830-1870: From Amateur to Artist" (Ph.D. diss., Yale University, 1980), see especially pp. 225-43, 305-7. Foster carries the discussion and analysis of La Farge's still lifes further in time than does Adams.

English Pre-Raphaelites. These earliest still lifes are among his most conventional. One of them, however, a depiction of water lilies (Mrs. Norman B. Woolworth Collection), already interprets the flower with which he was to become most associated. By 1862, La Farge painted the water lily again, this time showing it in its natural watery habitat rather than in a shallow vessel, a white bowl, which he used in 1859. This concept is more Ruskinian, or Darwinian, but it would be foolish to speculate on his scientific motivation, for such pictures as his *Water Lily and Linden Leaves* suggest an abandonment of such concerns rather than an adoption. Paint is richly applied in his broadly painted oils. The beautiful flower is absorbed in a luminous atmosphere, and the artist's concern is with its fragile vitality, not its botanical structure. The water lily had just recently become the object of several major, grandly illustrated publications: William J. Hooker's *Victoria Regia*, published in London in 1851, and John Fisk Allen's *Victoria Regia, The Great Water Lily of America*, published in the United States in 1854 and illustrated by William Sharp. Sharp's chromolithographs are the most splendid flower prints ever published in America. These publications reflect the interest in the water lily, which was successfully cultivated in 1851.

A number of fine oil paintings of water lilies by more botanically motivated painters already mentioned are known, among them one by George Henry Hall of 1881, and one by Paul Lacroix of 1865 (both Private Collections). La Farge's pictures, however, are very different.

La Farge's originality was recognized early. James Jackson Jarves, one of the most perceptive American writers on art at mid-century, compared his works with Hall's in 1864. Jarves had had an ample opportunity to see La Farge's flower pictures, one having been shown at the National Academy in 1862, and three in the following year. He wrote:

> Compare Hall's fruit pieces with La Farge's flower compositions . . . As Hinckley paints animals with the *animal* left out, so painters of horticulture like Hall exhaust their art on the outside of things, with the fidelity of workers in wax . . . Who thinks of the science of the horticulturist, or pauses to taste, weigh or price flowers and fruit painted as La Farge paints them? His violets and lilies are as tender and true suggestions of flowers — not copies — as nature ever grew, and affect our senses in the same delightful way. Their language is of the heart, and they talk to us of human love and God's goodness. Hall's fruit is round, solid, juicy — huckster's fruit; only it proclaims paint and painter too loudly to tantalize the stomach. The violets of La Farge, and, indeed, his landscape entirely, quiver with poetical fire. We bear them away from the sight of them, in our inmost souls, new and joyful utterances of nature.[2]

Almost twenty years later, after La Farge had temporarily discontinued his painting of still life, one of his first major biographers, George Parsons Lathrop, wrote:

> In the painting of flowers he has a peculiar strength and delicacy. It has been said of them that they "have no botanical truth, but they are burning with love and beauty." This gives the wrong impression; for the truth of structure is always present, and the drawing exquisite, though the flowers are bathed, as they should be, in the dreamy light of their poetic quality — instead of being stiffly defined as parts of "botanical truth."[3]

La Farge's most beautiful works were his paintings of water lilies and other flowers, such as his masterwork *Flowers on a Window Ledge* painted in Newport about 1861-1862. In place of the darkened interior of the 1859 water

[2]James Jackson Jarves, *The Art-Idea*, ed. Benjamin Rowland, Jr., pp. 204-5.

[3]George Parsons Lathrop, "John La Farge," *Scribner's Monthly Magazine* 21 (February 1881): 510.

lilies in a bowl, here the flowers are bathed in the gentle breeze, which blows the curtain above them, and are illuminated by the light that suffuses all outdoors beyond the window. La Farge was very interested in light and the effects of color in light. He himself spoke of his interest in analytical terms:

> I painted flowers to get the relation between the softness and brittleness of the flower and the hardness of the bowl or whatever it might be in which the flower might have been placed. Instead of arranging my subject, which is the usual studio way, I had it placed for me by chance, with any background and any light, leaving for instance the choice of flowers and vase to the servant girl or groom or any one.[4]

And again, to Royal Cortissoz, his admiring critic:

> My painting of flowers was in great part a study; that is, a means of teaching myself many of the difficulties of painting, some of which are contradictory, as, for example, the necessity of extreme rapidity of workmanship and very high finish. Many times in painting flowers I painted right on without stopping, painting sometimes far into the night or towards morning while the flower still remained the same shade, which it was sure to lose soon.[5]

Others, however, recognized the essential poetry of La Farge's flower pictures, his ability to capture the essence or inner meaning of the flower, its soul, so to speak. His colleague, Elihu Vedder, was one of these:

> This quality of subtlety is shown in those never-to-be forgotten flowers . . . in a shallow dish on a window-sill, where the outdoor air faintly stirring the lace curtains seems to waft the odour toward you. This quality, peculiarly his own, affects me in his writings, so that as a writer I was at one time inclined to find fault with him for a certain elaborate obscurity in his style, which I now see arises from his striving to express shades of thought so delicate that they seem to render words almost useless. Therefore, his words seem to hover about a thought as butterflies hover about the perfume of a flower.[6]

In the early 1870s and after a trip to Europe in 1872-1873, La Farge appears not to have produced any still-life paintings. In 1876, he once again showed works in this theme, exhibiting early examples at the Philadelphia Centennial. Two years later, he began a series of watercolor still lifes. Now, the luminosity and brilliance of color of his oil still lifes of the previous decade were translated into the glowing, transparent medium of watercolor, which is reflective also of his aesthetic concerns in stained glass. In 1879, he returned to his favored water lily motif in that medium — *Water Lily and Butterfly* (Wadsworth Atheneum) is probably one of the first and certainly one of his most beautiful watercolor still lifes. In such a work, the gradual abandonment of naturalism, the concern with often asymmetrical design, and the conscious patterning of shapes, with space read vertically rather than in recession, all suggest the growing Oriental influence on La Farge's art, which began as early as the late 1850s. By the close of the century, in works such as his *The Peony in the Wind* (1890, Middendorf Collection), the Oriental influence had become even stronger, the design defined totally by two dimensions; where in his early flower pieces the blooms were enveloped in gentle breezes, here, they are far more abstracted, the peonies swaying dramatically in the dynamics of the late nineteenth century.

While La Farge focused on the casual and the commonplace in his floral pictures, his real preference was for the water lily and, to a lesser

JOHN LA FARGE, *Flowers on a Window Ledge.* See plate 15, page 15.

[4]Quoted in Royal Cortissoz, *John La Farge: A Memoir and a Study*, p. 116.

[5]Cortissoz, *John La Farge: A Memoir and a Study*, p. 135.

[6]Elihu Vedder, *The Digressions of V.*, p. 260.

degree, the magnolia, prefiguring Heade's late concern with that flower. La Farge wrote about his involvements with the water lily — the lotus — defined by his biographer, Cecilia Waern, as "preeminently the flower of the mystic."[7] He said:

> Thinking again about the pictures of flowers which I used to paint, there were, besides the paintings that were studies of the flowers, and those that were painted as pictures, certain ones in which I tried to give something more than a study or a handsome arrangement. Some few were paintings of the water lily, which has, as you know, always appealed to the sense of something of a meaning — a mysterious appeal such as comes to use from certain arrangements of notes of music. Hence, I was not surprised a few weeks ago to find a design for a frame of one of these paintings of the water lily, treated as "the" water lily, not "a" water lily. The frame had a few bars of one of Schumann's songs, which was written to Heine's verses,
> "Du, schone weisse Blume,
> Kanst du das Lied verstehn?"[8]

[7]Cecilia Waern, "John La Farge," *The Portfolio* 26 (April 1896): 21.

[8]Cortissoz, *John La Farge: A Memoir and a Study*, pp. 135-36.

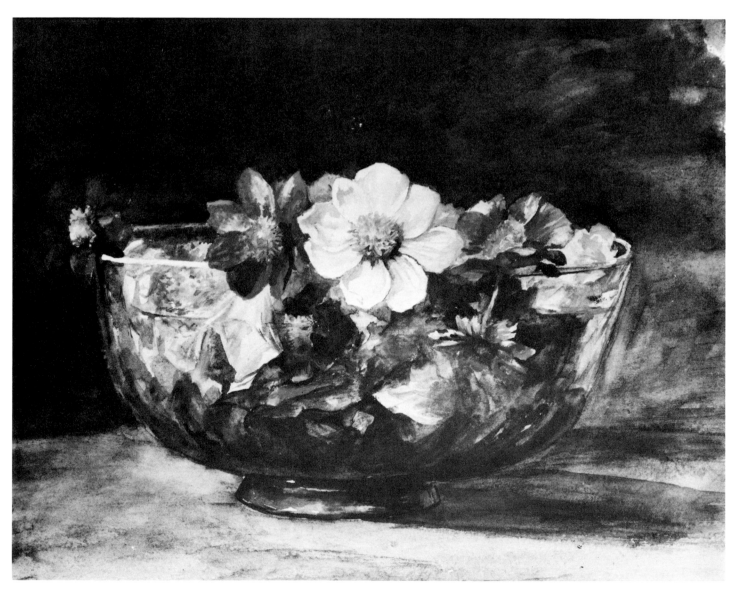

Figure 7.2. JOHN LA FARGE (1835-1910), *Bowl of Flowers;* watercolor, 10¼ x 13 inches; Washington County Museum of Fine Arts.

Figure 7.3. JOHN LA FARGE (1835-1910), *Waterlilies;* watercolor and gouache on paper,
7 x 5¾ inches; Sterling and Francine Clark Institute, Williamstown, Massachusetts.

Figure 7.4. JOHN LA FARGE (1835-1910), *Greek Love Token*, 1866; oil on canvas, signed at lower right —.*La Farge/1866*, 24⅛ x 13⅛ inches; National Museum of American Art, Smithsonian Institution, gift of John Gellatly.

144

La Farge's two hanging wreath still lifes — one painted in 1861, the other in 1866 — are among his most unusual works. They have precedent in a few even earlier pictures of his and look forward, of course, to the hanging objects rendered in a trompe l'oeil manner by William Michael Harnett and his followers of the next generation. Indeed, there are trompe l'oeil elements in the two wreath paintings, not only in their general formats, with the wreaths projecting out toward the spectator, but also in the successful illusion of stucco background in the scumbled paint and in the shadows cast by the wreaths upon the walls. But at the same time they are much more than exercises in illusion. Their haunting and poetic character has fascinated viewers for generations.

Although both pictures are the same size, the earlier wreath (Private Collection) is larger and bolder within the format, projecting more vigorously with more colors. Its alternate title of *Greek Love Token* suggests La Farge's acknowledgment of the ancient custom of a suitor stating his marriage proposal in the form of a wreath hung outside the home of his intended. The inscription, *Erosanthe Kale,* can be read "Love — Flower — Beautiful," to subscribe to the interpretations (though hardly the usual language) of the flower books. Indeed, the specific flowers of this wreath do subscribe exactly to those flowers that were expected to appear in Greek love tokens, according to Charles Duke Yonge's 1854 translation of Atenaeus' *Deipnosophistiae,* a book in La Farge's library. The picture appears to celebrate the joy of La Farge's first year of marriage while still expressing in floral terms the transience of such emotions.[9]

And transient they were, for by 1866 and by the appearance of the second wreath, that relationship had ended. That may, in part, account for the difference between these seemingly similar paintings. The second wreath is a more delicate form, paler, with fewer flowers, and is more distant from the viewer. Its inscription, *Thereos Neon Istamenoio,* translates "as summer was just beginning" and embodies not the association of love but that of the funereal. This mournful aspect may reflect the artist's marital estrangement, his recent recovery from a grave and difficult illness, or, perhaps most directly and pointedly, the death of his infant son Reynolds, who died in 1866.

La Farge's two wreath pictures were well known in their own time; one of them was exhibited at the National Academy of Design in 1869. Earlier, in 1864, Clarence Cook, critic for the *New York Daily Tribune,* expressed a typical Ruskinian prejudice when he complained that the artist had sacrificed everything for color, that ". . . there is nothing but the color; all that the painter has aimed at is a certain sentiment of flowers . . . We have neither truth of form nor structure."[10] That same year, a very different reaction was elicited from James Jackson Jarves. Though both of these critical estimations relate to the earlier wreath picture of 1861, both are also applicable to the one of 1866. Jarves wrote:

> A flower of his has no botanic talk or display of dry learning, but is burning with love, beauty, and sympathy, an earnest gift of the Creator, fragrant and flexible, bowed in tender sweetness and uplifted in stately pride, a flower whose seed comes from Eden, and which has not yet learned worldly ways and deformities. Out of the depth and completeness of his art-thought, by a few daring, luminous sweeps of his brush he creates the universal flower, the type of its highest possibilities of beauty and meaning, using color not as fact, but as moods of feeling and imagination, having the force of passion without

[9]See Adams, "John La Farge, 1830-1870," for his research and analysis of the wreath paintings, see especially pp. 264-68. Also see Foster, "Still-Life Paintings," pp. 19-20.

[10]Quoted in Foster, "Still-Life Paintings," p. 19, from the *New York Daily Tribune* (14 May 1864): 3.

[11]Jarves, *Art-Idea*, p. 186.

Figure 7.5. MARIA OAKEY DEWING (1845-1927), *Rose Garden*, 1901; *(before restoration)*, oil on canvas, signed at lower left — *Maria Oakey Dewing 1901*, 24¾ x 40¼ inches; Private Collection, New York. Detail.

[12]Maria Oakey Dewing, "Flower Painters and What the Flower Offers to Art," *Art and Progress* 6 (June 1915): 257.

[13]For the role of the peony and the chrysanthemum in Oriental art and a consideration of the relationship between Oriental and Western flower painting, see Paul Hulton and Lawrence Smith, *Flowers in Art from East and West*.

its taint. Such are his Wreath of Violets, the Rose-mallow, Lilies, and other evidences of his genius in unpretending motives, all of them suggesting capacity for greater themes.[11]

Fifty years later, La Farge's fine pupil, the sensitive flower painter Maria Oakey Dewing, wrote of the later picture:

> Never did he more exemplify this [his incisive knowledge of the essence of a flower] than in the painting of a small wreath of many kinds of flowers, bound in a rich classical form, casting its little shadow on a greyish white background. The forms of the petals are distinct one on the other, sometimes with little change of value or color, distinguished by texture. Here the tone is pallid with a luminous pallor, here it is magnificently brilliant with rich clear tints, here dark and mysterious and illusive. A group of green leaves brought down on the inner side of the wreath with sharp hard outlines, with broad flat surfaces of color, with opaque thick texture, accents the fragility of the flowers. This is to demonstrate the difference between mere representation and the art of picture-making, but most of all to loudly acclaim what flowers have to offer as a subject to art.[12]

Imitation may well be one of the sincerest forms of flattery, and perhaps particularly in Boston where the still-life tradition had never been strong and certainly was not comparable to that which had developed in New York and Philadelphia. Nevertheless, La Farge's still lifes were well received there; they were shown at the Doll and Richard's gallery in 1886 along with some critically successful works by Albion Bicknell who had, as we have discussed, been commissioned to paint panels for Freeland's dining room relinquished by La Farge in his illness. Bicknell obviously was influenced by La Farge in the early 1860s. Among Boston painters, the older William P. Babcock's flower pictures are more traditional, as are those by the younger artist Walter Gay, who had exhibited such work at William and Everett's gallery in Boston.

The poetic spirit of La Farge also infuses the flower pictures of the brothers John Ferguson and Julian Alden Weir and those of Abbott Henderson Thayer. Naturally, La Farge's influence was paramount in the work of those of his pupils who became still-life specialists. One of these was Wilton Lockwood, who was primarily a figure and portrait painter whose best-known likeness is that of his teacher. However, Lockwood also painted numerous flower paintings, especially of peonies. The peony was a favorite flower in the late nineteenth century. Other artists known to have painted them include Julia McEntee Dillon, Emil Carlsen, and John White Alexander. In part, the peony and the chrysanthemum were obvious flowers for the more painterly and more poetic artists of the period, given their soft, amorphous shapes, their airiness, and their more generalized, indistinct forms, which contrasted with the solid petals and clear botanical forms of the flowers preferred earlier. But the peony and the chrysanthemum were also favored flowers in Oriental painting — the chrysanthemum was one of the symbolic Four Noble Plants chosen by the scholar artists of the Ming Dynasty — and thus adoption of opulently decorative motifs favored in the art of China and Japan testifies to the growing Oriental influence in Western art in the late nineteenth century.[13]

A more individual artist than Lockwood was La Farge's other pupil, Maria Oakey Dewing, who married the figure painter Thomas Wilmer Dewing. The two are known to have collaborated on pictures, with Maria

painting the garden background for her husband's figures. Maria Oakey Dewing painted flowers, sometimes in bouquets that were presented on tabletops in which she occasionally utilized Oriental vases and fans. However, she was more interesting and innovative in outdoor garden studies that were made at their home in the art colony in Cornish, New Hampshire.[14] She studied at the Cooper Union and the National Academy of Design in New York City, at the latter associating with many artists such as Weir and Thayer who also painted occasional poetic flower pieces. She went on to study in France with Couture. She began professionally as a figure painter; the annual summer stays at Cornish with her husband, beginning in 1885 and lasting until 1903, undoubtedly contributed to her change of thematic preference. At their home, Doveridge, the Dewings cultivated a splendid garden, and Maria Oakey Dewing combined her sensitivity to the expression of the flower with keen botanical knowledge. Her finest works are those like her *Rose Garden* (1901), where the viewer assumes a worm's eye view, looking up through a tangle where no horizon appears and where no natural boundaries delimit the picture. The viewer is immersed into the garden, a jungle of floral delights. Though deeply botanical in awareness of floral structure, the decorative patterning of these paintings suggests some Oriental influence. Maria revered Oriental art, and the perceptive still-life historian Arthur Edwin Bye has likened her work to the screen paintings of the Japanese artist Sotatsu.[15]

In America, there are similarities in chronology and form to the garden pictures of Robert Vonnoh and Childe Hassam of the late 1880s and early 1890s, but these artists neither investigated flowers with such scientific concern nor aimed at the elucidation of the spiritual essence of each individual bloom as did Maria Oakey Dewing. Those same qualities distinguish Maria Oakey Dewing's flower paintings from those of her California contemporaries, Paul de Longpré and Edwin Deakin. All three artists were deeply involved in garden cultivation; they derived their floral subject matter from their own horticultural achievements. In the aforementioned article in which Maria so praised La Farge's wreath picture, she also spoke exultantly of Sotatsu, as well as several European still-life painters, and went on to explain her own philosophy of floral painting. She wrote: "The flower offers a removed beauty that exists only for beauty, more abstract than it can be in the human being, even more exquisite. One may begin with the human figure at the logical and realistic, but in painting the flower one must even begin at the exquisite and distinguished."[16]

Elihu Vedder was a contemporary and friend of La Farge, not a pupil, but he shared a poetic vision that in Vedder's case was even more individual, one inclined at times to fantasy. Vedder was only an occasional still-life painter; however, he revealed an interest in such work by his friends La Farge and Bicknell, and he himself painted a number of exquisite flower paintings, such as his haunting, dramatic, and mysterious *Pansies and Spirea* (1882). Although painted in a fairly broad and fluid manner, the dark recesses, out of which the flowers seem to emerge, the contrast between the fragile blooms and the exotic vessels in which they are contained, and even the cloth covering the tabletop with its "crawling" fringe, are quite close to some of Heade's concepts.

Of striking contrast is Vedder's *Japanese Still Life* of three years earlier. While the two works share a similar treatment of cloth — in the earlier and

[14]Jennifer Martin Bienenstock has written recently and most definitively on Maria Oakey Dewing; her articles include the following: (As Jennifer A. Martin), "The Rediscovery of Maria Oakey Dewing," *The Feminist Art Journal* 5 (Summer 1976): 24-27, 44; "Royal Cortissoz and Maria Oakey Dewing's 'Rose Garden,'" *The Yale University Library Gazette* 52 (October 1977): 84-88; and (as Jennifer Martin Bienenstock), "Portraits of Flowers: The Out-of-Door Still-Life Paintings of Maria Oakey Dewing," *American Art Review* 4 (December 1977): 48-55, 114-18.

[15]Arthur Edwin Bye, *Pots and Pans or Studies in Still-Life Painting*, pp. 198-99, discussed by Bienenstock, in "Portraits of Flowers," p. 114.

[16]Dewing, "Flower Painters," p. 255.

ELIHU VEDDER, *Pansies and Spirea*. See plate 16, page 16.

Figure 7.6. ELIHU VEDDER (1836-1923), *Japanese Still Life*, 1879; oil on canvas, signed at upper right — *Elihu Vedder*, 21½ x 34¾ inches; Los Angeles County Museum of Art, gift of the American Art Council.

[17]In addition to Vedder's autobiography, cited earlier in this chapter, in which he cites the exhibition of Babcock's and Bicknell's paintings in Boston (p. 277), the most important published works on Vedder are Regina Soria, *Elihu Vedder: American Visionary Artist in Rome (1836-1923)* (Rutherford, Madison, Teaneck, N.J., 1970), and *Perceptions and Evocations: The Art of Elihu Vedder*, with an introduction by Regina Soria and essays by Joshua C. Taylor, Jane Dillenberger, and Richard Murray. Vedder's still-life paintings are treated somewhat incidentally in all three volumes. In his autobiography Vedder spoke of his admiration for things Japanese on p. 316; the death of his brother and the receipt of the Japanese objects is mentioned on p. 471. The Japanese still life is discussed in Soria, *Perceptions and Evocations*, pp. 106-9.

larger picture the brocades seem to slither across the rug on which they lay — this work is far less poetic but much more exotic: it is almost a catalogue of Japanese bric-a-brac. Containing decorated cloths, a large Oriental ceramic, an illustrated book, and a screen showing herons against a flowered landscape, the picture includes many kinds of Far Eastern "collectibles," objects increasingly in use among Western artists as props. Vedder had a brother Alexander who served some years as a naval surgeon in Japan, then as a physician to the Imperial court, and who in 1871 died leaving three trunks of Japanese souvenirs to Vedder.[17] Whether or not the objects in this highly decorative picture are from Alexander's collection is not known, but in any case Vedder was familiar with such Japanese items, through ownership as well as through the increasing demand for such exotica and from their depiction in other paintings and illustrations. In fact, Vedder's picture resembles the display of Japanese objets d'art exhibited in Philadelphia at the Centennial Exposition in 1876 and may have been, in part at least, inspired by it. Vedder was not in Philadelphia that year, nor need he have been for his painting is extremely similar to an illustration in C. B. Norton's *Treasures of Art, Industry, and Manufacture Represented in the American Centennial Exhibition at Philadelphia, 1876,* which was published in Philadelphia in 1877-1878 just previous to Vedder's picture. This may have been the *Japanese Still Life* that was sold by Vedder to T. W. Hathaway in 1883 and that was shown in 1901 at the Chicago Art Institute. That Vedder was inspired at the

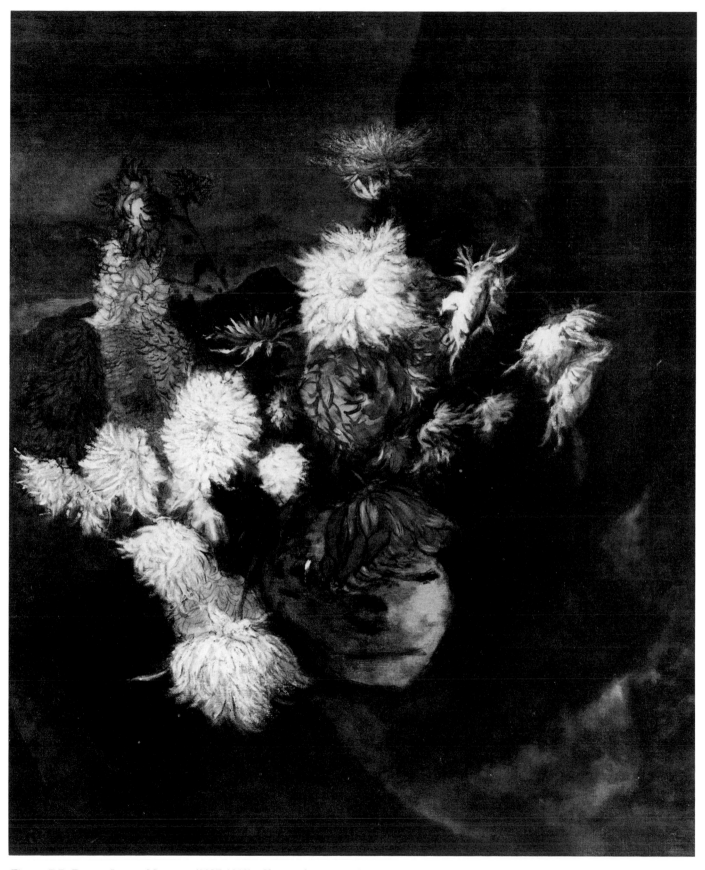

Figure 7.7. ROBERT LOFTIN NEWMAN (1827-1912), *Chrysanthemums;* oil on canvas, 25 x 30 inches; Virginia Museum of Fine Arts.

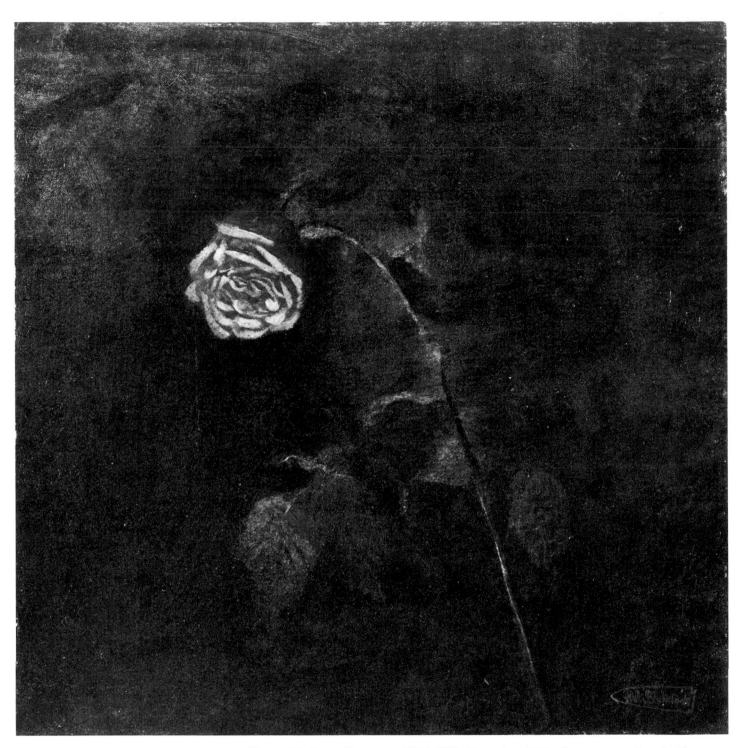

Figure 7.9. RALPH BLAKELOCK (1847-1919), *Rose*, circa 1900; oil on canvas, signed at lower right — *R. A. Blakelock*, 15 x 15 inches; Private Collection.

150

time by Japanese motifs is further suggested by his sale in 1881 of *Iris Flowers (Japanese Vase)* to Mrs. Agnes E. Tracy.[18]

Among the other artists of romantic, even visionary, aesthetic in the late nineteenth century, three of the most notable were Robert Loftin Newman, Albert Pinkham Ryder, and Ralph Albert Blakelock. Only one still-life painting by both Newman and Ryder has been located so far: the former's *Chrysanthemums* and the latter's *The Dead Bird.* There are a number of still-life drawings also known by Newman, and the *Chrysanthemum* oil was once owned by the famous collector John Gellatly, along with a now-unlocated pastel of the same subject.[19] As we have seen, the chrysanthemum, along with the peony, became a favorite flower in late nineteenth-century painting, due both to its own physical nature and to its Oriental origins. Among other artists to favor the chrysanthemum in their paintings were figures as diverse as Julia McEntee Dillon, Dennis Miller Bunker, John Haberle, Theodore Wendel, and Emil Carlsen, while one of the more beautiful renderings of that flower is by William Merritt Chase (National Gallery of Art, Washington, D.C.). Ryder's only known still life is quite different from any we have considered both in subject and in style. As we shall see, dead birds abound in the game pictures of William Michael Harnett and his followers (where their lifeless condition is a necessity of the subject matter), but in place of deceptive illusionism, Ryder presents a true image of death. The important critic and collector Duncan Phillips recognized this when he wrote of the picture that "no lyric ever written on the death of a song bird or for that matter on the mystery of the last sleep as it comes to us all has ever surpassed Ryder's tiny picture of a dead canary lovingly laid in a tomb of rock."[20]

Of this group of visionary artists, Ralph Albert Blakelock was the most involved with still life. His main concern was with evening and moonlight landscapes, often including Indian encampments, but as romantic fantasies rather than as the topographical renderings of Albert Bierstadt. His floral still lifes, sometimes of fragile bouquets of violets, sometimes of bunches of roses, seem to glow as apparitions that appear out of a mysterious darkness. Certainly, this is true of his *Red Rose,* a single flower of great beauty, which may be the painting shown at Young's Art Galleries in Chicago in April and May of 1916. It corresponds to the description of "A single deep red rose with the light falling on stem and leaves." This intense love of the flower, and the need to capture its soul, its very essence, allies Blakelock's art with that of La Farge and the other painters of poetic floral pieces.[21]

Figure 7.8. ALBERT P. RYDER (1847-1917), *The Dead Bird,* circa 1890-1900; oil on wood panel, 4¼ x 9⅞ inches; The Phillips Collection.

[18]Vedder, *Digressions of V.,* pp. 481, 483.

[19]For Newman's still lifes, see Marchal E. Landgren, *Robert Loftin Newman, 1827-1912* (exhibition catalogue; National Collection of Fine Arts, Washington, D.C., 1974), pp. 143, 176.

[20]Duncan Phillips, "Art is Symbolical," in *Tri-Unit Exhibition of Paintings and Sculpture* (exhibition catalogue; Phillips Memorial Gallery, Washington, D.C., 1929), pp. 10-11.

[21]*Catalogue of the Works of R. A. Blakelock, N.A., and of his daughter, Marian Blakelock* (exhibition catalogue; Young's Art Galleries, Chicago, 1916), p. 18.

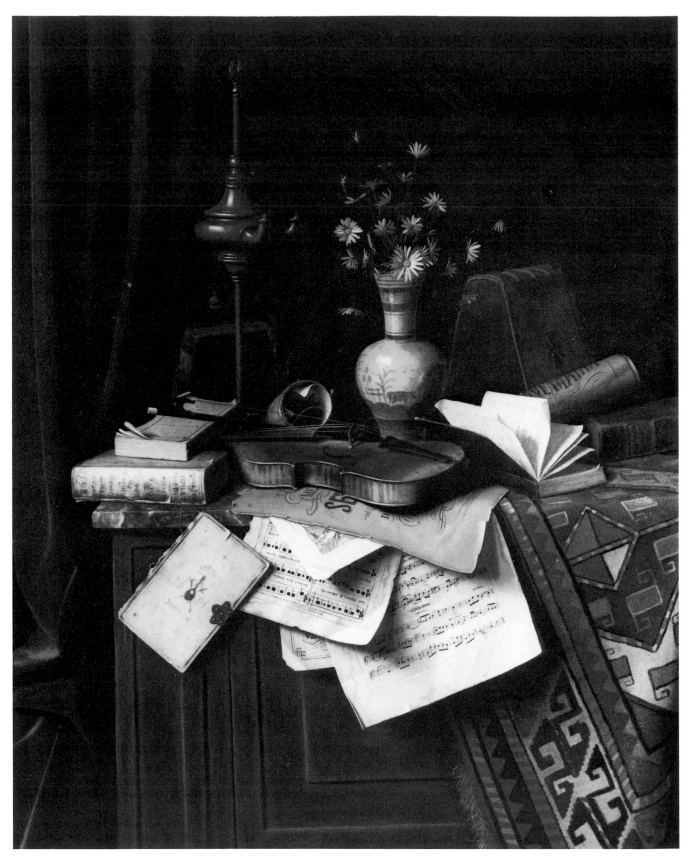

Figure 8.1. WILLIAM MICHAEL HARNETT (1848-1892), *Still Life*, 1888; oil on canvas, 48 x 46 inches; Private Collection.

8 William Michael Harnett and Illusionism

Today, the best-known school of American still-life painters is unquestionably that group of artists associated historically with the persona and oeuvre of the most talented of all of them, William Michael Harnett. Although Harnett and his followers introduced many innovations into American still-life painting, and there is much to be admired about their work, wholesale admiration is a product of the twentieth century. In their own time, the paintings of this group were often looked upon as mere trickery, amusing for their eye-fooling deceptiveness, but regarded as unrelated to the inspirational purposes of "true art." To choose just one critical response out of many, consider Howard J. Cave writing in 1901 of the Boston trompe l'oeil and of Alexander Pope, an animal painter, in the magazine *Brush and Pencil*. After describing the various animal portraits and even heroic depictions of animals including several historical works, Cave concluded with a short reference to Pope's deceptive still lifes, which the artist referred to as his "characteristic pieces." According to Cave: "They are certainly marvelous in the illusions they produce. They are, however (and the artist frankly admits it), tricks of the palette rather than strong conceptions ably expressed." He concluded, "It is not works of this sort, however, in which Pope prides himself."[1]

The fame of this group of painters today is due in part, of course, to their own undeniable talents, but equally to a major study of the school by Alfred Frankenstein.[2] It is important to realize that the art of Harnett and the others was not only one among many facets of late nineteenth-century still-life painting but also, in its own time, was regarded as of little significance. In the following generation, it was ignored by Arthur Edwin Bye, author of the first study to consider seriously the course of still-life painting in this country. For Bye, John La Farge, Emil Carlsen, William Merritt Chase, and Maria Oakey Dewing merited consideration, but Harnett did not.[3]

Nevertheless, beyond the fascinating illusionism of the pictures of this school, Harnett appealed to another aspect of late nineteenth-century interest. In place of the fruits and flowers that were drawn from natural sources, this group of artists chose to emphasize man-made objects. In many of their works, they catered to the interests of the wealthy, reflecting the habit of accumulating *objets de virtu*, bric-a-brac, and costly antiques that

[1] Howard J. Cave, "Alexander Pope, Painter of Animals," *Brush and Pencil* 8 (May 1901): 112.

[2] Alfred Frankenstein, *After the Hunt: William Michael Harnett and Other American Still Life Painters, 1870-1900.* Frankenstein has also written many other articles as well as essays in numerous exhibition catalogues relating to Harnett and his followers; many of these will be found in the bibliography of this catalogue. *After the Hunt* is the source for much of the information following and should be consulted when other references are absent.

[3] Arthur Edwin Bye, *Pots and Pans or Studies in Still Life Painting.*

began to become an obsession about the time of the Philadelphia Centennial in 1876. It is not a coincidence that in the same year Harnett himself turned from the more traditional fruit subject matter to the painting of man-made things. There is here also a contrast of motivation, for the painter of bric-a-brac and antiques is obviously attempting to appeal to a patronage on the basis of a fidelity that will reflect the costliness and antiquity of the objects represented, and at times even a favoritism of specific pieces of metalwork, ceramic, and glassware. The traditional fruit and flower painter seldom (though not *never*) chose the fruit and flowers for his or her pictures with a thought to his prospective buyer's favorite apples or roses. Furthermore, the nature still-life painter felt freer to indulge in artistic license in terms of arrangement and emphasis; the painter of *objets de virtu* must have felt impelled to imitate reality with total fidelity and hence easily made the transition to the world of trompe l'oeil, often projecting costly objects almost literally into the spectator's world.[4] Of course, not all the works painted by Harnett in his maturity reflected the growing vogue for antiques, nor even for costly things, and fewer still were depicted by his followers. Even so, Harnett's iconography represents a marked change from the preferences of previous generations, or even of alternate contemporary still-life specialists.

Harnett was born in Ireland, but shortly thereafter his family moved to Philadelphia where, around 1865, he began to practice the engraver's trade and became skillful at it, a skill that certainly supported his precisionism in his later painting technique. In 1871, he moved to New York City, studying at the schools of the National Academy and the Cooper Union. He was a painter of still life from the first, and for a few years these were fruit and vegetable pictures that he began to exhibit in 1875. But even these, in their starkness and in their concern for abstract simplifications rather than the

[4]For some considerations of this problem and of the bric-a-brac still life, see William H. Gerdts, "The Bric-a-Brac Still Life," *Antiques* 81 (November 1971): 744-48.

Figure 8.2. WILLIAM MICHAEL HARNETT (1848-1892), *Job Lot Cheap*, 1878; oil on canvas, signed at lower right — *WM Harnett/1878*, 18 x 36 inches; Reynolda House, Inc., Winston-Salem, North Carolina.

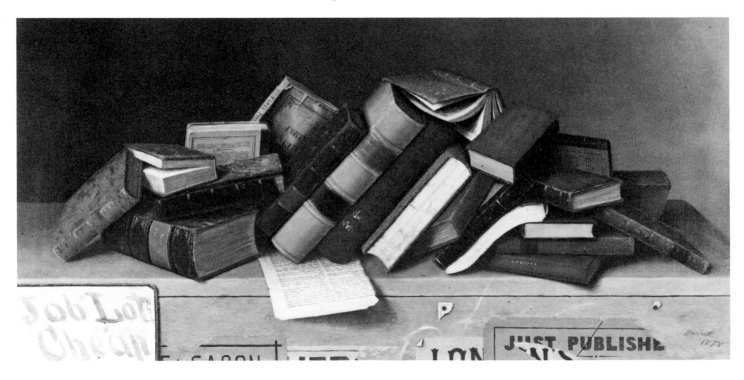

prevalent emphasis upon textural and botanical considerations, were unlike the contemporaneous fruit pictures of William Mason Brown, George Henry Hall, and others.

In 1876 and 1877, however, Harnett turned to the new range of subject matter with which he was to be subsequently identified: beer mugs and tobacco, books, musical instruments, pens and ink and letters on writing tables, money, and the skulls drawn from the old tradition of the memento mori. While most of Harnett's pictures of these years combine a variety of man-made objects, his *Job Lot Cheap* (1878) is composed only of books — books of various sizes and bindings, lying apparently at random on a plain wooden table or crate, with several signs affixed to the front, one of which states the picture's title. The randomness is deceptive, however, for the books are arranged to create a powerful, splayed pyramid, with a rich diversity of colors and patterns within. As in many of Harnett's pictures, one item, in this case a torn-out page, projects out into the space of the viewer. Fragments of titles are tantalizingly readable.

The books in *Job Lot Cheap* may be old and abandoned but many of them have elegant bindings, and the often deep, rich colors add to the sense of worth, quite unlike the anonymity of the books that appear in the work of many of the artist's followers. Early on, then, Harnett sensed the appeal possible for the collector of valuable objects, in this case the collector of rare books. In other words, his pictures might well be collected side by side with objects similar to those appearing in the pictures. A further aspect of Harnett's pictures should be acknowledged also. Books are the subject matter here, and books imply a solitary occupation and pleasure. Other pictures, such as *The Secretary's Table* of the following year, which contains an inkwell, an envelope, and a memo pad with a note to a Mr. Clarke, along

Figure 8.3. WILLIAM MICHAEL HARNETT (1848-1892), *The Secretary's Table*, 1879; oil on canvas, signed at lower right — *W. M. Harnett, 1879*, 14 x 20 inches; Collection of the Santa Barbara Museum of Art, gift of Mrs. Sterling Morton to the Preston Morton Collection.

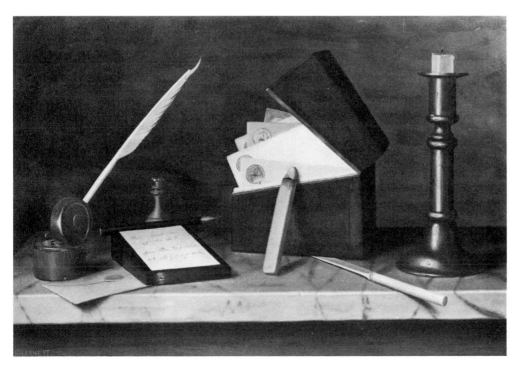

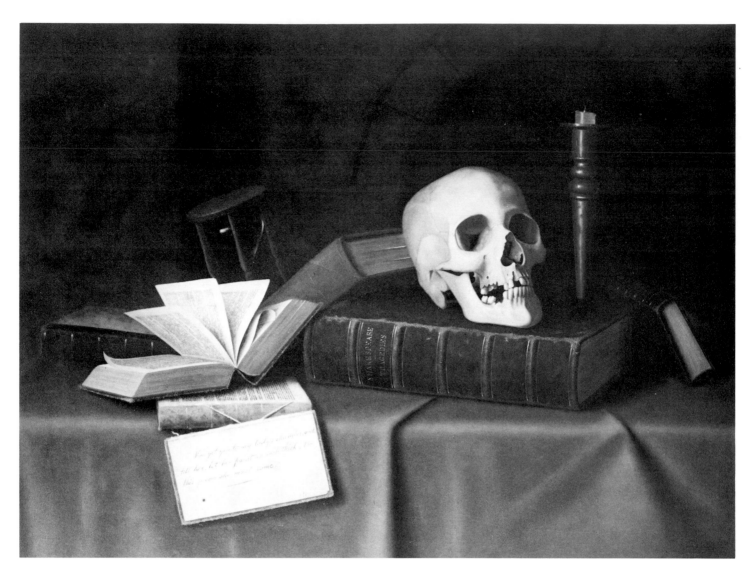

Figure 8.4. WILLIAM MICHAEL HARNETT
(1848-1892), *Memento Mori — "To This
Favour,"* 1879; oil on canvas, signed
at lower right —
 W
 Harnett 1879
 M
24 x 32 inches; The Cleveland Museum
of Art, Mr. and Mrs. William H. Marlatt
Fund, purchase.

with a candlestick, a letter box, and a stick of sealing wax, also suggest a private involvement: one writes a letter alone. There is no sense of togetherness, the sharing of a banquet at Roesen's marble tables, or the enjoyment of a luncheon or dessert *à la* John F. Francis. In this case, there is a clearly autobiographical element in the picture, for "Mr. Clarke" is almost certainly the great collector Thomas B. Clarke who owned at least one work by Harnett. This same year, 1879, Harnett painted another picture with a letter to Thomas B. Clarke, which is prominently featured (Addison Gallery of American Art, Andover, Massachusetts).

Thomas B. Clarke was the most prominent collector of contemporary American art of the period, and Harnett was not the only artist discussed here whom Clarke patronized; Joseph Decker's works were also in Clarke's collection. Still, Clarke may be an exception in regard to the kind of patronage that was directed toward Harnett and those artists who emulated his aesthetic. In general, there were two main artistic traditions in still-life painting in America in the late nineteenth century: the precise illusionism of the trompe l'oeil school and the more painterly, more expressive aesthetic of those artists from La Farge on who studied in Paris and Munich, working in what was to become the more "mainstream" manner. Likewise, the two still-life approaches found quite separate patronage. The work of the Euro-

pean-trained artists appealed to and was collected by patrons who were truly art collectors, people of wealth and social prominence who believed in "Art." These people recognized their cultural duty and accepted the traditional role of expressing refinement in amassing collections of the best paintings and sculptures of the time. Trompe l'oeil paintings, for the most part, were owned by well-to-do businessmen often without social pretensions, who enjoyed the great realism of the pictures and were amused by their deceptive qualities. Often the pictures had a personal appeal: an office board by John Frederick Peto that reflected the owner's business identification, a hanging game still life that related to the owner's pleasures in the hunt, or a representation of a newspaper in a picture that was owned by its publisher. Local pride in the display of skill underlying the reproductive illusionism led to interest in, and praise of, the work of George Cope, West Chester, Pennsylvania's local artist. An in-depth study of the patronage of the trompe l'oeil artists is still needed.

Harnett also reintroduced or, in terms of American art, "invented" the *vanitas* still life, the still life featuring a human skull. Although this motif had been an important accessory in a number of seventeenth-century portraits, its introduction into American art as an independent, even dominating, still-life element in the tradition of European, especially Dutch, baroque art, was due to Harnett. A number of his fellow artists, such as Alexander Pope and Louis Maurer, followed him in this regard, and one might also recall the seemingly coincidental use of the motif in Europe by such diverse painters as Arnold Böcklin, Vincent van Gogh, and Paul Cézanne. Among the several *vanitas* still lifes known to have been painted by Harnett, the earliest, in 1876, in his *Mortality and Immortality* (Art Museum, Wichita, Kansas), but certainly the finest is *Memento Mori — "To This Favour"* painted three years later. Here the skull is combined with traditional objects of implied mortality, the burnt-out candle, and the hourglass, along with some old books with elegant (and expensive) gold tooled bindings, one of which is entitled *Shakespeare's Tragedies*, while another bears a quotation from *Hamlet* on the open inside cover. The traditional *vanitas* implication here would be the transience of even the great and famous (Shakespeare). However, an alternative is open to speculation, namely, that things of the intellect and of the creative mind endure after death. On the other hand, Harnett's allusion here is probably also a direct one; the most famous skull in literature, after all, is probably that of "poor Yorick" whom the spectator may, along with Hamlet, know well. To be noted also in this painting are two favorite Harnett motifs: an open book with the pages fanned out, partly controlling the overall complex composition; and the book cover hanging beyond the table, literally by a thread, to tempt the viewer toward urgent rescue.

What led Harnett to adopt this variety of radically innovative subject matter in American still life has not been adequately determined. The traditional explanation, offered by the artist himself, was that he painted such forms as beer steins, pipes, books, and the like because they were what he had around him. "Because they were there" may be true to some extent but it is also inadequate. Raphaelle Peale and George Henry Hall probably had books, tobacco, and money (though Peale admittedly had little of the last) in their immediate vicinities, but they did not use such subject matter in their still lifes. Since Harnett developed such still lifes before he went to Europe, they cannot be accounted for by his experience in Munich, though that certainly led to a refinement of his manner and subject matter. More

possibly influential would have been the growing taste for Old Master paintings, including seventeenth-century still lifes, on the part of American collectors of the time, and the display of such pictures in such newly established institutions as the Metropolitan Museum of Art, which was founded in 1870. A number of still lifes by Jan de Heem and Abraham van Beyeren were shown at the Metropolitan Museum in the 1870s. The problem here, however, is that again Harnett's paintings that were done in Munich and after are much more similar to such Old Master still lifes than are the pictures that were painted in the late 1870s. To some extent, this still-life iconography — the beer stein, smoking materials, book, money, and letter writing materials — appears to have been at least partially invented by Harnett, and was calculated to find a different market and, certainly, a more purely masculine one than the "pretty" fruit and flower pictures of the previous generation. His pictures would certainly be hung and exhibited in studies and offices, rather than dining rooms and parlors.

These works were painted not in New York City but in Philadelphia, the city to which Harnett returned in 1876; he also studied at the Pennsylvania Academy, being listed as a student there in the year of his return. While in Philadelphia, Harnett saved enough money to pursue his study of art in London. He resided there in the spring of 1880, but the invitation of a resident in Frankfort, Germany, who had patronized Harnett in Philadelphia, persuaded him to visit that city for the rest of the year. He finally settled in Munich early in 1881 and remained there for four years, though his total six-year stay abroad is often referred to as his "Munich period."

From the 1860s, Munich had attracted young American artists and art students to its Royal Academy, although by the 1880s Paris had become the principal center of study and even expatriation. Still, Americans continued to reside in the Bavarian capital. The question arises, however, why Harnett? He was already a well-trained painter, and his special interest in still life was not especially favored in Munich. His attraction would not seem to have been to study at the academy there, for no trace of his association with that body has been found. Also, although a number of talented Americans such as Frank Duveneck and William Merritt Chase were inspired by the nonacademic, vigorous realism of Wilhelm Leibl and his circle of progressive young artists in Munich, Harnett's meticulous, smoothly finished still lifes are antithetical to the rough-hewn, monumental peasant imagery associated with the *Leibl-Kreis*.

But Munich offered other attractions, or rather a combination thereof. Harnett himself stated that he went to Europe to pursue his studies, but that did not necessarily mean enrollment in an art school.[5] What inspired Harnett, rather, were examples of Old Master still-life paintings of a fineness and precision that, on one hand, he had not yet been able to achieve in America and, on the other, represented one aspect of the collecting interests of contemporary wealthy Americans. That is, Harnett went to Europe to study the works of the Old Masters, particularly the Dutch, so as to emulate their style and to make his work even more appealing to the same collectors who were buying paintings by those Old Masters. In Munich, Harnett acquired a finesse and elegance of technique, and at the same time he created compositions, which were themselves filled with antique and pseudo-antique bric-a-brac, often of the seventeenth century, paintings that both naturally resembled seventeenth-century still lifes and included objects sought after by collectors as antiques.

[5]About 1889 or 1890, Harnett, at the height of his fame, gave an interview to the *New York News*. The specific reference is unlocated, but a copy of it is in a scrapbook once in the collection of William Blemly, a friend of Harnett's, and later owned by Edith Gregor Halpert of the Downtown Gallery in New York City. The interview was published in full in Hermann Warner Williams, Jr., "Notes on William M. Harnett," *Antiques* 43 (June 1943): 260-62. It is the most significant piece of autobiographical data on Harnett and the most important contemporary source of information on the artist.

It is obvious, of course, that Harnett could have gone to Holland to study such works more easily. But Holland was not a contemporary art center, certainly not for Americans, and Munich was. Furthermore, since its incorporation of the old Düsseldorf art gallery during the Napoleonic days, Munich's Royal collection was itself notable for its paintings by the Dutch masters. In addition, South Germany and Austria had an active group of still-life painters, such as Joseph Mansfeld and Camilla Friedländer, who were painting pictures of elegant bric-a-brac quite similar in subject matter to Harnett's. In this regard, however, Harnett was not drawn to Munich solely to learn and to emulate, but rather to compete. He may have aimed at controlling that market for he was, or became, a better painter than his contemporaries in Germany, and he certainly did exhibit and seek patronage from Europeans as well as Americans.

A clue to his relationship to these today all-but-forgotten still-life artists is his adoption of a miniaturistic format. On the face of it, Harnett's recasting of his conceptions on a miniature scale is anachronistic, for trompe l'oeil cannot work to its fullest effect in such a manner. Almost all still life is "life-size" (as is most portraiture but rarely landscape or genre); illusionistic still lifes need to be life-size in order to fool the eye. In Munich, Harnett painted a great many small pictures where all the objects are in scale, but that scale is smaller than reality. Occasionally, they contain humble, even kitchen, subjects, and there is a group of about half a dozen pictures featuring lobsters. The majority and the finest of the paintings that were done in Munich are jewellike renderings of old books (sometimes dated in their antique covers even earlier than the actual publication), antique tankards, valuable musical instruments, antique bronze busts of Dante or Shakespeare; often the table or cupboard supporting this arrangement is covered at least partially with a patterned rug, while the background is both enlivened and made more elegant with dark wooden paneling. These pictures — in the estimation of some critics, Harnett's finest — reflect the art of the Dutch little masters and those who specialized in still life; the lobster series, too, suggests the emulation of such Dutch artists as Abraham van Beyeren. At the same time, the preferred miniaturistic format suggests Harnett's relationship with Friedländer and others of his day. The miniaturistic scale he adopted suggests something more: it implies that, however much Harnett aimed at equaling or surpassing the illusionism of the Old Masters, he did not want his work to be seen *only* as illusionistic, so he deliberately rejected the most obvious qualification for deceptive realism, the *scale* of reality.

Even after Harnett returned to America in 1886, he continued to paint such miniaturistic pictures, sometimes adopting the typical composition and vertical format of the best of his Munich paintings. In one still life dated 1888, Harnett enlarged his Munich conception to the scale of life, completing the sense of illusionism and repeating almost identically a composition (Mr. and Mrs. Meyer Potamkin Collection) that he had recently painted miniaturistically. In reproduction, the two works are extremely similar; in actuality, one is five times the size of the other.

In Munich also, however, Harnett painted the first three versions of what was to become his most famous work, his *After the Hunt*, which exists ultimately in four variations (Private Collection; Columbus Gallery of Fine Arts; Butler Institute of American Art, Youngstown; Fine Arts Museums of San Francisco). As the title implies, the picture is a still life of game and of

WILLIAM MICHAEL HARNETT, *Still Life with Violin*. See plate 17, page 161.

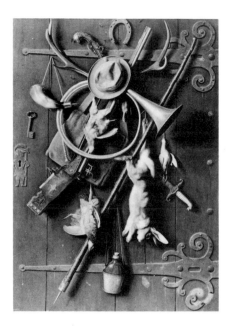

See figure 1.4, page 31.

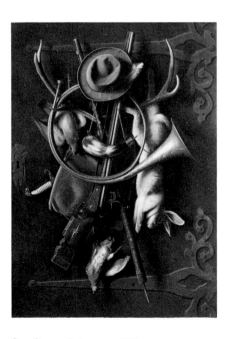

See figure 8.6, page 177.

Figure 8.5. WILLIAM MICHAEL HARNETT (1848-1892), *After the Hunt*, 1883; oil on canvas, signed at lower left—
 W
 Harnett
 /1883
 M
52½ x 36 inches; Columbus Museum of Art.

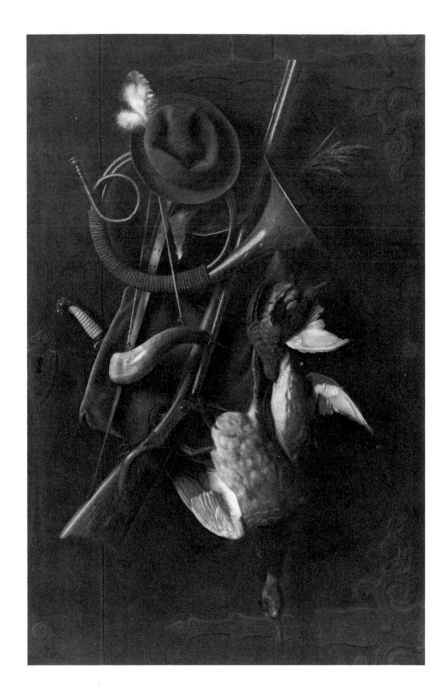

equipment used by a hunter — gun, horn, knife, and powder horn. It was used as a model for dozens of imitations and variations by many other artists who sometimes substituted fishing equipment, sometimes Western gear, sometimes military paraphernalia, but always emphasized a rugged and masculine ambience, which was derived in part from German nineteenth-century genre pictures. These similar arrangements in the backgrounds of such pictures became the epitome of trompe l'oeil — the eye was denied access to spatial recession by the impregnable door, and the hanging forms, arranged vertically, projected out into the viewer's space.

After the Hunt inspired an enormous amount of imitation, but none of the imitators orchestrated such lush compositions nor endowed the arrangements with such magnificence; the sense of wealth and elegance of the bric-a-brac pictures finds a parallel here in the baroque antique hinges and locks and expensive hunting gear. Harnett developed each of his own

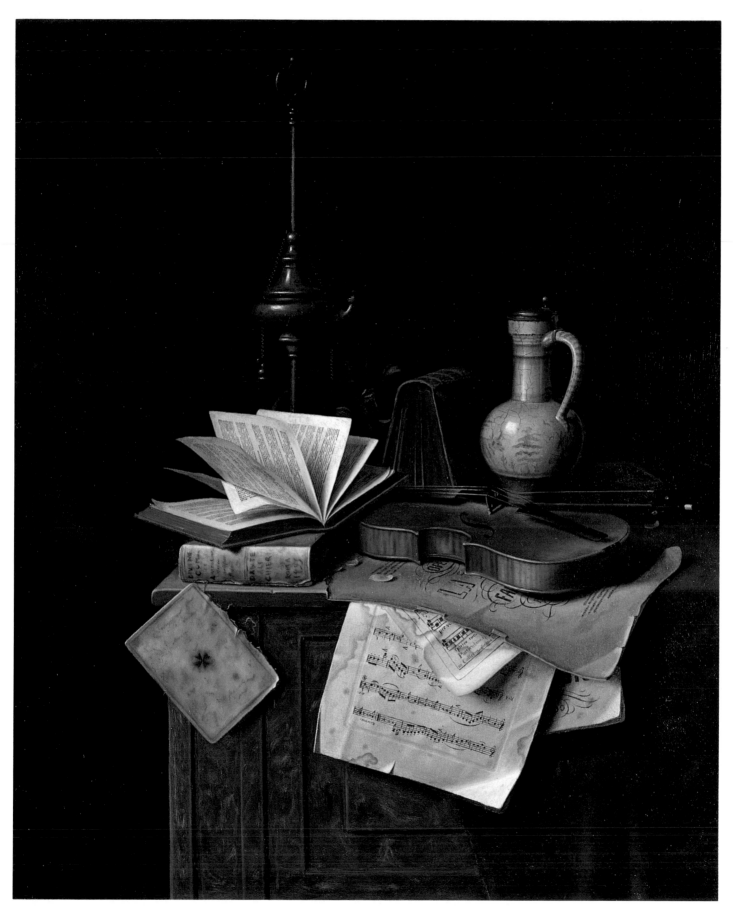

Plate 17. WILLIAM MICHAEL HARNETT (1848-1892), *Still Life with Violin*, 1885; oil on oak panel,
signed at lower right — *W M Harnett/Paris 1885*, 21⅝ x 17¾ inches; Private Collection (see
Chapter 8).

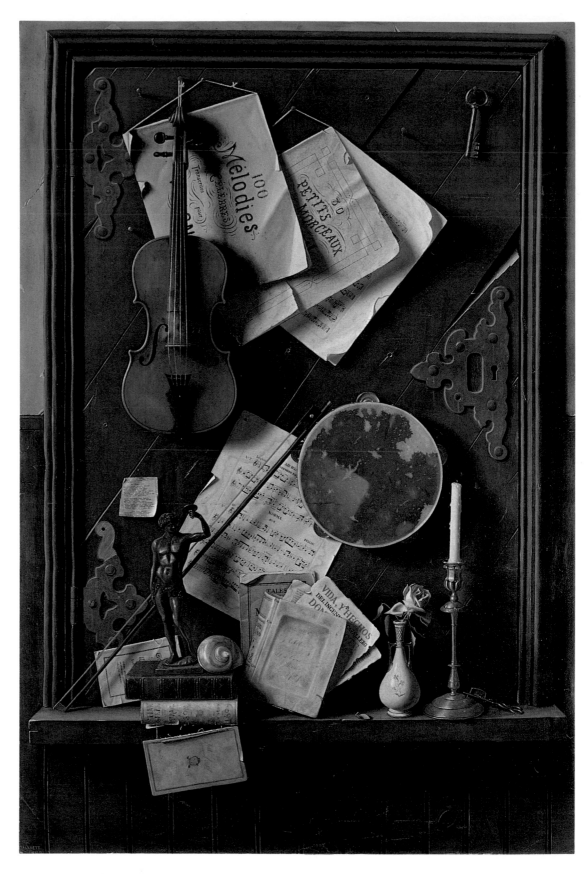

Plate 18. WILLIAM MICHAEL HARNETT (1848-1892), *The Old Cupboard Door*, 1889; oil on canvas, 61⅝ x 41 inches; Sheffield City Art Galleries (see Chapter 8).

Plate 19. JOHN FREDERICK PETO (1854-1907), *My Studio Door*, 1895; oil on canvas, signed at lower right — *John F. Peto/1895*, 49⅜ x 29½ inches; Collection of the Santa Barbara Museum of Art, Preston Morton Collection (see Chapter 8).

Plate 20. LEVI WELLS PRENTICE (1851-1935), *Apples in a Tin Pail*, 1892; oil on canvas, signed at lower right — *L. W. Prentice 1892*, 15½ x 12½ inches; Museum of Fine Arts, Boston, The Hayden Collection (see Chapter 8).

Plate 21. FRANK DUVENECK (1848-1919), *Still Life with Watermelon*, circa 1878; oil on canvas, signed at lower right — *FD*, 25$\frac{1}{16}$ x 38$\frac{1}{16}$ inches; Cincinnati Art Museum; The Dexter Fund (see Chapter 9).

Plate 22. GEORGE LUKS (1867-1933), *October Flowers*, 1920; oil on canvas, signed at lower right — *George Luks*, 36 x 30 inches; Mr. and Mrs. Stephen J. Heyman (see Chapter 9).

Plate 23. ABBOTT GRAVES (1859-), *The Chrysanthemum Show;* oil on canvas, signed at lower right — *A. Graves,* 37½ x 65½ inches; Private Collection (see Chapter 9).

Plate 24. CHILDE HASSAM (1859-1935), *Vase of Roses*, 1890; oil on canvas, signed at lower left — *Childe Hassam 1890*, 20 x 24¼ inches; The Baltimore Museum of Art, The Abram Eisenberg Collection, presented by Mrs. Abram Eisenberg in memory of her husband (see Chapter 9).

Plate 25. MAURICE PRENDERGAST (1859-1924), *Fruit and Flowers*, circa 1915; oil on canvas, signed at upper left — *Prendergast*, 18½ x 21½ inches; Montclair Art Museum, Montclair, New Jersey, Lang Acquisition Fund, 1954 (see Chapter 10).

Plate 26. PATRICK HENRY BRUCE (1880-1937), *Still Life with Tapestry*, circa 1911-1912; oil on canvas, signed at lower right — *Bruce*, 19½ x 27 inches; Collection of Mr. and Mrs. Henry M. Reed (see Chapter 10).

Plate 27. STANTON MACDONALD-WRIGHT (1890-1973), *Still Life Synchromy*, 1917; oil on
canvas, signed at lower right — *S. MacDonald-Wright*, 30 x 22 inches; Private Collection
(see Chapter 10).

Plate 28. Arthur B. Carles (1882-1952), *Still Life—Flowers;* oil on canvas, 36 x 32½ inches; Robert C. Graham, Jr. (see Chapter 10).

Plate 29. CHARLES DEMUTH (1883-1935), *Eggplant, Carrots and Tomatoes*, 1927; watercolor on paper, 13⅞ x 19⅞ inches; Norton Gallery and School of Art, West Palm Beach, Florida (see Chapter 11).

Plate 30. CHARLES SHEELER (1883-1965), *Dahlias and White Pitcher*, 1923; gouache on paper, signed at lower right — *Sheeler 1923*, 25½ x 19 inches; Columbus Museum of Art, Ohio, gift of Ferdinand Howald (see Chapter 11).

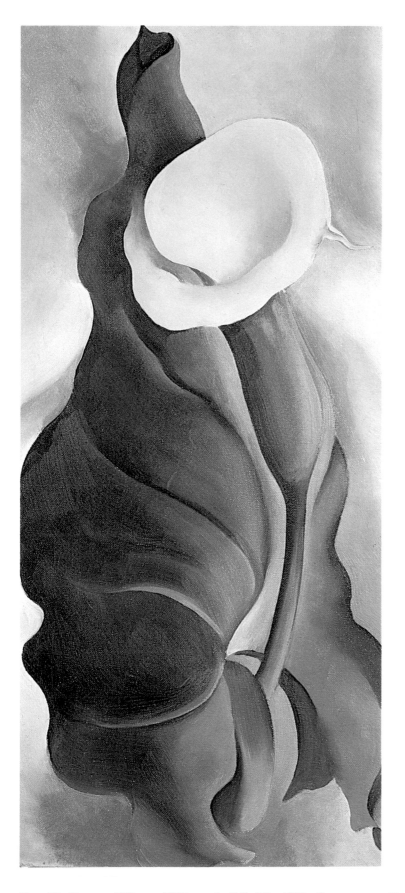

Plate 31. Georgia O'Keeffe (1887-), *Calla Lily*, 1927; oil on canvas, 20 x 9 inches; Private Collection, courtesy of Andrew Crispo Gallery, New York (see Chapter 11).

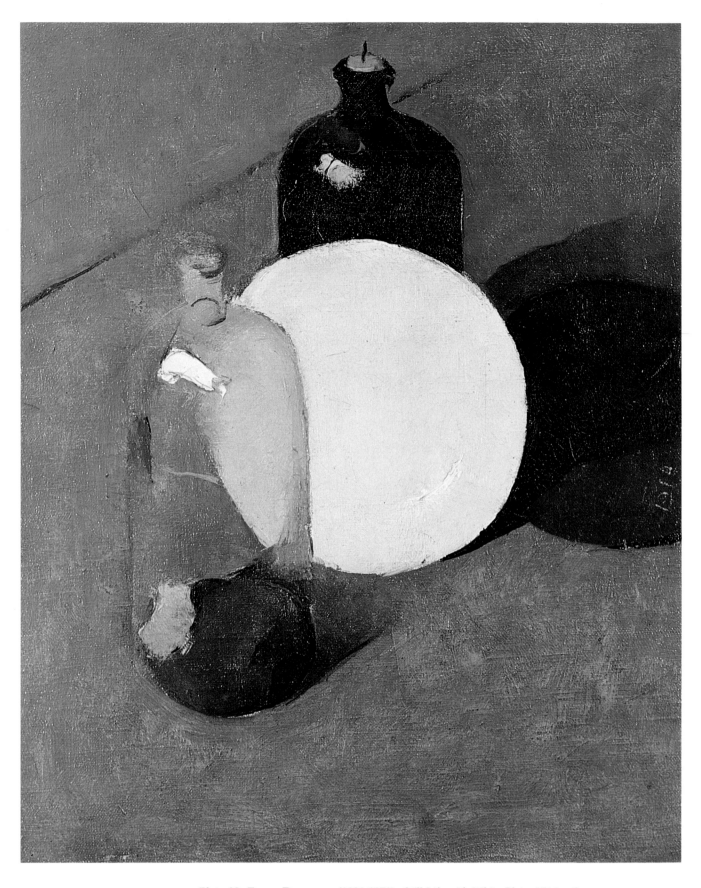

Plate 32. EDWIN DICKINSON (1891-1978), *Still Life with White Plate*, 1914; oil on canvas, 25 x 20 inches; Robert C. Graham, Jr. (see Chapter 11).

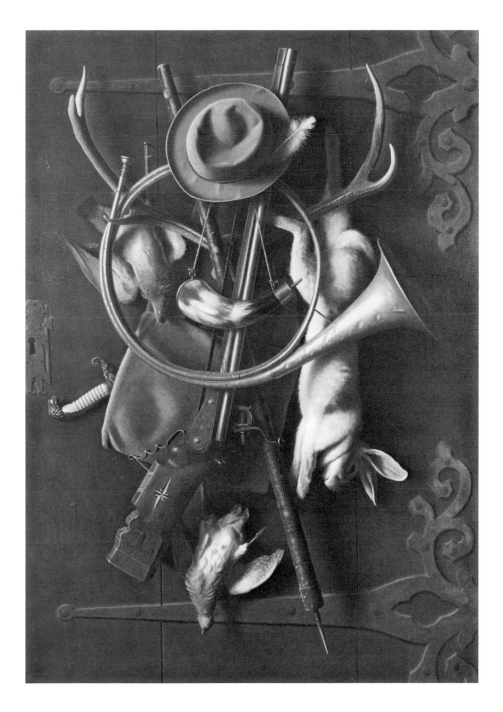

versions (two in 1883, one each in 1884 and 1885) more grandly than before, but his 1884 version was criticized by the Munich press, which claimed that his work consisted only of deceptive pedantry. As a result, Harnett moved on to Paris some time around the end of 1884 or around the beginning of the following year. It was there that he painted the last of his four versions of *After the Hunt*, which was exhibited in the Paris Salon. He did not remain in Paris long, however, for he was in London again that summer and back in New York City by April 1886.

The 1885 version of *After the Hunt*, which was unsold, was taken by the artist to New York where it finally achieved its deserved success — as one of the most famous barroom pictures of its time in America. The picture was purchased by Theodore Stewart for the Hoffman House on Warren Street, presumably immediately after Harnett's return in 1886, since Stewart died

Figure 8.6. WILLIAM MICHAEL HARNETT (1848-1892), *After the Hunt*, 1884; oil on canvas, signed at lower left —

 W
 Harnett
 /1884
 M

55 x 40 inches; The Butler Institute of American Art.

the following year. The picture gained great fame, or notoriety, depending upon the aesthetic pretensions of the viewer and critic, and in turn its public availability led both to a host of imitation and to the popularity of trompe l'oeil still-life painting as barroom and saloon decoration, vying for favor with the equally or more popular barroom nudes.

All four versions of *After the Hunt* include game birds; the last two versions also depict a hanging rabbit. Related to these pictures of 1884 and 1885 is *Trophy of the Hunt*, painted in 1885, which also includes a majestic hanging rabbit. This particular painting is a forerunner of a whole group of pictures that Harnett painted after his return to America, vertical trompe l'oeils of single hanging objects — a plucked chicken, an old horseshoe, a violin, a pipe, or a Colt revolver. Here, Harnett concentrated single-mindedly on one object, which projected out into the viewer's space and cast expertly realized shadows against a wooden door background — itself pierced with nails and nail holes and sometimes with printed paper labels affixed to them so that they can *almost* be read, but not quite. As Frankenstein perceptively remarked, these works, which were painted in the United States, are examples of the artist's return to the American vernacular and his shying away from the Old Master European traditions in both style and subject matter. Side by side with the miniaturistic arrangements that were similar to his Munich compositions and that he continued to paint in New York, he introduced into this country these monumental — always life-size — vertical trompe l'oeils, which also were imitated and varied by other artists.

WILLIAM MICHAEL HARNETT, *The Old Cupboard Door*. See plate 18, page 162.

Not all of Harnett's later vertical still lifes concentrated on a single or primary object. In his last years, there were three monumental, tremendously complex arrangements of dozens of diverse items that deserve to be singled out: *Music and Good Luck* (1888, Metropolitan Museum of Art); *The Old Cupboard Door* (1889, Graves Art Gallery, Sheffield, England); and *Old Models* (1892, Museum of Fine Arts, Boston), which is his last known work, intended for the Columbian Exposition in Chicago. The first combines a number of objects that Harnett favored elsewhere, although it centers upon an old violin in a composition more rigorously geometric than any other known work done by Harnett. The second, composed with strong parallel diagonal axes, also includes a violin, along with books, sheet music, a candlestick, a vase, and a transparent tambourine. It is Harnett's most dynamic composition. The last props his favorite violin on a shelf, along with books and an old Dutch ceramic jar, Harnett's other favorite motif. In all three of these paintings, Harnett aspired to increase the spatial complexities of his illusionism. In the first, all the objects hang on a door, within an enframement, which itself projects slightly into the viewer's space, casting a shadow at the right onto its own jamb — thus, objects project from a projecting surface. In the second and third pictures, a shelf is affixed to the painted wall just below the hinged door that allows for the construction of a limited tabletop arrangement in addition to the hanging forms above. Books, vases, candlesticks, and other forms are introduced that are not practical (or deceptive) in a vertical trompe l'oeil. Therefore, two kinds of illusionistic projections are suggested. Such progression, or development, encourages speculation on the nature of Harnett's later work. Had he not died at the early age of forty-four, he might hve invented even more varied solutions for the repertory of the trompe l'oeil still life.

Of the artists associated with Harnett, with his stylistic approach to still-life painting and/or with his iconography, John Frederick Peto is certainly the best known today, although recent scholarship has demonstrated that Peto's art is actually the most distinct from that of Harnett, in execution if not in subject matter.[6] That renown, however, was not always his reward. Until the late 1940s, Peto as an artistic personality, and his art only slightly less, had fallen into such total obscurity that he was, of all the painters of trompe l'oeil still life in the late nineteenth century, the most easily and conveniently forged with Harnett's signature. It was Alfred Frankenstein's unraveling of the forgery problem and the separation of the style of the two painters that led in turn to the comprehension and the popularity of the school, and to the emergence of Peto as a distinctly creative figure who was the most individual of Harnett's followers, if not necessarily the most talented of them.[7]

Peto was also one of the few artists of this group who personally knew the master. Indeed, Peto's daughter recalled that her father spoke constantly of Harnett and of his admiration for that artist's work. A great many of Peto's pictures are similar to Harnett's, both those that were painted in Philadelphia prior to 1889 and those that were painted after the move to Island Heights, in New Jersey. Peto knew Harnett prior to 1880, when Harnett went to Europe. They became acquainted while living in Philadelphia and while Harnett was beginning to make his mark, a level of recognition that Peto never realized. Still, Peto must have been hopeful in those earlier years, achieving a degree of patronage and buoyed up by his relationship with Harnett. His earlier pictures, painted in Philadelphia, are brighter, more exuberant than the dark and mournful paintings that were done while in Island Heights.

The relationship with Harnett may, in fact, have worked two ways. Peto's most successful Philadelphia paintings, and the best known today, are the series of rack pictures he painted for business establishments. These include arrangements of ribbons or tapes that were painted as though tacked on to a vertical panel, which appear to hold letters, cards, photographs, and memorabilia with specific references to the owners of the businesses. They might also include items that took on the artist's personal iconography, such as a looped piece of string or flower-ornamented card. Peto's early rack pictures have relatively complex tape arrangements, in light, bright colors, though even here the torn envelopes, broken tapes, and mundane backgrounds suggest a world quite remote from the increasingly well-to-do or even luxurious ambience projected in Harnett's work. In regard to the rack format, Peto appears to have been the innovator, even when reviving a format that was explored in the seventeenth century by the Flemish artists Wallerant Vaillant and Cornelis Gysbrechts. The rack picture tradition was brought to England from the Low Countries at the beginning of the eighteenth century by Everett Collier and a century later was explored by Raphaelle Peale, but by then it had become an international, if minor, artistic phenomenon. How Peto became familiar with it is not known; he might of course have come across an example by Peale, though this is not very likely. Since Vaillant's work was included in the notable collection of Charles Graff, it was known in Philadelphia. However, this painting was not a rack picture or even a still life, though it had elements of trompe l'oeil.

These early business or office board pictures by Peto are dated between 1879 and 1885. Harnett also painted a rack picture in 1879, *The Artist's Card*

[6] See particularly Lloyd Goodrich, "Harnett and Peto: A Note on Style," *Art Bulletin* 31 (March 1949): 57-58.

[7] See the essay by Alfred Frankenstein, in *John F. Peto* (exhibition catalogue; Smith College Museum of Art, the Brooklyn Museum, California Palace of the Legion of Honor, San Francisco, 1950). See also Harriet Sylvia Dolphin, " 'The Rack' by John Frederick Peto" (Master's thesis, Arizona State University, 1969).

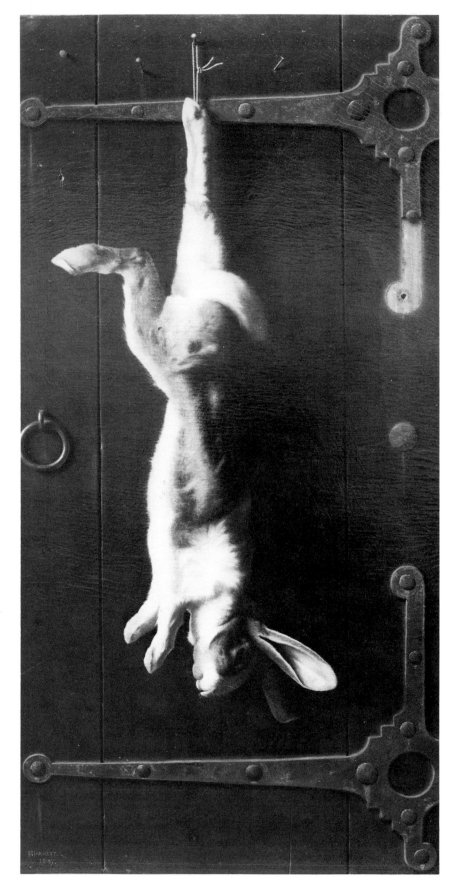

Figure 8.7. WILLIAM MICHAEL HARNETT (1848-1892), *Trophy of the Hunt*, 1885; oil on canvas, signed at lower left —
 W
 Harnett/1885
 M
42½ x 22 inches; Museum of Art, Carnegie Institute, Pittsburgh, purchase, 1941.

Figure 8.8. WILLIAM MICHAEL HARNETT (1848-1892), *Faithful Colt*, 1890; oil on canvas, signed at lower left —
 W
 Harnett
 M
22½ x 18½ inches; Wadsworth Atheneum, Hartford, The Ella Gallup Sumner and Mary Catlin Sumner Collection.

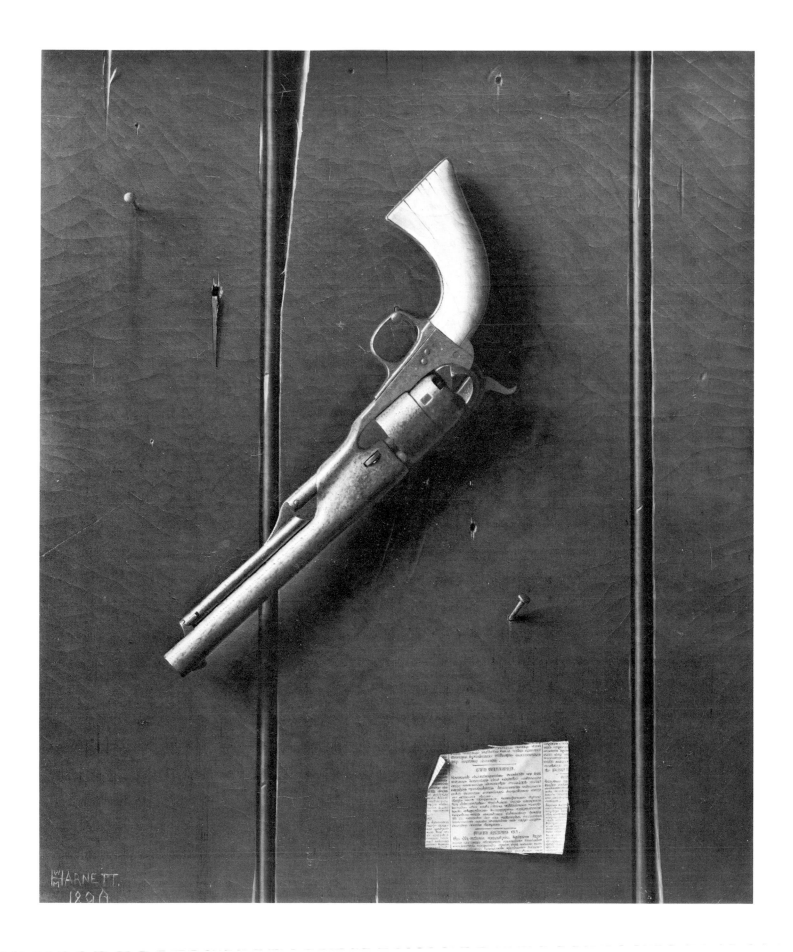

[8]For Harnett's later rack painting, see Alfred Frankenstein, "Mr. Huling's Rack Picture," *Auction* 2 (February 1969): 6-9.

Rack (Metropolitan Museum of Art), which is one of only two known today. Judging by the elements in this work, Harnett's picture was painted, or was completed, no earlier than late August 1879, while Peto's earliest known example is quite surely dated June of that same year. While some elements are common to both pictures, such as the looped yarn — suggesting that the two colleagues possibly conceived and certainly worked out their rack pictures in tandem — Harnett's tape rack itself is a much simpler affair than Peto's, a very basic "X" inside a square. His other rack picture, *Mr. Huling's Rack Picture* (1888), likewise makes use of the simple "X" rack, but it is a more complex composition of letters, cards, and newspaper notices.[8] It is more darkly and richly colored than the rather bright, almost bland coloration of the earlier work and reflects the greater drama that Harnett had developed during his European sojourn. Furthermore, the trompe l'oeil itself is far more developed. In his earlier rack picture, all the letters and the card are beneath the rack tapes; in this latter work, a letter at the right is under one tape and over another. There is much more overlapping of letters upon letters and, most significantly, the picture is awash with bent, folded, and torn corners and edges that naturally project outwards (since they cannot do so back *through* the wooden background), and cast shadows upon themselves or on other letters and the tapes. The protruding pins that hold the tapes are also more emphatic, and the tapes themselves are no longer completely flat as in the 1879 example but are taut in some places and sagging in others, creating their own spatial illusionism.

Mr. Huling's Rack Picture by Harnett may be the masterpiece of American rack painting, but Peto was the master of the genre. Not only did he paint more pictures in this genre than Harnett or any other American artist, but he subjected them to a new, more personal and more moving, if less illusionistic, interpretation when he took up the theme again in 1894. By then Peto was a thoroughly forgotten, unknown, and impoverished artist in a small New Jersey community. He was perhaps better known as a cornet player at camp meetings than as a painter. A sense of withdrawal, isolation, and introspection is reflected in his later still lifes, including his rack pictures. A work such as *Old Time Letter Rack* (1894) is typical of these late rack pictures at their finest. These are personal works, not office boards for businesses. The items in these pictures are truly "scraps" of the artist's life, torn clippings, bits of string, random calculations in chalk upon a simulated board, tattered personal letters, and torn signs. Even the racks themselves are torn and broken, lacking all elegance or even suggestions of former elegance. A frequent item of iconographic import is an old photograph of Abraham Lincoln, the martyred president whom Peto appears to have idolized. In *Old Time Letter Rack,* it is ingloriously inserted behind a letter in the rack, upside down with the head almost totally obscured. In these later rack pictures, Peto abandoned the vigorous complexity of his earlier multi-taped rack compositions and adopted Harnett's much simpler "X" in a square, though the broken and sagging tapes lacked the rigorous geometry of Harnett's two racks.

Old Time Letter Rack holds a special place in the modern recognition of the Harnett school of trompe l'oeil and in the emergence of Peto as a separate artistic identity, one whose work was most frequently forged with Harnett's signature. *Old Time Letter Rack* was such a forgery. It was even given a new title, *Old Scraps.* In addition to displaying a softer focus, less trompe l'oeil emphasis, and a different handwriting than that found on

Figure 8.9. WILLIAM MICHAEL HARNETT (1848-1892), *Mr. Huling's Rack Picture*, 1888; oil on canvas, signed at lower left — *Harnett 1888*, 30 x 25 inches; Mr. and Mrs. Jacob M. Kaplan.

Figure 8.10. JOHN FREDERICK PETO (1854-1907), *The Rack;* oil on canvas, signed at lower left — *John F. Peto,* 24 x 20 inches; Arizona State University Art Collection.

genuine works by Harnett, there are three envelopes and cards held in the rack with Ohio addresses, two with postmarks for November 1894, and one referring to Lerado in Ohio. Harnett had no connection with Lerado, but it was the hometown of Peto's wife, and he was visiting there in the fall of 1894. Even more conclusive, Harnett had died two years earlier.

Over twenty known works by Peto were forged with Harnett's signature. *Discarded Treasures* is another from this group. Not a vertical still life but a more traditional tabletop (or desk top) picture, it consists only of an arrangement of books and superficially resembles Harnett's *Job Lot Cheap.*[9] The overall organization of the books involves a pyramidal arrangement similar to Harnett's painting, but the clarity of composition of the latter is replaced by Peto with a sense of abandonment and chaos — books balance precariously on top of one another, leaning haphazardly, some about to fall off the table, and others falling apart. Harnett's books are old and often elegant, suggesting rare valuable editions; Peto's are old also, but they are

[9]See the publication of *Discarded Treasures* as an original Harnett at the time of the Harnett revival or rediscovery in 1939 in the *Bulletin of the Smith College Museum of Art* 20 (June 1939): 17-19.

Figure 8.11. JOHN FREDERICK PETO (1854-1907), *Old Time Letter Rack*, 1894; oil on canvas, signed on reverse of canvas — *Old Time Letter Rack/11.94/John F. Peto/Artist/Island Heights/N.J.*, 30 x 25⅛ inches; The Museum of Modern Art, New York, gift of Nelson A. Rockefeller, 1940.

"used books," and the sense of abandonment is not limited to the composition. If they were "treasures," they were so valued only personally, and they certainly have been discarded. Harnett's work may have been the stimulus and starting point, but trompe l'oeil is not the issue here. The books are used as a metaphor for the artist himself — forsaken objects of worth and intellect. Once treasured, presumably in a library, they are now available, as the card tacked to the desk top states, for "10 cents EACH." Peto's work in Island Heights was scarcely worth more; he often bartered it for needed services and remained isolated from the community of artists.

Books were a major item in the paintings of Harnett and Peto. Like all the elements of his still-life iconography, Peto's books are worn and battered. His still lifes are the most pessimistic in American art. While Harnett often identifies his volumes, Peto does not, nor does he attempt to so

[10]On this aspect of Peto's style see particularly both Goodrich, "Harnett and Peto," and John I. H. Baur, "Peto and the American Trompe L'Oeil Tradition," *American Magazine of Art* 43 (May 1950): 182-85.

JOHN FEDERICK PETO, *My Studio Door*. See plate 19, page 163.

engage the viewer's interest. Instead of using light to achieve the effects of illusionism, his books and other objects are bathed in a soft diffusion, a twilight luminosity that causes the objects to appear as though they emerge from the shadows.[10]

Peto did occasionally attempt to imitate to some degree the elegance of Harnett, but even then the results were easily distinguishable. His *Things to Adore: My Studio Door* displays a bugle, bowie knife, powder horn, flintlock, and other rugged masculine paraphernalia that is associated with combat mounted on a weather-beaten door with old, rusted hardware, in obvious imitation of Harnett's *After the Hunt*. Both formally and iconographically, however, there are apparent differences. Peto achieved here a rhythmic, swinging composition of forms that move back and forth from top to bottom but without the outward-moving dynamic orchestration of Harnett's great 1885 composition. Peto's individual objects are solely functional, some of them dangerously so. Harnett's antique gun has an elegantly decorated stock, and his hunting horn was chosen for its marvelous circular shape. While superficially all the objects in Harnett's picture might suggest the hunt and its aftermath, in actuality one did not hunt game birds or even rabbits with an antique handgun or a military sword. Peto's objects exist comfortably together without implication of aesthetic or antiquarian value. Even the rare elegance of the hardware of his decorative door appears truncated and insignificant when compared to that of Harnett, which stretches across the entire composition.

Peto is a romantic figure, personally and artistically, in late nineteenth-century painting. The distinctiveness of his work, with its soft luminous diffusion, its melancholy overtones, and its suggestion of an untold story, obviously contrasts with the startling "real" pictures of Harnett and of other painters in the trompe l'oeil still-life school. Yet, Peto's work is occasionally marred by hasty and slipshod performance, as indicated by a foreshortened pipe that is malformed and a jug handle that is misshaped. The pictures so affected may have have been potboilers, the run-of-the-mill pictures of his later years, and reveal an artistic inconsistency of which Harnett could not be accused.

Nor could such fault be found with Jefferson David Chalfant, perhaps the finest, technically, of all of Harnett's followers. There is no indication that Chalfant knew Harnett personally, but there is plentiful visual evidence that his work was modeled on and conditioned by that of the master. Chalfant worked throughout his mature career in Wilmington, Delaware. His art, however, falls into three quite distinct periods with only some overlap, a division not of style but of theme: his still lifes of the late 1880s; his genre pictures of the next decade and a half; and in his final years, through 1927, his portraits. The still lifes are marvelous trompe l'oeil; the genre pictures are engaging; and the less said about most of his portraits, the better.[11]

[11]"For Chalfant, see Joan H. Gorman, *J. D. Chalfant* (exhibition catalogue; Brandywine River Museum, 1979).

Harnett returned from Europe with *After the Hunt* in 1886 and began to reestablish his reputation in this country. That same year, Chalfant, who had been painting since 1883, turned to the production of trompe l'oeil still lifes, of which even the records, let alone the known examples, are distressingly few. The earliest recorded of these is his now-unlocated *Gunner's Outfit and Game*, a paraphrase of Harnett's masterwork, for which the artist produced an affidavit to affirm the originality of his picture. Its date is appropriately concurrent with the barroom notoriety of *After the Hunt*. He produced a

similar picture soon after that was actually entitled *After the Hunt*. It is now also lost. And like Harnett, Chalfant produced at least one picture with paper money as the theme. A work of almost total illusionism, depicting flat objects in a vertical format, is his now celebrated *Which Is Which* (circa 1889, Private Collection), which may have been the last such trompe l'oeil that was painted in his brief, four-year period of still-life concentration. In certain respects, it is the ultimate of illusionism, for Chalfant painted a duplicate of a two-cent stamp next to a real stamp affixed to the gesso-covered support; below the two is a "painted" newspaper clipping describing the dilemma posed by the juxtaposition. However, today the answer is all too clear: the "real" stamp is faded almost beyond recognition while the painted stamp remains in perfect condition.

Chalfant's brief but intense concern with trompe l'oeil, however, was concentrated upon a series of four violin pictures — just as Harnett had painted four versions of *After the Hunt*.[12] Like the latter, Chalfant's four violins can be divided into two pairs: two tabletop paintings, and two hanging violins. The former could have been inspired by a number of Harnett's works, either his *Still Life with Violin* (Museum of American Art, New Britain) or his *Toledo Blade* (Toledo Museum of Art), which were both painted in 1886. The hanging violins were obviously inspired by Harnett's great *The Old Violin* (1886). Because of their relative similarity of subject and format, and their close similarity of title, there has occurred an understandable confusion among Chalfant's quartet of strings.

The pictures were all painted in the period between 1887 and 1889, though the first may have been begun in 1886. This work is the one picture in the series that is undated by Chalfant; it is also the one known work by him that was forged with Harnett's signature and was given an equally spurious date of 1885. (The picture was most recently known in a private

[12]See William H. Gerdts, "A Trio of Violins," *The Art Quarterly* 22 (Winter 1959): 370-83; at the time, only three of Chalfant's violin pictures were known, though the existence of the fourth is suggested.

Figure 8.12. JOHN FREDERICK PETO (1854-1907), *Discarded Treasures*, circa 1904; oil on canvas, signed at lower right —
　　W
　　Harnett (spurious signature)
　　M
22 x 40 inches; Smith College Museum of Art, Northampton, Massachusetts, purchase, 1939.

Figure 8.13. JEFFERSON DAVID CHALFANT (1856-1931), *Violin and Music,* 1887; oil on canvas, signed at lower left — *J. D. Chalfant/87,* 16½ x 28½ inches; Collection of The Newark Museum.

collection from which it was stolen.) Its title, when exhibited in 1887 at the Pennsylvania Academy, was *Music-Still Life;* it was later known as *Violin.* The second picture, painted in 1887, is entitled *Violin and Music.* The third is *The Old Violin,* which was painted in 1888 and exhibited that year at the Pennsylvania Academy. The fourth, and last, is *Violin and Bow* (Metropolitan Museum of Art), painted in 1889 and also exhibited at the academy. The series as now established reveals a progression from controlled foreshortening to the use of forms parallel to and projecting into the viewer's space; from clutter to sparseness; and from complexity to austerity. The earliest composition includes the greatest number of objects — sheet music, violin and bow, busy-looking wallpaper, and damask tablecloth. The second includes a book and a newspaper, but shows far fewer torn-edged pages, and employs quieter patterns in the support and background. The third picture depicts only the violin and bow, a piece of sheet music that is also suspended, and a pair of thin spectacles; the last presents the violin and bow alone.

In all of these, Chalfant displays his own personal aesthetic while culling his iconography and his compositions from Harnett. In all, they are far simpler than Harnett's violin paintings. They lack Harnett's drama, but they are far more delicate, painted in a lighter key of golden and silvery tones, rather than the strong *chiaroscuro* of Harnett. Chalfant preferred a monochromatic palette — whites, tans, and browns — to the full chromatic scale of Harnett. Chalfant displays a fondness for pattern and decoration in

Figure 8.14. JEFFERSON DAVID CHALFANT (1856-1931), *The Old Violin*, 1888; oil on canvas,
signed at lower left — *J. D. Chalfant*, 40 x 28½ inches; Delaware Art Museum, Louisa du
Pont Copeland Memorial Fund.

the aforementioned wallpapers and tablecloths, and even in the backgrounds of his hanging violins, one of which has simulated cracks in the painted surface. In some ways, Chalfant's illusion is even greater than Harnett's — much more of his newspapers, clippings, and music sheets can be read.

In 1890, Alfred Corning Clark, one of the leading patrons of American art, sent Chalfant to Paris to study. There he attended the Académie Julian, which influenced not his style but his choice of subject. Parisian training had long emphasized the study of figure painting, and Chalfant's experience was no exception; he returned to America a genre painter. However, around 1898 he turned again, probably for the last time, to trompe l'oeil in his work *The Old Flintlock* (Brandywine River Museum), which predictably was inspired by Harnett's *Faithful Colt* (1890). Seemingly affixed to the painted panel is a painted label stating that the artist had returned to still life for the first time in nearly ten years. Unfortunately, it appears also to have been Chalfant's last.

Although Peto may have been the most original and Chalfant the most sensitive of the close followers of Harnett, there were many other artists of undeniable talent. Three of the best known today are George Cope, Richard La Barre Goodwin, and Alexander Pope. Cope, the most thoroughly studied of the three, spent his life in West Chester, Pennsylvania, a town near to both Philadelphia and Wilmington, but there is no record that he knew either Harnett or Chalfant.[13] Cope studied with Herman Herzog, the landscape painter, and throughout his career, he produced attractive views of the countryside near West Chester and the Pocono Mountains, but he is best known for his still lifes. Not all of these partake of Harnett-like trompe l'oeil, to which Cope turned in 1887, the year after Harnett returned from Europe. In a sense, however, Cope anticipated his own derivation from Harnett around 1885 when he began a series of hunting and game still lifes in which hanging game birds and rabbits were depicted close up, but in segments of room interiors. It was, therefore, a logical step for him to adopt in 1887 the vertical door format upon which to hang his hunting paraphernalia and trophies. Such pictures again were derived from Harnett's *After the Hunt*. Cope varied this format by using fisherman's equipment and Civil War mementoes as his subject matter. He continued to paint vertical still lifes throughout his career, alternating them with more traditional tabletop pictures of fruits, flowers, and books. Most of the vertical still lifes continued to have reference to Harnett's work; Cope's *Indian Relics* (1891, Brandywine River Museum) reflects, with particular originality, the dominant masculine emphasis upon violence in these trompe l'oeil pictures. This work juxtaposes emblems of war and peace while still making reference, with the hanging gun, to Harnett's great *Faithful Colt* of the previous year. Cope was often at his best when concentrating upon a single major item, as the dead duck in *A Day's Bag* (1910), where he renders the form, the soft downy texture, and the sense of weight and volume with great security, yet introduces a certain understated pathos by the touch of blood against the pure white feathers of the bird. Typical details of the trompe l'oeil school can be seen in the protruding nail, the gouges in the plank background, and the illusionistic crack between the boards, while the rusty hasp at the right, plunging downward like the duck's form — and the only element in the picture to compete with it for the viewer's attention — is specifically derived from Harnett's *Music and Good Luck* (1888).

[13]For Cope, see Joan H. Gorman and Gertrude Grace Sills, *George Cope, 1855-1929* (exhibition catalogue; Brandywine River Museum, 1978). Previously, Cope had been the subject of two essays by Dr. Henry Pleasants, Jr., "Our Own George Cope," in *Yesterday in Chester County Art,* and "George Cope — The Realist" in *Four Great Artists of Chester County.*

Figure 8.15. GEORGE COPE (1855-1929), *A Day's Bag*, 1910; oil on canvas, signed at lower
right — *George Cope, 1910;* 23 x 16¼ inches; Private Collection and the Brandywine River
Museum.

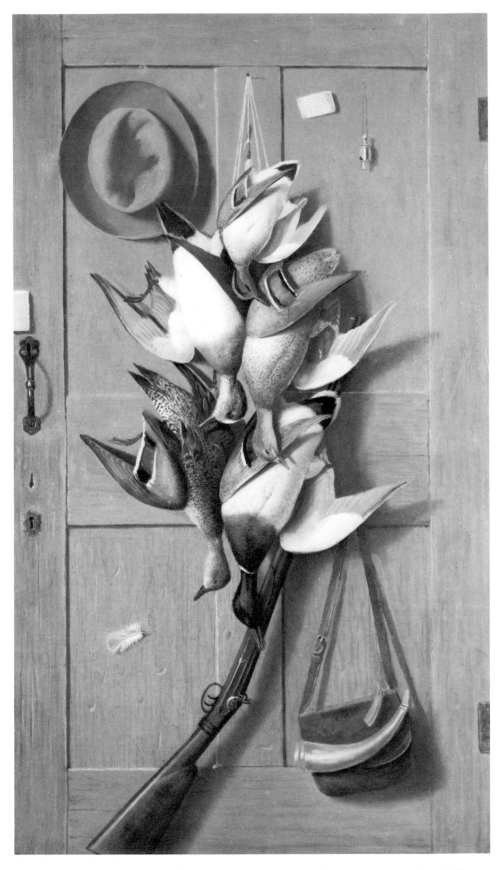

Figure 8.16. RICHARD LA BARRE GOODWIN (1840-1910), *Study for Theodore Roosevelt's Cabin Door;* oil on canvas, 21 x 12 inches; Vassar College Art Gallery, Suzette Morton Davidson Fund.

Chalfant and Cope had permanently settled down in Wilmington and West Chester. By contrast, Richard La Barre Goodwin was one of the most peripatetic of Harnett's followers. Born in Albany, he traveled from coast to coast. He too painted attractive but conventional tabletop fruit pictures; however, his reputation, both in his lifetime and today, was based on his vertical door still lifes of the trophies of the hunt, which were derived from Harnett's *After the Hunt*. Goodwin's earliest known examples in this familiar derivation date from 1889, but he too may have commenced the series a few years earlier. Various elements are borrowed from Harnett's repertory including the simulated carved signature and the floating, falling feather from one of the birds. Goodwin's coloration is monochromatic, emphasizing a range of browns, and he gives special attention to the paneled architecture of his doors, which he varied considerably. One of the best, and by far the most famous, of Goodwin's pictures of this type, though not particularly distinguishable from a good many others, is *Theodore Roosevelt's Cabin Door* (1905, Museum of Arts, Springfield, Massachusetts), which was painted in Portland, Oregon, at the Lewis and Clark Centennial. The work portrayed the door of a hunting cabin in the Dakotas where Roosevelt had stayed in 1890. Methodologically unique to Goodwin was his preparation of small-sized, finished versions of his large (life-sized) compositions, one of which corresponds to his famous picture of 1905.

Alexander Pope was the Boston representative of the trompe l'oeil school, though he appears to have painted only about a dozen of these trompe l'oeil "characteristic pieces" as he termed them — "characteristic" in the sense of intense verisimilitude.[14] We have seen at the beginning of this chapter that Pope himself (and his critical admirers) denigrated such work, preferring his true specialty in animal paintings (often traditional and heroic subjects in which animals are featured) and animal portraiture. Pope's vertical still lifes are among the largest of the school and again derive their format and often their subject matter from *After the Hunt*, though they also relate to Pope's own carved wooden trophy sculptures. His series of characteristic pieces began, as did Chalfant's and Cope's, in 1887. Also like Cope, Pope painted at least one variant of Civil War mementoes. Most of his large canvases — usually symmetrical and slightly mechanical — are hunting trophy pictures. Pope's preference for deep, rich coloration is closer to Harnett than the other painters of the school. Among the best of his works are the two paintings of a single swan in which the brilliant starkness of the monumental bird creates a strong dramatic image. The artists of the trompe l'oeil school ranged as far as they could in the selection of hunting trophies, beyond the standard image of the various species of ducks. Smaller birds, such as snipe, were not uncommon, but several artists sought out more unusual, powerful, and monumental forms. In addition to Pope's two swan pictures, there is a notable example by Goodwin that shows a hanging wild turkey.

Another New England representative of the trompe l'oeil school was John Haberle, but Haberle was much more original in his approach and iconography than were Pope, Cope, Chalfant, and Peto.[15] He was contemporary with Harnett, and his turn to deceptive realism coincides with Harnett's return from Europe, as with the others, but that is where Haberle's participation in the goals of this group of artists ends. He did paint paper money pictures, as did Harnett, but there are no trophies of the hunt, no hanging violins, no guns, or meerschaum pipes. Haberle's subject matter

[14]The most significant study of Pope and his still life is Donelson F. Hoopes, "Alexander Pope, Painter of 'Characteristic Pieces,' " *The Brooklyn Museum Annual* 8 (1966-1967): 129-46. See also Cave, "Alexander Pope, Painter of Animals," and Frank T. Robinson, "An American Landseer," *New England Magazine* 9 (January 1891): 631-41.

[15]Along with Harnett and Peto, Haberle is the one other artist who merits a complete chapter by Frankenstein in *After the Hunt*. Frankenstein is also the author of "Haberle: Or the Illusion of the Real," *American Magazine of Art* 41 (October 1948): 222-27. See also Jane Marlin, "John Haberle: A Remarkable Contemporaneous Painter in Detail," *The Illustrated American* 24 (30 December 1898): 516-17, and *Haberle*, foreword by Alfred V. Frankenstein (exhibition catalogue; New Britain Museum of American Art, 1962). See also Robert F. Chirico, "John Haberle and *Trompe L'Oeil*," *Marsyas* 19 (1977-1978): 37-43.

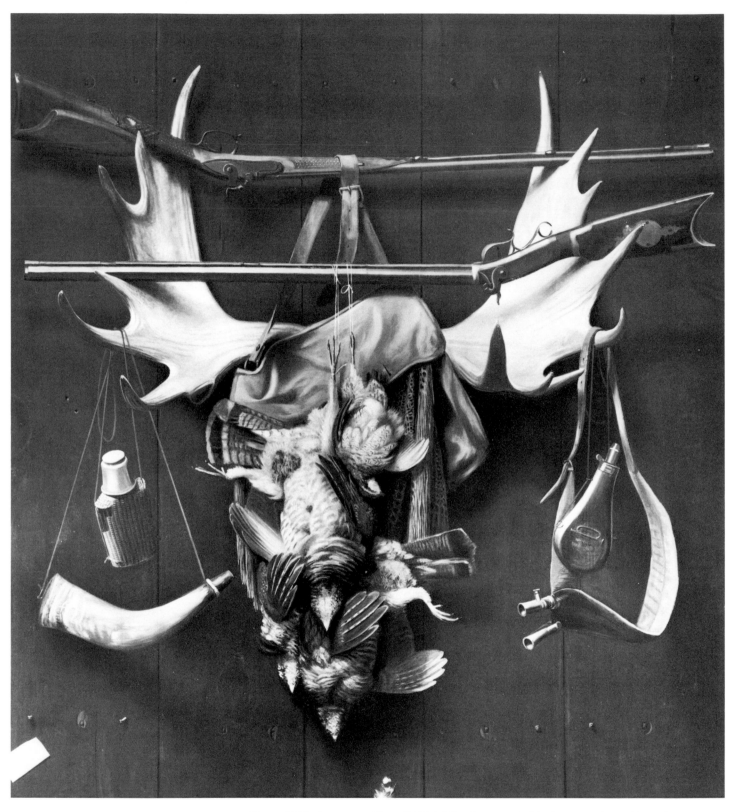

Figure 8.17. ALEXANDER POPE (1849-1924), *Sportsman's Trophy*, circa 1898-1899; oil on canvas, signed at lower left — *Alexander Pope*, 52 x 48¼ inches; San Antonio Museum of Art, San Antonio, Texas.

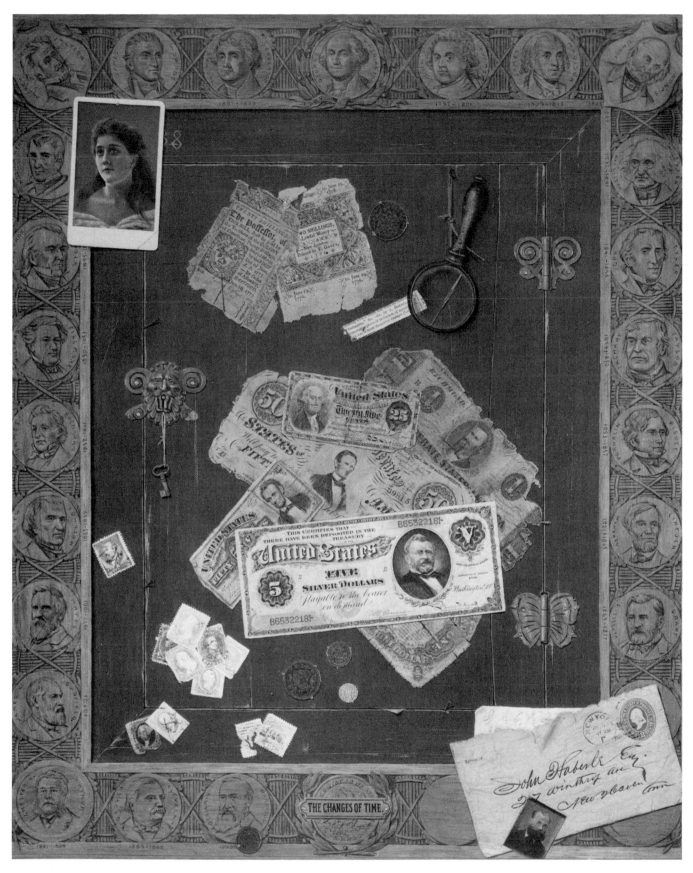

Figure 8.18. JOHN HABERLE (1853-1933), *The Changes of Time,* 1888; oil on canvas, signed at lower right on envelope — *Haberle,* 27½ x 19½ inches; Private Collection.

was original, often ingenious, and often extremely witty. Illusionism is a pictorial form of trickery, and trickery itself involves humor. But Harnett and most of his other followers did not usually capitalize on the humorous aspects of their art, although Chalfant's aforementioned stamp picture is a work of refined wit. Haberle's entire trompe l'oeil oeuvre is humorous.

Like Chalfant, Haberle's work in this manner is confined to an extremely brief period, beginning about 1887 and ending in the early years of the next decade. By then, the extreme demands that trompe l'oeil made upon Haberle's eyesight were taking their toll, and while he made a number of sporadic forays back into trompe l'oeil as late as 1909, most of his later works are broadly painted pictures of fruits and flowers, which are brightly colored and filled with sunlight. These later works are antithetical to his trompe l'oeil production.

One of Haberle's unlocated works, painted in 1889, was entitled *Conglomeration*, a title that effectively describes many of his pictures, with astounding assortments of disparate objects seemingly arranged randomly, if arranged at all. One of the masterworks of this kind, and his most elaborate money picture, is *The Changes of Time* (1888), a vertical "door" picture that is dominated by a central group of painted currency and shinplasters, coins ostensibly nailed onto the painted door, an assortment of cancelled stamps, a clipping praising a previously exhibited deception entitled *Imitation*, and a hanging magnifying glass. Overlapping the door enframement, itself also painted, is a favorite tintype of a woman, and in the opposite corner is an envelope with Haberle's name and address and yet another photograph, this one of the artist himself, which he used in a number of his works. The door and enframement are set into a frame (a painted one) over which the envelope is placed. The frame is decorated with medallion heads of all the presidents of the United States, leaving vacancies in the lower right for future presidents. At center bottom is a medallion of the American eagle with a painted title plate of "The Changes of Time" "fastened" across it. The run of presidents, of course, illustrates the changes of time, as does the series of paper money that is displayed, from a colonial twenty shilling piece of 1773 to contemporary bills, the latest issued in 1886. The iconography is further complicated by the associations that are formed among the different elements in the painting. The post-colonial money displays heads of presidents from Washington onward, repeating or approximating images that are incorporated into the frame; the postage stamps echo these again. As the presidents succeeded one another, and most of them had passed on, they were in several senses "cancelled," as they are literally on the stamps. To insure the identifications of frame and interior arrangement, one of the painted coins seemingly has slipped out of the picture down to the bottom of the frame, its tacking nails and a "ghost" image remaining in the original position above. But, of course, it is all an illusion.

Not all of Haberle's pictures are so complex. Some of his most striking images are small, single-item forms, such as a series of painted blackboards with crude chalk images "drawn" on them and with smudged erasures. The humor is in the contrast between the carelessness of the messy images on the blackboard and the precision of its actual painted form and that of the accompanying chalk that hangs on a string.

Even more fascinating is Haberle's series of works entitled *Torn in Transit*, of which three examples are presently known. Each depicts a "wrapped" painting whose imagery is largely visible because the wrapping

Figure 8.19. JOHN HABERLE (1853-1933), *The Slate;* oil on canvas, signed at upper left — *Haberle,* 12 x 9½ inches; Mr. and Mrs. O. Kelley Anderson, Jr.

paper encasing it has been torn away, though the express company labels and binding string remain. In all three cases, the depicted paintings are broadly handled; two would appear to be somewhat primitive or amateur pictures (Brandywine River Museum; Private Collection), and the third suggests an impressionist-style canal scene. The lack of meticulousness in their execution contrasts effectively with the trompe l'oeil nature of the jagged, torn-edged paper and labels and the precisely painted strings, which cast illusionistic shadows on the packages. Yet, in each the painted scene occupies about four-fifths of the entire image. As Frankenstein has perceptively pointed out, these are not landscape paintings but paintings of landscape paintings, and the achievement lies in creating a humorous trompe l'oeil in works where most of the picture is not trompe l'oeil at all.

Figure 8.20. John Haberle (1853-1933), *Torn in Transit;* oil on canvas, signed at lower right — *From Haberle,* 14 x 12 inches; Memorial Art Gallery of the University of Rochester, Marion Stratton Gould Fund.

Another artist of humorous trompe l'oeil was the New York painter Victor Dubreuil, although the humor as enjoyed today may derive from Dubreuil's almost maniacal obsession with a single theme: money. Dubreuil is a far less well documented artist than Haberle and a far less sensitive one, though when dealing with his favorite theme he rose to the aesthetic occasion. There are trompe l'oeil still lifes of other subjects known by him, of proclamations and photographs, and even conventional tabletop pictures, but currency and coins are his most frequent images, probably because in his actual life in New York City he had so little of them. There are pictures by him of individual pieces of paper money, of wads of bills, of barrels of bills, and of safes full of bills. There exist a painting of a revolver with

Figure 8.21. VICTOR DUBREUIL (active 1880-1910), *Barrels of Money;* oil on canvas, signed at lower left — *V. Dubreuil,* 25 x 30 inches; Private Collection and the Brandywine River Museum.

money, one of a pair of thieves engaged in stealing money, and a quasi self-portrait (Butler Institute of American Art, Youngstown, Ohio) that depicts the artist's eye looking out through a hole in a board, next to which is an envelope bearing his name — and above the envelope a five dollar bill.

The fascination of trompe l'oeil for artist and art lover alike has endured through the ages, even when critics claimed that such pictures were mere trickery and, indeed, were *not* works of art. But, though isolated examples of deceptive still lifes were known earlier and have continued to be painted to the present day by such able practitioners as Aaron Bohrod and Ken Davies, the late nineteenth century witnessed the heyday of the form. What remains unclear, however, is the role that Harnett may have played in influencing those artists who adopted elements of the mode but rejected his repertory of subject matter, as Peto, Chalfant, Cope, Pope, and Goodwin did not. There is the artist Edwin Romanzo Elmer, for instance, whose *Magic Glasses* (circa 1891) is a case in point. Elmer was a part-time painter who lived almost all of his life in Ashfield, Massachusetts. Only a few works of his have come to light; the magnifying-glass picture being the only still life in a trompe l'oeil manner.[16] The subject is certainly not a traditional one in American painting, in the trompe l'oeil school, or even in still-life painting, but rather the obsessive reality of its depiction and the concern with illusionism certainly ally it with the movement. Furthermore, its presumed date would suggest that the artist's inspiration for illusionism may have come from the increasing interest in and popularity of that still-life form, as it had obviously inspired Harnett's more immediate followers and imitators. Yet, Elmer's concern with reflections in the curved glass — dual landscape reflections in fact — suggests more the tradition of earlier Flemish and Dutch realism than the concerns of his American contemporaries.

Elmer's foray into still-life genre, in any event, is a unique case, for he was not a fully professional artist. Of more sustained interest is the work of those newly reconsidered artists who painted the traditional fruit subject matter in a trompe l'oeil format. Four painters in particular have undergone resurrection of reputation to varying degrees. All of them painted still lifes of fruit in a hard, linear manner, which is somewhat related to Harnett's earliest professional work, but they also adopted certain conventions of the trompe l'oeil manner that Harnett went on to develop. Again, a relationship to Harnett has not been established for any of them, but the works with which we are concerned here were done in the 1880s and 1890s — the height of activity of Harnett and his "school."

Of the four artists, the most famous in his own day was De Scott Evans, but his renown, such as it was, emphatically did not rest upon his still lifes. Evans was a midwestern artist who settled in Cleveland in 1874 as a portraitist, but his ambitions lay elsewhere, and three years later he joined the growing stream of young American artists and art students who went to study in Paris. Most of these artists came away with professional skills in figure painting and with a belief in its importance. Evans was no exception. A major theme of his subsequent years was the elegant woman at leisure in a late Victorian interior or a sunlit field. He returned to Cleveland in 1877, where he painted and taught at the Cleveland Academy of the Fine Arts for a decade, moving to New York City in 1887.[17]

Evans, so it appears, was always interested in still life, and several traditional tabletop pictures of fruit that were done during his Cleveland years are known. One cannot be precise as to when he turned to the

[16]For Elmer, see Alfred Frankenstein, "Edwin Romanzo Elmer," *American Magazine of Art* 45 (October 1952): 270-72; and Maud Valona Elmer, *Edwin Romanzo Elmer As I Knew Him.*

[17]On Evans, see Nancy Troy, "From the Peanut Gallery: The Rediscovery of De Scott Evans," *Yale University Art Gallery Bulletin* 36 (Spring 1977): 36-43. The earlier study of Evans by Cromwell Childe, "A Painter of Pretty Women," *The Quarterly Illustrator* 1 (October-December 1893): 279-82, does not touch on Evans's still lifes.

Figure 8.22. EDWIN ROMANZO ELMER (1850-1924), *Magic Glasses*, circa 1891; oil on canvas, 14 x 10½ inches; The Shelburne Museum.

painting of vertical still lifes, since most of these works are undated. One of them, however, shows the year 1888, which would seem consistent with his change from traditional forms of the previous decade and his succumbing to the new popularity of trompe l'oeil. In addition, several of them show "New York" next to the artist's name, suggesting a date of 1887 or later. His vertical pictures show luscious fruits painted somewhat in the style of Andrew J. H. Way — apples and pears hanging by strings that are tied to a painted nail that projects from a wooden background, which itself is complete with painted grain and painted knotholes. Painted paper labels affixed to the background identify the artist. The canvases appear to have been meant originally to be framed in encasements as part of the total conception — the nail painted on the frame, the string going over the top edge of the canvas. The canvas, in turn, was to protrude from the frame, for all four of its sides, folded around a stretcher, were painted to suggest saw-cut wood, the top and side "planes" somewhat dirty, the bottom one brighter and

more raw, for, of course, dirt would not accumulate underneath the panel as it would on the other three faces. Furthermore, some and perhaps all of these pictures of apples and of pears appear to have been painted as pairs, for they show a consistent light source, coming from the left, so that the shadows cast by the strings and fruits are closer to those objects in one of the pair than in the other, suggesting that one of the pair was meant to be thought of as being closer to the light source than the other. Also, this concept dictates that the pair hang side by side, rather than one above the other.

Some of these paintings of fruit are signed "De Scott Evans," a Gallicization that the artist adopted after his stay in France. Some other paintings are signed "Scott David," a reversal of his actual name — David Scott Evans. There is no evidence that these early pictures were exhibited, but there is room for speculation that they were personal artistic experiments and "off-

Figure 8.23. DE SCOTT EVANS (1847-1898), *Still Life with Apple;* oil on canvas, 11½ x 10 inches; Mr. James Ricau.

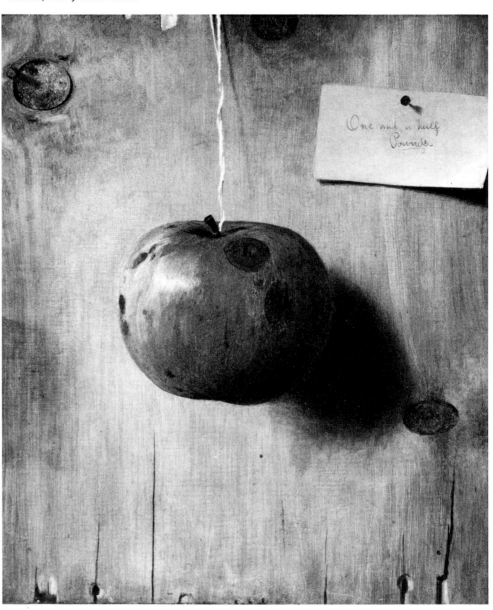

duty" pleasures of the artist; that he did not regard them as his serious professional work; and that, though he enjoyed painting them, he did not wish to be identified with them. Perhaps the examples signed with his real name were the first, and, knowing the critical denigration of still life and especially of trompe l'oeil, he signed the later ones with pseudonyms. One example of two hanging apples, obviously by the artist, is signed "Stanley David" (Yale University Art Gallery). Furthermore, there is a series of at least six (and presumably more) paintings of peanuts in glass-fronted cases, and one or two of almonds in similar settings, signed "S. S. David," a variant pseudonym also adopted for a now-unlocated painting entitled *Cat in Crate*. Why "S. S. David" was used by the artist is unknown, though it would suggest some sort of nautical implication. If so, it embodies an ultimate irony, for in 1898 Evans lost his life in the sinking of the *S.S. Bourgoyne*.

Figure 8.24. DE SCOTT EVANS (1847-1898), *Still Life with Pears*; oil on canvas, signed at lower left — *De Scott Evans/New York*, 12 x 10 inches; Mr. James Ricau.

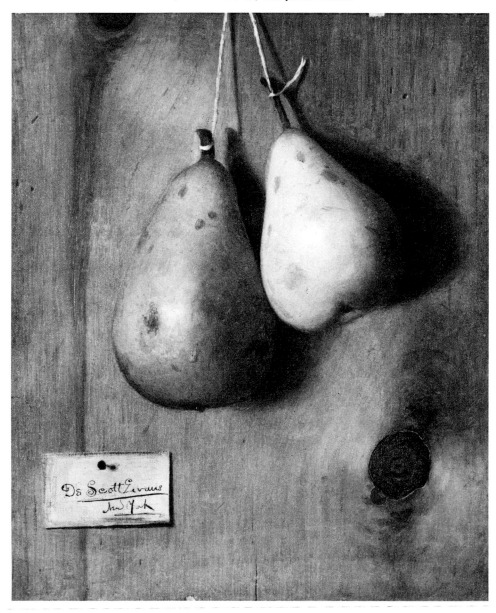

[18]For Decker, see Helen A. Cooper, "The Rediscovery of Joseph Decker," *The American Art Journal* 10 (May 1978): 55-71.

Evans was a respected artist in the late nineteenth century, but not for his still lifes. Joseph Decker was almost totally identified with that theme, although he also painted landscapes. Decker's two successive manners of painting still life were so disparate that at one time it was suggested that two specialists in the theme, coincidentally of the same name, were at work, and in an artistic sense there were.[18] This German-born and Munich-trained painter regularly exhibited in and around New York City and was patronized by Thomas B. Clarke, one of the outstanding collectors of American art. In the 1880s, he painted pictures of apples, peaches, and pears, some tabletop compositions, but his best-known works were depictions of fruit still growing on trees that were viewed close up. We have noted earlier examples of this form of nature study in the Ruskinian manner by artists such as Worthington Whittredge, but there is nothing of the "study" in Decker's work. The fruit and their leaves are so densely packed that they must be read two-dimensionally, and the insistent volumetricity of the fruit projects it out into the viewer's space, again in a recognized trompe l'oeil

Figure 8.25. DE SCOTT EVANS (1847-1898), *Peanuts;* oil on canvas, 11⅞ x 10 inches; Portland Art Museum.

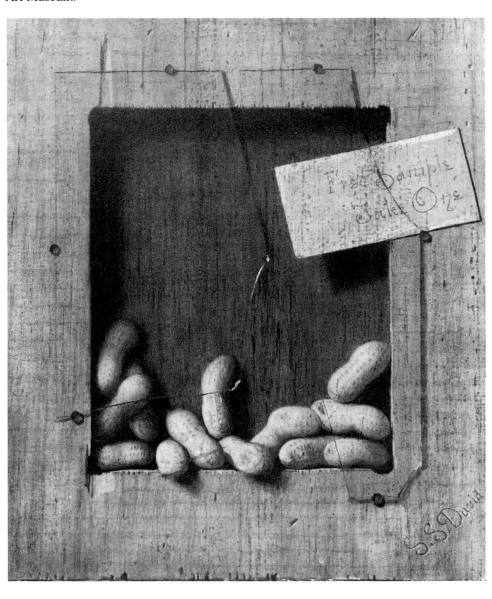

manner. In these living still lifes, dozens of pieces of fruit are painted in a tight, meticulous, super-realistic manner; the craftsmanship alone is much to be admired. But it was not so regarded in his own time, and Decker's "trickery" was indeed likened to that of Harnett. One critic who reviewed the exhibition held by the Society of American Artists wrote in 1887:

> Mr. Joseph Decker, whom we remember as the poet of green apples and greener pears, of ghastly hickory-nuts that would have frightened any country-boy from nutting, appears at this exhibition with a most painstaking piece of work, called "Upset," representing as we were assured, a box of candies turned out on a table for the sake of being painted . . . Mr. Harnett's popular success in cheating the untrained eye, following the earlier example of other mechanic painters, has had a bad influence of late; and the greater the handicraft-skill displayed by such disciples as Mr. Decker, the greater the regret we must feel that it could not be directed by better taste. Only children and half-taught people take pleasure in such tricks of the brush as Mr. Harnett has lately made the fashion.[19]

Two years earlier, another critic in reviewing Decker's paintings that were exhibited at the National Academy of Design complained, "And what has got into Mr. Decker's head, with cholera coming on, to offer us his hard green pears, and harder peaches?"[20]

Decker appears to have taken such criticism to heart, for after 1890 his style changed radically, although he remained a painter of still life. He was perhaps also influenced by George Inness, whose late, atmospheric landscapes Decker deeply admired. Decker's still lifes of the 1890s are pictures of fruit softly modeled in luminously modulated light, suggesting also the influence of the then much appreciated French artist, Chardin. The critics were impressed when in 1894 they saw some of these later works in Thomas B. Clarke's collection at the Fifth Avenue Galleries. According to one of them: "Joseph Decker, another Brooklynite, is coming along rapidly. He used to be hard and in his fruit pieces he is slightly hard still . . . It is well for a young artist to get command of his form before he frees his thought and Mr. Decker has established himself as a draftsman before coming out as a colorist."[21] And a final critical comment at the time of the sale of the Edward Runge Collection in 1902 confirms the critical preference for Decker's later pictures:

> Another man who should not be forgotten is a young Brooklynite, Joseph Decker, whose fruit and still life exhibit a delightful practice and certainty of touch, never degenerating into dryness and photographic effect in either line or tone. There is always a bloom and richness in his work that separate it from the most of still life in which there is almost inevitably a severity and academic quality.[22]

The still-life paintings of Levi Wells Prentice have not yet enjoyed the scholarly study accorded to those of Evans and Decker, but a great many of his fruit pictures have come to light in recent years. Prentice specialized in landscape paintings during the early part of his career. He was born in Lewis County in the Adirondacks, and his subject matter during the 1870s and early 1880s was the landscape of upper New York State. Prentice moved to Brooklyn, presumably in the late 1880s, and the semi-wilderness scenery he had previously painted was no longer available to him. His earliest known still life is dated 1892.[23]

[19]"The Society of American Artists, Ninth Exhibition," *The Studio* 2 (June 1887): 216-17.

[20]"The National Academy of Design, The Sixtieth Annual Exhibition," *The Studio*, n.s. 18 (11 April 1885): 210.

Figure 8.26. JOSEPH DECKER (1853-1924), *Still Life — Pears;* oil on canvas, 24½ x 12½ inches; Private Collection.

[21]"Some Pictures in Thomas B. Clarke's Exhibition," *Brooklyn Daily Eagle* (15 July 1894): 5.

[22]"Runge Collection," *Brooklyn Daily Eagle* (5 January 1902): 16.

[23]Levi Wells Prentice has been studied by the late William H. Bender, Jr., and by William K. Verner of the Adirondack Museum. The latter, however, has dealt almost exclusively with Prentice's earlier work in landscape.

LEVI WELLS PRENTICE, *Apples in a Tin Pail.*
See plate 20, page 164.

No record has yet been found of Prentice's associations with other artists of the Brooklyn community, but Brooklyn at the time had its own art association and artistic identity, which was quite apart from that across the East River. Decker lived there, as did the older William Mason Brown; Prentice's theme in his many pictures of fruit pouring out of baskets onto the ground may have been a product of Brown's well-known chromolithographed *Basket of Peaches Overturned.* Other works by Prentice are tabletop pictures, in which fruit is often combined with attractive ceramic wares. Fruit seems to have been his sole still-life subject: either berries, cherries, or peaches, but especially apples and plums.

He is not known to have essayed the vertical still life, and although there is an astounding sharpness to his forms, which are often emphasized with dark outlines, one might question whether or not he should be regarded more as a primitive artist rather than as a conscious practitioner of trompe l'oeil; his earlier landscapes are somewhat primitive. However, there are several works by Prentice in which he achieves a quality of illusionism that is unsurpassed, notably in his best-known picture, *Apples in a Tin Pail* (1892). In this work, everything is sharply delineated, the fruit is brought up close to the front of the picture plane, and the color is deep and rich, totally without elegance. The fruit is aging, the board on which it sits is an old, chipped plank, and the monumental container is no choice piece of bric-a-brac but a mundane, functional tin pail, its lid barely visible behind. The contrast of the hard apples and still harder metallic pail is skillfully achieved, but what is especially astounding are the reflections of the apples in the gleaming metals, which are distorted in the curved circumference of the container. It is a marvelous illusion — not dissimilar to Edwin Elmer's magnifying-glass reflections — which contributes to a composition that is a symphony of curvilinear and globular forms. This still life is the artist's masterwork, but it is interesting to note that after many years of activity and after his death he was recalled as a landscape painter, one particularly adept "in depicting the glorious lake and mountain beauty of the Adirondacks."[24]

The fourth of this group of trompe l'oeil, or hard-edged, fruit painters was William John McCloskey, who had studied under Christian Schussele and Thomas Eakins at the school of the Pennsylvania Academy. McCloskey married Alberta Binford, who was a student of William Merritt Chase, in Denver in 1883. The following year, they settled in Los Angeles, among the earliest professional artists there. It appears that they were extremely peripatetic, and in the next decade or two, they were in England, France, Salt Lake City, San Francisco, and New York City, as well as Los Angeles. In fact, conflicting records show them to be on both sides of the Continent at the same time.[25] On the West Coast, McCloskey was best known as a portrait painter, but in Philadelphia, Brooklyn, and New York City he exhibited still-life paintings. These were the traditional apples, grapes, peaches, plums, and the like, but they included also pictures of citrus fruits — oranges, lemons, and tangerines. Only these last have so far come to light among McCloskey's still lifes, and while they suggest a limited subject range they are also fascinating and unique.

McCloskey painted tabletop, not vertical, still lifes, and as a fruit painter he was competent but not inspired. His oranges and lemons are somewhat simplified, their forms reflected in the highly polished wooden surface on which they rest. What really distinguishes him from his contemporaries is the tissue paper in which some of his fruit is always wrapped. The treat-

[24]"Death Claims Levi W. Prentice," *Journal of Commerce* 60 (7 December 1935): 9.

[25]For McCloskey, see Nancy Dustin Wall Moure, *Dictionary of Art and Artists in Southern California before 1930,* p. 157.

ment of this paper — white for wrapping oranges, pastel for lemons — is a marvel of illusionism, the thinness and transparency, the crinkly texture, the delicate coloration tinged by the orange or yellow citrus fruit within constituting the real subject of the painting. Almost inevitably, McCloskey's wrapped fruits are better painted than his unwrapped ones. "Master of the Wrapped Citrus" may seem an epithet that damns with faint praise, but such is McCloskey's distinction. McCloskey may seem further in aesthetic from Harnett and his followers than even Evans, Decker, or Prentice, but he shares with all the school a concern for the superreal, for deception that engages the viewer and makes him want to touch the display before him.

Figure 8.27. JOHN MCCLOSKEY (circa 1860?-1900s), *Still Life, Lemons;* oil on canvas, signed at lower left — *W. J. McCloskey*, 10 x 17 inches; Dora L. Foster.

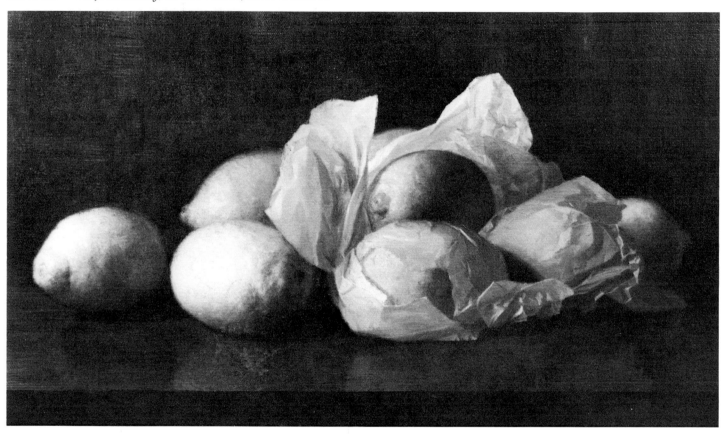

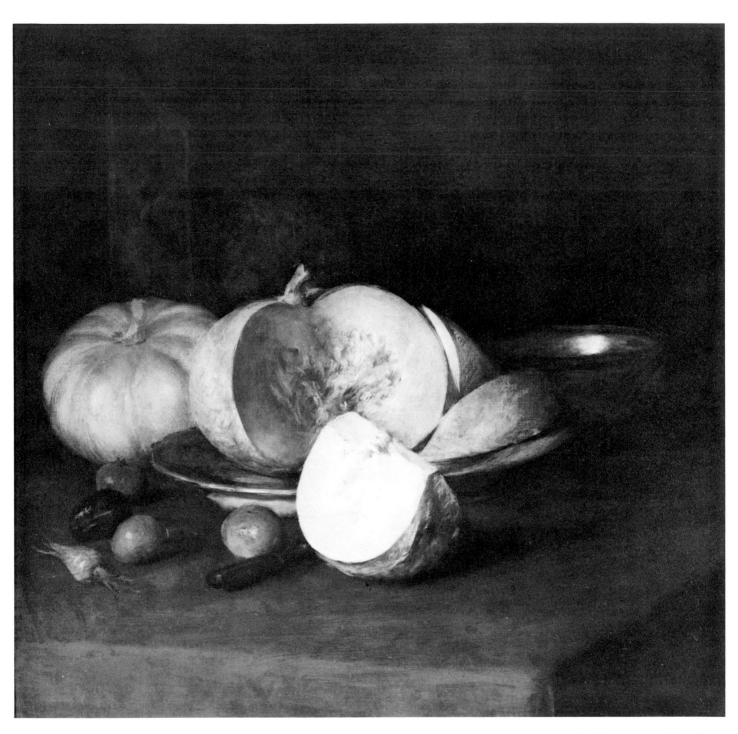

Figure 9.1. WILLIAM MERRITT CHASE (1849-1916), *Autumn Still Life;* oil on canvas, signed at upper right — *W M Chase,* 40 x 40¼ inches; The Pennsylvania Academy of the Fine Arts, presented by Joseph Nash Field, Chicago, as a memorial to Mrs. Frances Field.

9 The Still-Life Heritage of Munich and Paris

From the time that Benjamin West set foot upon Italian soil in 1760, American artists had realized the advantages of studying art in Europe and had recognized the limitations of schooling in their native land. Artists went abroad for various reasons. Some, like William Michael Harnett, went primarily to study and to emulate the Old Masters. Others went to work in the manner of contemporary European artists or to study with teachers of note such as West himself in London, Thomas Couture in France, and the several teachers of the academy in Düsseldorf, Germany, which attracted so many young Americans in the mid-nineteenth century. One European center or another was preferred by Americans at different times. The attraction of Munich and Paris was distinctly a late nineteenth-century phenomenon, although Americans did visit Munich earlier and some, such as John Vanderlyn, studied in Paris as early as the end of the eighteenth century.

Several factors were responsible for this mass exodus of American art students: the recognition of American inferiority in the arts by the end of the Civil War; the inadequacy of American artistic training; and a belief that this inferiority could be ameliorated by study abroad. Due in part to the success of this European training, American artists began to enter the mainstream of Western artistic development, qualitatively and stylistically, by routinely participating in the annual salon exhibitions in Paris.

This also coincided with the development of truly professional artistry in an international, cosmopolitan sense among American artists, and with the establishment of a complete professional structure in the American art world. Witness the growing network of commercial art galleries, the establishment of public museums in cities across America beginning in 1870, and the appearance of the first truly professional art critics in the 1860s and 1870s, some of whom we have met and who even deigned occasionally to comment on still-life painting — Clarence Cook, and a little later, Mariana Van Rensselaer, and William C. Brownell. In turn, these younger and more advanced European-trained artists brought home the manner they had learned and the ideals of professionalism they had witnessed abroad, from which resulted the establishment of art schools of note, such as the Art Students' League in New York City, and the new art organizations that exhibited the work of these more progres-

sive artists, such as the Society of American Artists, which was founded in 1877.

The history of these developments and the changes they wrought on the fabric of American artistic expression are not directly germane to our discussion here; figure painting was the form of art particularly encouraged by teachers in Munich and in Paris and for the first time became the dominant mode among American artists, but still life, too, was affected. The old hierarchy of thematic ranking was rapidly breaking down by the last decades of the century, and still lifes began to be more valued, either for their own intrinsic poetic expression or for the personal expressivity that the theme allowed the artist.

The latter was a quality particularly associated with the artists who were trained in Munich. As early as 1858, Munich was called the art capital of Europe in *The Crayon* magazine. Although it began to attract Americans in the early 1860s, it should be stressed that the attraction was not for any radical aesthetic but rather for the high standards of academic practices at the Royal Academy in Munich, which produced a grander classicism than was the standard in Düsseldorf. Even the artists who went to Munich in the 1870s, and who became the best-known Americans trained there — Frank Duveneck, William Merritt Chase, Walter Shirlaw, J. Frank Currier — were drawn to Munich because of its academy. The choice of Munich over Paris is a complex one, perhaps best analyzed on a one-by-one basis among the artists who made it. Many went to Munich because of their German heritage, which sometimes gave them the advantage of familiarity with the language; others understood more of Munich than of Paris because they lived in communities that had large German immigrant populations. Still others went because they preferred the nature of German art over French, or were importuned by their families to eschew Paris due to its reputation for decadence and immorality.

Midwestern communities such as Cincinnati and Indianapolis, with their large Germanic populations, provided many young art students who traveled to Munich. Frank Duveneck of Covington, Kentucky, across the Ohio River from Cincinnati, was one of the earliest of these. He is often thought of as the first American to study in Munich, but in fact he had a number of predecessors. He was, however, the first American to react favorably to the adoption of the aesthetic qualities of French Realism, as practiced by Gustave Courbet and as promoted by a group of young progressive German artists who were headed by Wilhelm Leibl. Courbet's work was exhibited in the first international exhibition held in Munich in 1869, with much resultant influence. Around Leibl developed in the early 1870s the *Leibl-Kreis*, a group of young painters who rejected the more pretentious subject matter favored by the academy, painting instead nonanecdotal aspects of humble peasant life infused with an emotional appeal brought about by the use of sumptuous and fluid brushwork, rich color, and dramatic *chiaroscuro*.[1]

This aesthetic became known in America as the "Munich Style," although it should be stressed that it was not the official style as practiced in the Munich Academy; and almost all the Americans who went to Munich studied at the academy, though many, such as Duveneck, gravitated toward instructors who were sympathetic to the innovations of Leibl and his followers. Though Duveneck's style reflects the influence of Leibl and

[1]For Munich and the Americans, see Axel von Saldern, *Triumph of Realism* (exhibition catalogue; The Brooklyn Museum, 1967); Michael Quick, *Munich and American Realism* (exhibition catalogue; Cincinnati Art Museum, 1978); and Aloysius George Weimer, "Munich Period in American Art" (Ph.D. diss., University of Michigan, 1940). There is a large contemporary literature in American periodicals concerning Munich, dealing with the state of art in Munich, the teaching at the Munich Academy, and student life there.

Courbet as well as that of the baroque Old Masters, such as Frans Hals and Rembrandt (note his use of a loaded brush, creating broadly defined forms with vivid painterly textures), he and his American colleagues still competed for academic prizes and sought commendation from official masters of the school such as Karl von Piloty.[2]

On his return to Cincinnati in 1873, Duveneck was acclaimed for his artistry, but he found little patronage among the local population that remained more comfortable with the anecdotal style of the Düsseldorf masters. Exhibiting a group of works in Boston in 1875, however, he won the acclaim of the doyen of contemporary artists there, William Morris Hunt, after which he returned to Munich to begin a second career as a teacher. A large number of American art students were trained by him, and that training was so influential that they were referred to as the "Duveneck Boys." Through his teaching in Munich, Florence, and Venice, and later for many years in Cincinnati, Duveneck instilled a vitality into the works of many American painters of note.

Duveneck was emphatically not a still-life painter. Only one work of significance on that theme is presently known and located, but it is perhaps the outstanding example of the Munich style in still-life painting. This work, *Still Life with Watermelon*, was probably painted in the late 1870s, when Duveneck's art was still infused with a vitality and drama that gradually lessened in the following decade as it did, indeed, in the work of Leibl, his mentor. In this picture, an assortment of studio props and fruits were chosen and arranged for maximum contrast and drama in form, shape, and outline, and yet they are subordinated to the vital expressivity of the artist's technique. The paint is laid on broadly, with the sweeping brushstrokes remaining visible and, in fact, infusing the whole work with the imprint of activity. There is no concern in this picture for the botanical examination that can be found in the earlier works of a George Henry Hall, nor the poetic lyricism of a John La Farge, in illusionism, or even in the assembling of objects that related rationally to a meal. It is the *act of painting* itself that is demonstrated here, the artist reveling in his own profession and in his ability to express his skill in its practice. The artist's professional vitality is expressed through his manipulation of still-life forms that are as skillful and unlabored as his more typical figures, and with a remarkably rich and varied colorism; Duveneck usually exhibited a preference for neutral tones with strong contrasts and *chiaroscuro*.

Walter Shirlaw and J. Frank Currier also painted still lifes occasionally and also in a vigorous, expressive mode. However, of all the major American artists who studied in Munich, the one most associated with still life is William Merritt Chase, who not only painted a great many pictures on that theme but also sustained the interest throughout his career. Like Duveneck, Chase was from the Midwest and was given his first formal instruction by Benjamin Hays, an Indiana painter.[3] Chase went to New York in 1869, then returned to the Midwest, and worked in St. Louis in 1871; at this time, he was primarily a still-life painter, and a number of his works from this period have begun to surface. They vary greatly both in quality and in style, but some of them reflect an interest in the work of William Mason Brown, who was one of the most highly regarded of American specialists in 1870-1871, however much his work may differ from the mature still-life style that Chase developed later. Chase himself said of *Catawba Grapes and Blue Plums* — one of the first two pictures he ever exhibited — that every grape was highly

[2]For Duveneck, see especially Norbert Heerman, *Frank Duveneck* (Boston and New York, 1918); *Exhibition of the Work of Frank Duveneck* (Cincinnati Art Museum, 1936); and Josephine W. Duveneck, *Frank Duveneck Painter-Teacher* (San Francisco, 1970).

FRANK DUVENECK, *Still Life with Watermelon*. See plate 21, page 165.

[3]The periodical and exhibition catalogue literature devoted to Chase is extremely extensive. The two full-length studies of his art are Katherine Metcalf Roof, *The Life and Art of William Merritt Chase*, and Ronald G. Pisano, *William Merritt Chase* (New York, 1979). Pisano is also preparing a major catalogue and exhibition of Chase's work.

[4]This is quoted in Roof, *Life and Art of Chase*, p. 22. However, Chase exhibited two still lifes, separate pictures of *Catawba Grapes* and *Blue Plums*, twice, in 1871. The first showing was at the National Academy of Design in the spring and the second was in October at the St. Louis Mercantile Library.

polished and showed the reflections of surrounding objects, a description fitting equally the style of Brown.[4] Chase found these early pictures highly salable. Attracting sufficient interest among local patrons in St. Louis, they were convinced to raise enough money so that he could go abroad in 1872 to study at the academy in Munich. Chase studied with Piloty, but his work in Munich also exhibits the influence of the *Leibl Kreis*; he shared a studio with Duveneck after the latter's return to Munich in 1875. Though he continued to paint still lifes, few of Chase's Munich works in that genre are known today. Likewise, though his associations with his fellow Americans were plentiful and are documented, those he may have enjoyed with contemporary young German artists remain undefined; one would wish particularly to be able to relate his still-life oeuvre with that of the leading specialist among the *Leibl-Kreis,* Karl Schuch.

Chase was open to far more diverse influences than Duveneck, and the painting that was done during his trip to Venice in 1877 and after his return to New York the following year can be related to the art of Manet, Sargent, Whistler, and the impressionists. His later still-life production, however, is a fairly unified body of work. Chase's work suggests a combination of dark, dramatic Munich bravura handling with the kitchen themes that was prominent in the eighteenth-century work of Jean-Baptiste Siméon Chardin, which was enjoying a great revival in the later decades of the nineteenth century. In fact, Chase's still lifes are often closest in style to the work of Antoine Vollon, one of the leading French painters who was involved in the Chardin revival. It is significant that in a 1912 sale of paintings belonging to Chase there were numerous examples by Vollon, including eight still lifes.

Chase painted a fair number of fruit pictures in which melons and pumpkins were featured, a preference he shared with Vollon. Some of these, such as his *Autumn Still Life* of pumpkins, are very large pictures, and a few are square, a format introduced into American art in the 1880s and 1890s by Albert Pinkham Ryder and John Twachtman. The square format was adopted most often for landscape, but Chase utilized it a number of times in paintings of other themes. Here, it successfully enframes a strongly centralized composition of balanced, rounded shapes centered upon the cut pumpkin in a flat, round dish. This is balanced by the pumpkin slice in the foreground, the whole pumpkin at the rear left, and the ubiquitous copper pot at the rear right. What interests Chase here — as it interested Vollon also in his melon pictures — is not the botanical anatomy of the fruit, but the bold coloration of brilliant pumpkins against the darkened interior background, and the opportunity to display rich but controlled painted surfaces. Pumpkins were not prevalent in American art, although Winslow Homer painted a notable series of watercolors depicting pumpkin fields, and other nineteenth-century genre painters such as John Whetton Ehninger featured them occasionally. One might consider the theme as an indigenous one, associated as it is with Thanksgiving and the Pilgrims in the New World. But in view of Chase's cosmopolitan training, habits, and attitudes, that consideration in regard to this particular still life is, in all likelihood, remote. He occasionally painted flowers, both in oil and pastel, the latter a medium whose American revival he helped pioneer in the 1880s. But, with Vollon, his favorite area in still life was the kitchen piece, often featuring large, dramatic copper dishes along with edibles that were not intrinsically elegant or decorative. Various kinds of fish were Chase's most frequent subjects. Vollon, too, painted many fish pictures.

Chase's fish pictures were painted in his later years — the last decade of the nineteenth century and the early years of the twentieth — at the same time that he was painting bright, light, semi-impressionist landscapes of the Shinnecock hills and dunes on Long Island, where he had a summer studio and an outdoor art school. The still lifes, however, do not reflect any interest in outdoor light or atmosphere; they are studio arrangements in which dark backgrounds provide an ideal foil for the white and silver surfaces of his fish. As Duveneck's watermelon was no botanical specimen, so Chase's fish suggest none of the verisimilitude of Samuel Brookes's denizens of the deep, with their lifelike scaly textures and pearly coloration. The Munich tradition was maintained by Chase in these pictures long after he had abandoned its dramatic *chiaroscuro*, and even after he had modulated its expressive brushwork, in his figure and landscape painting.

Figure 9.2. WILLIAM MERRITT CHASE (1849-1916), *Still Life, Fish,* 1912; oil on canvas, signed at lower left — *Wm M. Chase,* 32⅛ x 39⁹⁄₁₆ inches; The Brooklyn Museum, J. B. Woodward Memorial Fund.

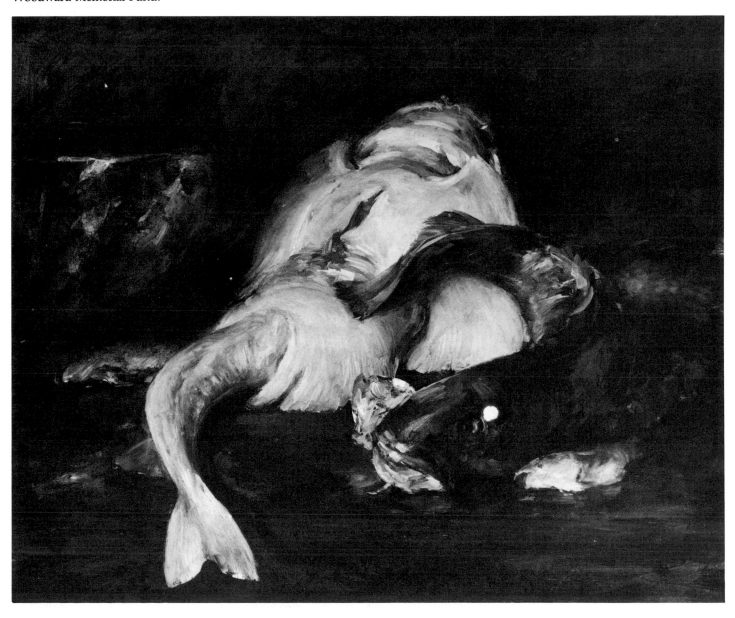

Chase was a rapid painter who usually finished a still life in less than one day. He would often start a picture in the morning, working with a quick-drying solution that would assume a tacky finish by the time he returned to the studio from lunch, which allowed him to apply the final touches. Of course, swiftness of execution was not only desirable but also necessary when painting dead fish. The best-known anecdote of Chase's involvement with still life relates to *The English Cod* (1904, Corcoran Gallery of Art, Washington, D.C.), a painting of a fish he had rented from a fishmonger's stall. When the painting took longer than the two hours for which the artist had contracted, the fishmonger went to Chase's studio to retrieve the cod so that he could sell it, but he was so impressed by the artist's skill that he refused the additional payment that Chase offered. Chase sold the work in America soon after, and on his return to England the next summer offered the fishmonger an honorarium for his share in the effort, but the merchant refused, only requesting a photograph Chase had made of the fish painting.[5]

The great critic and collector Duncan Phillips recognized that Chase was "unequalled by any other painter in the representation of the shiny, slippery fishiness of fish," and Chase himself speculated that he might be remembered as a painter of fish.[6] The attraction of such fish pictures is perhaps difficult to comprehend today, but Chase made this sub-genre dramatic and alive — alive as painting, not as fish, of course — often contrasting in color and in *chiaroscuro* the different kinds of fish, and, in turn, juxtaposing the slithering forms with the firm structure of the brass and copper pots he favored, and again contrasting the gleaming gold of the metal with the cool silvery tones of the fish.

Copper pots and fish were noted features of Chardin's work. The ray is found in a number of Chase's finest fish pictures, as it is the principal feature of the most famous of Chardin's fish paintings. Chase's fish pictures, too, are emphatically "kitchen pieces," not only in their lack of dining-room elegance, but in the relationship of their several components. These are not formal arrangements of objects that are combined in an abstract pattern; the pots and cauldrons are the logical containers in which to cook the fish, thus preparing a meal of them. Not only the individual components of the pictures but also their relationship and the activities they suggest are experiential in terms of daily life.

"If you can paint a pot, you can paint an angel," Chase is said to have stated. For our first historian of still-life painting, there was no mystery and little analysis in Chase's art. He was not the painter of the inwardness of things.[7] He was, however, a master teacher of technique and of the expressiveness of the act of painting, dynamic and yet controlled, which was the great heritage of Munich. It was a heritage Chase communicated to scores, even hundreds, of pupils, making him the greatest art teacher of his age, however much some of those pupils reacted against such an art for its own sake.

Robert Henri and the other members of the Ashcan School — including those eight artists who exhibited together at the Macbeth Gallery in New York City in 1908 — believed rather, according to Henri, in "Art for Life's Sake." As such, still-life painting, so often devoid of social or moral purpose, had little place in the artistic production of most of them, though we shall discuss later the concerns of Maurice Prendergast and William Glackens, the two members of "The Eight" who were most involved with fruit

[5]Roof, *Life and Art of Chase*, pp. 216-18. For Chase's painting of fish, see also William Henry Fox, "Chase on Still Life," *Brooklyn Museum Quarterly* 1 (January 1915): 196-200.

[6]Duncan Phillips, "William M. Chase," *The American Magazine of Art* 8 (December 1916): 49, and Fox, "Chase on Still Life," p. 199.

[7]Arthur Edwin Bye, *Pots and Pans or Studies in Still-Life Painting*, p. 202.

and flower painting. For the most part, however, the more socially conscious artists of the group avoided still life — but, not completely. Several still lifes by John Sloan are known, as is one by Henri himself; one of the most dramatic still lifes of the early twentieth century is a large flower piece painted by George Luks. Luks's *October Flowers* (1920) is painted with the artist's distinctive and characteristic, almost Tachiste, flat brushstrokes; pigment is thickly applied in chromatic contrast against the dark background. There is a degree of bravura that would most probably have appeared undisciplined to an academically trained artist such as Chase, but Luks's painting, with its exuberant enjoyment of the sheer act of artistic creation and with its willful ignoring of botanical verisimilitude, is part of the heritage of the Munich tradition, of which Chase was the greatest still-life practitioner.

GEORGE LUKS, *October Flowers*. See plate 22, page 166.

The Munich tradition in the training and development of American artists in the late nineteenth century was a strong one. Critics of the early exhibitions of the Society of American Artists in the late 1870s and early 1880s regarded the shows as reflective of Munich standards, but this gave way rather quickly to a recognition of the dominance of Parisian artistic ideals. The great majority of American painters in the late nineteenth century sought European training, and most of them studied in Paris, at the École des Beaux-Arts and at private ateliers. Indeed, many of the painters who went to Munich in the 1870s and returned to this country went back for further study in the 1880s — but to Paris. John Twachtman was only the best known of these.

Even in the scholarly studies that are beginning to appear concerning the nature of academic training, the role that still life played in such training, if any, has been ignored.[8] Although a special committee called for a still-life class at the National Academy of Design in New York City as early as 1870 — one was taught there by Thomas Le Clear three years later, which was followed by classes emphasizing still life at the Pennsylvania Academy of the Fine Arts in Philadelphia in the late 1870s and early 1880s — still-life classes were not institutionalized in the United States until they were regularly offered by Chase at the Art Students' League and by Francis C. Jones at the National Academy in the 1890s.[9] Europe may not have been more advanced in this regard. Certainly, for the young Americans beginning to study in Paris in the later 1860s, which developed into a ground swell in the succeeding decades, figure painting was paramount to their training and to the works they painted for exhibition at the salon and back in America. Many of the Americans also spent their summers in the French countryside; some painted scenes of peasant life, while others depicted the landscape, particularly of Brittany and of Normandy. Yet, still life may have been of greater interest for them than has been recognized. In the Salon of 1868, for instance, William Babcock, Elizabeth Gardner, Louis Comfort Tiffany, and Milne Ramsey were all represented by still-life paintings; presumably, as the years went on and as more Americans exhibited at the salons, the number of examples of still life by them would have correspondingly increased.[10]

Similarly, the evidence is far too meager at present to associate still-life interest among Parisian-trained Americans with inspiration drawn from their respective academic masters. A few still lifes do exist by that leading French instructor of Americans of an earlier generation, Thomas Couture. However, still-life painting is not associated with any of the leading aca-

[8] The outstanding work here is Albert Boime, *The Academy and French Painting in the Nineteenth Century* (London, 1971).

[9] See the brilliant essay by Doreen Bolger, "The Education of the American Artist," in *In This Academy: The Pennsylvania Academy of the Fine Arts, 1805-1976* (exhibition catalogue; The Pennsylvania Academy of the Fine Arts, Philadelphia, 1976).

[10] I am grateful to Dr. H. Barbara Weinberg for information on the still lifes in the Salon of 1868; Dr. Weinberg and Dr. Lois Fink are both working on the fascinating subject of the Americans in Paris in the late nineteenth century and those who exhibited in the salon exhibitions there.

demic masters and instructors of the last four decades of the century who taught at the École des Beaux-Arts or the leading private ateliers such as Julian's or Colarossi's — masters such as Gérôme, Bouguereau, Cabanel, Lefèbvre, Dagnan-Bouveret, Boulanger, Robert-Fleury, Herbert, Laurens, and Benjamin-Constant. Perhaps they painted still life for their private delectation, but if they did so it was seldom and not for public exhibition. Therefore, one cannot even speculate upon the instruction or encouragement those masters might have given to their pupils who evinced an interest in still-life painting. Most likely, the pupils were encouraged to consider still life only in terms of the simplest practice work and to concentrate rather on more challenging figural themes. Yet, some of these American pupils of French masters did produce an occasional still life, and a few went on to produce a sizable still-life oeuvre of great distinction in addition to their more numerous figure and landscape paintings.

Figure 9.3. THOMAS HOVENDEN (1840-1895), *Peonies,* 1886; oil on canvas, signed at lower left — *H,* 19½ x 24 inches; The Pennsylvania Academy of the Fine Arts, gift of Mrs. Edward H. Coates in memory of Edward H. Coates.

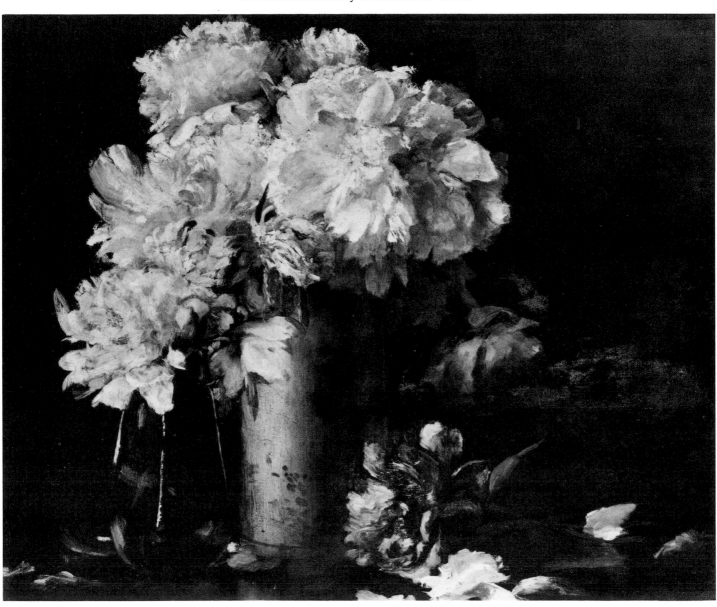

Alexandre Cabanel was one of the leading academic French painters of the period, due to the success of his *Birth of Venus* (1863), several replicas of which came early into American collections (Pennsylvania Academy of the Fine Arts; Metropolitan Museum of Art). Cabanel had a number of American pupils who became well known as artists, and some also as teachers, after their return to the United States. One of the ablest and probably the most renowned was Thomas Hovenden. Hovenden was strictly a figure painter. His *Peonies* (1886) is a rare, perhaps unique, still life by him.[11] His breadth of painterly treatment does not suggest his academic heritage, being rather more related, in brushwork if not in color, to his later semi-impressionistic landscapes. This, and the strong *chiaroscuro*, suggests some relationship to the work of Chase, an artist whom Hovenden admired and from whom he purchased a picture of *Flowers* and six other paintings in 1891. The chromatic breadth of pinks and whites in the peonies against the

[11]I am much indebted to Prof. Anne Gregory Terhune for information on Hovenden and his still life *Peonies;* Professor Terhune is writing a dissertation on Hovenden for the City University of New York.

Figure 9.4. DENNIS MILLER BUNKER, *Vase with Yellow Rose;* oil on canvas, signed at upper right — *D.M.B./1887*, 14 x 12 inches; Mr. and Mrs. Jared I. Edwards.

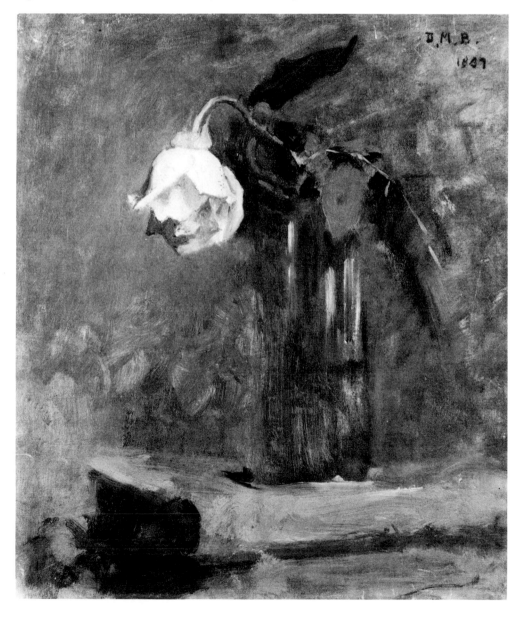

[12]I am very grateful to Prof. Gerald M. Ackerman of Pomona College who informs me that the only still life he has located by Gérôme is of dead game; letter of 12 January 1981.

[13]Quoted in R. H. Ives Gammell, *Dennis Miller Bunker*, p. 73. For the "pure" still lifes of roses by Bunker, see *Dennis Miller Bunker (1861-1890) Rediscovered*, essay by Charles B. Ferguson (exhibition catalogue; New Britain Museum of American Art, 1978).

[14]Thayer's still lifes are discussed most perceptively in the standard monograph on him, Nelson C. White, *Abbott H. Thayer: Painter and Naturalist*, p. 215; the pictures of water lilies are discussed on pp. 49-50.

[15]See the "Introduction" by Virgil Barker to *Abbott H. Thayer Memorial Exhibition* (exhibition catalogue; Corcoran Gallery of Art, Washington, D.C., 1922), p. viii.

[16]Maria Oakey Dewing, "Abbott Thayer — A Portrait and an Appreciation," *International Studio* 74 (August 1921): vii-xiv.

blue green vases is also unusual for the artist and was much admired when the picture was exhibited in New York City at the National Academy of Design in 1893.

The subject of peonies, as we have seen, is drawn from the popular, Oriental-inspired artistic trends of the late nineteenth century, and many depictions of these flowers are recorded. Peonies also lend themselves to freer, more painterly, treatment than do the more linearly defined flowers such as roses, which would themselves seem more academically and traditionally appealing. A large number of paintings featuring roses are known by pupils of the most popular of all the French academic masters, Jean-Léon Gérôme. Since Hovenden's *Peonies* is the only still life so far located by a pupil of Cabanel, and since no flower paintings at all are known by either Cabanel or Gérôme themselves, it would be folly to equate either subject preferences or stylistic emphasis to the influence or instruction of one or another master.[12]

Dennis Bunker studied in Paris between 1882 and 1885, primarily with Gérôme. He returned to this country, settling in Boston, in the fall of 1885, and within the next year or so executed a number of paintings of roses, probably as gifts and tributes to friends rather than as works for exhibition or sale. Similar to these is the rose still life that accompanies his *Portrait of Anne Page* (1887, Private Collection), which is integral, both in form and expression, with the human subject. In a letter written to Anne Page in 1886, Bunker stated his credo:

> The highest phase of art is to be perfectly lovely, gorgeous, or beautiful, beautiful through some quality of light or life or solemnity, or richness or loving elaboration of delicate form, anything so that it be a gracious beautiful canvas to look at — leaves, flowers or faces or limbs or draperies or skies.[13]

Such a credo would seem to inform even more fully the few known still lifes of roses by Abbott Thayer, who was also a pupil of Gérôme and a close friend of Bunker, the two having met in 1882 before Bunker went to Europe. On his return to America, Bunker renewed his friendship with Thayer and spent the summer of 1886 at South Woodstock, Connecticut, with the older artist; this was probably the period of his several known still lifes. Thayer painted a number of flower studies at the same time, though his several known pictures of roses, his most beautiful still lifes, are all undated. His rose paintings are more monumental than those known by Bunker, but they express a similar spirit, and the two artists may have shared a mutual influence and inspiration.[14] As Virgil Barker stated of Thayer in 1922, "A bowl of roses in his hands becomes more than a flower-piece; it is a glimpse into the very center of beauty,"[15] a declaration that is similar to Bunker's letter to Anne Page.

About 1886, also, Thayer painted at least one picture of water lilies. The theme and even its presentation would suggest the somewhat earlier still lifes of John La Farge, and indeed the rose pictures of Bunker and Thayer suggest a relationship with, and continuation of, the poetic spirit of La Farge's work. It is not surprising that one of the finest tributes to Thayer was written by La Farge's pupil and follower, Maria Oakey Dewing, herself a notable flower painter.[16] Still another pupil of Gérôme, and one who produced a really sizable group of still lifes, was Julian Alden Weir. Despite the much and long acknowledged admiration for Gérôme's art and the appreciation of his teaching on the part of Weir and of many of his other

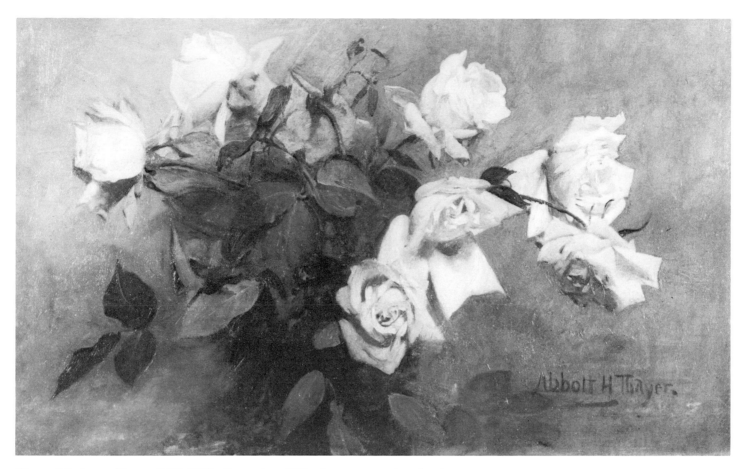

Figure 9.5. ABBOTT THAYER (1849-1921), *Roses,* circa 1897; oil on canvas, signed at lower right — *Abbot H. Thayer,* 12 x 20 inches; Collection of Mr. and Mrs. Raymond J. Horowitz.

pupils, Weir's still lifes, again, suggest the heritage of La Farge. Indeed, Weir's rose pictures of the 1880s undeniably reflect the fragile beauty and pictorial fragrance of the still lifes of the earlier master.

Weir had studied in Paris with Gérôme between 1873 and 1877. Although he was later to be counted as one of the leading American impressionists, and was a member of the organization "The Ten" that has been termed an academy of American impressionism, during his years of study he expressed revulsion at the new movement. Weir continued to paint still lifes into the early twentieth century, but the decade of the 1880s saw the finest and greatest number of these works, which were painted before he turned to the impressionist aesthetic in the 1890s. The still lifes of the 1880s are not at all impressionist; one of the best known, *The Delft Plate* (1888, Museum of Fine Arts, Boston), suggests the vigorous brushwork and strong *chiaroscuro* of Munich where he did not study or, perhaps more aptly, the painting of Edouard Manet, whose art Weir had come to admire by that time.

Weir also painted still lifes of vegetables and of dead game; one of the latter, his *Still Life with Pheasant* (1889, Wadsworth Atheneum, Hartford), was owned by his friend and fellow impressionist, Childe Hassam. But most of his works in this genre are flower pictures, and while he depicted the popular softer, airier flowers of the day — chrysanthemums, peonies, and lilacs — his real preference was for the rose. These sometimes appear as

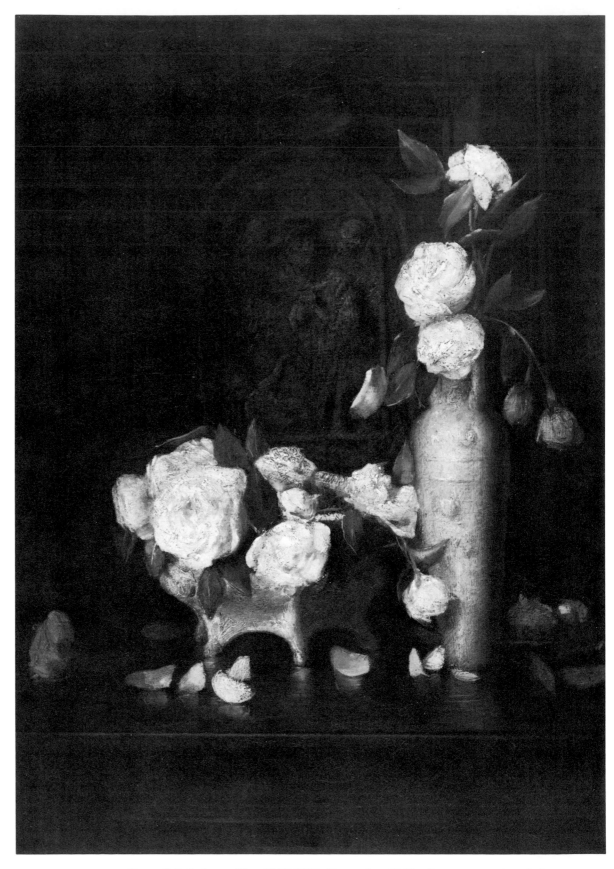

Figure 9.6. J. ALDEN WEIR (1852-1919), *Roses*, circa 1884; oil on canvas, signed at upper right — *J. Alden Weir*, 35½ x 24¾ inches; The Phillips Collection, Washington.

accessories in his figure pieces, similar to Bunker's *Anne Page*. Some of the pure still lifes are simple, a single sprig of roses on a tabletop. Others are of elaborate flowers that are combined with ornate and expensive silver, china, and glass. On the one hand, soft fragility is contrasted with hard gleaming objects, the transient with the antique; on the other, the natural and the man-made share a common beauty. Mariana van Rensselaer was quite correct and perceptive in 1888 to equate Weir with La Farge as "the best American painters of flowers . . . both of whom paint flowers beautifully in the most poetic way."[17] Five years later, she again expressed her admiration for their work, though she now distinguished between their styles. Speaking of La Farge's flowers, she wrote:

> . . . he paints in a different way from any one else — poetizing them, not by enwrapping them in mist like Mr. Weir, but by carefully defining their forms with a hand so delicate and with color so lovely that, while faithfully following Nature, he seems almost to have improved upon her.[18]

Weir's greatest champion, however, was Duncan Phillips, who wrote of the artist's still lifes, after his death, that "these things possess so delicious and unctuous a pigment, so charmingly rendering their subjects with especial regard to richness of tone and texture, that they would make Weir sure of a reputation as a painter's painter even if he had not gone on to greater achievements."[19] And later, in regard to one of Weir's paintings of roses, Phillips commented that it was "another dark picture more or less influenced by Munich and unctuous in color and brush work. The spirit, however, is not that of virtuosity. This still life is as solemn as a prayer."[20]

In the 1880s and after, Weir was much associated with his close friend and colleague John Twachtman, who had left Cincinnati to study in Munich in the 1870s but in 1883 went to Paris to study at the Académie Julian. At that time, Twachtman deserted the dark and dramatic style of Munich for an evocative approach to landscape interpretation based upon closely modulated tonal relationships and careful, asymmetric arrangements of form that suggest the influence of Whistler and of Oriental art. By 1889, Twachtman was living near Weir in Connecticut, and there he developed the semi-impressionist style for which he is best known.[21]

Unlike Weir, Twachtman confined his art almost totally to the landscape, although he painted a few figure pictures and several still lifes, including his *Still Life: Flowers in a Vase* (Pennsylvania Academy of the Fine Arts). Of greater interest, however, are his outdoor garden pictures of flowers growing in pots, of azalea bushes, of meadow flowers, and tiger lilies, painted in a broad and free impressionist manner, both in oil and in pastel. Twachtman was one of the finest and most original artists to investigate the pastel medium. Beginning sometime in the second half of the 1880s, he participated in the revival of interest in pastel that had its roots in Europe in the 1860s and 1870s with the work of Millet and Whistler.[22]

Twachtman's garden pictures differ from the previously described nature studies that were painted by Worthington Whittredge and others in that the viewer does not zero in upon growing, living flowers. In those earlier nature studies, the flower or fruit is studied individually, and the formal arrangement of these specific objects is the basic subject of the picture, however much the natural growth process is meant to be suggested. But in Twachtman's garden pictures it is the landscape itself that is primary; one might think of these paintings as "near-landscapes" as con-

[17]Mariana van Rensselaer, "Flower and Fruit Pictures at the Academy of Design," *Garden and Forest* 1 (25 April 1888): 107.

[18]Mariana van Rensselaer, "Exhibitions: Flower Pictures at the Academy of Design," *Garden and Forest* 6 (15 February 1893): 83.

[19]Duncan Phillips, "J. Alden Weir," *Art Bulletin* 2 (June 1920): 199, reprinted in Phillips et al., *Julian Alden Weir: An Appreciation of His Life and Works*, p. 23. The standard monograph on Weir is by his daughter, Dorothy Weir Young, *The Life and Letters of J. Alden Weir* (New Haven, 1960).

[20]Duncan Phillips, "American Old Masters," *A Bulletin of the Phillips Collection Containing a Catalogue and Notes of Interpretation Relating to a Tri-Unit Exhibition of Painting and Sculpture* (Phillips Memorial Art Gallery, Washington, D.C., February-May 1928), pp. 31-32.

[21]The most recent monograph on Twachtman is Richard J. Boyle, *John Twachtman* (New York, 1979).

[22]See the catalogues of Twachtman's work included in John Douglass Hale, "The Life and Creative Development of John H. Twachtman," 2 vols. (Ph.D. diss., Ohio State University, 1957).

Figure 9.7. JOHN HENRY TWACHTMAN (1853-1902), *Meadow Flowers*; oil on canvas, signed at lower left — *J H Twachtman*, 33¹/₁₆ x 22¹/₁₆ inches; The Brooklyn Museum, Polhemus Fund.

[23]William H. Gerdts is organizing an exhibition of late nineteenth-century American paintings of the floral environment to be presented by the Montclair Art Museum, Montclair, New Jersey, in 1983.

trasted with the more traditional views of flowing and open space. In these "near-landscapes," the specific flowers are often the dominant color accents or formal foci, but they are incorporated into the setting rather than individually defined. As such, therefore, they perhaps should not be thought of as still life at all. Yet, they are flower pictures, and they are indicative, in fact, of a major direction taken in the painting and interpretation of flowers at the end of the nineteenth century. This development is presently unstudied, but it is an artistic phenomenon that resulted in a large number of very beautiful pictures.[23] While the traditional floral bouquets in vases or in other containers on tabletops continued to be popular with artists and patrons alike, the flower moved out of the single container, sometimes filling a room but more often studied in the outdoors, in flower markets, in gardens, and in open fields, so that such pictures are at once landscapes *and* still lifes, with the distinction between the two genres becoming blurred. Although garden pictures were painted earlier in America, the increased popularity of this

Figure 9.8. JOHN TWACHTMAN (1853-1902); *In The Greenhouse*, circa 1890-1902; oil on canvas, signed at lower right — *J. H. Twachtman*, 25 x 16 inches; North Carolina Museum of Art.

form was a development of the late nineteenth century. Twachtman's work was part of this development. Strangely, while Weir painted a great many formal floral still lifes, he was one of the few American artists associated with the impressionist movement who did not attempt the garden picture, despite his subsequent turn in the 1890s to landscape painting.

An artist whose reputation has only recently been revived and who became a specialist in this theme was Abbott Fuller Graves, of Boston. An important early article on Graves, in fact, was entitled "A Painter of Colorful Gardens."[24] Graves was considered the finest flower painter in Boston even before he went to Paris in 1884 to study specifically flower painting. When he returned to Boston, he began to teach flower painting at the Cowles School. In 1887, Graves again went to Paris, this time to study figure painting at the Académie Julian. The garden pictures, which were the majority of his artistic production after his return in 1891, usually included figures — lovely women in floral settings and in gardens from lands as distant as Spain and South America.[25] The paintings Graves produced after his years of European study are broadly painted in thick impasto with bright color and sunlight; they are attractive decorative pictures.

An earlier, much more tonal manner is shown in Graves's unusual *Chrysanthemum Show* (1886), depicting the dramatically lighted floral display that took place at Horticultural Hall, but this is essentially a subject picture describing a feature of life in Boston, which combines flowers and the figure in an urban setting.[26] The painting is not unlike some of the better known early views of Boston painted at the same time by Graves's good friend and colleague Childe Hassam, who was also teaching at the time at the Cowles School. Graves may have been *the* specialist in the garden picture, but Hassam was the most significant figure in its development. Hassam began to paint garden pictures on his second stay abroad from 1886 to 1889, during which time he studied at the Académie Julian. The earliest of Hassam's garden pictures that is located so far dates from 1887; the subject appeared frequently in his oeuvre for the next ten years and sporadically thereafter. Graves's *Chrysanthemum Show*, a large, major work, was painted a year before Hassam's earliest known garden painting, and one might speculate as to its role in prompting Hassam to investigate pictures of floral environment, given the friendship of the two artists and the similarity of their formal styles at the time. However, the early professional years of the two have not been studied enough to allow firm conclusions.

The period from the mid-1880s to the end of the century constitutes the heyday of garden painting, although of course many artists continued to paint the subject after that time. Hassam's garden pictures developed concurrently with his adoption of the impressionist palette and technique, and certainly Monet's impressionist example, particularly of gardens and poppy fields, was crucial to this phase of Hassam's art. Hassam followed up his depictions of French gardens and floral settings with the recording of the flower gardens cultivated by his close friend, the poet Celia Thaxter, on the Island of Appledore, one of the Isles of Shoals off the coast of New Hampshire and Maine. Hassam began to paint these views of her gardens of poppies and other flowers, with the sea beyond, in 1890. One of them, dated 1892, depicts Celia herself in the midst of those gardens (National Museum of American Art, Washington, D.C.). A lasting memorial to those gardens and to Hassam's association with Celia was her book, *An Island*

[24]George Alfred Williams, "A Painter of Colorful Gardens [Abbott Graves]," *International Studio* 76 (January 1923): 304-9.

[25]The most recent study of Graves is Joyce Butler, *Abbott Fuller Graves, 1859-1936* (exhibition catalogue; Brick Store Museum, Kennebunk, Maine, 1979).

[26]Graves's early flower pictures are very thoroughly and perceptively discussed in the section devoted to him in Frank T. Robinson, *Living New England Artists*, pp. 83-88. The *Chrysanthemum Show* is specifically mentioned on p. 87.

ABBOTT GRAVES, *The Chrysanthemum Show*. See plate 23, page 167.

CHILDE HASSAM, *Vase of Roses*. See plate 24, page 168.

Figure 9.9. CHILDE HASSAM (1859-1935), *The Room of Flowers*, 1894; oil on canvas, signed at bottom center — *Childe Hassam-1894*, 34 x 34 inches; Arthur G. Altschul.

Garden, which includes reproductions of Hassam's watercolors and which was published in 1894, the year of Celia's death.[27]

Hassam shared Celia's love of flowers and undertook to record the floral environment in varied ways. Another of his major works painted in Appledore is *The Room of Flowers* (1894, Arthur G. Altschul Collection), in which a woman, not Celia, is almost lost in the flower-filled clutter of the lived-in room. One Parisian critic felt that the picture should have been entitled *"Cherchez le Femme,"* but in fact the room and the flowers *were* Celia.[28] Hassam also painted flower markets and stalls, stands of potted plants, flowers in backyards and on rooftops, and, of course, an occasional pure still life. Only about a dozen of these are presently known, one of the most beautiful of which is his *Vase of Roses* (1890), which was painted at the height of Hassam's interest in flowers and, indeed, at the peak of his abilities in general. The painting is more formal and traditional than his outdoor flower pictures, and more academic, too — most American painters reflected their Parisian training more completely when they moved indoors. Yet, it is painted in the full chromaticism of Hassam's involvement with impressionism, and the brushwork is exuberant, more ridged and "gutsy" than that of Monet and of most French impressionist artists. All is sparkling and alive: reflections swim on the tabletop, the glass bowl gleams, and the

[27]For Hassam, see Adeline Adams, *Childe Hassam*, and Donelson H. Hoopes, *Childe Hassam*. Also see the essay by William H. Gerdts in *American Impressionism* (exhibition catalogue; The Henry Art Gallery, University of Washington, Seattle, 1980), pp. 57-64. That volume has extensive bibliographies on most of the artists discussed in this chapter, but most of these references mention still life only incidentally. The author would also like to thank Stuart Feld, Director, Hirschl & Adler Galleries, Inc., New York City, who is compiling a catalogue of the work of Childe Hassam and generously allowed the author to consult his extensive files for information on the garden pictures and the formal still lifes of Hassam.

[28]Adams, *Childe Hassam*, p. 83.

yellow and pink roses are full of vitality. Some flowers and petals have fallen on the table, but in place of traditional suggestions of frailty and transience as in the work of Lambdin or La Farge, these convey a sense of having fallen from the bouquet out of bursting abundance.

By the time of the Columbian Exposition in Chicago in 1893, and thereafter for about two decades, impressionism was a dominant aesthetic in American art. Among the many artists who adopted it were a number who painted the occasional still life, usually of flowers but also garden pictures. Although historically associated more with the group known as "The Eight," one of the most talented painters of the younger generation to adopt the impressionist aesthetic was William J. Glackens. At the end of the nineteenth century, Glackens, also renowned as an illustrator, began to paint city and park scenes in a vigorous *chiaroscuro* that suggested a latter-

Figure 9.10. CHILDE HASSAM (1859-1935), *Reading*, 1888; oil on masonite panel, signed at lower left — *Childe Hassam 1888*, 14¼ x 18 inches; Nelson Gallery, Atkins Museum, gift from the Howard P. Treadway and Tertia F. Treadway Collection.

day Manet and showed the influence of Henri and other young artist friends of the future Ashcan School. However, early in his career as a painter he converted to the style of Pierre Auguste Renoir. This change is usually related to Glackens's association with the wealthy collector Albert Barnes, for whom Glackens acted as adviser in assembling the great collection of art now in the public domain in Merion Station, Pennsylvania. Barnes's first acquisition was a work by Renoir, whose manner Glackens closely emulated. Yet, Glackens's relationship with the French impressionists, and especially with Renoir, seems to have developed even before his contact

Figure 9.11. WILLIAM GLACKENS (1870-1938), *Bouquet in a Quimper Pitcher*, circa 1937; oil on canvas, signed at lower left — *W. Glackens*, 24½ x 18¼ inches; Private Collection.

[29] The major studies of Glackens's art are Vincent John De Gregorio, "The Life and Art of William J. Glackens" (Ph.D. diss., Ohio State University, 1955), and Ira Glackens, *William Glackens and the Ashcan Group*.

[30] De Gregorio, "Life and Art of Glackens," pp. 231-37.

[31] Bye, *Pots and Pans*, p. 213.

with Barnes, as early as 1906, when Glackens made his second trip to Europe.[29]

In the manner of Renoir, Glackens painted monumental figure compositions, scenes of New York, of Long Island beaches, and particularly of the lively activity around Washington Square in New York City. These were more illustrational than Renoir's city and country scenes and kept closer to the aims, if not the formal manner, of the majority of "The Eight." Figure paintings, cityscapes, and landscapes have overshadowed Glackens's still lifes, and certainly the literature on Glackens has tended to ignore his fruit and flower pictures, but these constitute some of his finest work. The majority of them date from 1925 on, and while a number are rather soft and a bit unsubstantial, at their best they exhibit strong drawing and marvelous color and design, often with boldly decorative tablecloths and brilliantly chromatic backgrounds. His *Bouquet in a Quimper Pitcher* (1937), one of Glackens's last completed works, utilizes a favorite container that is shown in a number of his finest flower paintings and suggests the French origins of the artist's aesthetic. Unlike the earlier flower pictures by Hassam in an impressionist mode, Glackens substitutes here the soft, feathery brushstroke of Renoir for the tougher and grittier manner of Hassam, and his chromatic transitions are far more gentle. As has been pointed out, perhaps the key to the attraction and effectiveness of Glackens's flower pictures is their informality. Though it is hard to credit fully the suggestion made by Emma Bellows and by others that Glackens simply painted the flowers as they happened to fall when placed into a container — they appear very unstudied in their arrangement.[30]

Any artist working in an impressionist aesthetic is bound to suggest a connection with French art. Likewise, the still-life painting of William Merritt Chase can be linked with French developments by an admirer familiar with Vollon's painting. But probably no American still-life painter in the late nineteenth century was so completely related and indebted to contemporary and earlier French developments than Emil Carlsen. Arthur Edwin Bye, our earliest historian of still-life painting, was subjective in what he acknowledged and admired, overlooking any developments before the later years of the nineteenth century and even ignoring the trompe l'oeil and other movements, but he was extremely perceptive about what he did regard highly. For Bye, the greatest American specialists in still-life painting were John La Farge, William Merritt Chase, Maria Oakey Dewing, and Emil Carlsen. Writing in 1921, Bye illustrated more pictures by Carlsen than by any other painter in the history of still life, referring to him as "unquestionably the most accomplished master of still-life painting in America today."[31] Indeed, Bye dedicated his book to Carlsen.

Carlsen was a Dane and brother of the director of the Danish Royal Academy. On first coming to America in 1872, he taught at the Art Institute of Chicago. Three years later, he returned to Europe to study in Paris. After six months, Carlsen's funds were soon depleted, and he returned to New York. During the following years, he gradually established a reputation for himself as a still-life specialist and gained significant recognition with the exhibition of one of his pictures at the Pennsylvania Academy in 1883. The following year he returned to Europe. In Paris, he supported himself for two years painting on commission for the New York dealer Theron J. Blakeslee but gave up this relatively lucrative practice, weary with the incessant demand for his exuberant pictures of yellow roses. Between 1887 and 1891,

he was a leading artist and teacher in San Francisco. On his return to New York City, he became integrated with the established art world there and developed friendships with Weir, Twachtman, and others.[32]

Although he painted quasi-impressionist landscapes later in his career, and landscapes and seascapes at the end of his career, some of which even took on mystical, semireligious overtones, Carlsen was first and foremost a painter of still life. The chronology of his diverse artistic interests and the interrelationships of the various aspects of Carlsen's art, which seem to be quite complex, still await in-depth scholarly study. Although it is perhaps an oversimplification, one can divide his still lifes into three groups: the flower pictures, the dead game pictures, and the kitchen still lifes. The often large, baroque flower pictures, brightly colored and broadly handled, depict the popular flowers of the period — peonies, chrysanthemums, or the favorite

[32]There is no definitive biography or study of Carlsen's art. Numerous writers such as Eliot Clark, Duncan Phillips, Frederic Newlin Price, and others wrote appreciative articles on him in the early twentieth century; a number of these were republished and incorporated into *The Art of Emil Carlsen, 1853-1932* (exhibition catalogue; Wortsman-Rowe Galleries, San Francisco, 1975). For his still-life painting, the section in Bye, *Pots and Pans*, pp. 213-22, is indispensable.

Figure 9.12. EMIL CARLSEN (1853-1932), *Still Life;* oil on canvas, signed at lower right — *Emil Carlsen*, 14¹⁵⁄₁₆ x 17⅞ inches; Worcester Art Museum.

[33]The influence in America of Chardin and the nineteenth-century Chardin revival still awaits examination. For the Chardin revival in France, see John W. McCoubrey, "The Revival of Chardin in French Still-Life Painting, 1850-1870," *Art Bulletin* 46 (March 1964): 39-53, derived from his "Studies in French Still-Life Painting, Theory and Criticism, 1660-1860" (Ph.D. diss., New York University, 1958).

yellow roses, which are often placed in highly decorated vases and in other containers. Some of these certainly date from his early career in the 1870s but may also have been painted later. Second are his large dead game pictures, not illusionistic hanging arrangements, but birds, pots, and other paraphernalia that is spread out on a flat surface, dark and dramatic, and broadly painted in the manner of Chase's later still lifes, although usually not so painterly. Finally, there are those pictures that constitute the largest group of his still-life painting and that are the greatest testament of the Chardin revival in America.[33]

After Carlsen, Chardin is the artist most reproduced in Bye's 1921 volume on still-life painting, and Bye perceptively recognized the link between the two artists. This finest group of all Carlsen's still lifes suggests Chardin in both subject matter and style, and, indeed, Chardin had been the principal object of Carlsen's study during his years in Paris. In these pictures, Carlsen places his objects on usually inelegant but somewhat unspecified surfaces. They are often kitchen still lifes of metal pots, simple ceramic vessels, combined with fish, seafood, vegetables, and other elements that help to create a meal. The objects themselves are often totally lacking in traditional beauty. What makes the *painting* beautiful is Carlsen's sensitivity in its arrangement — large shapes are juxtaposed with small, flat forms and tall ones, their outlines are often united in refined harmonious curves, and are placed backward and forward upon their limited support surface to allow for "breathing room," for slow movement in space. The arrangements are always subtle, never jarring, and always suggest great tranquillity. Overall, the compositions are bathed in a soft luminosity, which does not obscure the form but does allow for gentle surface reflections. In the finest of these paintings, the tonal harmonies are very close and evince Carlsen's preference for the monochromatic — grays, silver, and beige tones — embodying an aesthetic in still life that closely resembles the contemporaneous tonalist or Quietist movement in landscape painting, of which J. Francis Murphy was a leading exponent. As in Murphy's landscapes so in Carlsen's still lifes, one can deduce the influence of close harmonies in the work of the much admired James A. M. Whistler, but the greatest influence of all is, of course, that of Chardin.

Not all of the Paris-trained painters of still life worked in the then avant-garde impressionist manner. Some artists adopted an approach that has been looked upon as being extremely conservative, and their works have, until recently, been unfairly denigrated. In fact, such artists painting in an academic mode could and often did create extremely beautiful pictures. The firm draftsmanship, the solid rendering of form through acutely observed *chiaroscuro*, the delicately modulated color hues, and the well-adjusted arrangements in these works all testify to the artists' mastery of the lessons that they had received in various academies.

One such painter was Harry Watrous. Watrous was born in San Francisco but grew up in New York City. In 1881, he sailed for Europe with a fellow artist, H. Humphrey Moore. The two spent much of their first year in Spain, where Watrous fell under the influence of the Spanish master Mariano Fortuny. In 1882, he began to study with Léon Bonnat and attended classes at the Académie Julian. Watrous emerged from his Parisian training as a figure painter very much in the manner of the popular French master Jean Louis Meissonier. He returned to the United States in 1886.

Figure 9.13. HARRY WATROUS (1857-1940), *Still Life;* oil on canvas, signed at lower right — *Watrous,* 18 x 21½ inches; Montclair Art Museum, Montclair, New Jersey.

Watrous concentrated, though probably not exclusively, on different subjects during various periods of his career, moving from historical genre to sentimental genre, then from the single female figure in profile to landscape painting, and finally to still life. This last became his only concern from 1923 on. The reasons for Watrous's shift to this theme are not known, but it has been speculated that it may be due in part to his reaction to the negative criticism of his Ralph Blakelock-inspired landscapes as being predictable and derivative.[34] The conservative trends in American culture of the 1920s, reflective of an increasingly isolationist political outlook, may also have contributed to Watrous's turn to still life. Bye's groundbreaking study of the theme, *Pots and Pans* (1921), which was probably also related to the political climate, may have influenced Watrous as well.

[34]There are few works on Watrous. The principal article on him is William B. McCormick, "Watrous, Public Force in Art," *International Studio* 78 (October 1923): 79-83, written just when Watrous was moving from landscape to still-life specialization. I am therefore greatly indebted to Barbara Gallati for her study of "The Still Life Paintings of Harry Willson Watrous," prepared for my graduate course at the City University Graduate School in the spring of 1979.

Figure 9.14. HENRY ALEXANDER, *Still Life with Phoenician Glass*; oil on canvas, 15½ x 19 inches; Dr. Oscar Lemer.

[35]See Gerdts, "The Bric-a-Brac Still Life," *Antiques* 81 (November 1971): 744-48.

Watrous's still-life subjects, however, were not the traditional fruits and flowers but objects of value and rarity — religious devotional objects, precious porcelains (usually Oriental), and antique glass. They are thus later reflections of the bric-a-brac still lifes that were so popular in the 1870s and after, usually identified with the French painter, Blaise Desgoffes, who was much patronized by Americans and was emulated by some American artists.[35] Harnett's Munich pictures are particularly reflective of this aesthetic as are some of Weir's works that were painted in the 1880s. The taste to which such artists responded was often frankly vulgar; the still lifes themselves often were not. In choosing such subjects, Watrous was emulating some of the preferences of Carlsen and even more of the latter's son, Dines Carlsen, who was beginning to exhibit and to be noticed at just this time. Such works appealed to collectors, of course, who were themselves often also collectors of *objets de virtu* similar to (or possibly even identical with) those that appeared in the paintings of Watrous and of the Carlsens. Henry Golden Dearth is another artist who enjoyed painting such subjects. Each of

these artists used his own individual approach for the rendition of precious objects; Watrous's paramount concern was verisimilitude, which is reflective of his academic training. His objects are usually silhouetted against bare, darkened backgrounds, and their smooth, polished surfaces gleam. He was truly a master of the texture of porcelain particularly.

When Watrous painted ancient glass, outline and formal solidity dominated his aesthetic, though he carefully rendered the lovely iridescence of the patina that had formed on the objects. The subject of ancient glass, however, had been investigated much earlier by another artist, also born in San Francisco, Henry Alexander. Alexander grew up in his native town, went to Munich to study in 1876, and returned to San Francisco where he worked until he moved to New York in 1887, dying there at the young age of thirty-three. Alexander's career was short and his oeuvre is small because much of his work was lost in the San Francisco earthquake and fire of 1906. His best-known paintings are concerned with glass objects. They are not still lifes but rather laboratory pictures in which the artist's primary fascination was with the glass laboratory equipment, its transparency and reflective quality. Alexander, however, also created a number of formal still lifes of Phoenician glass in which, unlike Watrous, he concentrated on the shimmering color of the iridescence. These pure still lifes were painted while Alexander was in New York, for he based them upon examples in the Cesnola Collection at the Metropolitan Museum of Art, having obtained special permission from General di Cesnola who had formed the collection and was then director of the museum.[36] These are "romantic" works relative to Watrous's "classicism"; they are "warm" as Watrous's are "cold." But both artists created minor masterworks out of their arrangements of exotic objects from the past.

[36]There is no adequate bibliography on Henry Alexander. See Frankenstein, *After the Hunt*, pp. 145-46; Alfred Trumble, *The Collector* 5 (1 June 1894): 227-28; "Emerges from the Ashes of 'The Great Fire,' " *Art Digest* 12 (15 October 1937): 11. The Trumble article contains the information concerning the origins of the Phoenician glass still lifes. See also Raymond L. Wilson, "Henry Alexander: Chronicler of Commerce," *Archives of American Art Journal* 20: 2 (1980): 10-13. This most recent publication regarding Alexander deals with his figural pieces but does not mention his still lifes.

Figure 10.1. HENRY McFEE (1886-1953), *Still Life;* oil on canvas, 25 x 30 inches; National Academy of Design, New York.

10 The Still Life in Early Modernism

A number of the still-life paintings described in the last chapter were painted in the early years of the twentieth century. Indeed, artists such as John F. Peto, Robert Dunning, and John La Farge, who were previously discussed, survived into the present century and were active up until their last years. Conversely, very traditional, very nineteenth century-looking still lifes of great beauty were painted in our century, but they are not dealt with in this historical study.

This and the following chapter are concerned with American still life from approximately 1900 to 1940, that is, up to the predominance of abstraction; the focus here is thus primarily on still lifes by artists working in the modernist mode. Modernist developments, mostly originating in Europe, were tremendously complex in their evolution, in their relationship to traditional art, and particularly in their relationship to each other. The involvement of American modernists in those movements adds additional complexity. Some went abroad and embraced modernism early in the twentieth century, others later. Some formed associations with the movements secondhand, either through the experience of European work in America or through that of Americans who were directly influenced by their European colleagues.

Given this enormous complexity, it was not feasible to deal with modernist still life in any strict subdivisions, either to discuss the artists and their art chronologically by decades or to consider them according to the specific modern movements that they had joined and explored. To illustrate, perhaps the most powerful of all American cubist still lifes are those created by Alfred H. Maurer, but while Maurer was one of the earliest Americans to join the mainstream of European modernism, his cubist still lifes were not painted until the late 1920s. And again, there may be no more impressive Fauve painting by an American than the still-life example by Arthur B. Carles, which was painted in 1911 — the heyday of American involvement with Fauvism — but most of Carles's Fauve still lifes known today were painted two decades after the apogee of the movement in France.

The other reason for choosing to incorporate the many aspects of still-life painting into a large, overall consideration of the first four decades of the twentieth century, breaking this into two somewhat arbitrary subdivi-

sions, is that the consistent pattern of thematic specialization did not remain sufficiently strong for the creation of a historical structure and pattern, however magnificent the works were of several artists who did demonstrate a special fascination with the theme, among them Charles Demuth and Georgia O'Keeffe. With the disappearance of the centuries-long respect for thematic hierarchy went the subconscious injunction toward specialization. Most twentieth-century artists did paint still lifes, but the majority of the more innovative ones did so only occasionally. Twentieth-century still life was the domain of traditional artists who viewed it as somewhat immune to radically different interpretations and painted it accordingly, although often with great understanding and with true qualitative distinction. The more innovative painters viewed it as one of the many themes equally susceptible to radical interpretation and treated it as such, but only occasionally. Disassociated from these still lifes was the traditional respect for the theme *as* theme, the concern for the underlying botanical structure of the objects involved or of their poetic emanations.

American modernism, that is, the association of young American artists with the radical foment developing in Europe in the early years of the present century, appears as one of two major directions taken in American art at the time. The other was a vigorous new realism, often with social concerns that were centered in imagery drawn from contemporary urban life. As we have seen, Robert Henri was the leader of this movement, and still life was fairly incidental to its concerns. Perhaps not surprisingly, still life was investigated more by members of "The Ashcan School" who were also more European oriented. We have noted William J. Glackens especially as an artist who, in his later, Renoir-related, impressionist-motivated work, often painted fruit and flower pictures. Earlier, although to a lesser degree, his colleague Maurice Prendergast was briefly involved with the theme.

Prendergast grew up in Boston and first went to Paris in the mid-1880s, but his artistic career matured only in the beginning of the following decade when he returned to Paris and became influenced by some of the post-impressionists. He also formed friendships crucial to his art with fellow "provincials" studying abroad, the Canadian James Morrice and the Australian Charles Conder. In Paris, Prendergast began to build up a repertory of figural gestures and of movements of women on the boulevards, which he transferred to scenes set on the beaches and in the gardens and parks of New England, and in later life in New York. Prendergast increasingly adopted an interest in color and light that was impressionist, but the lack of atmospheric concerns and the two-dimensional, tapestrylike effects of thickly encrusted paint suggest rather post-impressionism.

Prendergast was also an early champion of Cézanne. He may first have heard of Cézanne through the Irish painter Roderic O'Connor, a friend of Morrice. He would also have had the opportunity of seeing Cézanne's work at Vollard's gallery in Paris, where he returned in 1898 on his way to Italy. Certainly he was in attendance at the great memorial show of Cézanne in the French capital in 1907. Yet, he was an admirer even earlier. He spoke passionately to his colleagues among "The Eight" of Cézanne's art in 1905, to which John Sloan replied, "Prendergast, who is this man, Cézanne?"[1]

Despite much admiration, Cézanne's actual influence upon Prendergast did not become apparent until about 1913, and it has been postulated that it was the sizable collection of Cézanne's work shown in the historic

[1]The lack of a definitive study of Cézanne's influence on American art is a strange scholarly lacuna; John Rewald presented a course in the subject at the Graduate School of the City University of New York in the Fall of 1979 and lectured on the subject at a Symposium on American Impressionism in Los Angeles on 29 March 1980. Hedley Rhys relates the story of Prendergast and Sloan concerning Cézanne in *Maurice Prendergast, 1859-1924* (exhibition catalogue; Museum of Fine Arts, Boston, 1960), p. 50. For Prendergast's interest in Cézanne in Paris in 1907, at the time of the Cézanne exhibition, see his letter to Mrs. Oliver Williams, reproduced in *Maurice Prendergast* (exhibition catalogue; University of Maryland Art Gallery, College Park, 1976), p. 23.

Armory Show in New York that led to Prendergast's exploration of problems of color and structure similar to those of the French master. The group of still lifes by Prendergast date from this time and immediately afterward although he is known to have painted the theme earlier. Yet, although it is a subject very much associated with Cézanne, there was only one still life, a flower piece, exhibited by him in the Armory Show. Prendergast often combined simplified fruit forms, particularly those of oranges and apples, with ceramics and potted plants on a tabletop, and he applied color in broad patches to suggest mass and space rather than pattern. Despite the decorative nature of the flowers and the artist's instinctive concern for design, the still lifes that Prendergast produced in these years, approximately 1913-1915, are his most austere works, divorced as they are from the bright outdoor light and from the activity of people in an animated environment.[2]

In his *Fruit and Flowers* (1915), one of the artist's most complex, most dense arrangements, Prendergast adopted a careful asymmetry, emphasizing structure and form in a manner that demonstrates his debt to Cézanne. This was cautiously admired by a critic for the *New York Post* some two decades later. Writing on 15 April 1933, the reviewer of a Prendergast exhibition at the Kraushaar Gallery in New York recognized that a still life shown displayed "the solidity of form and sound organization of the spatial design [to] indicate that the painter chose pure decoration as his characteristic expression, rather than accepted it from any limitations of ability to paint objects with naturalistic fidelity in plastic design."

Cézanne's influence upon American art is a complex subject. Although it underlies the American response to cubism, much more has been written about the latter relationship. Prendergast's actual adoption of Cézanne's concerns and methodology was relatively brief in time and almost solely confined to still life. No matter how much he admired Cézanne's work, Prendergast's still lifes, imbued as they are with the color and light of another aesthetic, simply do not "look like" Cézanne's paintings.

A "purer" adaptation of Cézanne, especially in the realm of still life, occurred later in the art of Henry Lee McFee and Walt Kuhn. McFee studied with Birge Harrison in Woodstock, New York, in 1908 and stayed at the art colony there. In the following decade, particularly under the influence of Andrew Dasburg, he was involved with modernist directions, and his paintings, primarily still lifes of the late 1910s and early 1920s, are very cubist. Like many artists of his generation, however, he actually moved away from the avant-garde in the 1920s, evolving a more representational manner in studio paintings, primarily in still lifes. Some of their works were not only directly inspired by but also derived from specific examples of Cézanne, though his concerns for the subject and sense of the vernacular are greater than that of the French master he was emulating. McFee himself told his colleague Alexander Brook that he "could never pass by a still life." He further elaborated his artistic credo in the catalogue of the 1916 Forum Exhibition of Modern American Painters in New York:

> I am endeavoring, by analysis, to find the essential planes of the emotional form of my motif, and to realize these planes by right placing of color and line, and by such a just relation of shape to shape, that the canvas will be, when completed, not a representation of many objects interesting in themselves, but a plastic unit expressive of my understanding of the form-life of the collection of objects.[3]

[2]Prendergast's still lifes, somewhat incidental to the artist's total oeuvre, have only been incidentally treated by historians and critics, as in the two exhibition catalogues cited in footnote 1. Shelly Dinhofer prepared a paper on the subject of Prendergast and Cézanne in regard to their still-life paintings in a course at the City University Graduate School in the spring of 1975.

MAURICE PRENDERGAST, *Fruit and Flowers*. See plate 25, page 169.

[3]On Henry Lee McFee see his own statement, "My Painting and Its Development," *Creative Art* 4 (March 1929): xxvii-xxxii; Elizabeth Luther Cary, "Henry Lee McFee," *Creative Art* 4 (March 1929): xxxiii; Alexander Brook, "Henry Lee McFee," *The Arts* 4 (November 1923): 25-61; Virgil Barker, *Henry Lee McFee*, and "Henry Lee McFee," essay by Arthur Miller, Scripps College, Claremont, Calif., 1950.

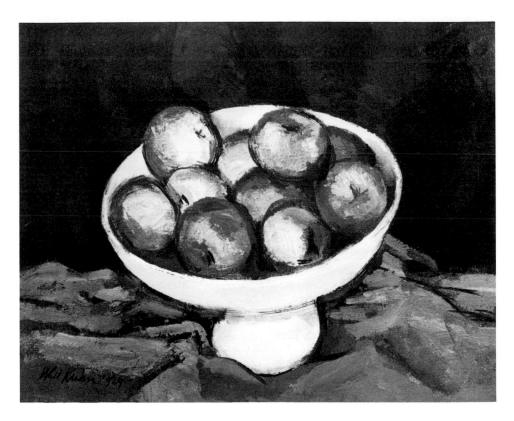

Figure 10.2. WALT KUHN (1877-1949), *Apples in White Bowl*, 1929; oil on canvas, signed at lower left — *Walt Kuhn 1929*, 16 x 19⅞ inches; Sloan Collection, University Art Galleries, Valparaiso University.

Walt Kuhn was a more original artist. He was closely involved in organizing the Armory Show, and — though cubism's concern for structure, even as it amounted to reconstruction, did affect his art — he derived his sense of form, as achieved through manipulation of color, primarily and directly from Cézanne, "the Father of us all," according to Matisse. The emphasis upon plastic form is evident in Kuhn's famous series of clowns and other circus performers, but it is even more vivid in his brilliant still lifes of fruit.

Unlike Prendergast and, indeed, a good many of the other artists discussed in this chapter, Kuhn retained an interest in painting still life throughout his career. In the wake of the Armory Show, he adopted a style, perhaps the most radical in his career, that was based upon the broad fragmented planes and higher colorism of synthetic cubism. His turn to more direct Cézannesque influence occurred in the next decade, never more surely than in the pictures of apples, pears, bananas, plums, peaches, lemons, oranges, and even potatoes and pumpkins constructed in broad planes of color and often outlined in black to emphasize the spherical form created by patches of close tones of a single hue. The fruit sometimes is depicted on the ground, sometimes in a container, sometimes accompanied by a cloth on which some of the fruit may lay, all in the manner of Cézanne. The fruit is usually of a single variety to insure repetition of color and shape, and the container is often the simplest of bowls, which effectively enhances the basic geometric shape of the fruit itself. Kuhn painted a number of flower pictures between 1918 and 1922 and began to depict fruit occasionally from 1922 on, but his true mastery of the theme began with his *Apples in*

White Bowl (1929), a work of great quality, although overshadowed that year by what is perhaps the finest of all his figure pieces, the great *White Clown* (National Gallery of Art). The concentration on still life began in the 1930s; *Apples in White Bowl*, almost the first of his great series of apple still lifes, prefigured that emphasis in his oeuvre and established the formal color-and-structure relationship, which they all share.[4]

Prendergast and Kuhn developed their mature art at home, however much it was influenced by Cézanne and by more recent European developments. A number of other Americans went to Europe in the first decade of the century and developed their painting directly under European influences. One of the most brilliant of these was Patrick Henry Bruce. Bruce had studied with Chase and then Henri in New York in 1902-1903, but around the end of the latter year he was in Paris. By 1906, he had become immersed in modernism and was a frequent visitor of the Steins — Gertrude, Leo, Michael, and Sarah. He met Matisse there early the following year, becoming a close friend and a pupil, along with Sarah Stein, in the Matisse School, which began in 1908.[5]

For the next five years, Bruce developed the first of his three quite distinct artistic manners, one very much influenced by the broad simplifications and high-keyed colorism of Matisse's Fauvism. During these years, he painted figures and landscapes, but still lifes predominated, and he exhibited works of this theme in several of the Paris salons. Although Bruce was close to Matisse, he followed Matisse's advice, taking Cézanne as the dominant influence in his art during this period. In these early paintings by Bruce, the high colorism of Matisse — but also of the late Cézanne — is combined with an obsession for structured forms.

The still lifes of this period are usually quite small and relatively simple — vases of flowers or arrangements of fruit on a table, often with many areas of bare canvas, providing an "open" appearance against the picture plane, which itself was a frame of spatial reference, as Bruce adopted Cézanne's tipped-up tabletop to support his arrangements. Spatially, Bruce's *Still Life with Tapestry*, painted late in 1912, is one of his most traditional, with bowls placed on an eighteenth-century-style table against a backdrop of tapestry in a naturalistic manner and limited recession. But the table, the bowls, and the tapestry are broken into a broad mosaic of color patches so that they merge into one dazzling display of chromaticism, retaining the high color of Fauvism and the patchy brushwork of Cézanne and infusing them with a swirling vitality that reflects his new interest in the radical coloristic innovations of Orphism, which was acquired through his friendship with Robert Delaunay and Sonia Delaunay. Bruce was to follow the aesthetics of that movement a step further in the mid-1910s abandoning references to the object and creating an individual art of abstraction that combined the high colorism and the dynamic movement of Orphism with the structural emphasis of cubism. This second manner was developed in the mid-teens, but underlying it was the Fauve color and Cézannesque structure so expressively developed in his early still lifes.

Bruce's works of these years were complete abstractions in the most radical and innovative manner of the time. He himself destroyed the paintings of 1913-1915, and only a handful that were painted the next year survive. He had moved away from Delaunay's Orphism and remained independent of the allied movement called synchromism, developed in Paris by the expatriate Americans Stanton MacDonald-Wright and Morgan

[4]For Kuhn, see Philip Rhys Adams, *Walt Kuhn, Painter: His Life and Work,* especially pp. 152-57.

[5]For Bruce, the definitive studies are the pair of essays by William C. Agee and Barbara Rose in *Patrick Henry Bruce: American Modernist* (exhibition catalogue; Museum of Modern Art, New York, 1979).

PATRICK HENRY BRUCE, *Still Life with Tapestry.* See plate 26, page 170.

STANTON MACDONALD-WRIGHT, *Still Life
Synchromy*. See plate 27, page 171.

[6]In addition to Willard Huntington
Wright's book, synchromism has been
studied most fully in two exhibition
catalogues that also treat of Bruce's
work. These are *Synchromism and Color
Principles in American Painting,
1910-1930,* essay by William C. Agee
(M. Knoedler & Co., New York, 1965);
and *Synchromism and American Color
Abstraction, 1910-1925,* essay by Gail
Levin (Whitney Museum of American
Art, 1978). In addition, the reader
should consult *The Art of Stanton
Macdonald-Wright* (exhibition catalogue;
National Museum of American Art,
Washington, D.C., 1967).

[7]The standard work on Benton is
Matthew Baigell, *Thomas Hart Benton.*
For his early modernist works, see the
two exhibition catalogues dealing with
synchromism cited in footnote 5. See
also *Thomas Hart Benton: A Retrospective
in His Early Years, 1907-1929* (exhibition
catalogue; Rutgers University Art
Gallery, New Brunswick, N.J., 1972);
and *Benton's Bentons* (exhibition
catalogue; Spencer Museum of Art,
The University of Kansas, Lawrence,
1980), especially the essay by Elizabeth
Broun, "Benton and European
Modernism." In addition, there are
Benton's two autobiographies: *An
Artist in America* and "An American in
Art," *Kansas Quarterly* 1 (Spring 1969):
9-78, especially pp. 32-43.

Russell, although because of his national origin Bruce is sometimes associated with them. Both of these artists had begun their artistic studies in America — Russell in New York before going to Paris in 1906; and MacDonald-Wright in Los Angeles, journeying to Europe a year after Russell. Russell had shown an early interest in still life and MacDonald-Wright in the figure, but after they met in 1911, they developed together an intense interest in color theory that in 1912 evolved into an independent approach to color abstraction termed *synchromism,* a name adopted the following year. Russell's work remained more abstract and more opaque in its juxtaposed color planes; MacDonald-Wright's took on a more transparent, faceted quality, which was closer to contemporaneous Orphism in its thinner color planes that merged with one another and, incidentally, retained more consistent references to the natural world. His paintings were often figural; that is, figures were interpreted in faceted and dynamic light planes, almost as though seen through a prism. However, MacDonald-Wright also painted a number of still-life compositions in a synchromist manner during these years, such as his *Still Life Synchromy* (1917). In MacDonald-Wright's mature synchromist works of 1916-1921, the evidences of naturalistic basis are both fragmentary and fragmented; these paintings belong to the world of color theory and experimentation, the complexities of the theories and application of which are beyond the scope and purpose of this study. The pursuit of such goals was, in any case, short-lived, although MacDonald-Wright's brother, Willard Huntington Wright, wrote a book called *Modern Painting* (1926), which "proved" that synchromism was the ultimate aesthetic goal.[6]

Though Bruce's work of the mid-teens shared with the synchromists an interest in the totally abstract and in the kinetic movement of forms, his art was separated from the aesthetic goals of that movement by his concern for rigorously ordered geometry in three-dimensional construct. One artist who did become a synchromist, if only for a short while, was Thomas Hart Benton. Later, Benton became a realist champion of American regionalism and an outspoken opponent of modernism, but during his earlier years — those spent in Paris from 1908 to 1911, and the remainder of the second decade of the century — Benton investigated and tried to comprehend various modernist movements. In 1914, he was introduced to synchromism by MacDonald-Wright, who was a close friend in his Parisian years, and then had returned to New York for an exhibition of synchromist works. Most of Benton's synchromist works were later destroyed, including those he had exhibited at the 1916 Forum Exhibition of Modern American Painters, a nationalist but still modernist response to the cosmopolitan Armory Show of three years earlier. About this time, during a period when he was also sculpting, Benton withdrew from the color dominance of the synchromist aesthetic and began to create compositions of blocky, multifaceted shapes, with an interwoven, broken geometry coincidentally not dissimilar from Bruce's work of the year or two previous. These he termed "Constructivist Still Lifes" although they are, in fact, completely abstract; the concern for "construction" replaced the synchromist emphasis upon color. Yet, the constructivist concern for building shapes and emphasizing geometry stayed with Benton throughout his long career.[7] His 1919 *Still Life,* though relatively traditional in its representational mode, is thus something of a key, transitional work. The formal simplifications and curvilinear rhythms of colored arcs and crescents suggest his synchromist investigations, while the strong geometric emphasis in the books and other forms and the planar

emphases in the background attest to his budding constructivist concerns. Benton's ability to adapt his synchromist and other modernist derivations to more traditional themes is manifested in perhaps his most notable painting of this period, *The Bather* (1917, Private Collection).

This was also true of Bruce, although his art took a different and untraditional direction in the 1920s. Around 1917, abandoning his involvement with total abstraction, Bruce began to produce a series of monumental geometric still lifes. How many he ultimately painted is not known. In 1933, he destroyed all but twenty-one of these, and four others are also extant, having been given away to friends. These pictures display recognizable and identifiable objects that are rendered in a powerful three-dimensional fashion through contrasting but repeating planes of flat color in the various

Figure 10.3. THOMAS HART BENTON (1889-1975), *Still Life — Fruit and Flowers,* 1919; watercolor, 18 x 14 inches; Lyman Field and United Missouri Bank of Kansas City, N.A., Trustees, Thomas Hart Benton Testamentary Trusts.

faces of the objects. The color planes interact with one another, with the slanted and tilted tabletop on which the objects sit, with the geometry of the room wall behind, and with three-dimensional beams that project vertically in front of the table arrangement, or thrust dynamically as diagonals through the pictures's space in some of the examples. The forms that compose the still lifes, however, are not invented. They are rigorously simplified objects from the artist's daily life in his Parisian home — hats, vases, shapes drawn from furniture — and the beams themselves are adapted from the interior architecture of his apartment.

In a peculiar way, Bruce's still lifes embody a form of trompe l'oeil and are thus allied to an earlier aspect of American art that he almost assuredly did not know, or which at least held no interest for him. While Harnett and his followers achieved illusionism through flattened forms, Bruce created volume through planes of color that were manipulated by perspective convergence so they would project into the viewer's space. The forms were rigidly constructed through a knowledge of mechanical draftsmanship that was rooted in his early training in Richmond, Virginia. Bruce's palette is unique to him. With totally unmodulated colors, the planes defining two perpendicular sides of an object are both made to appear flat, so that each face is at once in space and yet parallel to the picture plane. When the objects are read three-dimensionally, each one seems to project off at an oblique angle different from any other and at a unique "rate" of projection, so that the viewer observes the still-life composition from many viewpoints, many angles, simultaneously. What appear to be the backgrounds in these canvases — larger planes of color without abutting planes to create volume — are composed of several flat areas. The colors used for these areas are the same as those of the planes that form the still-life objects. Thus the planes of the still-life objects, as flat as the background, occupy their spatial plane and are "holes" back into the composition. In these great still lifes, Bruce created a world of monumental order out of the mundane paraphernalia of his private world but shattered the surety of traditional order through the fragmentation of expected spatial perception.[8] The paintings thus become metaphors of modern life, and perhaps of the painter's also.

In the second decade of the century, Marsden Hartley created out of his contacts with European modernism an aesthetic form of modernism that may constitute the most original contribution of any American artist. Early in his career, while painting landscapes in Maine, he worked out a strange but effective combination of impressionist color and brushwork fused with forms and emotional overtones drawn from the landscapes of the much-admired Albert Pinkham Ryder. Contact with European modernism at Alfred Stieglitz's 291 Gallery influenced Hartley's later artistic direction, as did the articles appearing in the modern periodicals such as *Camera Work*. Matisse's influence was paramount at first, and in 1912 Hartley was mentioned as "another of our fauves."[9] Also in 1912, Hartley traveled to Europe, where he spent a year in Paris, gravitating to the salon of Leo Stein and Gertrude Stein as did other young Americans and investigating the flat interlocking geometry of analytical cubism. Early in 1913, however, he made a three-week trip to Berlin and visited with Kandinsky whose writings he had known back in America. This visit, together with his personal and professional satisfaction with its artistic community, led Hartley to move to Berlin in the spring of that year. During the next three years, Hartley developed a complex aesthetic based on strongly colored flat patterns drawn

[8]For a formal analysis of Bruce's late works, see especially the essay by Rose in *Patrick Henry Bruce* (exhibition catalogue), particularly pp. 70-88.

[9]Quoted by Elizabeth McCausland in *Marsden Hartley,* p. 19, quoting a reprint from the *New York Mail,* which appeared in *Camera Work,* April 1912.

Figure 10.4. PATRICK HENRY BRUCE (1880-1937), *Peinture: Nature Morte;* oil and pencil on canvas, 35 x 46 inches; The Museum of Fine Arts, Houston, gift of the Brown Foundation.

from recognizable German military imagery (this was the beginning of World War I), from native American sources, and from his own personal iconography. The geometry of shapes, the circular color areas, and the unmodulated chromaticism relate respectively to cubism, Orphism, and Fauvism, but Hartley's fusion was essentially his own. His personal spiritual expressiveness is closer to Kandinsky than to any artists of the modern French school, though his means of projecting it was quite distinct from that of the great Russian modernist.[10]

While in Berlin in late 1914, Hartley learned of the death of Karl von Freyburg, a German lieutenant and a close friend of his. Before leaving Germany the next year, Hartley created a series of his abstracted emblem paintings that are, to varying degrees, "portraits" of von Freyburg; one, in fact, is entitled *Portrait of a German Officer* (1914, Metropolitan Museum of Art). On his return to New York, Hartley felt emotionally depleted. Sensing the anti-German mood of the country, he turned to the more neutral theme of still life, which had served him in the past and which he continued to explore in many aesthetic modes throughout his career.[11]

[10]For Hartley, see McCausland, *Marsden Hartley,* and especially the essay by Barbara Haskell in *Marsden Hartley* (exhibition catalogue; Whitney Museum of American Art, 1980).

[11]"Though Hartley painted a good many still lifes throughout his fairly long and prolific career, the works of that theme have never been singled out for special study in the quite sizable literature on the artist.

[12]See the discussion of this work in Haskell, *Marsden Hartley* (exhibition catalogue), p. 52. For additional discussion of the painting and an alternate dating of the picture to 1912, see William Innes Homer, *Alfred Stieglitz and the American Avant-Garde*, pp. 158-60, and Percy North in *Hudson D. Walker: Patron and Friend* (exhibition catalogue; University Gallery, University of Minnesota, Minneapolis, 1977), p. 28. North and Homer date the picture to 1912, but Haskell provides convincing evidence for the later dating of 1916.

One Portrait of One Woman, painted in 1916 soon after his return, is the picture that perhaps best expresses Hartley's concern with spiritual abstraction — despite reliance on somewhat more naturalistic representation than in his European paintings — which would dominate almost all his subsequent work.[12] The picture, which was shown in the Forum Exhibition of Modern American Painters in 1916, is considered a symbolic portrait of Gertrude Stein. It presents a monumental cup and saucer over the French word "MOI," against a flat checkered pattern representing a tablecloth. As Gertrude Stein created literary symbolic portraiture, including a study of Hartley, so Hartley created a pictorial equivalent of the writer, who was known for her afternoon teas and for her indomitable ego. Hartley's good friend and colleague Charles Demuth was to create a series of symbolic portraits in the next decade. The backdrop — a patterned hanging with repeated curved triangular shapes — derives from the forms, if not the iconography, of Hartley's earliest Berlin pictures, as do the strict, almost iconic symmetry and frontality that reinforce the suggestion of Stein's "personality." At the same time, these triangulated forms evoke Kandinsky's description of the movement of the triangle as representing the "life of the spirit" in his *Concerning the Spiritual in Art*, a book that had had a profound influence on Hartley at least as early as 1912. In 1917, the year following *One Portrait of One Woman*, Hartley would further his commitment to still life in a more representational yet still expressionist manner, based more upon primitivizing simplification than upon the direct heritage of European modernism.

Other Americans frequenting Gertrude Stein's salon were Arthur B. Carles and Alfred Maurer. Carles arrived in Paris as early as 1905, having studied at the Pennsylvania Academy of the Fine Arts with William Merritt Chase. Carles's first stay was brief; his second, from 1907 to 1910, had a more profound impact, for it was during this period that Carles began to associate with other young Americans in the Steins' circle who were gravitating toward modernism. Carles and Maurer shared a Paris address by the end of 1907, and both men were strongly influenced by Matisse at the time, an influence that remained with Carles for the next several decades and was undoubtedly reinforced by periodic visits to France, first in 1912, and several more times in the 1920s. Until Carles developed a rather belated pictorial homage to cubism in the 1930s, Matisse, and to some degree Fauvism, remained his primary European-derived influence and commitment. Nowhere is this better seen than in his still lifes.[13]

[13]There is no major publication devoted to the life and art of Carles, a gap that will be filled by Barbara A. Wolanin in the forthcoming catalogue of the exhibition at the Pennsylvania Academy of the Fine Arts, drawn from Ms. Wolanin's Ph.D. dissertation for the University of Wisconsin. The author is most grateful to Ms. Wolanin for sharing with him her information and analysis of Carles's *Still Life with Compote* and other works by the artist of this period. At present, see Henry G. Gardiner, "Arthur B. Carles: A Critical and Biographical Study," in *Arthur B. Carles*, pp. 139-84.

Edward Steichen had brought Carles to the attention of Alfred Stieglitz who included Carles's work in his show "Younger American Painters," which was held in March 1910 at Stieglitz's 291 Gallery. Also shown were the paintings of Arthur Dove, John Marin, Max Weber, Alfred Maurer, Marsden Hartley, and others — in other words, Carles was associated with the American avant-garde. Two years later, early in 1912, Carles had his first and only one-man show at 291. Included in this exhibition was a group of fruit still lifes, including his *Still Life with Compote* (1911), in which Carles's Fauve-like sensuousness in the enjoyment of color and paint is combined with a solidity of form and an application of brushstroke that derives very much from Cézanne. This combination of French modernist influences was also to be seen in Arthur Dove's best-known early work, *The Lobster* (1908, Mr. and Mrs. Hubbard H. Cobb Collection), and really represents an initial, basic American reaction to European avant-garde painting.

Figure 10.5. MARSDEN HARTLEY (1877-1943), *One Portrait of One Woman*, 1916; oil on composition board, 30 x 25¼ inches; University Gallery, University of Minnesota, Minneapolis, bequest of Hudson Walker from the Ione and Hudson Walker Collection.

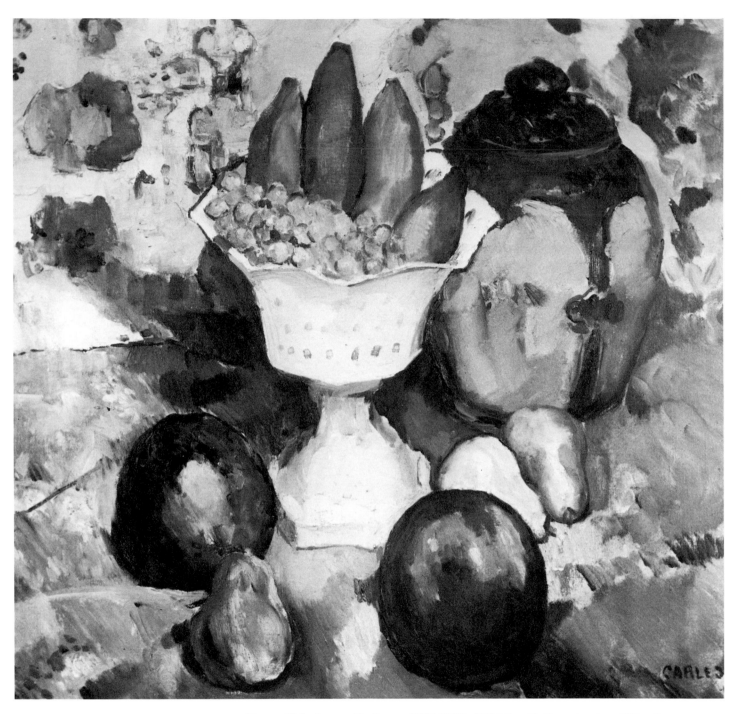

Figure 10.6. ARTHUR B. CARLES (1882-1952), *Still Life with Compote*, circa 1911; oil on canvas, signed at lower right — *Carles*, 24¼ x 25⅛ inches; Collection of The Newark Museum.

In Carles's *Still Life with Compote,* we have one of the most eloquent tributes to Cézanne's and Matisse's art to be found in American painting. In fact, parallels can be made with still lifes by both those masters. In the pear and melons in front of the white compote, the paint is laid on in broad swatches of contrasting colors, which build up the volume. The compote of fruit and the large Oriental jar are also rounded, three-dimensional forms built out of color. Space is compressed but not eliminated by the tilted tabletop and by the flat background plane; all the forms of still life stretch up vertically following the patterns of the decorated wallpaper background, either through attenuation in arrangement such as the red plantains all extending upward, or from the direction of the brushstrokes. Yet, color, not form, is the dominant element here. Witness the strongly contrasting pigments, interweaving one with another in both fruits and background, and the strong, exotic tones of the plantains, their rich reds contrasting with the brilliant white of their container, which itself alternates with blue shadows. As Carles himself said, "If there's one thing in all the world I believe, it's painting with color. So damn few people paint with color, and what on earth else is painting for?"[14] Carles's color dismayed many of the critics who visited the exhibition, but at least his sureness of draftsmanship left some of the more conservative writers — such as Arthur Hoeber of the *New York Globe* — reassured. Others, such as the writer in the *Philadelphia Inquirer* for 28 January 1912, commended Carles's "beautiful and joyous color." *Still Life with Compote* was exhibited later that year at the Salon d'Automne in Paris.

Carles brought the same sensual enjoyment of color and paint to his still lifes that he did to the painting of the female figure and nudes, which were frequent subjects of his brush. Yet, the still lifes, particularly the floral pieces that were done later in his career, were not rare in his art, as is revealed in the catalogues of his exhibitions of the 1920s and 1930s. These later flower pieces show the artist reveling in the broad application of pigment and achieving maximum effects in the contrasts of Fauve-like colors while often abandoning a Cézanne-derived grasp of structure, until he adopted a cubist manner in the last years of his life.

Of the young Americans who became associated with modernism, Alfred Maurer was the first to arrive in Paris. He was there in 1897 and stayed until 1914. He also quickly became a close friend and habitué of the Steins. Both through the Steins' collection and from firsthand experience, Maurer was an early convert to Fauvism and was strongly influenced by Matisse.[15] However, as in the work of Carles and of other Americans influenced by Matisse, Maurer's still lifes — those done as early as about 1908, and over the next twenty years — combine the colorism of Matisse with structural concerns derived from Cézanne. Gradually, there was a weakening of Maurer's concern with Fauve color so that some of the quite structural still lifes of the mid-1920s, painted in more muted tones, confirm the continually growing respect for Cézanne. Matisse's influence on Maurer's art is actually more apparent in the artist's landscapes.

In the last four or five years, before Maurer's tragic suicide in 1932, his work underwent a profound readjustment. It was during these years that he produced startling abstracted and double-head images, and also the most original and powerful of his still lifes; both groups were based upon a new and novel assessment of cubism.[16] In one sense, this might be seen as a retardataire: Maurer returning to a radical modernist aesthetic of an earlier decade, the aesthetic that had originally had a far more appreciable impact

ARTHUR B. CARLES, *Still Life — Flowers.* See plate 28, page 172.

[14]Jo Mielziner, "Arthur Carles: The Man Who Paints with Color," *Creative Art* 2 (February 1918): xxxv.

[15]For Maurer, see Elizabeth McCausland, *A. H. Maurer,* and the essay by Sheldon Reich in *Alfred H. Maurer, 1868-1932* (exhibition catalogue; National Museum of American Art, Washington, D.C., 1973).

[16]McCausland discusses the late still lifes in *A. H. Maurer,* pp. 211-17; Reich discusses the development of Maurer's still-life conceptions in *Alfred H. Maurer* (exhibition catalogue, pp. 62-76.

Figure 10.7. ALFRED H. MAURER (1868-1932), *Brass Bowl*, circa 1930; oil, 21⅜ x 18⅛ inches; University of Minnesota.

248

upon a number of his compatriots, such as Max Weber and Hartley, than it had had on Maurer himself. Beginning in about 1928, Maurer produced in these still lifes some of the finest cubist pictures by an American, while discovering combined emotional and aesthetic balance in the solving of the limited artistic problems of this genre. In these pictures, Maurer assumed a bird's eye viewpoint above the bowls of fruit and vegetables, flattening the forms against the underlying tabletops and faceting those tabletops and the walls and doors of the surrounding space into geometric planes of remarkably balanced design. Flattened forms are large, colors are bright though not overpowering, and textures are rich and varied, all suggesting the influence of the continuing synthetic cubist investigations of Georges Braque. These works were well received by critics when they were shown in Maurer's almost annual exhibitions at the galleries of Erhard Weyhe, who had begun to subsidize the artist in 1924. They have continued to be Maurer's most admired paintings and the most satisfying in his oeuvre.[17]

[17]In this chapter, I owe a debt of gratitude to Anne Gregory Terhune for her splendid paper, "Fauvism — The American Response in Still Life," prepared for a course in American still-life painting at the City University Graduate School in the spring of 1975.

Figure 11.1. ARTHUR DOVE (1880-1946), *Ten Cent Store*, circa 1924; collage, 18 x 16¼ inches; Nebraska Art Association, Nelle Cochrane Woods Collection.

11 Vernacular Modernism

Cubist-Realist Still Life and Beyond

The artists whose works were previously discussed applied an aesthetic to still-life painting that was drawn from European modernism and reflected that derivation directly, however much they informed their creations with distinct interpretations. Maurer's late still lifes are cubist; Carles derives from a Fauve aesthetic; and in the case of Hartley, Bruce, and others, the heritage of the related components of their art is essayable, however fascinating and complex the amalgamations. Furthermore, none of their paintings need have been painted in America and many were not.

All the artists discussed in this final chapter also worked within European-derived idioms. However, they translated foreign aesthetics into a vernacular readily identifiable, at least with the hindsight of art historical development, as American. Some of these artists worked in individual manners; others have been grouped within larger "movements." Some of them displayed an abiding interest in still life; others produced only an occasional or even a rare example of the theme.

Arthur Dove was certainly one of the latter. Dove was in Paris for a year beginning in 1908 and while there formed a close friendship with Alfred Maurer. In that year, he painted his one true still life, *The Lobster*, which was shown in the Paris Salon d'Automne of 1909. The picture reflects (even more directly than Maurer's painting of the time) a direct derivation from the work of Matisse in its sumptuous color and patterning, and from Cézanne in its structural organization. On his return to New York in 1909, Dove joined the group of young American moderns who exhibited at Stieglitz's 291 Gallery and began to produce the series of nature-based abstractions that marked him as one of the most advanced Americans of his generation.[1]

Although these works were nature based, they were not still lifes. However, among Dove's most original contributions to the world of art were the collages he produced between 1924 and 1930, "things" as he himself called them. Barbara Haskell has perhaps more properly referred to them as assemblages, because the majority of them are composed of three-dimensional objects that are assembled on a flat background. Collage was of course not new. It had been a favorite device of the cubists in the previous decade to stress the flatness of the planar surfaces of painting and to introduce new textural elements, while it divorced their work from tradi-

[1]See the essay by Barbara Haskell in *Arthur Dove* (exhibition catalogue; San Francisco Museum of Art, 1975).

tional aesthetic properties. But Dove's utilization of materials "foreign" to the art of painting took collage in a different direction, a much more pragmatic one and closer to the Dada collages of Kurt Schwitters yet still very original. Dove wittily assembled objects that retained their referential origins; they were chosen as much for thematic as for formal purpose. Since "objects" are the basic components of still lifes, many of these collages, or assemblages, began with still-life elements, as is seen in *Ten Cent Store*. A ten-cent store is an enterprise made up of thousands of objects regarded separately *as* objects. The cloth flowers and pipestems that, along with some real pressed leaves and flowers, make up the collage are objects that were, and are, available at a Woolworth's store. Brought together in masterly fashion by the artist-craftsman, they also reflect the gaiety and tinsel charm of a five-and-dime store and, at the same time, autobiographically reflect the economic level served by such an establishment, appropriate to the artist himself. *Ten Cent Store* may well have been the earliest of the some twenty-five collage-assemblages Dove is known to have created.[2]

If American pragmatism may be viewed as essentially underlying Dove's exceptional use of collage, Stuart Davis's art was even more rooted in a nativist tradition, in spite of his adaptation of a modernist, principally cubist, aesthetic. Davis was also much more concerned with expression through still life. Davis studied at Robert Henri's school in New York and his earliest professional works are vigorously realist street scenes from Newark and Hoboken in the Ashcan manner. With the experience of the Armory Show in 1913, Davis began to rebel against Henri's emphasis on subject matter and began to move in a formalist direction toward cubism. Within the stream of European modernism, the Cubists were the ones who most frequently used still-life motifs and arrangements, and the Armory Show included more cubist paintings than those of any other "ism."

Among Davis's earliest resolved works within his highly original application of the cubist idiom are a number of paintings relating to commercial packaging — itself, of course, an aspect of the still-life theme. Davis's use of such subject material is consciously and wittily antithetical to the concern with man-made objects that had motivated Harnett a generation earlier. In the same way, Harnett's illusionism is opposite to the total compression of space that characterizes works by Davis, such as *Bull Durham* (1921), *Lucky Strike* (1921, Museum of Modern Art), and several others done in watercolor. This is true despite the recognition in 1945 by James Johnson Sweeney that "we find him imitating newstype and cigarette trademarks with a meticulous illusionism and precision of detail that is perhaps more native, in its resemblance to the work of the nineteenth-century American painter William Harnett, than it is Cubist." Davis chose the strictly utilitarian and commercial from which to abstract formal patterns of colors, shapes, and simulated textures while at the same time manipulating their printing, to exploit further not only the flatness of lettering but also the dramatic and decorative values implicit therein. Instead of collages, these are paintings done in imitation of collages.[3]

The works of the following several years were crucial to the development of Davis's mature and individual manner, and the steps taken during those years were best manifested in his still lifes. His examples of 1922 were still dependent upon traditional French cubist models, but by 1924 he had eliminated the vestiges of modeling and the more neutral tones derived from analytical cubism and evolved an art of totally flat forms in bright

[2]On Dove's collages, in addition to Haskell, *Arthur Dove*, pp. 49-68, see especially the essay by Dorothy Rylander Johnson in *Arthur Dove: The Years of Collage* (exhibition catalogue; University of Maryland Art Gallery, College Park, 1967); *Ten Cent Store* is discussed as perhaps Dove's earliest collage on p. 19. The collages were also exhibited separately; see *Collages Dove* (exhibition catalogue; The Downtown Gallery, New York, 1955), and *Arthur G. Dove: Collages* (exhibition catalogue; Terry Dintenfass, Inc., New York, 1971), the latter with an excerpt from Johnson's essay in *Arthur Dove: The Years of Collage. Ten Cent Store* also figured in both of these exhibitions.

[3]The most recent published essay on Davis's art is that by John R. Lane in *Stuart Davis: Art and Art Theory* (exhibition catalogue; The Brooklyn Museum, 1978). The collage-imitated paintings are discussed on p. 94. For James Johnson Sweeney's comment, see his essay in *Stuart Davis* (exhibition catalogue; Museum of Modern Art, New York, 1946), p. 13. This essay and the later one by Lane are more concerned with Davis's still lifes than are most publications dealing with his art.

Figure 11.2. STUART DAVIS (1894-1964), *Bull Durham*, 1921; oil on canvas, signed at lower right — *Stuart Davis*, 30¼ x 15¼ inches; The Baltimore Museum of Art.

Figure 11.3. STUART DAVIS (1894-1964), *Matches*, circa 1927; oil on canvas, signed at upper left — *Stuart Davis*, 26 x 21 inches; The Chrysler Museum, on loan from the Collection of Walter P. Chrysler, Jr.

Figure 11.5. STUART DAVIS (1894-1964), *Eggbeater #5* (Study for); ink and gouache on paper, signed at lower right — *Stuart Davis*, 22 x 14 inches; Andrew Crispo Gallery.

Figure 11.4. STUART DAVIS (1894-1964), *Eggbeater #5*, 1930; oil on canvas; signed at lower right — *Stuart Davis*, 50⅛ x 32¼ inches; Museum of Modern Art.

[4]A group of these significant, transitional still lifes was exhibited in 1980. See *Stuart Davis Still Life Paintings, 1922-24* (exhibition catalogue; Borgenicht Gallery, New York, 1980).

[5]Davis's cubist still lifes, above all the *Eggbeater* series, are discussed by Lane, *Stuart Davis* (exhibition catalogue), pp. 16-19, 103-6.

[6]Sweeney, *Stuart Davis* (exhibition catalogue), p. 16.

[7]For Murphy, see *The Paintings of Gerald Murphy*, essay by William Rubin (exhibition catalogue; Museum of Modern Art, New York, 1974).

colors, radically simplifying his forms and isolating them through sharp, but thick, black boundary lines.[4] Some of the major works of that year and those immediately following are traditional still-life setups, chosen because "they were there" and because they offered the necessary forms for pictorial and spatial manipulation. Others, such as his well-known *Odol* (1924, Private Collection), refer back to his slightly earlier commercial packaging pictures. However, all express an aesthetic of broad rhythms, clear forms, bright colors, and an openness of space that differs from the mechanistic work of Fernand Léger, the French cubist who seems to have influenced Davis the most. These works may be seen as "American" in spirit. They look forward to the jazziness and effervescence of his best-known pictures — the scenes and abstractions of the thirties and later — which are certainly pictorial analogues for the spirit of this country.

These last works referred to — the bulk of Davis's output — were not still lifes. However, immediately preceding them, and crucial to the development of his art, were the famous *Eggbeater* series, four pictures painted between 1927 and 1928, and two other works of 1927, *Matches* and *Percolator* (Metropolitan Museum of Art).[5] In all of these, of course, Davis deliberately concentrated upon ordinary, exceedingly mundane objects of no aesthetic or philosophic associations, objects he chose so as to be free to concentrate on purely pictorial problems — the analysis, fragmentation, and reconstruction of their structural elements. Davis regarded the subject matter of the *Eggbeater* series — an eggbeater, rubber glove, and electric fan nailed to a tabletop — as being unaesthetic, absurd, non-arty, worthless, but in these works the actual forms and their environment are all but irrelevant and unrecognizable. Davis himself best described his attitude toward the still life in these pictures:

> The pictures themselves are not decorations. They are pictures. Their subject is an invented series of planes which were interesting to the artist . . . In fact this eggbeater series was very important to me because in this period I got away from naturalistic forms. I invented these geometrical elements. What led to it was probably my working on a single still life for a year, not wandering around the streets. Gradually through this concentration I focused on the logical elements. They became the foremost interest and the immediate and accidental aspects of the still life took second place.[6]

The *Eggbeater* series was inspired in part by a more representational, if somewhat cartoonlike, *Eggbeater* painting of 1923. A reconstituted and recognizable eggbeater figures prominently in a more traditional still-life arrangement such as *Eggbeater No. 5* (1930, Museum of Modern Art), with its simplified forms in strong outline.

The reflection of an aesthetic that is somewhat similar to Davis's can be found in the still-life pictures of Gerald Murphy, which were painted at the same time as Davis's: Murphy's *Razor* (1924), *Watch* (1924-1925, Dallas Museum of Fine Arts), and *Wasp and Pear* (1929). These works, painted in France rather than in America, suggest the influence of cubism and even more of purism, in their preciseness and purity of form and in the monumentality with which Murphy endowed familiar objects. As in Davis's approach to subject matter, these are objectively rendered as commonplace paraphernalia, and in the case of *Razor* with its "Three Star Safety Matches" as very recognizably American.[7] The earlier two works depict manufactured items, flattened into geometric components, but not at all abstracted. Unlike Davis's work, or even most cubist precedent, Murphy's still lifes take on an

Figure 11.6. GERALD MURPHY (1888-1964), *Razor*, circa 1924; oil on canvas, signed at lower center — *G Murphy*, 32⅝ x 36½ inches; Dallas Museum of Fine Arts, Foundation for the Arts Collection, gift of Gerald Murphy.

iconic monumentality from two related factors. First, they are symmetrical (in the case of the earlier two, extremely so). And second, they are tremendously enlarged from their "real" models — prefiguring, indeed, the work of such later twentieth-century still-life artists as Lowell Nesbitt, Don Nice, and the increasingly more specialized work of Tom Wesselman. In *Wasp and Pear*, the various components almost compete with one another for monumentalization, even within the same object. The isolated pear seed is a giant all on its own, and the wasp's "foot" appears literally to be microscopically enlarged. Such an approach demands psychic readjustments by the viewer. We have pointed out that an almost universal characteristic of still life was its one-to-one scale relationship with reality. Only occasionally

Figure 11.7. GERALD MURPHY (1888-1964), *Wasp and Pear*, 1927; oil on canvas, signed at lower right — *G. Murphy*, 36¾ x 38⅝ inches; The Museum of Modern Art, gift of Archibald MacLeish.

had still life been miniaturized. In the case of Murphy, and those who came several generations after him, an opposite phenomenon appears. This giganticism runs counter not only to our experience of the actual objects but also to our preconceptions of the accepted scale of still life.

Perhaps the most distinct American development from cubism can be found in the work of that group of artists — they were never a cohesive school — who have been variously labeled as precisionists or immaculates. Neither name is really satisfactory. The latter suggests a preciousness and a

lack of strength that the work belies, and the former is too inclusive — after all, the Hudson River School landscape artists and the American Pre-Raphaelites all painted in a precise manner. Perhaps the term *cubist-realist* is most apt and certainly most descriptive.[8] That is, this group of painters, some of whom began to work in this distinctive manner as early as the later 1910s, adapted certain cubist devices, not to shatter representational form for the purposes of re-creation but rather to clarify definition, reducing objects to their basic cubic shapes — an essentially realist purpose. As Milton Brown has suggested, their work derives from cubism and adapts that aesthetic in somewhat the same way that French purism does. Interestingly, and not coincidentally, purism developed at exactly the same time, although forms in purist canvases were abstracted in a way that the cubist-realists mostly avoided.[9]

Of course, the concern for precisionism and for simplification of form of the cubist-realists, or precisionists, is usually considered in regard to paintings of industrial architecture and machine forms, much as the purists who thought of their works as "architectural" art. Yet, while the mechanistic urge was a strong force in Western art in the second and third decades of this century, cubist-realist principles were applicable to many artistic forms,

[8]For precisionism, see *The Precisionist View in American Art*, essay by Martin Friedman (exhibition catalogue; Walker Art Center, Minneapolis, 1960); *The Precisionist Painters, 1916-1949: Interpretations of a Mechanical Age*, essay by Susan Fillin Yeh (exhibition catalogue; Heckscher Museum, Huntington, New York, 1978); the "Precisionism" issue of *Art in America* 48: 3 (1960); and Milton Brown's seminal essay, "Cubist Realism: An American Style," *Marsyas* 3 (1943-1945): 139-60.

[9]Brown, "Cubist Realism," pp. 139-40.

Figure 11.8. PRESTON DICKINSON (1891-1930), *Still Life;* oil on canvas, 20 x 24 inches; Dr. and Mrs. Harold Rifkin.

[10]For Schamberg, see Ben Wolf, *Morton Livingston Schamberg*.

[11]For Preston Dickinson, see the essay by Ruth Cloudman in *Preston Dickinson, 1889-1930* (exhibition catalogue; Sheldon Memorial Art Gallery, University of Nebraska-Lincoln, 1979).

still life among them. Man-made, and even more, machine-made objects would seem the most logical choice for cubist-realist interpretation, but actually such themes constituted a minority of these still lifes. It is true, however, that the earlier cubist-realist still lifes are concerned primarily with the preciseness of basic geometric shapes, harking back through cubism to Cézanne's reduction of nature to the cylinder, the sphere, and the cone. This is the case of the rare works of the short-lived Morton Schamberg who, as early as 1916, interpreted such mechanical objects as the telephone and the camera in terms of their basic rectilinear and rounded component parts.[10]

While he was in Paris from 1911 to 1914, Preston Dickinson was also profoundly affected by European modernism, especially by Cézanne's work. He was also one of the earliest Americans to investigate the industrial landscape, applying a cubist-inspired aesthetic of sharply faceted forms, at once clearly rendered and broken. Dickinson's chronology is not easy to interpret. He might paint fragmented and near-abstract scenes at much the same time as the realistic, if simplified, ones.[11] In general, however, his more radical interpretations of the landscape, both the natural and industrial, seem to have occurred in the years immediately following his return to New York. His work of the 1920s is more realistic and more conservative. This seems to be equally true of his still lifes, the theme to which he turned about 1922. Those of the earlier years of that decade are more cubist, but even later ones, such as his *Still Life with Flowers*, continued a concern with sharply rendered forms and with a strongly manipulated *chiaroscuro* that created arbitrary tonal patterns. Surfaces seem to glow and light-dark patterns seem to exist semi-independently of the actual forms that they define. Dickinson's still-life paraphernalia is fairly standard — fruit, flowers, glassware, and crockery — but the man-made elements tend to dominate and to be emphasized. The artist obviously enjoyed exploring the sharp outlines of ceramic vases and glassware. The reflections of the former and the refraction of light through the latter exist as independent patterns, along with emphasis given to the patterned geometry of napkins, table coverings, and wall hangings. In cubist fashion, still-life displays are usually upended, not, however, to emphasize the flatness of the picture plane by bringing the table support up close to it but to create a greater dynamism. In *Still Life with Flowers*, for instance, the two contrasting oblique lines of the table provide the main axes along which the objects upon the table are aligned and provide a foil against which darker objects and background planes are set off. In the earlier still lifes, planes are faceted, rounded shapes are more dynamic, and the perspective is more radically tilted; in the later ones, objects are more solid and volumetric.

Dickinson was something of a loner, but in Paris he became friendly with Charles Demuth who was there between 1912 and 1914. In 1914, he exhibited at Charles Daniel's New York Gallery, which had opened in 1913. Daniel's was one of the few galleries at the time to show the more European-influenced modernists. It exhibited the works of most of the artists who became known as precisionists, including Dickinson. Demuth, who came from Lancaster, Pennsylvania, became a close friend of Marcel Duchamp when the latter came to New York from France in 1915. The following year, Demuth went to Bermuda with his good friend Marsden Hartley, and his early cubist landscapes date from this time. Working first in watercolor, he changed to oils around 1920 when he started creating architectural and

industrial landscapes. He too adapted cubism to simplify and to purify forms and to reduce structures to their basic geometry.[12]

However, watercolor was his earliest medium, which was utilized in the 1910s for flower pieces and for figural compositions, and he continued to reserve the medium for still lifes and figures until his death in 1935. Demuth's still lifes, almost all in watercolor, fall into two major chronological groups.[13] There are the early flower pieces of the 1910s and the later fruit and flower pieces painted during the period of 1922-1933. Demuth's approach to the still life in the two periods is quite distinct, but it should be emphasized that in both the underlying influence is that of Cézanne. The early works, such as *Cyclamen* and *Poppies* (both 1918), are tremendously delicate and expressive. The flower pictures done a few years earlier, beginning in 1914, have a somewhat flat, primitive look, the earliest ones enmeshing the flowers within an overall patterning, but by the end of the decade his soft washes glow with jewellike color, some fading into one another and others appearing like colored mist out of the paper. The flowers glow with a sensory equivalent of floral fragrance, while the colored forms, sometimes gently outlined, bend sinuously in the organic rhythms of the individual flowers. Purples and carmines are among the favored tones, along with the various greenish hues of leaves. The washes are finely transparent and much of the paper remains untouched, both techniques following, yet not imitating, the work of Cézanne.

By about 1921 or 1922, Demuth's compositions became more solidified, the color somewhat stronger, and the outlines sharper. These outlines are sometimes in pencil and sometimes created by negation, that is, the placement of washes close to one another but not abutting so that white "outlines" appear from the untouched paper. About this time, he introduced alternate still-life subjects — fruits and vegetables — although still drawing from nature. These forms were presented, true to their existence in reality, as being more solid and volumetric than flowers. The volumes were created, as in Cézanne's work, by juxtaposing large swatches of color. Particularly in the vegetable pictures, outlines tend to be broad, and the colors rich and sometimes dark, as in his *Eggplant, Carrots and Tomatoes* (circa 1927), where the composition is dominated by the dark purple of the eggplant. Tomatoes seem to have been Demuth's particular favorite. He shows them as being rich in color and solid in shape, creating strong pleasing color harmonies and contrasts with other vegetables. Here again, Demuth leaves much of the paper untouched, and some areas of forms are only lightly outlined; however, the work is finished because the problems involved were solved and the aesthetic rendering was completed. In many of the paintings, fruit and flowers were rendered against hanging or lying cloths or in bowls, again Cézannesque, although a kind of relaxed faceting of light and shadow patterning of these background elements suggest a cubist heritage. Although Demuth's architectural paintings and his "Poster Portraits" have received far more attention in the literature and exhibitions of twentieth-century art, his most beautiful paintings are his still lifes. Indeed, he ranks as one of the American "greats" in this field, as he is one of the finest of American watercolorists.

Still lifes constitute the majority of Demuth's works. This is not true of the precisionist pictures of Charles Sheeler, although after studying at the Pennsylvania Academy, where he was enrolled in the still-life and life-drawing classes of William Merritt Chase, Sheeler went briefly to Europe

[12]The standard published work on Demuth is Emily Farnham, *Charles Demuth: Behind a Laughing Mask,* based upon her dissertation for Ohio State University, 1959. Also to be noted is Alvord L. Eiseman, "A Study of the Development of an Artist: Charles Demuth" (Ph.D. diss., New York University, 1976); for the still lifes, see especially vol. 1, pp. 221-44, and vol. 2, pp. 432-508.

[13]A volume that deals almost exclusively with Demuth's still lifes is Thomas E. Norton, *Homage to Charles Demuth, Still Life Painter of Lancaster.* It is perhaps worth noting here that the still lifes of the precisionist painters and, indeed, of most noted twentieth-century artists have been scantily studied; Norton's volume is the exception. This may not seem unusual, given the historical disdain for still life, but it is nevertheless surprising, particularly in regard to some of the painters discussed in this chapter. For instance, the majority of Demuth's paintings are still lifes; yet most of the published essays concerning his art deal with this body of work very cursorily. As will be discussed, Charles Sheeler's still lifes constitute only a small segment of his art, but they are both distinctive and significant; they have never been separately treated and are usually overlooked or little noted in historical criticism and analysis. This contrasts, for instance, with published articles and even books on the still lifes of such European artists as Courbet and Manet, in whose oeuvres still lifes figure no more prominently than in Sheeler's.

CHARLES DEMUTH, *Eggplant, Carrots and Tomatoes.* See plate 29, page 173.

Figure 11.9. Charles Demuth (1883-1935), *Cyclamen*, 1918; watercolor on paper, signed at lower left — *Demuth-1918*, 13⅞ x 9¾ inches; Phillip A. Bruno Collection, New York.

Figure 11.10. CHARLES DEMUTH (1883-1935), *Poppies*, 1918; watercolor, signed at lower left of center — *C. Demuth, 1918*, 17⅞ x 11⅞ inches; Munson-Williams-Proctor Institute, Utica, New York, Edward W. Root bequest.

[14] For Sheeler, see the essay by Martin Friedman in *Charles Sheeler* (exhibition catalogue; National Museum of American Art, Washington, D.C., 1968); Martin Friedman, *Charles Sheeler*; Lillian Natalie Dochterman, "The Stylistic Development of the Work of Charles Sheeler" (Ph.D. diss., University of Iowa, 1963); and the more recent study by Susan Fillin Yeh, "Charles Sheeler and the Machine Age" (Ph.D. diss., City University of New York, 1981).

CHARLES SHEELER, *Dahlias and White Pitcher*. See plate 30, page 174.

[15] Constance Rourke, *Charles Sheeler: Artist in the American Tradition*, p. 107.

[16] Ibid., p. 183.

and returned to the states to paint primarily still lifes.[14] These fruit and bouquet pictures in deep lustrous color and rich impasto are fully proficient, mature works, but in their expressionism they do not at all foretell the precisionist style Sheeler was to assume later. Cubism was the major source for the change in Sheeler's artistic direction. He had become aware of it in Paris but was affected by it more deeply in 1913 at the Armory Show. Like his fellow precisionists, Sheeler drew from cubism an emphasis upon planar surfaces. His formal concern was for simplification, not fragmentation or a disregard for subject matter. As early as 1912, Sheeler became a commercial photographer to supplement his livelihood as a painter, and photography played a crucial part in the shaping of his aesthetic, however much he may have tried to segregate his attitudes toward each. Another important factor in his artistic development was the art of his close friend Schamberg, with whom he studied and lived before Schamberg's death in 1918.

Sheeler's subject matter was naturally chosen for its compatibility with a cubist-realist manner, and of course he is best known for his industrial and architectural subjects. He too, like Dickinson and others, "relaxed" into still life, although their "cleanness" of form, the impersonality, and the formality of their presentation ally these with his major efforts. His best-known precisionist still lifes were painted between 1923 and 1927, with others done occasionally during the next decades. A greater number of these still lifes are of flowers in containers; the precision of the vases and pitchers is as prominent as the organic forms themselves. Noteworthy in the case of all Sheeler's mature still lifes is the amount of surrounding space with which he endows the arrangements. Whether positioned against a bare wall or within a more defined environment, the still life can "breathe." As Sheeler himself put it, "the table is the result of all things that are happening to it."[15] It is not therefore surprising that in the early thirties Sheeler took the logical step of drawing and of painting a considerable number of remarkably precisionist interiors in which the still life remains prominent but is merged with its setting. One might draw an analogy here with the innovations of Childe Hassam and others of the previous generation who set the floral still life into its natural environment as a major new artistic theme, although the freedom of form and the loose painterly brushwork of these earlier artists are antithetical to Sheeler's precisionism. In such works, Sheeler could manipulate a variety of real, yet geometric, items of furniture, along with patterned rugs, spreads, paneling, tiles, and stairs, creating a fascinating cat's cradle of geometric pattern. The furniture itself was usually of the spare, unupholstered wooden Shaker type that Sheeler admired and collected. In such pictures, the still-life elements themselves — the irregularity of the plant forms and the curvature of bowls and pots — offer some contrast and relief to the rigidity that predominates, although they too are "precisely" painted. That Sheeler was aware of the still-life heritage that he shared is perceptively indicated in his statement concerning Raphaelle Peale's *After the Bath:*

> While the subject is really the sheet this is so packed with visual interest that one never remembers how commonplace it is. There are great variations of form within its boundaries, elaborated by the creases and curvatures in the surface. The color consists of gradations of white, cool white, with the highest light inclined to be bluish. It's the finest nude I ever saw![16]

Often grouped with the precisionists, and discussed by Milton Brown in his article on the cubist-realists, is Georgia O'Keeffe, who shared with Demuth a fascination for floral imagery. Indeed, the two are the greatest

American flower painters in the century. O'Keeffe was closely involved with Stieglitz, both personally and professionally, at his 291 Gallery where her work was first shown in 1916, without her previous knowledge of the exhibition. Her first one-person show held the following year was also the gallery's last exhibition. O'Keeffe's earliest mature works were nature abstractions not dissimilar from those of Dove. She painted her first major flower pictures in 1924, the year she had married Stieglitz. As early as 1916, O'Keeffe had begun spending time in the southwest for health reasons and to teach. In 1929, she made her first trip to New Mexico, staying in Taos with her friend the art patron Mabel Dodge Luhan. From then on, she continued to spend her summers in Taos, buying a house in Abiquiu in 1945, the year before Stieglitz died. In 1949, she began to live there year round.[17]

[17]For Georgia O'Keeffe's work, see the essay by Lloyd Goodrich in *Georgia O'Keeffe* (exhibition catalogue; Whitney Museum of American Art, New York, 1970); and *Georgia O'Keeffe* (New York, 1976). To be noted also is Charles Child Eldredge, "Georgia O'Keeffe: The Development of an American Modern" (Ph.D. diss., University of Minnesota, 1971).

Georgia O'Keeffe continued to paint nature abstractions in addition to her flower pieces. Beginning in 1926, she did architectural views of the city of New York, which, as would be expected, are the works most completely in the precisionist idiom. Not all of her still lifes are of flowers. Some that immediately preceded the flower pictures represent only leaves and some few are of fruit or vegetables, while some of the best known are her depictions of bleached skulls and bones, mostly animal, sometimes human. However, the flower paintings, sometimes conceived as serial interpretations of a single flower, are the most vital and the most monumental of all her work. They too are in the precisionist idiom, sharply delineated and cleansed of accident.

O'Keeffe's flower pictures do not suggest a clear European heritage, as Demuth's works do, and they differ from Demuth's contemporaneous work in several other respects. While much of Demuth's flower oeuvre is delicate and exquisite, O'Keeffe's is truly monumental, the artist conceiving in broad, flowing areas of form rather than in faceted, broken ones. Interestingly, O'Keeffe recalled that she and Demuth "always talked about doing a big picture together, all flowers. I was going to do the tall things up high, he was going to do the little things below."[18] Although O'Keeffe sometimes created in series, each representation is nevertheless an individual, fully realized work. O'Keeffe usually painted single flowers, not the traditional bouquets. She does not approach the flower from the outside, standing back from it and composing a satisfying composition as did Demuth. She zeroes in with a beelike perspective and enters the flower; as a result, the viewer is often plunged into its vortex, sometimes with no outer confines or surrounding space. She has shown a preference for flowers with deep recesses — petunias, lilies, irises, and tulips. The flower may still be growing or it may be picked; this is not of concern to O'Keeffe or to the viewer. If picked, the flower nevertheless is much alive; the artist manipulates light so that some petals have the translucence of freshness, and their swelling, curving forms suggest living organic rhythms. She positions her flowers so that we face into them. They are frontal, and wide open. Petals appear to pulsate, and the stamens shoot up out of the flower before the viewer's eyes. Again unlike Demuth, but like the contemporaneous work of Murphy, O'Keeffe's flowers are tremendously magnified, larger than life.

Magnification — what Brown refers to as her microscopic vision — is basic to O'Keeffe's flower, leaf, and vegetable pictures.[19] As Brown points out, it serves a dual purpose, heightening reality and at the same time destroying the normal appearance of the magnified object so that formal

GEORGIA O'KEEFFE, *Calla Lily*. See plate 31, page 175.

[18]Quoted in Eldredge, "Georgia O'Keeffe," p. 54, footnote 34, from Dorothy Seiberling, "Horizons of a Pioneer," *Life* (1 March 1968): 52. See Eldredge, "Georgia O'Keeffe," pp. 52ff., for a particularly incisive study of O'Keeffe's flower paintings.

[19]Brown, "Cubist Realism," pp. 155-56.

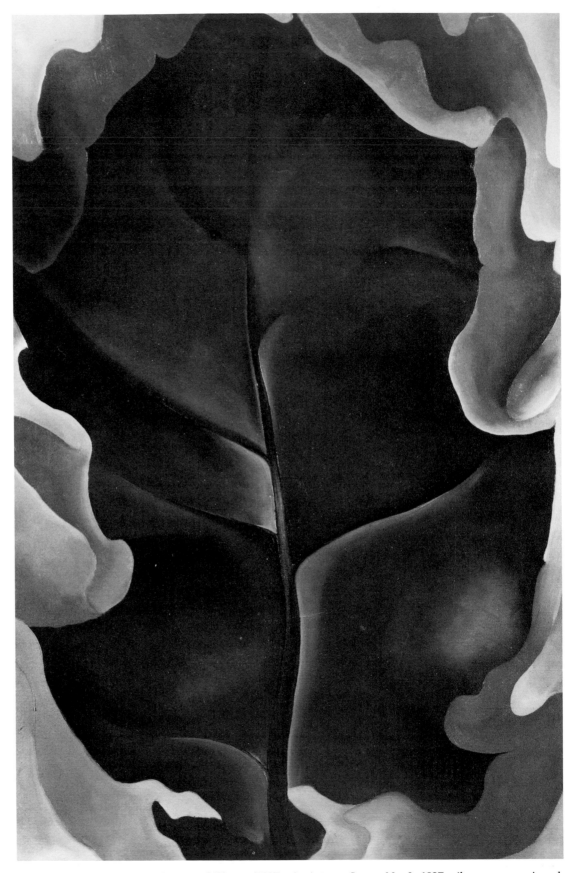

Figure 11.11. GEORGIA O'KEEFFE (1887-), *Autumn Leaves No. 2*, 1927; oil on canvas, signed
verso — *initials with star* (monogram), 32¼ x 21 inches; courtesy of Kennedy Galleries,
Inc., New York.

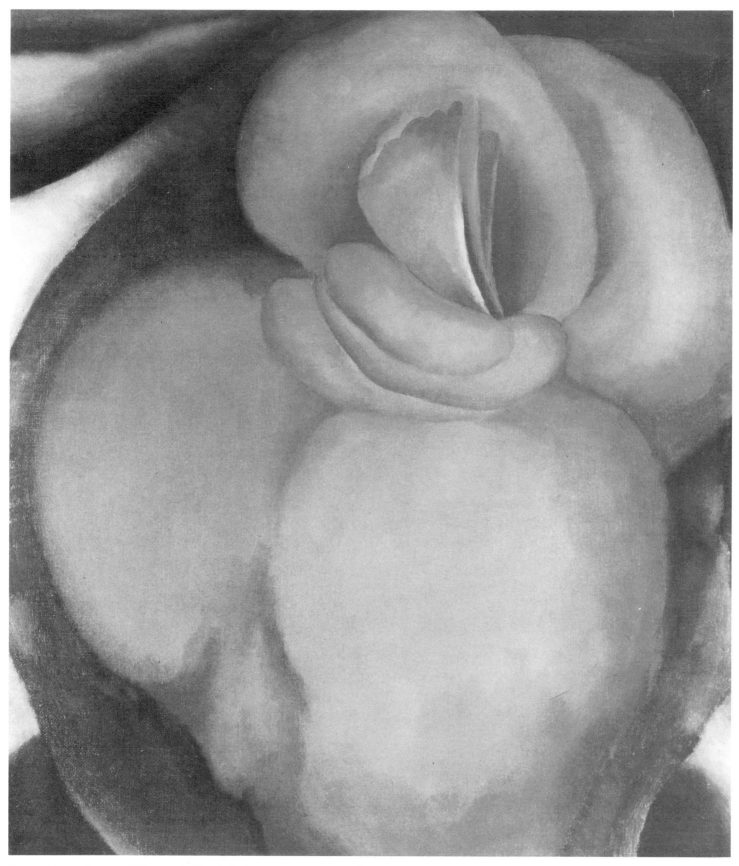

Figure 11.12. GEORGIA O'KEEFFE (1887-), *Red Flower*, circa 1919; oil on canvas, 20 x 17 inches; Private Collection, Norfolk, Virginia.

relationships with which the viewer was previously unfamiliar take on abstract characteristics. Brown also convincingly demonstrates O'Keeffe's indebtedness in this regard to the photographs of Paul Strand of about 1917, which are in turn part of the cubist heritage. But, in O'Keeffe's case, that heritage has been so transformed that it is not a simple derivation.

The artist herself wrote in 1939 that she translated her love of the flower into its magnification, so that the viewer "will be surprised into taking time to look at it."[20] Yet, she was also disturbed at what the viewers often claimed to see and what critics deduced from her floral imagery. O'Keeffe's flowers pulsate like human flesh, and their soft, sensuous textures are also analogous. Drawn from living imagery, the sexual connotations and associations are vivid; her flower forms may be seen as descriptive of female genitalia — the *Alligator Pears*, for instance, might suggest the swelling forms of breasts. Paul Rosenfeld wrote in 1924: "Whether deep-toned, lustrous, gaping tulips or wicked, regardful alligator pears; it is always as though the quality of the forms of a woman's body, the essence of the grand white surfaces, has been approached to the eye, and the elusive scent of unbound hair to the nostril."[21]

[20]Quoted in Goodrich, *Georgia O'Keeffe* (exhibition catalogue), p. 18.

[21]Paul Rosenfeld, *Port of New York,* rev. ed., pp. 205-6.

Figure 11.13. GEORGIA O'KEEFFE (1887-), *Alligator Pears,* circa 1923; oil on board, 9 x 12 inches; Collection of The Williams Companies, Tulsa.

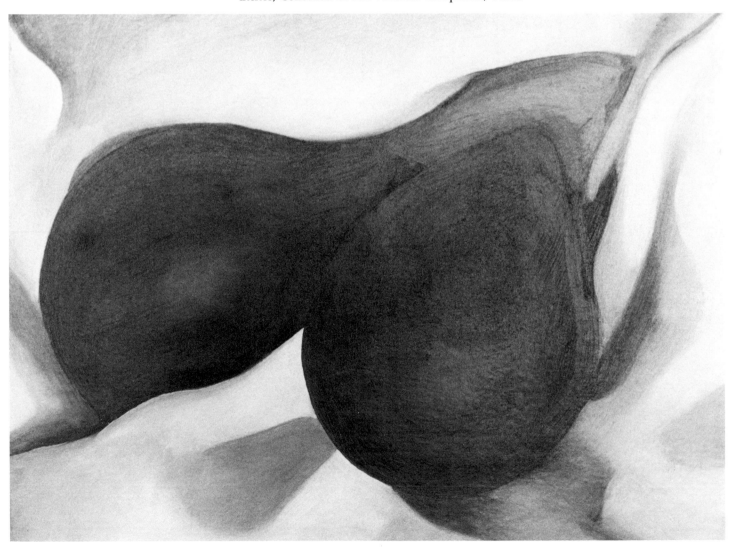

A Freudian interpretation of O'Keeffe's flower pictures was prevalent in the years immediately after she first began to produce them. In turn, in the 1960s, many writers reacted against such an approach, admiring the works rather as precursors of contemporary abstraction and condemning the subjective indulgence in the search for hidden meanings.

O'Keeffe herself strongly objected to the sexual analogies, accusing her critics of interjecting their own associations into her interpretations.[22] Nevertheless, consciously intended or not, the identification of the still life with the sexual generative force is neither new nor unique to O'Keeffe's painting. We have noted this interpretation of Heade's flower pictures, although admittedly it is a twentieth-century, post-Freudian interpretation. Heade's earlier orchid pictures are aggressive forms; his later magnolias are luxuriantly reclining.[23] O'Keeffe's flowers share qualities of both. Furthermore, if their magnification creates a magic by projecting the flowers beyond the life-likeness of the floral scale, it sets the flower within *human* scale, carrying the sexual analogy beyond that of her nineteenth-century precursor. Among the artists of her own generation, Demuth again comes to mind. In works such as the latter's *Daisies and Tomatoes* (1924, Private Collection) and *Corn and Peaches* (1929, Museum of Modern Art), Demuth combines his natural forms in a manner that can only be seen as willfully analogous to male genitalia. Also, the combination of the objects themselves is peculiar as well as untraditional: a vase of daisies with tomatoes suggests neither a usual decorative arrangement nor the preparations for a meal. This was recognized early by Demuth's good friend, the poet William Carlos Williams, when he wrote, "In my painting of *Orchids* which Charlie did — the one called *Pink Lady Slippers* (1918) he was interested in the similarity between the forms of the flowers and the phallic symbol, the male genitals. Charlie was like that."[24]

Demuth's manipulation of his forms to suggest sexual connotations was obviously intentional; O'Keeffe denies that purpose in her work, and one can only speculate in the case of Heade. Consciously motivated or not, the question of autobiographical meaning is another aspect of such critical interpretation. Stebbins convincingly suggests the possible analogy of male-female sexuality, of sexual duality, and even of sexual jealousy in the earlier orchid and hummingbird pictures of Heade, contrasted with the relaxed pleasures of his late marital state that were reflected in the magnolia pictures.[25] Demuth's homosexual inclinations are quite wittily sublimed in his flower and fruit phallicisms. O'Keeffe's still lifes are a joyous exultation of female sexuality, a triumph of generative power, the artist's denial notwithstanding.

The 1930s in American art was a complex period for both easel and mural painting. Various representational modes found outlets in regional subjects and social realism, among other manifestations, while competing with the rising surge of abstraction. However, little new invention was found in the realm of still life. At the end of the decade, the New York artist Bradley Walker Tomlin turned from a modified realism to an original adaptation of cubism. He was concerned not so much with either fragmentation or structure but with utilizing a cubist format as underpinning for a basically decorative arrangement of symbolic forms that were chosen with seemingly surreal implications. This phase of Tomlin's career lasted about five years (the course of World War II) before he emerged with the white-

[22]In addition to ibid., footnote 21, see especially the article by Louis Kalonyme, "Georgia O'Keeffe: A Woman in Painting," *Creative Art* 2 (January 1928): xxxv-xl, especially p. xxxv. Statements in reaction to a Freudian interpretation of O'Keeffe's flower pictures can be found in Peter Plagens, "A Georgia O'Keeffe Retrospective in Texas," *Artforum* 4 (May 1966): 27-31; Eugene Goossen, "Georgia O'Keeffe," *Vogue* 149 (1 March 1967): 177-79, 221-24, especially p. 222, and Eldredge, "Georgia O'Keeffe," chap. 7, for a complete discussion of the controversy. O'Keeffe's own reaction to such a Freudian interpretation can be found in Georgia O'Keeffe, *Exhibition of Oils and Pastels*, statement by Georgia O'Keeffe (New York, An American Place, 1939), quoted in Goodrich, *Georgia O'Keeffe* (exhibition catalogue), p. 19.

[23]Theodore E. Stebbins, Jr., *The Life and Works of Martin Johnson Heade*, pp. 142-43.

[24]Ibid., pp. 142-43, 176.

[25]Demuth's sexuality and its impact upon his art are discussed in Kermit Champa, "Charlie Was Like That," *Artforum* 12 (March 1974): 54-59; Williams is quoted on p. 54. The phallic symbolism in Demuth's still lifes is also discussed in a term paper for a graduate course in American still-life painting at the Graduate School of the City University of New York in the spring of 1975 by Mitchell Cutler, "Demuth Still Lifes."

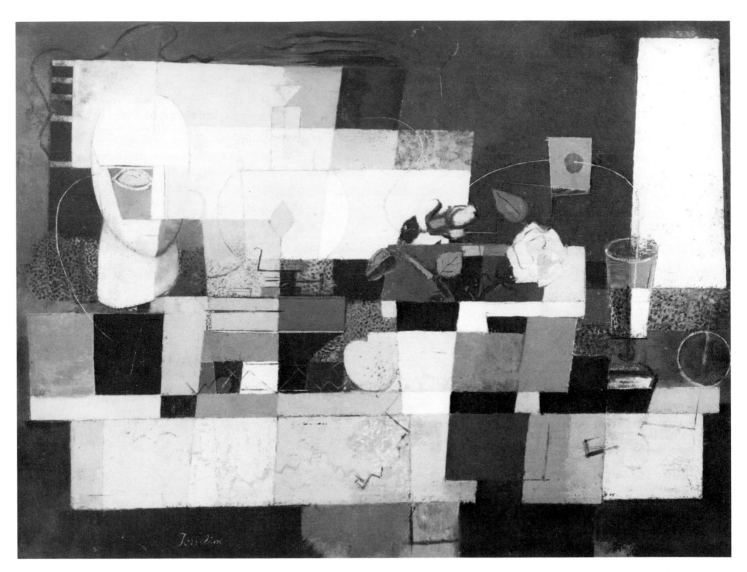

Figure 11.14. Bradley Walker Tomlin (1899-1953), *Still Life (Inward Preoccupation)*, 1939; oil on canvas, signed at lower left — *Tomlin*, 34 x 46 inches; lent by the Whitney Museum of American Art, New York, 1942.

[26]For Tomlin, see John I. H. Baur, *Bradley Walker Tomlin,* and the essay by Jeanne Chenault in *Bradley Walker Tomlin: A Retrospective View* (exhibition catalogue; Emily Lowe Gallery, Hofstra University, Hempstead, 1975), drawn from Chenault's Ph.D. dissertation for the University of Michigan, 1971.

[27]For Hofmann, see Clement Greenburg, *Hofmann; Hans Hofmann,* with an introduction by Sam Hunter

line, cubist abstraction for which he is best known. Tomlin's work of the mid-thirties is presently unlocated and unknown, and the development of this personal, semi-abstract approach is unclear, but the paintings of the early forties that resulted are usually, although not always, in a still-life format. They are also among the most poetic American pictures of the period.[26]

Like Tomlin and other major artists who embraced abstract expressionism in the 1940s, Hans Hofmann had previously concentrated on still life. Hofmann was born in Munich but lived in Paris during the advent of the Fauve and cubist movements. He came to America in 1931. Before his arrival in America, and until 1935, he was solely occupied with drawing, rather than painting, to which he returned only about 1935. At the beginning of the following decade, Hofmann became almost totally involved with abstraction, but during the late 1930s, many of his major works were large interiors with prominent still lifes.[27] In these, the heritage of Fauvism and cubism merges in a wild frenzy of splashing color within the quite structured interiors. The still-life components, the geometric forms of rooms, and

the furniture are vigorously "drawn" in paint and are defined with an energetic linearity. The still recognizable subject matter, consisting of fruit and flowers and other objects on tabletops, is comfortable, for all the dynamic invention of the artist's style. Subject matter, as such, is not fortuitous here. These are still lifes of the studio, and the life of the studio is primarily defined as the gesture of the brush, which is indeed the "language" that defines these compositions. In this half-decade, color replaced drawing as the artist's major concern, allowing him greater freedom of invention, which culminated around 1940 in totally abstract works. Many of Hofmann's later paintings, however, retain a referential basis in nature and natural forms. Particularly around 1950, he painted a number of major works in which still life is clearly suggested: these include *Magenta and Blue*

Figure 11.15. HANS HOFMANN (1880-1966), *Table with Fruit and Coffeepot*, 1936; oil and casein on plywood, signed at lower right — *Hans Hofmann '36*, 60⅛ x 48⅛ inches; University Art Museum, University of California, Berkeley, gift of the artist.

(New York, 1963); the essays by Frederick S. Wight in *Hans Hofmann* (exhibition catalogue; Whitney Museum of American Art, New York, 1957), and by William C. Seitz in *Hans Hofmann* (exhibition catalogue; Museum of Modern Art, New York, 1963); and also the historical discussion by Bartlett H. Hayes, Jr., in Hans Hofmann, *Search for the Real and Other Essays*. In these and other writings on Hofmann, the semirepresentational works of about 1935-1940 receive little attention. Moreover, what comment they do elicit is directed toward describing those formal qualities seen as harbingers of his later, abstract paintings and toward viewing their recognizable elements as manifestations of the artist's limitations or hesitations in "going all the way" to complete abstraction. They have not been studied, to the author's knowledge, in regard to their interpretation of the representational mode.

EDWIN DICKINSON, *Still Life with White Plate*. See plate 32, page 176.

[28]See the essay by Lloyd Goodrich in *Edwin Dickinson* (exhibition catalogue; Whitney Museum of American Art, New York, 1965), p. 5.

(1950, Whitney Museum of American Art, New York) and a series entitled *Fruit Bowl* (1950, University of Nebraska Art Galleries, Lincoln; Newberger Museum, State University of New York at Purchase).

Hofmann had directed an art school in Munich, Germany. He resumed teaching when he arrived in the states and opened his own school again in New York in 1933. Since this was also just about the time he began painting his still-life interiors, such works would have significance beyond their own intrinsic quality. Holding class in New York, and in Provincetown, Massachusetts, during the summers Hofmann became the most influential art teacher in this country in the mid-twentieth century.

Those mid-century decades in American art were dominated by abstraction in which for the most part still life, and indeed any traditional thematic concern, could have little relevance. Of course, individual painters, often of great ability and originality, continued to paint the theme. Some, like Walter Murch, made it a specialty; others, like Edwin Dickinson, investigated it along with landscape, figure painting, interiors, architectural subjects, and even portraiture. Dickinson is certainly not an abstract artist, but, as Lloyd Goodrich has written, he "does not fit into any neat classification. He is a representational painter who uses reality with the utmost freedom, a traditionalist who is entirely unacademic."[28] The present study of bottles and plates is thoroughly representational, yet the arrangement of crisply painted, monumental man-made forms is related to the aesthetic interests of the cubist-realists, and the syncopation of alternating round and oval shapes emphasizes abstract rhythms that are divorced from any interest in subject matter. Individual painters such as Dickinson and Murch upheld the torch of the still-life theme during the 1940s and 1950s, though Dickinson had begun to essay the theme earlier. Murch turned to still life around 1940, and for the next decade he was probably the leading American specialist.

In the 1960s and 1970s, representational art again became prominent. Still-life manifestation has had a significant place in this movement, but this immediate period is beyond the scope of our present survey. Some of these recent works have involved magnification of form, suggesting a heritage from O'Keeffe and Murphy; other works occasionally suggest and even bear tribute to earlier art, including trompe l'oeil. Much recent still life has been aligned with new aesthetic movements, such as pop art and photo-realism. Nevertheless, the tradition of still-life painting established so exquisitely, if humbly, in the work of Raphaelle Peale remains a vital aspect of American art.

Bibliography

EXHIBITICN CATALOGUES

(Catalogues are listed in chronological order)

The Exhibition of the Columbianum or American Academy of Painting, Sculpture, Architecture, & etc. Established at Philadelphia 1795. Philadelphia, 1795.

An Index to the Original Water Color Drawings and Oil Paintings, Executed by Mr. (George) Harvey, and Now Exhibiting for a Short Time at No. 322 Broadway, Opposite the Hospital. New York, 1843.

Harvey's Royal Gallery of Illustration, Next Door to the Haymarket Theatre. A Descriptive Pamphlet of the Original Drawings of American Scenery, Under Various Atmospheric Effects of Storm and Calm; of Sunshine and Shade; Together with Sketches of the Homes and Haunts of the British Poets, by George Harvey, A.N.A. To Which Is Prefixed, a Brief Autobiography of the Artist's Life. London, 1850.

Catalogue of Pictures, Fruit & Flower Studies, and Sketches from Nature, Painted by Mr. Geo. H. Hall, Now on Exhibition at the Academy of Design, Tenth Street, near Broadway. Sale, New York, 29 February 1860.

Catalogue of a Choice Collection of Paintings, and Studies from Nature, of Fruit and Flowers, Painted by Arnoldus Wydeveld, June 8th, 1863. Henry H. Leeds & Co., New York, 1863.

The A. D. Shattuck, N.A., and George Henry Hall, N.A., Collection Now on View at the Schenck Art Gallery, No. 10 Maiden Lane, New York. Sale, 21-22 March 1878.

The Drawings, Water-Colors, and Oil-Paintings by John La Farge. To be sold at auction on Thursday and Friday, 18 and 19 December [1879], at three o'clock, at Leonard's Gallery, Boston.

Catalogue of the Art Department of the New England Manufacturers' and Mechanics' Institute, essay on "American Flower Painters" by Candace Wheeler. Boston, 1883.

Catalogue of Water-Color Paintings by J. H. Hill and the Late J. W. Hill, S. Field's Art Gallery, Brooklyn. 11 December 1888.

Paintings of the Late W. M. Harnett, essay by E. Taylor Snow. Earle's Galleries, Philadelphia, November 1892.

Catalogue of Exquisite Examples in Still Life Being Oil Paintings by the Late William Michael Harnett, Etc., essay by E. Taylor Snow. Executrix's Sale, Thomas Birch's Sons, Philadelphia, 23-24 February 1893.

Exhibition of Paintings by Cadurcis Plantagenet Ream. The Art Institute of Chicago, 7-26 December 1909.

Exhibition of Paintings, Drawings, and Unfinished Work of Robert S. Dunning. Fall River Public Library, Fall River, Mass., 14-28 December 1911.

The Forum Exhibition of Modern American Painters, introduction by Willard Huntington Wright, forewords by Christian Brinton, Robert Henri, W. H. de B. Nelson, Alfred Stieglitz, John Weischsel, Willard Huntington Wright, explanatory notes by the artists included. Anderson Galleries, New York, 13-25 March 1916.

Catalogue of the Works of R. A. Blakelock, N.A., and of His Daughter, Marian Blakelock. Young's Art Galleries, Chicago, 27 April-13 May 1916.

Garden and Flower Pictures. Ehrich Galleries, New York, 2 April 1917.

Intimate Decorations; Chiefly Paintings of Still Life in New Manners, essay by Duncan Phillips. Phillips Memorial Gallery, Washington, D.C., 1-29 November 1927.

Tri-Unit Exhibition of Paintings and Sculpture, essay by Duncan Phillips, "Art Is Symbolical." Phillips Memorial Gallery, Washington, D.C., October 1928-January 1929.

Flower Exhibition, essay by Lloyd Goodrich. Whitney Studio Galleries, New York, Spring 1930.

Paintings of Still Life, introduction by Gordon Washburn. Fogg Art Museum, Harvard University, Cambridge, Mass., 4-30 April 1931. (The Fogg Museum states that no catalogue was produced; however, Charles Sterling lists this exhibition, with the Washburn introduction, in his bibliography.)

Floreros y Bodegones en la Pintura Espanola, essay by Julio Cavestany. Palacio de la Biblioteca Nacional, Madrid, 1936 and 1940.

The Development of Flower Painting From the Seventeenth Century to the Present, essay by Meyric R. Rogers. City Art Museum of St. Louis, May 1937.

The Painters of Still Life, essay by Arthur Everett Austin, Jr. Wadsworth Atheneum, Hartford, Conn., 25 January-15 February 1938.

Paintings and Water Colors by James Peale & His Family, 1749-1891. Walker Galleries, New York, 13 February-11 March 1939.

Nature-Vivre by William M. Harnett. The Downtown Gallery, 18 April-6 May 1939.

Early American Genre and Still-Life Paintings. Victor D. Spark, New York, 5 May-5 June 1941.

American Realists and Magic Realists, introduction by Lincoln Kirstein. The Museum of Modern Art, New York, 1943.

Exhibition of Still Life Paintings 17th to 19th Century and Recent Acquisitions, essay by Wolfgang Stechow. Allen Memorial Art Museum, Oberlin College, Oberlin, Ohio, March 1945.

250 Years of Painting in Maryland, essay by J. Hall Pleasants. The Baltimore Museum of Art, 11 May-17 June 1945.

Stuart Davis, essay by James Johnson Sweeney. Museum of Modern Art, New York, 17 October 1945-3 February 1946.

Still Life and Flower Paintings. The Baltimore Museum of Art, 2 November-9 December 1945.

American Still-Life Paintings, 1820-1920. Victor D. Spark, New York, 11 May-30 June 1946.

Flowers of Ten Centuries an Exhibition, essay by Eleanor C. Marquand. The Pierpont Morgan Library, New York, 28 April-26 July, 15 September-15 November 1947.

Harnett Centennial Exhibition. The Downtown Gallery, New York, 13 April-1 May 1948.

Illusionism and Trompe L'Oeil, essays by Alfred V. Frankenstein, Douglas MacAgy, and Jermayne MacAgy. California Palace of the Legion of Honor, San Francisco, 3 May-12 June 1949.

Exhibition of Still Life Painting Panorama (monthly magazine of the gallery). The Harry Shaw Newman Gallery, New York, December 1949.

Henry Lee McFee, essay by Arthur Miller. An exhibition held at Scripps College, Claremont, Calif., 1950.

John F. Peto, essay by Alfred V. Frankenstein. Brooklyn Institute of Arts and Sciences, The Brooklyn Museum, 11 April-21 May 1950.

Gastronomy in Fine Arts, essay by René de Messieres. Cultural Division of the French Embassy, New York, 29 November 1951-30 January 1952.

Botanical Books, Prints & Drawings From the Collection of Mrs. Roy Arthur Hunt, essay by Elizabeth Mongan. Carnegie Institute, Pittsburgh, 3 January-17 February 1952.

La Nature Morte de l'Antiquité à Nos Jours, essay by Charles Sterling. Orangerie des Tuileries, Paris, April-June 1952.

American Still-Life: Peale to Peto, foreword by Christian Grote, mimeographed. (No catalogue appears to have been published.) Williams College Museum of Art, Williamstown, Mass., 1953.

Arthur B. Carles, 1882-1952. The Pennsylvania Academy of the Fine Arts, Philadelphia, 18 March-12 April 1953.

Harnett and His School, essay by Alfred V. Frankenstein. American Federation of Arts, New York (circulating exhibition), September 1953-June 1954.

Magic of Flowers in Painting. Wildenstein (Gallery), New York, 13 April-15 May 1954.

Commemorative Exhibition: Paintings by Martin J. Heade and F. H. Lane from the Karolik Collections in the Museum of Fine Arts, Boston, essay by John I. H. Baur. M. Knoedler & Co., New York, May 1954.

Inaugural Exhibition of American Still Life Paintings. M. Knoedler & Co., New York, October 1954.

Paintings by the Peale Family, essay by Edward H. Dwight. Cincinnati Art Museum, 1-31 October 1954.

Collages Dove. The Downtown Gallery, New York, 1-26 November 1955.

Natures mortes d'hier et d'aujourdui. Musée des Beaux Arts, Besançon, France, 9 June-31 July 1956.

Still Life Painting Since 1470, essays by Philip R. Adams and Edward H. Dwight. Milwaukee Art Institute, September 1956.

Hans Hofmann, essay by Frederick S. Wight. Whitney Museum of American Art, New York, 24 April-16 June 1957.

"The Painted Flower" an Exhibition of Floral Paintings in the Collection of Mr. and Mrs. Herbert Mortimer Stoll, Jr., essay by Paul Mills. The Oakland Museum, 5 May-2 June 1957.

American Still Life Paintings from the Paul Magriel Collection, essay by John I. H. Baur. The Corcoran Gallery of Art, Washington, D.C., 2 October-10 November 1957.

Nature's Bounty and Man's Delight, American 19th-Century Still-Life Painting, essay by William H. Gerdts. The Newark Museum, 15 June-28 September 1958.

Fruits and Flowers in Painting, essay by Peter Selz. Santa Barbara Museum of Art, 12 August-14 September 1958.

A Catalogue of Paintings by John F. Francis, introductory essay by George L. Hersey. Bucknell University, Lewisburg, Pa., 19 October-15 November 1958.

Raphaelle Peale, 1774-1825: Still Lifes and Portraits, introductory essay by Charles Coleman Sellers. Milwaukee Art Center, 15 January-15 February 1959.

Jefferson D. Chalfant, 1856-1931. Wilmington Society of the Fine Arts, Wilmington, Del., 8 January-1 February 1959.

Flower Paintings. The Westmoreland County Museum of Art, Greensburg, Pa., 20 September-16 October 1959.

Four Centuries of Still Life, essay by Richard Hirsch. The Allentown Art Museum, Allentown, Pa., 12 December-31 January 1960.

"The Painted Flower" the Second Exhibition of Floral Paintings from the Collection of Mr. and Mrs. Herbert Mortimer Stoll, Jr., essay by Paul Mills. The Oakland Museum, 17 April-8 May 1960.

The Fabulous Peale Family. Kennedy Galleries, Inc., New York, 13 June-8 July 1960.

Maurice Prendergast, 1859-1924, essay by Hedley Rhys. Museum of Fine Arts, Boston, 26 October-4 December 1960.

Fruit and Flowers, essay by Eleanor P. Spencer. The Baltimore Museum of Art, 7 March-4 April 1961.

Haberle, foreword by Alfred V. Frankenstein. New Britain Museum of American Art, New Britain, Conn., 6-28 January 1962.

The Age of the Thousand Flowers, essay by Jermayne MacAgy. University of St. Thomas, Houston, Tex., 9 March-30 April 1962.

Five Hundred Years of Flowers and Gardens in Western Art. Cummer Gallery of Art, Jacksonville, Fla., 17 October-25 November 1962.

Samuel Marsden Brookes, essay by Joseph Armstrong Baird, Jr. California Historical Society, San Francisco, 10 November-29 December 1962.

Fêtes de la Palette, essay by James B. Byrnes. The Isaac Delgado Museum of Art, New Orleans, La., Thanksgiving 1962-Twelfth Night 1963.

Flowers in February. Smith College Museum of Art, Northampton, Mass., 19 February-9 March 1963.

A World of Flowers Painting and Prints, essay by Henry Clifford. Philadelphia Museum of Art, Philadelphia, 2 May-9 June 1963.

Hans Hofmann, essay by William C. Seitz. Museum of Modern Art, New York, 11 September-28 November 1963.

The Salzer Collection: Trompe L'Oeil and Still-Life Painting, essay by A. Bret Waller. The University of Kansas Museum of Art, Lawrence, Kans., October-November 1964.

Still Life Painters. Finch College Museum of Art, New York, February 1965.

Flowers. Hirschl & Adler Galleries, Inc., New York, 18 May-30 June 1965.

The Reminiscent Object, Paintings by William Michael Harnett, John Frederick Peto and John Haberle, Frederick essay by Alfred V. Frankenstein. La Jolla Museum of Art, La Jolla, Calif., 11 July-19 September 1965.

Synchromism and Color Principles in American Painting, 1910-1930, essay by William C. Agee. M. Knoedler & Co., New York, 12 October-6 November 1965.

Edwin Dickinson, essay by Lloyd Goodrich. Whitney Museum of American Art, New York, 20 October-28 November 1965.

A Century of American Still-Life Painting, 1813-1913, essay by William H. Gerdts. The American Federation of Art, New York (circulating exhibition), 1966.

Contemporary American Still Life, introduction by William H. Gerdts. The Museum of Modern Art, New York (circulating exhibition), 1966.

Painter of Vision: A Retrospective Exhibition of Oil, Watercolors and Drawings by Walt Kuhn, 1877-1949, essay by Philip Rhys Adams. The University of Arizona Art Gallery, Tucson, 6 February-31 March 1966.

Mid-Nineteenth Century American Painting from the Collections of Henry M. Fuller and William H. Gerdts, essay by William H. Gerdts. Crummer Gallery of Art, Jacksonville, Fla., July and August 1966.

Recent Still Life, essay by Daniel Robbins. Museum of Art, Rhode Island School of Design, Providence, 23 February-4 April 1966.

25 Still Life Paintings. Indiana University Art Museum, Bloomington, 15 April-15 May 1966.

Still Life Movement. Schweitzer Gallery, New York, 10-31 October 1966.

Walter Murch: A Retrospective Exhibition, essay by Daniel Robbins. Museum of Art, Rhode Island School of Design, Providence, 9 November-4 December 1966.

American Still-Life Painting, 1913-1967, essay by William H. Gerdts. The American Federation of Arts, New York (circulating exhibition), 1967.

Three Centuries of Botany in North America. The Rockefeller University, New York, 1967.

The Peale Family, Three Generations of American Artists, essay on still life by Edward H. Dwight. The Detroit Institute of Arts, 18 January-5 March 1967.

Miss Sarah Miriam Peale, 1800-1885: Portraits and Still Life, essay by Wilbur H. Hunter and John Mahey. The Peale Museum, Baltimore, 5 February-26 March 1967.

Cubism: Its Impact in the USA, 1910-1930, essay by Clinton Adams. University of New Mexico Art Museum, Albuquerque, 10 February-27 August 1967.

Arthur Dove: The Years of Collage, essay by Dorothy Rylander Johnson. University of Maryland Art Gallery, College Park, 13 March-19 April 1967.

The Art of Stanton Macdonald-Wright. National Collection of Fine Arts, Washington, D.C., 4 May-18 June 1967.

American Flowers: Loan Exhibition of Oils, Pastels, and Watercolors Assembled by Paul Magriel, essay by Barbara Novak O'Doherty. Wickersham Gallery, New York, 23 May-10 June 1967.

The Mr. and Mrs. Walter Reisch Collection. Long Beach Museum of Art, Long Beach, Calif., 14 July-18 August 1968.

The American Vision Paintings, 1825-1875, essay on still life by William H. Gerdts. Sponsored by The Public Education Association, M. Knoedler & Co., Inc., Hirschl & Adler Galleries, Inc., Paul Rosenberg and Co., New York, 8 October-2 November 1968.

Charles Sheeler, with essays by Martin Friedman, Bartlett Hayes, and Charles Millard, and a catalogue by Abigail Booth. National Collection of Fine Arts, Washington, D.C., 10 October-24 November 1968.

American Still Life Painting, 1860-1900. Adelson Galleries, Inc., Boston, 4-30 November 1968.

Marsden Hartley: Painter/Poet, 1877-1943. University of Southern California, Los Angeles, 20 November-20 December 1968.

Illusionism in American Art, essay by William H. Gerdts. Landau-Alan Gallery, New York, 23 November-24 December 1968.

The Mr. and Mrs. Walter Reisch Collection. Phoenix Art Museum, Phoenix, Ariz., December 1968.

American Trompe L'Oeil. The Parrish Art Museum, Southampton, N.Y., 14 June-6 July 1969.

Martin Johnson Heade, essay by Theodore E. Stebbins, Jr. Museum of Fine Arts, Boston, 9 July-25 August 1969.

American Still Life Painting, Nineteenth Century: The Paul Magriel Collection, essay by Elaine Evans Dee. Guild Hall, East Hampton, N.Y., 19 July-10 August 1969.

The Reality of Appearance; The Trompe L'Oeil Tradition in American Painting, essay by Alfred V. Frankenstein. National Gallery of Art, Washington, D.C., 21 March-3 May 1970.

The Fall River School, 1853-1932. Greater Fall River Art Association, Fall River, Mass., 5-19 April 1970.

150 Years of American Still-Life Painting, essay by William H. Gerdts. Coe Kerr Gallery, Inc., New York, 27 April-16 May 1970.

John Haberle (1856-1933): An Exhibition of Paintings, Drawings and Watercolors. Kennedy Galleries, Inc., New York, 8 June-15 July 1970.

Ijdelheid der Ijdelheden: Hollandse Vanitas-voorstellingen uit de zeventiende eeuw, essay by Ingvar Bergström (in Dutch). Stedelijk Museum "De Lakenhal," Leiden, the Netherlands, 26 June-23 August 1970.

Georgia O'Keeffe, essay by Lloyd Goodrich. Whitney Museum of American Art, New York, 8 October-29 November 1970.

American Still Life in New Jersey Collections. Montclair Art Museum, Montclair, N.J., 25 October-13 December 1970.

The American Painting Collection of Mrs. Norman B. Woolworth, essay by William H. Gerdts. Coe Kerr Gallery, Inc., New York, 10-28 November 1970.

Arthur G. Dove: Collages. Terry Dintenfass, Inc., New York, 22 December 1970-23 January 1971.

Still Life Today. American Federation of Arts, New York (circulating exhibition), 1971-1972.

American Nineteenth Century Still Life Painting, essay by William H. Gerdts. The High Museum of Art, Atlanta, Ga., 10-31 January 1971.

American Still Lifes: 19th and 20th Centuries. Kennedy Galleries, Inc., New York, November 1971.

American Still Lifes of the Nineteenth Century, introduction by Cecily Langdale. Hirschl & Adler Galleries, Inc., New York, 1-31 December 1971.

Still Life Today. American Federation of Arts, New York (circulating exhibition), 1972-1973.

The Paintings of Edward Edmondson (1830-1884), essay by Bruce H. Evans. The Dayton Art Institute, 8 January-13 February 1972.

Flowers in Art. Flint Institute of Arts, Flint, Mich., 13 April-21 May 1972.

Eats: An Exhibition of Food in Art, essays by Frances Field and Maxime McKendry. The Emily Lowe Gallery, Hofstra University, Hempstead, N.Y., 18 June-31 August 1972.

Thomas Hart Benton: A Retrospective of His Early Years, 1907-1929, essay by Phillip Dennis Cate. Rutgers University Art Gallery, New Brunswick, N.J., 19 November-30 December 1972.

American 19th Century Still Life Paintings, essay by William H. Gerdts. Noah Goldowsky Inc., New York, December 1972.

19th Century American Still Life Paintings. United Virginia Bank Gallery, Norfolk, Va., 19 February-30 March 1973.

Alfred H. Maurer, 1868-1932, essay by Sheldon Reich. National Collection of Fine Arts, Washington, D.C., 23 February-13 May 1973.

Alfred Maurer and the Fauves: The Lost Years Rediscovered, essay by Peter Pollack. Bernard Danenberg Galleries, New York, 27 February-31 March 1973.

The Good Things in Life: Nineteenth Century American Still Life, essay by Marilyn Friedman Hoffman. Brockton Art Center, Brockton, Mass., 8 March-29 April 1973.

Masterpieces in Bloom. Wildenstein, New York, 5 April-5 May 1973.

John William Hill (1812-1879), John Henry Hill (1839-1922). Washburn Gallery, New York, June-July 1973.

Say It With Flowers, essay by Cynthia Wolk Nachmani. The Emily Lowe Gallery, Hofstra University, Hempstead, N.Y., 17 June-31 August 1973.

Genre, Portrait and Still Life Painting in America: The Victorian Era, essay by Elizabeth Gaidos. Cranbrook Academy of Art Museum, Bloomfield Hills, Mich., 26 August-30 September 1973.

Robert Loftin Newman, 1827-1912, essay by Marchal L. Landgren. National Collection of Fine Arts, Washington, D.C. 26 October 1973-6 January 1974.

The Paintings of Gerald Murphy, essay by William Rubin with the collaboration of Carolyn Lanchner. The Museum of Modern Art, New York, 19 April-19 May 1974.

Rose Museum. Glenbow-Alberta Gallery, Calgary, Alberta, Canada, July 1974.

Reality and Deception, essay by Alfred V. Frankenstein. University of Southern California, Los Angeles, 16 October-24 November 1974.

The Fine Art of Food, introduction by David W. Steadman. Lang Art Gallery, Scripps College, Claremont, Calif., 5 November-3 December 1974.

Arthur Dove, essay by Barbara Haskell. San Francisco Museum of Art, 21 November 1974-5 January 1975.

The Art of Emil Carlsen, 1853-1932, essays by Arthur Edwin Bye, Eliot Clark, Duncan Phillips, Frederic Newlin Price, and John Steele. Wortsman-Rowe Galleries, San Francisco, 10 January-21 February 1975.

Four Generations of Commissions: The Peale Collection of the Maryland Historical Society, essay on Raphaelle Peale by Edward H. Dwight. The Maryland Historical Society, Baltimore, 3 March-29 June 1975.

The Object as Subject: Still Life Paintings from the Seventeenth to the Twentieth Century. Wildenstein, New York, 4 April-3 May 1975.

Bradley Walker Tomlin: A Retrospective View, essay by Jeanne Chenault. The Emily Lowe Gallery, Hofstra University, Hempstead, N.Y., 17 April-15 May 1975.

Art and the Kitchen. The Westmoreland County Museum of Art, Greensburg, Pa., 23 May-29 June 1975.

The Inspiration of Nature, Paintings of Still Life, Flowers, Birds and Insects by Dutch and Flemish Artists of the 17th Century, essay by Peter Mitchell. John Mitchell & Sons, London, 1976.

From Seed to Flower, Philadelphia, 1681-1876, a Horticultural Point of View. The Pennsylvania Horticultural Society, Philadelphia, 1976.

A Tribute to American Realism: The Collection of Amanda K. Berls and Ruth A. Yerion. Coe Kerr Gallery, Inc., New York, 7-31 January 1976.

Look Again, essay by Marsha Semmel. The Taft Museum, Cincinnati, Ohio, 23 January-28 March 1976.

American Cornucopia: 19th Century Still Lifes and Studies, essay by William H. Gerdts. The Hunt-Mellon University, Pittsburgh, Pa., 5 April-30 July 1976.

Still Lifes. Hammer Galleries, New York, 10-22 May 1976.

Maurice Prendergast, essay and chronology by Eleanor Green, Ellen Glavin, and Jeffrey R. Hayes. University of Maryland Art Gallery, College Park, 1 September-6 October 1976.

Drawings and Watercolors, John William Hill, John Henry Hill. Washburn Gallery, New York, 3-27 November 1976.

The Chosen Object: European and American Still Life, essay by Ruth H. Cloudman. Joslyn Art Museum, Omaha, Nebr., 23 April-5 June 1977.

Hudson D. Walker: Patron and Friend, essay by Percy North. University Gallery, University of Minnesota, Minneapolis, 9 October-6 December 1977.

The Paintings of Charles Bird King, (1785-1862), essay by Andrew Joseph Cosentino. The National Collection of Fine Arts, Washington, D.C., 4 November 1977-22 January 1978.

Stuart Davis: Art and Theory, essay by John R. Lane. The Brooklyn Museum, 21 January-19 March 1978.

Synchromism and American Color Abstraction, 1910-1925, essay by Gail Levin. The Whitney Museum of American Art, New York, 24 January-26 March 1978.

American Flower Painting, 1850-1950, essay by Dennis R. Anderson. ACA Galleries, New York, 1-22 April 1978.

George Cope, 1855-1929, essays by Joan H. Gorman and Gertrude Grace Sills. Brandywine River Museum, Chadds Ford, Pa., 3 June-4 September 1978.

Dennis Miller Bunker (1861-1890) Rediscovered, essay by Charles B. Ferguson. The New Britain Museum of American Art, New Britain, Conn., 1 April-7 May 1978.

Flowers in Art, a Loan Exhibition and Flower Show with the Memphis Garden Club. The Dixon Gallery and Gardens, Memphis, Tenn., 28 April-4 June 1978.

Nature Morte de Brueghel à Soutine. Palais des Beaux-Arts, Bordeaux, France, 5 May-1 September 1978.

On the Table an Exhibition of American Still Life Paintings, essay by Leah Lipton. Danforth Museum, Framingham, Mass., 24 September-19 November 1978.

The Big Still Life. Allan Frumkin Gallery, New York, March 1979.

Peintres de Fleurs en France du XVIIe au XIXe siècles, essay by Michel and Fabrice Faré. Musée du Petit Palais, Paris, 19 May-2 September 1979.

J. D. Chalfant, essay by Joan H. Gorman. Brandywine River Museum, Chadds Ford, Pa., 2 June-3 September 1979.

1850, Delight and Deception; Important American Still-Life Painting, 1890. Adams, Davidson Galleries, Washington, D.C., 27 June-28 July 1979.

Abbott Fuller Graves, 1859-1936, essay by Joyce Butler. The Brick Store Museum, Kennebunk, Maine, 1 July-15 September 1979.

Patrick Henry Bruce: American Modernist, essays by William C. Agee and Barbara Rose. Museum of Modern Art, New York, 22 August-21 October 1979.

Preston Dickinson, 1889-1930, essay by Ruth H. Cloudman. Sheldon Memorial Art Gallery, University of Nebraska, Lincoln, 4 September-7 October 1979.

Stilleben in Europa, essays by numerous authors. Münster, West Germany, 25 November 1979-24 February 1980.

American Impressionists, essay by William H. Gerdts. The Henry Art Gallery, University of Washington, 3 January-2 March 1980.

The Collection of Amanda K. Berls and Ruth A. Yerion, essay by William H. Gerdts. Brandywine River Museum, Chadds Ford, Pa., 12 January-9 March 1980.

Marsden Hartley, essay by Barbara Haskell. The Whitney Museum of American Art, New York, 4 March-25 May 1980.

Still Life Today, introduction by Janice Oresman. Goddard-Riverside Community Center, New York, 1-20 May 1980.

An American Flower Show, essay by J. Frederick Cain. Heritage Plantation of Sandwich, Sandwich, Mass., 9 May-13 October 1980.

Plane Truths: American Trompe L'Oeil Painting, essay by Roxana Barry. The Katonah Gallery, Katonah, N.Y., 7 June-20 July 1980.

Benton's Bentons, with essays by Elizabeth Broun, Douglas Hyland, and Marilyn Stokstad. Spencer Museum of Art, The University of Kansas, Lawrence, 13 July-13 September 1980. See especially Broun's essay on "Benton and European Modernism."

Flowers in Books and Drawings, ca. 940-1840, essay by Helen B. Mules. The Pierpont Morgan Library, New York, 2 September-9 November 1980.

Stuart Davis Still Life Paintings, 1922-24. Borgenicht Gallery, New York, 27 September-23 October 1980.

BOOKS, ARTICLES, AND DISSERTATIONS

Adams, Adeline. *Childe Hassam.* New York, 1938.

Adams, Henry. "A Fish by John La Farge." *The Art Bulletin* 62 (June 1980): 260-80.

————. "John La Farge, 1830-1870: From Amateur to Artist." Ph.D. dissertation, Yale University, 1980.

Adams, Philip Rhys. *Walt Kuhn, Painter: His Life and Work.* Columbus, Ohio, 1978.

Ahrens, Kent. "Pioneer Abroad, Henry R. Newman (1843-1917): Watercolorist and Friend of Ruskin." *The American Art Journal* 8 (November 1978): 85-98.

"American Still Life Painting." *American Artist* 22 (June 1958): 70-71.

Anderson, Dennis R. *American Flower Painting.* New York, 1980.

Austin, Arthur Everett, Jr., and Hitchcock, Henry-Russell, Jr. "Aesthetic of the Still Life Over Four Centuries." *Art News* 36 (5 February 1938): 12.

Baigell, Matthew. *Thomas Hart Benton.* New York, 1973.

Barcelo, L. J. "La nature morte et la table." *Vie des arts* 21 (Christmas 1960): 39-43.

Barker, Virgil. *Henry Lee McFee.* New York, 1931.

Battersby, Martin. *Trompe L'Oeil: The Eye Deceived.* New York, 1974.

Baur, John I. H. *Bradley Walker Tomlin.* New York, 1957.

————. "The Peales and the Development of American Still Life." *The Art Quarterly* 3 (Winter 1940): 81-92.

————. "Peto and the American Trompe L'Oeil Tradition." *American Magazine of Art* 43 (May 1950): 182-85.

————. *Revolution and Tradition in Modern American Art.* Cambridge, Mass., 1958.

Baur, John I. H., ed. *New Art in America: Fifty Painters of the 20th Century.* New York, 1957.

Benton, Thomas Hart. "An American in Art." *Kansas Quarterly* 1 (Spring 1969): 9-78.

————. *An Artist in America.* New York, 1937.

Bergström, Ingvar. "Disguised Symbolism in 'Madonna' Pictures and Still Life." *The Burlington Magazine* 97 (October 1955): 303-8; (November 1955): 342-49.

————. *Dutch Still-Life Painting in the Seventeenth Century.* New York and London, 1956.

————. *Maistros españoles de bodegones y floreros del siglo XVII.* Madrid, 1970.

Bienenstock, Jennifer Martin. "Portraits of Flowers: The Out-of-Door Still-Life Paintings of Maria Oakey Dewing." *American Art Review* 4 (December 1977): 48.

Black, Mary, and Lipman, Jean. *American Folk Painting.* New York, 1966.

Blunt, Wilfrid. *The Art of Botanical Illustration.* London, 1950.

Born, Wolfgang. "American Still Life Painting from Naturalism to Impressionism." *Gazette des beaux-arts*, 6th ser. 29 (May 1946): 303-8.

————. "The Female Peales: Their Art and Its Tradition." *American Collector* 15 (August 1946): 12-14.

————. "Notes on Still Life Painting in America." *Antiques* 50 (September 1946): 158-60.

————. *Still-Life Painting in America.* New York, 1947.

————. "William M. Harnett, Bachelor Artist." *American Magazine of Art* 39 (October 1946): 248-54.

Brace, Ernest. "Henry Lee McFee." *American Magazine of Art* 27 (July 1934): 375-82.

Brook, Alexander. "Henry Lee McFee." *The Arts* 4 (1923): 251-61.

Brown, Milton W. *American Painting from the Armory Show to the Depression.* Princeton, N.J., 1955.

————. "Cubist Realism: An American Style." *Marsyas* (New York University Institute of Fine Arts) 3 (1943-1945): 139-60.

Burbidge, R. Brinsley. *A Dictionary of British Flower, Fruit, and Still Life Painters.* 2 vols. Leigh-on-Sea, England, 1974.

Bye, Arthur Edwin. *Pots and Pans or Studies in Still-Life Painting.* Princeton, N.J., and London and Oxford, England, 1921.

Carlsen, Emil. "On Still-Life Painting." *Palette and Bench* 1 (October 1908): 6-8.

Carmean, E. A., Jr. "An American Hunting Game Still Life (Goodwin)." *The Museum of Fine Arts, Houston, Bulletin* n.s. 3 (April 1972): 14-18.

Cary, Elisabeth Luther. "Henry Lee McFee." *Creative Art* 4 (March 1929): xxxiii.

Cave, Howard L. "Alexander Pope, Painter of Animals." *Brush and Pencil* 8 (May 1901): 105-12.

Champa, Kermit. "Charlie Was Like That." *Artforum* 12 (March 1974): 54-59.

Chirico, Robert F. "John Haberle and Trompe L'Oeil." *Marsyas* 19 (1977-1978): 37-43.

Chwast, Seymour, and Chewings, Emily Blair. *The Illustrated Flower.* New York, 1977.

Clark, Edna M. *Ohio Art and Artists.* Richmond, Va., 1932.

Coats, Alice M. *The Book of Flowers: Four Centuries of Flower Illustration.* London, 1973; 2d ed., 1974.

————. *The Treasury of Flowers.* London, 1975.

Comstock, Helen. "Return of Trompe L'Oeil." *Connoisseur* 125 (May 1950): 114-15.

Cook, Clarence. "Mr. Farrer's Pictures at Goupil's." *New York Daily Tribune* 24 (1 June 1866): 8.

Cooper, Helen A. "The Rediscovery of Joseph Decker." *The American Art Journal* 10 (May 1978): 55-71.

Cortissoz, Royal. *John La Farge: A Memoir and a Study.* Boston and New York, 1911.

Cosentino, Andrew Joseph. "Charles Bird King: American Painter, 1785-1862." Ph.D. dissertation, University of Delaware, 1976.

————. "Charles Bird King: An Appreciation." *The American Art Journal* 6 (May 1974): 54-71.

Cowdrey, Mary Bartlett. *American Academy of Fine Arts and American Art-Union, 1816-1852.* 2 vols. New York, 1953.

————. *National Academy of Design Exhibition Record, 1826-1860.* 2 vols. New York, 1943.

Cowdrey, (Mary) Bartlett, and Williams, Hermann Warner, Jr. *William Sidney Mount, 1807-1868: An American Painter.* New York, 1944.

De Gregorio, Vincent John. "The Life and Art of William J. Glackens." Ph.D. dissertation, Ohio State University, 1955.

De Logu, Giuseppe. *Natura morta italiana.* Bergamo, 1962.

Dewing, Maria Oakey. "Flower Painters and What the Flower Offers to Art." *Art and Progress* 6 (June 1915): 255-62.

Dirksen, Victor A. *Das holländische Stilleben des 17. Jahrhunderts.* Hamburg, 1921.

Dochterman, Lillian Natalie. "The Stylistic Development of the Work of Charles Sheeler." Ph.D. dissertation, University of Iowa, 1963.

"The Dollars and Cents of Art." *Cosmopolitan Art Journal* 4 (March 1860): 30.

Dolphin, Harriet Sylvia. " 'The Rack' by John Frederick Peto." Master's thesis, Arizona State University, 1969.

Drepperd, Carl W. "Still Life Paintings and Pretty Pieces in the Garbisch Collection of Primitives." *Art in America* 42 (May 1954): 126-33.

Dunthorne, Gordon. *Flower and Fruit Prints of the 18th and Early 19th Centuries.* Washington, D.C., 1938.

Earp, Thomas Wade. *Flower and Still-Life Painting.* (Studio, Special Number), London, Winter, 1928.

Eiseman, Alvord L. "A Study of the Development of an Artist: Charles Demuth." Ph.D. dissertation, 2 vols., New York University, 1975.

Eldredge, Charles Child. "Georgia O'Keeffe: The Development of an American Modern." Ph.D. dissertation, University of Minnesota, 1971.

Elles, Iris. *Das Stilleben in der französischen Malerei des 19. Jahrhunderts.* Zurich, 1958.

Elmer, Maud Valona. *Edwin Romanzo Elmer As I Knew Him.* Northampton, Mass., 1964.

Failey, Dean F. "Recent Acquisitions: Victorian Bouquet (Roesen)." *The Museum of Fine Arts, Houston, Bulletin,* n.s. 3 (June 1972): 42-46.

Faré, Michel. *La nature morte en France, son histoire, son évolution, du XVII au XXe siècle.* Geneva, 1962.

Farnham, Emily E. *Charles Demuth: Behind a Laughing Mask.* Norman, Okla., 1971.

————. "Charles Demuth: His Life, Psychology and Works." Ph.D. dissertation, Ohio State University, 1959.

"A Few Words About Art Criticism (George Henry Hall)." *The Nation* 2 (29 March 1866): 409.

Forman, H. Buxton. "An American Studio in Florence (Henry Roderick Newman)." *The Manhattan* 3 (June 1884): 525-39.

Foshay, Ella M. "Charles Darwin and the Development of American Flower Imagery." *Winterthur Portfolio* 15 (Winter 1980): 299-314.

————. "The Emergence of the Flower Genre in Nineteenth Century American Art." Ph.D. dissertation, Columbia University, 1979.

Foster, Kathleen A. "The Still-Life Paintings of John La Farge." *The American Art Journal* 11 (July/Summer 1979): 4-37.

Fox, William Henry. "Chase on Still Life." *Brooklyn Museum Quarterly* 1 (January 1915): 196-200.

Frankenstein, Alfred V., *"After the Hunt" — and After: William Michael Harnett and Other American Still Life Painters, 1870-1900.* Berkeley and Los Angeles, 1953; 2d ed., 1969.

————. "Edwin Romanzo Elmer." *American Magazine of Art* 45 (October 1952): 270-72.

————. "Fooling the Eye." *Artforum* 12 (May 1974): 32-35.

————. "Haberle: Or the Illusion of the Real." *American Magazine of Art* 41 (October 1948): 222-27.

————. "William Harnett's *After the Hunt* in Both Its Known Versions, Along with Eight Adaptations of It." *California Palace of the Legion of Honor Bulletin* 6, nos. 4-5 (1948): 1-23.

————. "Harnett: One Century." *Art News* 47 (September 1948): 14.

————. "Harnett, Peto, Haberle." *Artforum* 4 (October 1965): 27-33.

————. "Harnett True and False." *Art Bulletin* 31 (March 1949): 38-56.

————. "Illusion and Reality." *Horizon* 22 (July 1979): 25-31.

————. "J. F. Francis." *Antiques* 59 (May 1951): 374.

————. "Mr. Huling's Rack Picture." *Auction* 2 (February 1969): 6-9.

————. *William Sidney Mount.* New York, 1975.

————. "Yankee Rhyparography." *Art News* 69 (March 1970): 50.

Friedlander, Max J. *On Art and Connoisseurship.* Translated by Tancred Borenius. London, 1942. Essay on "Still Life," pp. 131-33.

————. *Landscape, Portrait, Still Life.* Translated by R. F. C. Hull. New York, 1963 (first published den Haag, 1947).

Friedman, Martin. *Charles Sheeler.* New York, 1975.

Furst, Herbert. *The Art of Still-Life Painting.* London, 1927.

Gallatin, Albert E. *Charles Demuth.* New York, 1927.

Gardiner, Henry G. "Arthur B. Carles: A Critical and Biographical Study." In *Arthur B. Carles.* Philadelphia Museum of Art, Philadelphia, Pa., 1970.

Gardner, Albert Teneyck. "Harnett's Music and Good Luck." *The Metropolitan Museum of Art Bulletin* 22 (January 1964): 156-65.

Gelder, Jan Gerrit Van. *Catalogue of the Collection of Dutch and Flemish Still-Life Pictures Bequeathed by Daisy Linda Ward.* Ashmolean Museum, Oxford, 1950.

Georgia O'Keeffe. New York, 1976.

Gerdts, William H. "The Bric-a-Brac Still Life." *Antiques* 81 (November 1971): 744-48.

————. "The Influence of Ruskin and Pre-Raphaelitism on American Still Life Painting." *The American Art Journal* 1 (Fall 1969): 80-97.

————. "Nineteenth Century Still-Life Painting in New Jersey." *Antiques* 86 (December 1964): 718-21.

————. "On the Table Top: Europe and America." *Art in America* 60 (March-April 1972): 62-69.

————. "Paul Lacroix." *Antiques* 82 (November 1972): 855-61.

————. "A Still Life by Severin Roesen." *The Registrar of the Museum of Art* (The University of Kansas, Lawrence), 5 (Bicentennial Issue, 1976): 26-45.

————. "A Trio of Violins." *The Art Quarterly* 22 (Winter 1959): 370-83.

Gerdts, William H., and Burke, Russell. *American Still-Life Painting.* New York, Washington, and London, 1971.

Giolli, Raffaello. "L'ottocento Italiano e la 'natura morta.'" *Emporium* 83 (January 1936): 10-17.

Glackens, Ira. *William Glackens and the Ashcan Group.* New York, 1957.

Gombrich, Ernst H. "Tradition and Expression in Western Still Life." *Burlington Magazine* 103 (May 1961): 174-80.

Goodrich, Lloyd. "Harnett and Peto: A Note on Style." *Art Bulletin* 31 (March 1949): 57-58.

————. "Paintings of Flowers." *Arts* 16 (April 1930): 561-63.

Grant, Maurice H. *Flower Paintings Through Four Centuries: A Descriptive Catalogue of the Collection Formed by Major the Hon. Henry Rogers Broughton.* Leigh-on-Sea, England, 1952.

Greenburg, Clement. *Hofmann.* Paris, 1961.

Greindl, Edith. *Les peintres flamands de nature morte au 17ième siècle.* Paris, 1956.

Guldener, Hermine van. *Het Bloemstuk in de Schilderkunst.* Amsterdam, 1949. Trans. *Flowers: The Flowerpiece in Painting.* London, 1950.

Gwynne-Jones, Allan. *Introduction to Still-Life.* London, 1954.

Haig, Elisabeth. *The Floral Symbolism of the Great Masters.* London, 1913.

Hairs, Marie-Louise. *Les peintres flamands de fleurs au XVIIe siècle.* Paris and Brussels, 1955.

Hale, John Douglass. "The Life and Creative Development of John H. Twachtman." 2 vols. Ph.D. dissertation, Ohio State University, 1957.

Hardie, Martin. *Flower Paintings.* Leigh-on-Sea, England, 1947.

Hartley, Marsden. "Art — and the Personal Life." *Creative Art* 2 (June 1928): xxxi-xxxiv.

Hill, John Henry. *John William Hill: An Artist's Memorial.* New York, 1888.

————. *Sketches from Nature.* Nyack Turnpike, N. Y., 1867.

Hofmann, Hans. *Search for the Real and Other Essays.* Andover, Mass., Addison Gallery of American Art, Phillips Academy, 1948.

Homer, William Innes. *Alfred Stieglitz and the American Avant-Garde.* Boston, 1977.

Hoopes, Donelson F. "Alexander Pope, Painter of 'Characteristic Pieces.'" *The Brooklyn Museum Annual* 8 (1966-1967): 127-46.

————. *Childe Hassam.* New York, 1979.

Hulton, Paul, and Smith, Lawrence. *Flowers in Art from East and West.* London, 1979.

Hunter, Sam. Introduction to *Hans Hofmann.* New York, 1963.

Jarves, James Jackson. *The Art-Idea.* New York, 1864. Reprint, edited by Benjamin Rowland, Jr. Cambridge, Mass., 1960.

Kalonyme, Louis. "Georgia O'Keeffe: A Woman in Painting." *Creative Art* 2 (January 1928): xxxv-xl.

Karr, Louise. "Paintings on Velvet." *Antiques* 20 (September 1931): 162-65.

Kayser, Stephen S. "The Revolution of Still Life." *Pacific Art Review* 1: 2 (1941) 16-28.

Kirby, J. C. "Grapes from Mr. Walter's Greenhouse." *The Bulletin of the Walters Art Gallery* 3 (January 1951): n.p.

Lambdin, George Cochran. "The Charm of the Rose." *The Art Union Magazine* 1 (June-July 1884): 137.

Lathrop, George Parson. "John La Farge." *Scribner's Monthly Magazine* 21 (February 1881): 503-16.

Lipman, Jean. *American Primitive Painting.* London, New York, and Toronto, 1942.

Little, Nina Fletcher. *American Decorative Wall Painting.* New York, 1952.

Luttervelt, R. Emmet Van. *Schilders van het stilleven.* Naarden, 1947.

M. B. "Discarded Treasures by Harnett (now, Peto)." *Bulletin of the Smith College Museum of Art* 20 (June 1939): 17-19.

McCausland, Elizabeth. *A. H. Maurer.* New York, 1951.

————. "American Still-Life Paintings in the Collection of Paul Magriel." *Antiques* 67 (April 1955): 324-27.

————. *Marsden Hartley.* Minneapolis, 1952.

McClinton, Katherine M. "American Flower Lithographs." *Antiques* 49 (June 1946): 361-63.

————. *The Chromolithographs of Louis Prang.* New York, 1973.

McCormick, William B. "Watrous, Public Force in Art." *International Studio* 78 (October 1923): 79-83.

McCoubrey, John W. "The Revival of Chardin in French Still-Life Painting, 1850-1870." *Art Bulletin* 46 (March 1964): 39-53.

————. "Studies in French Still-Life Painting, Theories and Criticism, 1660-1860." Ph.D. dissertation, New York University, 1958.

McFee, Henry Lee. "My Painting and Its Development." *Creative Arts* 4 (March 1929): xxvii-xxxii.

McIntyre, Robert G. *Martin Johnson Heade, 1819-1904.* New York, 1948.

Marcus, Lois Goldreich. *Severin Roesen: A Chronology.* Williamsport, Pa., 1976.

Marcus, Margaret Fairbanks. *Flower Painting.* New York, 1953.

————. *Flower Painting by the Great Masters.* New York, 1954.

Marlin, Jane. "John Haberle: A Remarkable Contemporaneous Painter in Detail." *The Illustrated American* 24 (30 December 1898): 516-17.

Marlor, Clark S. *A History of The Brooklyn Art Association with an Index of Exhibitions.* New York, 1970.

Martin, Jennifer A. "The Rediscovery of Maria Oakey Dewing." *The Feminist Art Journal* 5 (Summer 1976): 24.

————. "Royal Cortissoz and Maria Oakey Dewing's 'Rose Garden.' " *The Yale University Library Gazette* 52 (October 1977): 84-88.

Marzio, Peter. *The Democratic Art.* Boston, 1979.

Mastai, Marie-Louise d'Otrange. *Illusion in Art: A History of Pictorial Illusionism.* New York, 1975.

Maytham, Thomas N. *"The Poor Man's Store,* 1885. John Frederick Peto." *Bulletin of the Museum of Fine Arts* (Boston) 60 (January-March 1962): 137-38.

Mielziner, Jo. "Arthur Carles: The Man Who Paints with Color." *Creative Art* 2 (February 1928): xxx-xxxv.

Miller, Lillian B. *The Collected Papers of Charles Willson Peale and His Family.* Millwood, N. Y., Kraus Microform, 1980.

"Minor Topics (George H. Hall)." *The Nation* 2 (22 March 1866): 357.

Mitchell, Peter. *The Flower Painters.* London, 1973.

Mitnick, Barbara J. "A Look at the Symbolism of the Rose and Its Place in American Painting." Term paper, City University of New York Graduate School, Spring 1979.

Mook, Maurice A. "Severin Roesen: Also the Huntington Painter." *Lycoming College Magazine* 26 (June 1973): 13.

————. "Severin Roesen and His Family." *The Journal of the Lycoming County Historical Society* 8 (Fall 1972): 8-12.

————. "S. Roesen, 'The Williamsport Painter.' " *The Allentown* (Pa.) *Morning Call,* 3 December 1955.

————. "Severin Roesen, The Williamsport Painter." *The Lycoming College Magazine* 25 (June 1972): 33-42.

Naylor, Maria K. *The National Academy of Design Exhibition Record, 1861-1900.* 2 vols. New York, 1973.

Neve, Christopher. "Victorian Bird's Nester (William Henry Hunt)." *Country Life* 151 (27 April 1972): 988-89.

Nissen, Claus. *Die botanische Buchillustration: Ihre Geschichte und Bibliographie.* 2 vols. Stuttgart, 1951; Supplement, 1966.

Norton, Thomas E. *Homage to Charles Demuth, Still Life Painter of Lancaster.* With additional essays by Alvord L. Eiseman, Sherman E. Lee, and Gerald S. Lestz, and a valedictory by Marsden Hartley. Ephrata, Pa., 1978.

O'Connor, John, Jr. "The Trophy of the Hunt." *Carnegie Magazine* 15 (January 1942): 245-46.

Oja, Carol J. "The Still-Life Paintings of William Michael Harnett." *The Musical Quarterly* 63 (October 1977): 505-23.

Parker, Barbara Neville. " 'The Old Cupboard Door' by William Michael Harnett." *Bulletin of the Museum of Fine Arts* (Boston) 38 (February 1940): 17.

Paviere, Sydney H. *A Dictionary of Flower, Fruit & Still Life Painters.* 4 vols. Leigh-on-Sea, England, 1962-1964.

————. *Floral Art, Great Masters of Flower Painting.* Leigh-on-Sea, England, 1965.

Perkins, Robert F., Jr., and Gavin, William J., III. *The Boston Athenaeum Art Exhibition Index, 1827-1874.* Boston, 1980.

Perl, Jed. "The Life of the Object: Still-Life Painting Today." *Arts* 52 (December 1977): 124-28.

Peters, Harry T. *America on Stone.* Garden City, N.Y., 1931.

————. *Currier & Ives, Print Makers to the American People.* 2 vols. Garden City, N.Y., 1929-31.

Phillips, Duncan. "J. Alden Weir." *Art Bulletin* 2 (June 1920): 189-212.

Phillips, Duncan, et al. *Julian Alden Weir: An Appreciation of His Life and Works.* The Phillips Publications Number One, New York, 1922.

Piwonka, Ruth, and Blackburn, Roderick H. "New Discoveries about Emma J. Cady." *Antiques* 113 (February 1978): 418-21.

Pleasants, Henry, Jr. "George Cope — The Realist." *Four Great Artists of Chester County.* West Chester, Pa., 1936.

———. "Our Own George Cope." *Yesterday in Chester County Art.* West Chester, Pa., 1936.

Popper-Voskuil, Naomi. "Selfportraiture and vanitas still-life painting in 17th-century Holland in reference to David Bailly's vanitas oeuvre." *Pantheon* 31 (January 1973): 58-74.

Prang, Louis, & Co. *Illustrated Catalogue of Art Publications for Spring, 1876.* Boston, 1876.

Price, Frederick Newlin. "Flowers and Gardens." *The American Magazine of Art* 14 (October 1923): 529-39.

Randall, Katherine Sawtelle. "Connecticut Artists and Their Work (Fidelia Bridges)." *Connecticut Magazine* 7 (February-March 1902): 583-88.

"Recent Acquisitions: Still-Life with Fruit, 1910, a Painting by John Johnston, American, ca. 1952-1818." *The Bulletin of the City Art Museum of Saint Louis,* N.S. 2 (March-April 1967): 4-5.

"The Return of Tromp-L'Oeil." *The Connoisseur* 125 (May 1950): 114-15.

Rensselaer, Mariana Van. "Exhibitions: Flower Pictures at the Academy of Design." *Garden and Forest* 6 (15 February 1893): 83.

———. "Flower and Fruit Pictures at the Academy of Design." *Garden and Forest* 1 (25 April 1888): 107-8.

Riley, Maude Kemper. "This Matter of Forgery." *MKR's Art Outlook* 7 (February 1946): 6-7. Reprint from *Island Ocean County Heights* (N.J.) *Courier* 1939.

Riley, Morgan T. "Meaning in the Rose." *American Rose Annual* (Harrisburg, Pa.) 34 (1949): 176-82.

Robinson, Frank T. "An American Landseer." *New England Magazine* 9 (January 1891): 631-41.

———. *Living New England Artists.* Boston, 1888.

Rogers, Meyric R. "Flower Painting Over Four Centuries." *Art News* 35 (22 May 1937): 8.

Rogers, Millard F., Jr. "Fishing Subjects by Junius Brutus Stearns." *Antiques* 98 (August 1970): 246-50.

Roof, Katherine Metcalf. *The Life and Art of William Merritt Chase.* New York, 1917.

Rosenfeld, Paul. *Port of New York.* New York, 1924; rev. ed., Urbana, Ill., 1961.

Rourke, Constance. *Charles Sheeler: Artist in the American Tradition.* New York, 1938.

Rutledge, Anna Wells. *Cumulative Record of Exhibition Catalogues: The Pennsylvania Academy of the Fine Arts, 1807-1870; the Society of Artists, 1800-1814; the Artists' Fund Society, 1835-1845.* Philadelphia, American Philosophical Society Memoirs, vol. 38, 1955.

Salinger, Margaretta. *Flowers: The Flowerpiece in European Painting.* New York, 1949.

Schriever, George. "An Endless World of Things: American Still-Life Painting to 1900." *Southwest Art* 10 (February 1981): 42-51.

Seiberling, Dorothy. "Horizons of a Pioneer (O'Keeffe)." *Life* 1 (March 1968): 40-53.

Sellers, Charles Coleman. "Rubens Peale: A Painter's Decade." *The Art Quarterly* 23 (Summer 1960): 139-52.

Sharf, Frederic A. "Fidelia Bridges 1834-1923, Painter of Birds and Flowers." *Essex Institute Historical Collections* 104 (July 1968): 1-22.

Sitwell, Sacheverell, and Blunt, Wilfred. *Great Flower Books, 1700-1900: A Bibliographic Record of Finely-Illustrated Flower Books.* London, 1956.

Snow, E. Taylor. "William Michael Harnett, a Philadelphia Catholic Artist." *American Catholic Historical Researches* 10 (April 1893): 74-76.

Soria, Regina, et al. *Perceptions and Evocations: The Art of Elihu Vedder.* Washington, D.C., 1979.

Staiti, Paul. "William Harnett." *Mount Holyoke College Art Museum* 4 (Fall 1980): 1-4.

Stebbins, Theodore E., Jr. *The Life and Works of Martin Johnson Heade.* New Haven and London, 1975.

Stein, Aaron Marc. "Still-Life in American Primitive Art." *Fine Arts* 19 (June 1932): 14.

Sterling, Charles. *Still Life Painting from Antiquity to the Present Time.* New York, 1959.

"Still Life." *The Aldine* 9: 6, 1878-1879 (November-December 1878 ?): 181-82.

Stone, Richard B. "Not Quite Forgotten: A Study of the Williamsport Painter, S. Roesen." *Lycoming Historical Society Proceedings and Papers* (Williamsport, Pa.) 9 (1951).

Troubnikoff, Aleksandr Aleksandrovitch. "'Trompe-L'Oeil': Tours de Force of Realism by Masters of the Brush." *Illustrated London News,* Christmas Number, vol. 193, 23 November 1938, pp. 11-15.

Troy, Nancy. "From the Peanut Gallery: The Rediscovery of De Scott Evans." *Yale University Art Gallery Bulletin* 36 (Spring 1977): 36-43.

Trumble, Alfred (Henry Alexander). *The Collector* 5 (1 June 1894): 227-28.

Tucker, Marcia. *American Paintings in the Ferdinand Howald Collection.* The Columbus Gallery of Fine Arts, Columbus, Ohio, 1969.

Tuckerman, Henry T. *Book of the Artists: American Artists Life.* New York, 1867.

———. "Flowers." *Godey's Ladies Book* 40 (January 1850): 13-18.

"Two Picture Sales (George Hall)." *The Nation* 2 (8 March 1866): 313.14.

Vedder, Elihu. *The Digressions of V.* Boston and New York, 1910.

Waern, Cecilia. *John La Farge: Artist and Writer.* London, 1896.

Warner, Ralph. *Dutch and Flemish Flower and Fruit Painters of the 17th and 18th Centuries.* London, 1928.

Watson, Ernest. "Still Life Painting by McFee." *American Artist* 12 (February 1948): 20-23.

Watson, Forbes. "A Note on Henry Lee McFee." *American Magazine of Art* 30 (March 1937): 142-43.

Wedmore, Frederick. *Whistler and Others.* New York, 1906. Essay on "Still Life," pp. 215-16.

Weitenkampf, Frank. "A Hackensack Ruskin Disciple." *New York Times,* 8 December 1901, Supplement, p. 11.

Weston, Latrobe. "Art and Artists in Baltimore." *Maryland Historical Magazine* 33 (September 1938): 213-27.

Wharton, Anne H. "Some Philadelphia Studios." *The Decorator and Furnisher* 7 (December 1885): 78.

Wheelock, Warren. "Henry Lee McFee — Comments on the Man and His Painting." *Art Instruction* 2 (November 1938): 4-9.

White, Nelson C. *Abbott H. Thayer Painter and Naturalist.* Hartford, 1951.

Whittet, George Sorley. *Bouquet: A Galaxy of Flower Painting.* New York, 1949.

Williams, George Alfred. "A Painter of Colorful Gardens (Abbott Graves)." *International Studio* 76 (January 1923): 304-9.

Williams, Hermann Warner, Jr. "Notes on William M. Harnett." *Antiques* 43 (June 1943): 260-62.

Wilson, Raymond L. "Henry Alexander: Chronicler of Commerce." *Archives of American Art Journal* 20, no. 2 (1980): 10-13.

Winchester, Alice. "Looking at Still Life." *Antiques* 42 (October 1952): 296-99.

Wolf, Ben. *Morton Livingston Schamberg.* Philadelphia, 1963.

Wright, Willard Huntington. *Modern Art, Its Tendency and Meaning.* New York, 1915.

Yeh, Susan Fillin. *Charles Sheeler and the Machine Age.* Ph.D. dissertation, City University of New York, 1981.

Zarnowska, E. *La nature-morte hollandaise. Les principaux representants, ses origines, son influence.* Brussels and Maestricht, 1929.

Index

Index of Illustrations

This book was produced by Philbrook Art Center, Tulsa, Oklahoma, and the University of Missouri Press, Columbia, Missouri.

Printed by Eastern Press, New Haven, Connecticut, on eighty-pound Warren's Lustro Offset Enamel Dull. Bound with twelve-point Carolina Cover (paper edition) and Joanna Arrestox C (cloth).
Set in ITC Palatino by Typo Photo Graphics Inc., Tulsa, Oklahoma.

Designed by Carol Haralson
Edited by Natalia Nadraga